THE TRUTH
IN PAINTING

JACQUES DERRIDA

THE TRUTH IN PAINTING

Translated by
Geoffrey Bennington
and Ian McLeod

The University of Chicago Press
Chicago and London

The University of Chicago Press, Chicago 60637
The University of Chicago Press, Ltd., London

24 23 22 21 20 19 18 17 12 13 14 15

ISBN: 978-0-226-50462-9 (paper)

First published as LA VÉRITÉ EN PEINTURE in Paris, © 1978,

Flammarion, Paris.

LIBRARY OF CONGRESS CATALOGING-IN-PUBLICATION DATA

Derrida, Jacques.
 The truth in painting.

 Translation of: La vérité en peinture.
 Includes index.
 1. Aesthetics. I. Title.
BH39.D45 1987 701'.I'7 86-30914
ISBN 0-226-14324-4 (pbk.)

Contents

List of Illustrations

+R (Into the Bargain)

Cartouches

Restitutions

Translators' Preface

Classically speaking, any translator is placed in the uncomfortable position of absolute generosity with respect to his or her readers, giving them as a gift a meaning they would not otherwise be able to obtain. The translator's task, in this conception, is a noble and even saintly one, an act of pure charity independent of incidental financial reward. This position is uncomfortable because it is false: in fact the translator's attitude to the reader is profoundly ambivalent, and this ambivalence can only be increased when s/he has learned from the author to be translated that the task is strictly speaking an impossible one. The absolutely generous project of giving Derrida's meaning to be read would rapidly produce the absolutely ungenerous result of leaving the text in French, leaving ourselves a certain amount of self-congratulation on being able at least to begin to read it that way, and slyly affecting commiseration for those unable to do so. The classical ideal of self-effacing, respectful, and charitable translation is in fact the death of translation.

Yet Derrida's work undeniably calls for translation, but for translation as transformation: that transformation affects both languages at work—our English is transformed as is Derrida's French. As Derrida notes, however, such a transformation must be regulated (though not, we would add, by the principle of charity for the reader): yet no *single* rule is sufficient for that regulation, and least of all the rule that our aim should be to reproduce in the English or American reader the same "effect" that Derrida's French produces on the French. Any such rule would be a radical

refusal of the trace of translation, and is in fact the fantasy of logocentrism itself. Refusing any such rule implies the adoption of flexible strategies, including those of supplying some of the French text, adding some explanatory footnotes, sometimes being guided almost exclusively by the signifier, as in parts of "+R" and in the subtitle of "Restitutions."

The problems facing the translator are at their greatest in the case of *idiom* (*The Truth in Painting* is also "about" the idiom [in painting]): pure idiom is the untranslatable itself. Here the best we can hope is that the reader might learn some French—it was a guiding fantasy of our work (a fantasy which remained just that) that by the end of the book the reader would have learned French and that our translation would thus have made itself unnecessary, although not self-effacing. No translation could be self-effacing before the *mise en boîte* of "Cartouches" or the *revenir* and *rendre* of "Restitutions." Not that these are *pure* idioms: but in Derrida's work of reliteralization and etymologization of such examples, the idiom becomes disseminated throughout the whole of French (and therefore several other languages too). This type of strategy completes the translators' discomfiture, in that it dispossesses of mastery even the claim to have *read La Vérité en peinture.*

It may seem paradoxical that in this situation we should claim the need for accuracy and rigor: but rigor here needs to be rethought in terms of flexibility and compromise, just as, in "Restitutions," stricture has also to be thought in terms of destricturation. The "compromise English" in which this translation is written is inevitable and should stand in no need of excuse, if only because the supplement is never simply a substitute. "Compromise English" also recognizes that the supplement is never final or definitive: this version is therefore also a call for retranslation and modification.

<div style="text-align: right">

Geoff Bennington
Ian McLeod

</div>

THE TRUTH
IN PAINTING

Passe-Partout

— I —

Someone, not me, comes and says the words: "I am interested in the idiom in painting."

You get the picture: the speaker is impassive, he remained motionless for the duration of his sentence, careful to refrain from any gesture. At the point where you were perhaps expecting it, near the head and around certain words, for example "in painting," he did not imitate the double horns of quotation marks, he did not depict a form of writing with his fingers in the air. He merely comes and announces to you: "I am interested in the idiom in painting."

As he comes and has just come [*vient de venir*], the frame is missing, the edges of any context open out wide. You are not completely in the dark, but what does he mean exactly?

Does he mean that he is interested in the idiom "in painting," in the idiom itself, for its own sake, "in painting" (an expression that is in itself strongly idiomatic; but what is an idiom?)?

That he is interested in the idiomatic expression itself, in the words "in painting"? Interested in words in painting or in the words "in painting"? Or in the words " 'in painting' "?

That he is interested in the idiom in painting, i.e., in what pertains to the idiom, the idiomatic trait or style (that which is singular, proper, inimitable) in the domain of painting, or else—another possible translation—in the singularity or the irreducible

specificity of pictorial art, of that "language" which painting is supposed to be, etc.?

Which makes, if you count them well, at least four hypotheses; but each one divides again, is grafted and contaminated by all the others, and you would never be finished translating them.

Nor will I.

And if you were to bide your time awhile here in these pages, you would discover that I cannot dominate the situation, or translate it, or describe it. I cannot report what is going on in it, or narrate it or depict it, or pronounce it or mimic it, or offer it up to be read or formalized without remainder. I would always have to renew, reproduce, and reintroduce into the formalizing economy of my tale—overloaded each time with some supplement— the very indecision which I was trying to reduce. At the end of the line it would be just as if I had just said: "I am interested in the idiom in painting."

And should I now write it several times, loading the text with quotation marks, with quotation marks within quotation marks, with italics, with square brackets, with pictographed gestures, even if I were to multiply the refinements of punctuation in all the codes, I wager that at the end the initial residue would return. It would have set in train a divided Prime Mover.

And I leave you now with someone who comes and says the words, it is not I: "I am interested in the idiom in painting."

— 2 —

The Truth in Painting is signed Cézanne. It is a saying of Cézanne's.

Resounding in the title of a book, it sounds, then, like a due.

So, to render it to Cézanne; and first of all to Damisch, who cites it before me,[1] I shall acknowledge the debt. I must do that. In order that the trait should return to its rightful owner.

But the truth in painting was always something owed.

Cézanne had promised to pay up: "I OWE YOU THE TRUTH IN PAINTING AND I WILL TELL IT TO YOU" (to Emile Bernard, 23 October 1905).

1. *Huit thèses pour (ou contre?) une sémiologie de la peinture, Macula* 2 (1977). From Damisch I even take the saying "saying" ("following the deliberately ambiguous saying or utterance of Cézanne") even if I were not to take what it says literally, for a reserve as to the limits of deliberation always remains here.

A strange utterance. The speaker is a painter. He is speaking, or rather writing, for this is a letter and this "bon mot" is more easily written than spoken. He is writing, in a language which shows nothing. He causes nothing to be seen, describes nothing, and represents even less. The sentence in no way operates in the mode of the statement/assertion [*constat*], it says nothing that exists outside the event which it constitutes but it commits the signatory with an utterance which the theorists of speech acts would here call "performative," more precisely with that sort of performative which they call "promise." For the moment I am borrowing from them only some convenient approximations, which are really only the names of problems, without knowing if there really are any such things as pure "constatives" and "performatives."

What does Cézanne do? He writes what he could say, but with a saying that does not assert anything. The "I owe you" itself, which could include a descriptive reference (I say, I know, I see that I owe you) is tied to an *acknowledgment* of debt which commits as much as it describes: it subscribes to.

Cézanne's promise, the promise made by the one whose signature is linked to a certain type of event in the history of painting and which binds more than one person after him, is a singular promise. Its performance does not promise, literally, to *say* in the constative sense, but again to *"do."* It promises another "performative," and the content of the promise is determined, like its form, by the possibility of that other. Performative supplementarity is thus open to infinity. With no descriptive or "constative" reference, the promise makes an event (it "does something" in uttering) provided that this possibility is assured by a certain conventional framing, in other words a context marked by performative fiction. Henceforth the promise does not make an event as does any "speech act": as a supplement to the act which it is or constitutes, it "produces" a singular event which depends on the performative structure of the utterance—a promise. But by way of another supplement, the object of this promise, that which is promised by the promise, is another performative, a "saying" which might well be—we do not yet know this—a "painting" which neither says nor describes anything, etc.

One of the conditions for the performance of such an event, for the unchaining of its chain, would, according to the classical theorists of speech acts, be that Cézanne should mean to say something and that one should be able to understand it. This

condition would be part of the fiction, in other words of the set
of conventional protocols, at the moment when someone such as
Emile Bernard sets about opening a letter.

Let us suppose that I wrote this book in order to find out
whether that condition could ever be fulfilled, whether there was
even any sense in defining it—which remains to be seen.

Does speech-act theory have its counterpart in painting? Does
it know its way around painting?

Since it always, and necessarily, has recourse to the values of
intention, truth, and sincerity, an absolute protocol must im-
mediately stick at this first question: what must truth be in order
to be *owed* [*due*], even be *rendered* [*rendue*]? In painting? And if
it consisted, in painting, of *rendering*, what would one mean when
one promised to render it itself as a due or a sum rendered [*un
rendu*]?

What does it mean, to render?

What about restriction? And in painting?

Let us open the letter, after Emile Bernard. So "the truth in
painting" would be a characteristic trait of Cézanne.

He supposedly signed it as one signs a shaft of wit. How can
this be recognized?

First of all by this: that the event, the doubly uncertain double
event contracts, and makes a contract with itself only at the
instant when the singularity of the trait divides in order to link
itself to the play, the chance, and the economy of a language. If
there existed, in full purity, any (quantity of) idiom or dialect,
one ought to be able to recognize them, at work, in this trait of
Cézanne. They alone would be capable of providing so powerful
an economic formalization in the elliptical savings of a natural
language, and of saying so many things in so few words, as long
as there still remain remainders (*leipsomena*), to exceed and over-
flow the ellipse in its reserve, to set the economy going by ex-
posing it to its chance.

Let us suppose that I have ventured this book, in its four
movements, for the interest—or the grace—of these remainders.

Remains—the untranslatable.

Not that the idiom "of the truth in painting" is simply un-
translatable, I mean the idiom of the locution, for the quotation
marks are not enough to assure us of it: it could be a matter of
the idiom of truth in painting, of that to which this strange lo-
cution seems to be able to refer and which can already be under-
stood in a multitude of ways. Untranslatable: this locution is not

absolutely so. In another language, given enough space, time, and endurance, it might be possible for long discourses to propose laborious approaches to it. But untranslatable it remains in its economic performance, in the ellipsis of its trait, the word by word, the word for word, or the trait for trait in which it contracts: as many words, signs, letters, the same quantity or the same expense for the same semantic content, with the same revenue of surplus value. That is what interests me, this "interest," when I say: "I am interested in the idiom of truth in painting."
You can always try to translate.

As for the meaning, for which of its pertinent features [*traits*] should one account in a translation which would no longer have an eye to pedagogical expense? There are at least four of them, supposing, *concesso non dato*, that the unity of each one remains unbroachable.

1. That which pertains to [*a trait à*] *the thing itself*. By reason of the power ascribed to painting (the power of direct reproduction or restitution, adequation or transparency, etc.), "the truth in painting," in the French language which is not a painting, could mean and be understood as: truth itself restored, in person, without mediation, makeup, mask, or veil. In other words the true truth or the truth of the truth, restituted in its power of restitution, truth looking sufficiently like itself to escape any misprision, any illusion; and even any representation—but sufficiently divided already to resemble, produce, or engender itself twice over, in accordance with the two genitives: truth of truth and truth of truth.

2. That which pertains, therefore, to adequate *representation*, in the order of fiction or in the *relief* of its effigy. In the French language, if such a one exists and is not a painting, "the truth in painting" could mean and be understood as: the truth faithfully represented, trait for trait, in its portrait. And this can go from reflection to allegory. The truth, then, is no longer itself in that which represents it in painting, it is merely its double, however good a likeness it is and precisely other by reason of the likeness. Truth of truth still, with the two genitives, but this time the value of adequation has *pushed aside* that of unveiling. The painting of the truth can be adequate to its model, in representing it, but it does not manifest it *itself*, in presenting it. But since the model here is truth, i.e., that value of presentation or representation, of unveiling or adequation, Cézanne's stroke [*trait*] opens up the abyss. (Heidegger in *The Origin of the Work of Art* names

the "stroke" [*Riss*] which not only opens above the gulf but also holds together the opposite edges of it.) If we are to understand Cézanne's sentence, the truth (presentation *or* representation, unveiling *or* adequation) must be rendered "in painting" either by presentation or by representation, according to the two models of truth. Truth, the painter's model, must be rendered in painting according to the two models of truth. Henceforth, the abyssal expression "truth of the truth," which will have made it be said that the truth is the nontruth, can be crossed with itself according to all sort of chiasmi, according as one determines the model as presentation or as representation. Presentation of the representation, presentation of the presentation, representation of the representation, representation of the presentation. Have I counted them correctly? That makes at least four possibilities.

 3. That which pertains to the *picturality,* in the "proper" sense, of the presentation or of the representation. Truth could be presented or represented quite otherwise, according to other modes. Here it is done *in painting:* and not in discourse (as is commonly the case), in literature, poetry, theater; nor is it done in the time of music or in other spaces (architecture or sculpture). Thus we retain here that which is proper to an art, the art of the signatory, of Cézanne the painter. That which is proper to an art and an art understood in the proper sense this time, in the expression "in painting." We did not do this in the two previous cases: "painting" was there to figure the presentation or representation of a model, which happened to be the truth. But this troping figuration was valid for the logic of any other art of presentation or representation. In the French language, if there is one that is one and if it is not a painting, "the truth in painting" could mean and be understood as: the truth, as shown, presented or represented in the field of the pictural properly speaking, in the pictural, properly pictural mode, even if this mode is tropological with respect to truth itself. To understand the expression "truth in painting" in this way, no doubt one has to move away a little from the greater force of usage (assuming that there are any rigorous criteria for evaluating it), while nevertheless maintaining grammatical and syntactical and even semantic normality. But that's what an idiom is, if there is any such thing. It does not merely fix the economic propriety of a "focus," but regulates the possibility of play, of divergences, of the equivocal—a whole economy, precisely, of the trait. This economy parasitizes itself.

4. That which pertains to truth in the order of painting, then, and *on the subject of* painting, not only as regards the pictorial presentation or representation of truth. The parasitizing of the expression "in painting" by itself allows it to harbor a new sense: the truth as regards painting, that which is *true on* that art which is called pictural. If one now defines that art by its truth-value, in one sense or the other, one will understand here the true on the true. In the French language, if there is one that is one and which is not painting, and if nonetheless it can open its system up to its own parasitism, "the truth in painting" can mean and be understood as: truth in the domain of painting and on the subject of it, *in painting*, as in the saying "to be knowledgeable in painting." I owe you the truth on painting and I will tell it to you, and as painting ought to be the truth, I owe you the truth about the truth and I will tell it to you. In letting itself be parasitized, the system of language as a system of the idiom has perhaps parasitized the system of painting; more precisely, it will have shown up, by analogy, the essential parasitizing which opens every system to its outside and divides the unity of the line [*trait*] which purports to mark its edges. This partition of the edge is perhaps what is inscribed and occurs everywhere [*se passe partout*] in this book; and the protocol-frame is endlessly multiplied in it, from *lemmata* to *parerga*, from *exergues* to *cartouches*. Starting with the idiom of the *passe-partout*. One is always tempted by this faith in the idiom: it supposedly says only one thing, properly speaking, and says it only in linking form and meaning too strictly to lend itself to translation. But if the idiom were this, were it what it is thought it must be, it would not be that, but it would lose all strength and would not make a language. It would be deprived of that which in it plays with truth-effects. If the phrase "the truth in painting" has the force of "truth" and in its play opens onto the abyss, then perhaps what is at stake in painting is truth, and in truth what is at stake (that idiom) is the abyss.

Cézanne's trait is easily freed from an immediate context. Is it even necessary to know that it was signed by a painter? Its force even depends on this capacity to play with the determinations of the context without making itself indeterminate. No doubt the trait acts as a passe-partout. It circulates very quickly among its possibilities. With disconcerting agility it displaces its accents or its hidden punctuation, it potentializes and formalizes and economizes on enormous discourses, it multiplies the deal-

ings and transactions, the contraband and graft and parasitizing among them. But it only *acts as* a passe-partout, this is only an appearance: it does not mean everything and anything. And besides, like every passe-partout (in the strictest sense!), it must formally, i.e., by its forms, answer to a finite system of constraints.

What does a passe-partout do? What does it cause to be done or shown?

— 3 —

The painter does not promise to *paint* these four truths in painting, to render what he owes. Literally, at least, he commits himself to *saying* them: "I owe you the truth in painting and I will tell it to you." If we understand him literally, he swears an oath to *speak*; he does not only speak, he promises to do so, he commits himself to speak. He swears an oath to say, by speech, the truth in painting, and the four truths in painting. The act of speech—the promise—gives itself out as true, or in any case truthful and sincere, and it veritably does promise to say truly the truth. In painting, don't forget.

But must we take a painter literally, once he starts to speak? Coming from a Cézanne, "I will tell it to you" can be understood figuratively: he could have promised to tell the truth, in painting, to tell these four truths according to the pictorial metaphor of discourse or as a discourse silently working the space of painting. And since he promises to tell them "in painting," one does not even need to know of the signatory, for this hypothesis, that he is a painter.

This connection [*trait*] between the letter, discourse, painting is perhaps all that happens in or all that threads its way through *The Truth in Painting*.

The signatory promises, it seems, to "say" in painting, by painting, the truth and even, if you like, the truth in painting. "I owe you the truth in painting" can easily be understood as: "I must render the truth to you in painting," in the form of painting and by acting as a painter myself. We have not got to the end of this *speech act* promising perhaps a *painting act*. With this verbal promise, this performative which does not describe anything, Cézanne *does* something, as much as and more than he says. But in doing so, he promises that he will *say* the truth in painting. What he does is to commit himself to say something. But that saying could well be a doing, or a discursive doing, another performative

saying, producing a truth which was not already there, or a pictorial doing which, by reason of some occupancy of painting by speech, would have the value of saying. In the performance of this performative promising another performative saying nothing that will be *there*, the allegory of truth in painting is far from offering itself completely naked on a canvas.

Thus one dreams of a painting without truth, which, without debt and running the risk of no longer saying anything to anyone [of not interesting anyone: *ne plus rien dire à personne*—Trans.], would still not give up painting. And this "without," for example in the phrase "without debt" or "without truth," forms one of the lightweight imports of this book.

What happens everywhere where these supplements of unchained performatives interlace their simulacra and the most serious quality of their literality? What happens in a game so perverse but also so necessary? One wonders what is left of it when the idiom-effect joins the party, the trait scarcely leaving the initiative to the so-called signatory of the promise. Did Cézanne *promise, truly* promise, promise to *say*, to say *the truth*, to say *in painting* the truth *in painting?*

And me?

— 4 —

I write four times here, *around* painting.

The first time I am occupied with folding the great philosophical question of the tradition ("What is art?" "the beautiful?" "representation?" "the origin of the work of art?" etc.) on to the insistent atopics of the *parergon:* neither work (*ergon*) nor outside the work [*hors d'oeuvre*], neither inside nor outside, neither above nor below, it disconcerts any opposition but does not remain indeterminate and it *gives rise* to the work. It is no longer merely around the work. That which it puts in place—the instances of the frame, the title, the signature, the legend, etc.—does not stop disturbing the *internal* order of discourse on painting, its works, its commerce, its evaluations, its surplus-values, its speculation, its law, and its hierarchies. On what conditions, if it's even possible, can one exceed, dismantle, or displace the heritage of the great philosophies of art which still dominate this whole problematic, above all those of Kant, Hegel, and, in another respect, that of Heidegger? These prolegomena of *The Truth in Painting,* themselves the *parergon* of this book, are ringed together by a circle.

The second time, more attentive to the ring [*cerne*] itself, I attempt to decrypt or unseal a singular contract, the one that can link the phonic trait to the so-called *graphic* trait, even prior to the existence of the word (e.g., GL, or TR, or +R). Invisible and inaudible, this contract follows other paths, through different point-changes: it has to do with the letter and the proper name *in painting*, with narration, technical reproduction, ideology, the phoneme, the biographeme, and politics, among other things and still in painting. The opportunity will be given by *The Journey of the Drawing* by Valerio Adami.

The third time, putting in question again the trait as a signature, whether this signature passes via the proper name known as *patronymic* or via the idiom of the draftsman sometimes called *ductus*, I explore in its logical consistency the system of *duction* (production, reproduction, induction, reduction, etc.). This amounts to treating the trait, its unity and divisibility, otherwise, and it goes without saying that this has to do with the initial, as in "someone's initials," and with repetition and number, the model and paradigm, the series, the date, the event (the time, the chance, the throw, the turn), above all with genealogy and remainders, in the work of mourning: *in painting*. *Cartouches* gives its name—proper and common, masculine and feminine[2]—to the opportunity furnished by *The Pocket Size Tlingit Coffin*, by Gérard Titus-Carmel.

The fourth time, I interweave all these threads through a polylogue of n + 1 voices, which happens to be that of a woman. What happens (and of what? and of whom?) wherever shoelaces are presented? Present themselves and disappear (*da/fort*), pass over and under, inside and outside, from left to right and vice versa? And what happens with (does without) shoelaces when they are more or less undone? What takes place when they are unlaced in painting? One looks for the revenue (return on investment) or the ghost [*revenant*], that which has just come back [*vient de revenir*], in these steps without steps, in these shoes of which nothing assures us that they make a pair. Thus the question of the *interlace* [*l'entrelacs*] and the *disparate* resounds. To whom and to what do the "shoes of Van Gogh" return in their truth of painting? What is a desire of *restitution* if it pertains to [*a trait à*] the truth in painting? The opportunity here was given by a sort of duel between Heidegger and Schapiro. A third party (more than a third party, nothing *less* than witnesses) feigned death while the

2. *Le cartouche* means a cartouche, *la cartouche* a cartridge.—
TRANS.

two of them fenced, for the sake of giving back [*rendre*] these shoes, properly, honestly, and lawfully, to their true addressee.

Four times, then, *around* painting, to turn merely around it, in the neighboring regions which one authorizes oneself to enter, that's the whole story, to recognize and contain, like the surrounds of the work of art, or at most its outskirts: frame, title, signature, museum, archive, reproduction, discourse, market, in short: everywhere where one legislates on *the right to painting* by marking the limit, with a slash marking an opposition [*d'un trait d'opposition*] which one would like to be indivisible. Four times around color, too, which is thought to be extraneous to the trait, as if chromatic difference did not count. Now a *parergon* and some *cartouches* leave no assurance as to the right of such an approach. We have to approach things otherwise.

The common feature [*trait*] of these four times is perhaps the trait. Insofar as it is never common, nor even one, with and without itself. Its divisibility founds text, traces and remains.

Discourses on painting are perhaps destined to reproduce the limit which constitutes them, whatever they do and whatever they say: there is for them an inside and an outside of the work as soon as there is work. A series of oppositions comes in the train of this one, which, incidentally, is not necessarily primary (for it belongs to a system whose edging itself reintroduces the problem). And there the trait is always determined as an opposition-slash.

But what happens *before* the difference becomes opposition in the trait, or *without* its doing so? And what if there were not even a *becoming* here? For *becoming* has perhaps always had as its concept this determination of difference as opposition.

So the question would no longer be "What is a trait?" or "What does a trait become?" or "What pertains to such a trait?" but "How does the trait treat itself? Does it contract in its retreat?" A trait never appears, never itself, because it marks the difference between the forms or the contents of the appearing. A trait never appears, never itself, never for a first time. It begins by retrac(t)ing [*se retirer*]. I follow here the logical succession of what I long ago called, before getting around to the turn of painting, the *broaching* [*entame*] of the origin: that which opens, with a trace, without initiating anything.

One space remains to be broached in order to give place to the truth in painting. Neither inside nor outside, it spaces itself without letting itself be framed but it does not stand outside

the frame. It works the frame, makes it work, lets it work, gives it work to do (let, make, and give will be my most misunderstood words in this book). The trait is attracted and retrac(t)ed there by itself, attracts and dispenses with itself there [*il s'y attire et s'y passe, de lui-même*]. It is situated. It situates between the visible edging and the phantom in the center, from which we *fascinate*. I propose to use this word intransitively, as one would say "we hallucinate," "I salivate," "you expire," "she has a hard-on," or "the boat lies at anchor" [*le bâteau mouille*]. *Between* the outside and the inside, between the external and the internal edge-line, the framer and the framed, the figure and the ground, form and content, signifier and signified, and *so on* for any two-faced opposition. The trait thus divides in this place where it takes place. The emblem for this *topos* seems undiscoverable; I shall borrow it from the nomenclature of framing: the *passe-partout*.

The passe-partout which here creates an event must not pass for a master key. You will not be able to pass it from hand to hand like a convenient instrument, a short treatise, a viaticum or even an organon or pocket canon, in short a transcendental pass, a password to open all doors, decipher all texts and keep their chains under surveillance. If you rushed to understand it in this way, I would have to issue a warning [*avertissement*]: this forward [*avertissement*] is not a passe-partout.

I write right on the passe-partout well known to picture-framers. And in order to broach it, right on this supposedly virgin surface, generally cut out of a square of cardboard and open in its "middle" to let the work appear. The latter can, moreover, be replaced by another which thus slides into the passe-partout as an "example." To that extent, the passe-partout remains a structure with a movable base; but although it lets something appear, it does not form a frame in the strict sense, rather a frame within the frame. Without ceasing (that goes without saying) to space itself out, it plays its card or its cardboard *between* the frame, in what is properly speaking its internal edge, and the external edge of what it gives us to see, lets or makes appear in its empty enclosure: the picture, the painting, the figure, the form, the system of strokes [*traits*] and of colors.

What appears, then, and generally under glass, only appears to do without the passe-partout on which it banks [*fait fonds*].

This would be almost the place for a preface or a foreward, *between*, on the one hand, the cover that bears the names (au-

thor and publisher) and the titles (work and series or field), the
copyright, the fly leaf, and, on the other hand, the first word of
the book, here the first line of *Lemmata*, with which one ought
to "begin."

Passe-partout, the word and the thing, has other uses, but
what would be the point of listing them? They can be found
easily [*ils se trouvent tout seuls*]. And if I were to put them all
in a table [*tableau: also "picture"*—TRANS.], there would always
be one that would play among the others, one taken out of the
series in order to surround it, with yet one more turn.

Passe-partout nevertheless cannot be written in the plural,
by reason of grammatical law. This derives from its idiomatic
makeup and the grammatical invariability of the adverb. But it
can be understood in the plural: "Curiosities of all sorts, plaster
casts, molds, sketches, copies, passe-partout containing engrav-
ings" (Théophile Gautier). In a word, it is written in the singular
but the law of its agreements may require the plural.

The internal edges of a passe-partout are often beveled.

PARERGON

Fragments detached (unframed) from the course of an exposition. Or in other words, of a seminar.

 A first (shorter) version—very abridged in the protocols entitled "Lemmata"—appeared in *Digraphe* 3 and 4 (1974). The fourth section, "The Colossal," is entirely unpublished.

 The first version was not accompanied by any "illustrative" exhibition. Here it is different. But in this first chapter or quarter-book, the iconography has not the same purpose as in the three following it, where the writing seems to refer to the "picture." Here, a certain illustrative detachment, without reference, without title or legitimacy, comes as if to "illustrate," in place of ornament, the unstable *topos* of ornamentality. Or in other words, to "illustrate," if that is possible, the *parergon*.

1. Lemmata

it's enough

to say: abyss and satire of the abyss —

|

|— begin and end with a "that's enough"
which would have *nothing to do with* the sufficing or self-suffic-
ing of sufficiency, *nothing to do with* satisfaction. Reconsider,
further on, the whole syntax of these untranslatable locutions,
the *with* of the *nothing to do* [*rien à voir avec, rien à faire avec*].
Write, if possible, finally, without *with*, not *without*[1] but without
with, finally, *not even oneself*.

Opening with the *satis*, the *enough* (inside and outside,
above and below, to left and right), satire, farce on the edge of
excess —

NOTE.—Unless followed by the author's initials, all notes to "Par-
ergon" have been added by the translators. The longer passages from Kant
are quoted from the English translation, *Kant's Critique of Aesthetic
Judgement* by James Creed Meredith (Oxford: Clarendon Press, 1911),
and page references to this work are given in brackets in the text.

1. In English in the text.

| displacement of the "pivot" [*cheville*, also "ankle"] ("avec," "cum," "ama," "simul," etc.) *since* "Ousia et grammē."[2] Seek as always the lock and the "little key." Lure of writing *with oneself.* "With resources which would lead into the interior of the system of painting, importing *into* the theory of painting all the questions and all the question-codes developed here, around the effects of the 'proper name' and the 'signature,' stealing, in the course of this break-in, all the rigorous criteria of a framing—between the inside and the outside—carrying off the frame (or rather its joints, its angles of assembly) no less than the inside or the outside, the painting or the thing (imagine the damage caused by a theft which robbed you only of your frames, or rather of their joints, and of any possibility of reframing your valuables or your art-objects)." (*Glas*)

 what is a title?
And what if *parergon* were the title?

Here the false title is art. A seminar would treat *of art.* Of art and the fine arts. It would thus answer to a program and to one of its great questions. These questions are all taken from a determinate set. Determined according to history and system. The history would be that of philosophy within which the history of the philosophy of art would be marked off, insofar as it treats of art and of the history of art: its models, its concepts, its problems have not fallen from the skies, they have been constituted according to determinate modes at determinate moments. This set forms a system, a greater logic and an encyclopedia within which the fine arts would stand out as a particular region. The *Agrégation de philosophie* also forms a history and a system

2. "Ousia et grammē: note sur une note de *Sein und Zeit*," in *Marges: de la philosophie* (Paris: Minuit, 1972), 31–78; translated by Alan Bass as *Margins of Philosophy (Chicago: University of Chicago Press, 1982),* 29–67.

|___ how a question of this type—art—becomes inscribed
in a program. We must not only turn to the history of philosophy,
for example to the Greater Logic or the Encyclopedia of Hegel, to
his *Lectures on Aesthetics* which sketch out, precisely, one part
of the encyclopedia, system of training for teaching and cycle of
knowledge. We must take account of certain specific relays, for
example those of so-called philosophy teaching in France, in the
institution of its programs, its forms of examinations and com-
petitions, its scenes and its rhetoric. Whoever undertook such an
inquiry—and I do no more here than point out its stakes and its
necessity—would no doubt have to direct herself, via a very over-
determined political history, toward the network indicated by the
proper name of Victor Cousin, that very French philosopher and
politican who thought himself very Hegelian and never stopped
wanting to *transplant* (that is just about his word for it) Hegel
into France, after having insistently asked him, in writing at least,
to impregnate him, Cousin, and through him French philosophy
(letters quoted in *Glas*, pp. 207ff). Strengthened, among other
things, by this more or less hysterical pregnancy, he played a
determinant role, or at least represented one, in the construction
of the French University and its philosophical institution—all the
teaching structures that we still inhabit. Here I do no more than
name, with a proper name as one of the guiding threads, the
necessity of a deconstruction. Following the consistency of its
logic, it attacks not only the internal edifice, both semantic and
formal, of philosophemes, but also what one would be wrong to
assign to it as its external housing, its extrinsic conditions of
practice: the historical forms of its pedagogy, the social, economic
or political structures of this pedagogical institution. It is because
deconstruction interferes with solid structures, "material" insti-
tutions, and not only with discourses or signifying representa-
tions, that it is always distinct from an analysis or a "critique."
And in order to be pertinent, deconstruction works as strictly as
possible in that place where the supposedly "internal" order of
the philosophical is articulated by (internal *and* external) neces-
sity with the institutional conditions and forms of teaching. To
the point where the concept of institution itself would be sub-

jected to the same deconstructive treatment. But I am already
leading into next year's seminar (1974–5) ——
 |

|
—— to delimit
now a narrower entry into what I shall try to expound this year
in the course. Traditionally, a course begins by the semantic anal-
ysis of its title, of the word or concept which entitles it and which
can legitimate its discourse only by receiving its own legitimation
from that discourse. Thus one would begin by asking oneself:
What is *art*? Then: Where does it come from? What is the origin
of art? This assumes that we reach agreement about what we
understand by the word *art*. Hence: What is the origin of the
meaning of "art"? For these questions, the *guiding thread* (but it
is precisely toward the notion of the *thread* and the *interlacing*
that I should like to lead you, from afar) will *always* have been
the existence of "works," of "works of art." Hegel says so at the
beginning of the *Lectures on Aesthetics:* we have before us but a
single representation, namely, that there are works of art. This
representation can furnish us with an appropriate point of depar-
ture. So the question then becomes: What is "the origin of the
work of art"? And it is not without significance that this question
gives its title to one of the last great discourses on art, that of
Heidegger.
 This protocol of the question installs us in a fundamental
presupposition, and massively predetermines the system and
combinatory possibilities of answers. What it begins by implying
is that art—the word, the concept, the thing—has a unity and,
what is more, an originary meaning, an *etymon*, a truth that is
one and *naked* [*une vérité une et nue*], and that it would be
sufficient to unveil it *through* history. It implies first of all that
"art" can be reached following the three ways of word, concept,
and thing, or again of signifier, signified, and referent, or even by
some opposition between presence and representation.
 Through history: the crossing can in this case just as well
denote historicism, the determining character of the historicity
of meaning, as it can denote ahistoricity, history crossed, trans-
fixed in the direction of meaning, in the sense of a meaning [*le
sens d'un sens*] in itself ahistorical. The syntagm "through his-

tory" could entitle all our questions without constraining them in advance. By presupposing the *etymon*—one and naked [*un et nu*]—a presupposition without which one would perhaps never open one's mouth, by beginning with a meditation on the apparent polysemy of *tekhnē* in order to lay bare the simple kernel which supposedly lies hidden behind the multiplicity, one gives oneself to thinking that *art* has a meaning, one meaning. Better, that its history is *not* a history or that it is *one* history only in that it is governed by this one and naked meaning, under the regime of its internal meaning, as history of the meaning of art. If one were to consider the *physis/tekhnē* opposition to be irreducible, if one were to accredit so hastily its translation as *nature/art* or *nature/ technique*, one would easily commit oneself to thinking that art, being no longer nature, is history. The opposition nature/history would be the analogical relay of *physis/tekhnē*. One can thus already say: as for history, we shall have to deal with the contradiction or the oscillation between two apparently incompatible motifs. They both ultimately come under one and the same logical formality: namely, that if the philosophy of art always has the greatest difficulty in dominating the history of art, a certain concept of the historicity of art, this is, paradoxically, because it too easily thinks of art as historical. What I am putting forward here obviously assumes the transformation of the concept of history, from one statement to the other. That will be the work of this seminar

|

|____ If, there-
fore, one were to broach lessons on art or aesthetics by a question of this type ("What is art?" "What is the origin of art or of works of art?" "What is the meaning of art?" "What does art mean?" etc.), the form of the question would already provide an answer. Art would be predetermined or precomprehended in it. A conceptual opposition which has traditionally served to comprehend art would already, always, be at work there: for example the opposition between meaning, as inner content, and form. Under the apparent diversity of the historical forms of art, the concepts of art or the words which seem to translate "art" in Greek, Latin, the Germanic languages, etc. (but the closure of this list is already problematic), one would be seeking a one-and-naked meaning [*un*

sens un et nu] which would inform from the inside, like a content, while distinguishing itself from the forms which it informs. In order to think art in general, one thus accredits a series of oppositions (meaning/form, inside/outside, content/container, signified/signifier, represented/representer, etc.) which, precisely, structure the traditional interpretation of works of art. One makes of art in general an object in which one claims to distinguish an inner meaning, the invariant, and a multiplicity of external variations *through* which, as through so many veils, one would try to see or restore the true, full, originary meaning: one, naked. Or again, in an analogous gesture, by asking what art *means* (to say), one submits the mark "art" to a very determined regime of interpretation which has supervened in history: it consists, in its *tautology* without reserve, in interrogating the *vouloir-dire* of every work of so-called art, even if its form is not that of saying. In this way one wonders what a plastic or musical work means (to say), submitting all productions to the authority of speech and the "discursive" arts

|

|

___ such that
by accelerating the rhythm a little one would go on to this collusion: between the question ("What is art?" "What is the origin of the work of art?" "What is the meaning of art or of the history of art?") and the hierarchical classification of the arts. When a philosopher repeats this question without transforming it, without destroying it in its form, its question-form, its onto-interrogative structure, he has already subjected the whole of *space* to the discursive arts, to voice and the *logos*. This can be verified: teleology and hierarchy are prescribed in the envelope of the question

|

|___

the philosophical en-
closes art in its circle but its discourse on art is at once, by the
same token, caught in a circle.

Like the figure of the third term, the figure of the circle asserts
itself at the beginning of the *Lectures on Aesthetics* and the *Origin
of the Work of Art*. So very different in their aim, their procedure,
their style, these two discourses have in common, as a common
interest, that they exclude—(that) which then comes to form,
close and bound them from inside and outside alike.

And if it were a frame

one of them, Hegel's,
gives classical teleology its greatest deployment. He finishes off,
as people say a little too easily, onto-theology. The other, Hei-
degger's, attempts, by taking a step backwards, to go back behind
all the oppositions that have commanded the history of aesthetics.
For example, in passing, that of form and matter, with all its
derivatives. Two discourses, then, as different as could be, on
either side of a line whose tracing we imagine to be simple and
nondecomposable. Yet how can it be that they have in common
this: the subordination of all the arts to speech, and, if not to
poetry, at least to the poem, the said, language, speech, nomi-
nation (*Sage, Dichtung, Sprache, Nennen*)? (Reread here the third
and final part of the *Origin* . . . , "Truth and Art.")

not go any further, for the moment, in the reading
of these two discourses. Keeping provisionally to their introduc-
tions, I notice the following: they both start out from a figure of
the circle. And they stay there. They stand in it even if their
residence in the circle apparently does not have the same status
in each case. For the moment I do not ask myself: What is a circle?
I leave to one side the figure of the circle, its place, its privilege
or its decadence in the history of art. Since the treatment of the
circle is part of the history of art and is delimited in it as much
as it delimits it, it is perhaps not a neutral gesture to apply to it

something that is also nothing other than one of its figures. It is still a circle, which redoubles, re-marks, and places *en abyme* the singularity of this figure. Circle of circles, circle in the encircled circle. How could a circle place itself *en abyme*?

The circle and the abyss, that would be the title. On the way we will no doubt encounter the question of the title. What happens when one entitles a "work of art"? What is the *topos* of the title? Does it take place (and where?) in relation to the work? On the edge? Over the edge? On the internal border? In an overboard that is re-marked and reapplied, by invagination, within, between the presumed center and the circumference? Or between that which is framed and that which is framing in the frame? Does the *topos* of the title, like that of a *cartouche*, command the "work" from the discursive and juridical instance of an *hors-d'oeuvre*, a place outside the work, from the exergue of a more or less directly definitional statement, and even if the definition operates in the manner of a performative? Or else does the title play *inside* the space of the "work," inscribing the legend, with its definitional pretension, in an ensemble that it no longer commands and which constitutes it—the title—as a localized effect? If I say for example that the circle and the abyss will be the title of the play that I am performing today, as an introduction, what am I doing and what is happening? Will the circle and the abyss be the object of my discourse and defined by it? Or else do they describe the form which constrains my discourse, its scene rather than its object, and moreover a scene stolen away by the abyss from present representation? As if a discourse on the circle also had to *describe* a circle, and perhaps the very one that it describes, describe a circular movement at the very moment that it describes a circular movement, describe it displacing itself in its meaning [*sens*]; or else as if a discourse on the abyss had to know the abyss, in the sense that one knows something that happens to or affects one, as in "to know failure" or "to know success" rather than to know an object. The circle and the abyss, then, the circle *en abyme.*

beginning
of the *Lectures on Aesthetics*. From the first pages of the intro-
duction, Hegel poses, as always, the question of the point of
departure. How is one to begin a philosophical discourse on
aesthetics? Hegel had already linked the essence of the beautiful
to the essence of art. According to the determinate opposition
of nature and mind, and *thus* of nature and art, he had already
posited that a philosophical work devoted to aesthetics, the
philosophy or science of the beautiful, must exclude natural
beauty. It is in everyday life that one speaks of a beautiful sky.
But there is no natural beauty. More precisely, artistic beauty is
superior to natural beauty, as the mind that produces it is su-
perior to nature. One must therefore say that absolute beauty,
the *telos* or final essence of the beautiful, appears in art and not
in nature as such. Now the problem of the introduction causes
no difficulty in the case of the natural or mathematical sciences:
their object is given or determined in advance, and with it the
method that it requires. When, on the contrary, the sciences
bear on the products of the mind, the "need for an introduction

rà R. P. CAROLI MALAPERTII Belg
Montenſis è Societate IESV.

DVACI,

Officina BALTAZARIS BELLERI Typograp

or preface makes itself felt." Since the object of such sciences is produced by the mind, by that which knows, the mind will have to have engaged in a self-knowledge, in the knowledge of what it produces, of the product of its own production. This autodetermination poses singular problems of priority. The mind must put itself into its own product, produce a discourse on what it produces, introduce itself of itself into itself. This circular duction, this intro-reduction to oneself, calls for what Hegel names a "presupposition" (*Voraussetzung*). In the science of the beautiful, the mind presupposes itself, anticipates itself, precipitates itself. *Head first.* Everything with which it commences is already a result, a *work*, an effect of a projection of the mind, a *resultare.* Every foundation, every justification (*Begründung*) will have been a result—this is, as you know, the mainspring of the speculative dialectic. Presuppositions must proceed from a "proven and demonstrated necessity," explains Hegel. "In philosophy, nothing must be accepted which does not possess the character of necessity, which means that everything in philosophy must have the value of a result."

We are, right from the introduction, encircled.

No doubt art figures one of those productions of mind thanks to which the latter returns to itself, comes back to consciousness and cognizance and comes to its proper place by *returning* to it, in a circle. What is *called* [*s'appelle:* lit. "calls itself"] mind is that which says to itself "come" only to hear *itself* already saying "come back." The mind is what it is, says what it means, only *by returning.* Retracing its steps, in a circle. But art forms only one of the circles in the great circle of the *Geist* or the revenant (this visitor can be called *Gast,* or *ghost, guest* or *Gespenst*). The end of art, and its truth, is religion, that other circle of which the end, the truth, will have been philosophy, and so on. And you know—we shall have to get the most out of this later on—the function of the ternary rhythm in this circulation. The fact remains that here art is studied from the point of view of its end. Its pastness is its truth. The philosophy of art is thus a circle in a circle of circles: a "ring" says Hegel, in the totality of philosophy. It turns upon itself and in annulling itself it links onto other rings. This annular concatenation forms the circle of circles of the philosophical encyclopedia. Art cuts out a circumscription or takes away a circumvolution from it. It encircles itself —

|___ the inscription of a circle
in the circle does not necessarily *give* the abyss, onto the abyss,
en abyme. In order to be abyssal, the smallest circle must inscribe
in itself the figure of the largest. *Is there* any abyss in the Hegelian
circulation? To the question posed in this form there is no decid-
able answer. What does the "there is" mean in these statements?
Wherein does the "there is" differ from a "there exists," or "X
is," "X presents itself," "X is present," etc.? Skirting round a nec-
essary protocol here (it would proceed via the *gift* or the giving
of the abyss, onto the abyss, *en abyme*, via the problematic of
the *es gibt, il y a, it gives* [*ça donne*], and of the *es gibt Sein*,
opened by Heidegger), I note only this: the answer arrests the
abyss, unless it be already dragged down into it in advance. And
can be in it without knowing it, at the very moment that a prop-
osition of the type "this is an abyss or a *mise en abyme*" appears
to destroy the instability of the relations of whole to part, the
indecision of the structures of inclusion which throws *en abyme*.
The statement itself can *form part of the whole* ___|

|___ meta-
phor of the circle of circles, of training (*Bildung*) as philosophical
encyclopedia. Organic metaphor, finalized as a whole whose parts
conspire. Biological metaphor too. But it is also a metaphor, if it
is a metaphor, for art and for the work of art. The totality of
philosophy, the encyclopedic corpus is described *as* a living or-
ganism *or as* a work of art. It is represented on the model of one
of its parts which thus becomes greater than the whole of which
it forms part, which it makes into a part. As always, and Kant
formalized this in an essential way, the communication between
the problem of aesthetic judgment and that of organic finality is
internal. At the moment of describing *lemmatic* precipitation,
the need to treat the concept of *philosophy of art* in an anticipatory

way, Hegel has to have recourse, certainly, to the metaphor of the circle and of the circle of circles which he says, moreover, is *only* a representation. But also to the metaphor of the organic whole. Only philosophy in its entirety (*gesammte Philosophie*) gives us knowledge of the universe as a unique organic totality in itself, which develops "from its own concept." Without losing anything of what makes it a whole "which returns to itself," this "sole world of truth" is contained, retained, and gathered together in itself. In the "circlet" of this scientific necessity, each part represents a "circle returning into itself" and keeping a tie of solidarity with the others, a necessary and simultaneous interlacing. It is animated by a "backward movement" (*ein Rückwärts*) and by a "forward movement" (*Vorwärts*) by which it develops and reproduces itself in another in a fecund way (*fruchtbar*). Thus it is that, for us, the concept of the beautiful and of art is "a presupposition given by the system of philosophy." Philosophy alone can pose the question "What is the beautiful?" and answer it: the beautiful is a production of art, i.e., of the mind. The idea of beauty is given to us by art, that circle inside the circle of the mind and of the philosophical encyclopedia, etc.

Before beginning to speak of the beautiful and of the fine arts, one ought therefore, by right, to develop the whole of the *Encyclopedia* and the *Greater Logic*. But since it is necessary, in fact, to begin "lemmatically, so to speak" (*sozusagen lemmatisch*) by anticipation or precipitation of the circlet, Hegel recognizes that his point of departure is vulgar, and its philosophical justification insufficient. He will have begun by the "representation" (*Vorstellung*) of art and of the beautiful for the "common consciousness" (*im gewöhnlichen Bewusstsein*). The price to be paid may seem very heavy: it will be said for example that the whole aesthetics develops, explicates, and lays out the representations of naïve consciousness. But does not this negative cancel itself at once? On the immediately following page, Hegel explains that on a circle of circles, one is justified in starting from any point. "There is no absolute beginning in science."

The chosen point of departure, in everyday *representation: there are* works of art, we have them *in front of us* in representation (*Vorstellung*). But how are they to be recognized? This is not an abstract and juridical question. At each step, at each example, in the absence of enormous theoretical, juridical, political, etc. protocols, there is a trembling of the limit between the "there is" and the "there is not" "work of art," between a "thing" and

a "work," a "work" in general and a "work of art." Let's leave it. What does "leave" [*laisser*] mean ([*laisser*] *voir* [allow to see (or be seen)], [*laisser*] *faire* [allow to do (or be done)], *voir faire, faire voir, faire faire* [cause (something) to be done], leave as a remainder, leave in one's will), what does "leave" do? etc. ———

|

|——— certainly not insignificant that more than a century later, a meditation on art begins by turning in an analogous circle while pretending to take a step beyond or back behind the whole of metaphysics or western ontotheology. *The Origin of the Work of Art* will have taken a running start for an incommensurable leap. Certainly, and here are some dry indications of it, pending a more patient reading.

1. All the oppositions which support the metaphysics of art find themselves questioned, in particular that of form and matter, with all its derivatives. This is done in the course of a questioning on the being-work of the work and the being-thing of a thing in all the determinations of the thing that more or less implicitly support any philosophy of art (*hypokeimenon, aistheton, hylē*).

2. As the *Postface* indicates, it is from the possibility of its death that art can here be interrogated. It is possible that art is in its death throes, but "it will take a good few centuries" until it dies and is mourned (Heidegger does not mention mourning). The *Origin* is situated in the zone of resonance of Hegel's *Lectures on Aesthetics* in as much as they think of art as a "past": "In the most comprehensive (*umfassendsten*) meditation which the West possesses on the essence of art—comprehensive because thought out from metaphysics—in Hegel's *Lectures on Aesthetics*, stands the following proposition: 'But we no longer have an absolute need to bring a content to presentation (*zur Darstellung*) in the form of art. Art, from the aspect of its highest destination, is for us something past (*ein Vergangenes*).' " After recalling that it would be laughable to elude this proposition under the pretext that works have survived this verdict—a possibility which, one can be sure, did not escape its author—Heidegger continues: "But the question remains: is art still, or is it no longer, an essential and necessary mode (*Weise*) according to which the decisive [deciding] truth

happens (*geschieht*) for our historical (*geschichtliches*) Dasein? But if it is no longer that, then the question remains: why? The decision about Hegel's proposition has not yet been reached." So Heidegger interrogates art and more precisely the work of art as the advent or as the history of truth, but of a truth which he proposes to think beyond or behind metaphysics, beyond or behind Hegel. Let's leave it for the moment.

3. Third indication, again recalled in the *Postface:* the beautiful is not relative to pleasure or the "pleasing" (*Gefallen*) as one would, according to Heidegger, always have presupposed, notably with Kant. Let us not be too hasty about translating this as: the beautiful beyond the pleasure principle. Some mediations will be necessary, but they will not be lacking.

4. The beautiful beyond pleasure, certainly, but also art beyond the beautiful, beyond aesthetics as beyond callistics (Hegel says he prefers the "common word" aesthetics to this word). Like Hegel, who saw in it the destination of universal art, Heidegger places Western art at the center of his meditation. But he does so in order to repeat otherwise the history of its essence in relation to the transformation of an essence of truth: the history of the essence of Western art "is just as little to be conceived on the basis of beauty taken for itself as on the basis of lived experience (*Erlebnis*)." Even supposing, concludes Heidegger, that it could ever be a question of a "metaphysical concept" acceding to this essence. Thus nothing rules out the possibility that this concept is even constructed so as not to accede to it, so as not to get around to what happens [*advient*] under the name of art. And which Heidegger already calls "truth," even if it means seeking that truth *beneath* or *behind* the metaphysical determination of truth. For the moment I leave this "beneath" or this "behind" hanging vertically.

Keeping to these preliminary indications, one receives Heidegger's text as the nonidentical, staggered, discrepant "repetition" of the Hegelian "repetition" in the *Lectures on Aesthetics*. It works to untie what still keeps Hegel's aesthetics on the unperceived ground of metaphysics. And yet, what if this "repetition" did no more than make explicit, by repeating it more profoundly, the Hegelian "repetition"? (I am merely defining a risk, I am not yet saying that Heidegger runs it, simply, nor above all that one must in no circumstances run it: in wanting to avoid it at all costs, one can also be rushing toward the false exit, empirical chit-chat, spring-green impulsive avant-gardism. And who said it

was necessary to avoid all these risks? And risk in general?) And
yet, what if Heidegger, too, once again under the lemmatic con-
straint, went no further than the "common representation" [rep-
résentation courante] of art, accepting it as the guiding thread
(saying for example also "works of art are before us," this one,
that one, the well-known shoes of Van Gogh, etc.) of his powerful
meditation ___
 |

|
___ deposits here the "famous
painting by Van Gogh who often painted such shoes." I leave them.
They are, moreover, abandoned, unlaced, take them or leave them.
Much later, interlacing this discourse with another, I shall return
to them, as to everything I leave here, in so apparently discon-
certed a way. And I shall come back to what comes down to
leaving, lacing, interlacing. For example more than one shoe. And
further on still, much later, to what Heidegger says of the trait of
the "interlacing" (Geflecht), of the "tie which unties" (or frees,
delivers) (entbindende Band) and of the "road" in Der Weg zur
Sprache. Accept here, concerning the truth in painting or in effigy,
that interlacing causes a lace to disappear periodically: over under,
inside outside, left right, etc. Effigy and fiction ___
 |

|
___ and in this discrepant repetition,
it is less astonishing to see this meditation, closed upon a refer-
ence to Hegel, open up by a circular revolution whose rhetoric,
at least, greatly resembles that which we followed in the intro-
duction to the Lectures on Aesthetics.
 Why a circle? Here is the schema of the argument: to look
for the origin of a thing is to look for that from which it starts
out and whereby it is what it is, it is to look for its essential
provenance, which is not its empirical origin. The work of art
stems from the artist, so they say. But what is an artist? The
one who produces works of art. The origin of the artist is the

work of art, the origin of the work of art is the artist, "neither
is without the other." Given this, "artist and work *are* in them-
selves and in their reciprocity (*Wechselbezug*) by virtue of a third
term (*durch ein Drittes*) which is indeed the first, namely that
from which artist and work of art also get their name, art."
What is art? As long as one refuses to give an answer in advance
to this question, "art" is only a word. And if one wants to
interrogate art, one is indeed obliged to give oneself the guiding
thread of a representation. And this thread is the work, the fact
that *there are* works of art. Repetition of the Hegelian gesture
in the necessity of its lemma: there are works which common
opinion [*l'opinion courante*] designates as works of art and they
are what one must interrogate in order to decipher in them the
essence of art. But by what does one recognize, commonly [*cou-
ramment*], that these are works of art if one does not have in
advance a sort of precomprehension of the essence of art? This
hermeneutic circle has only the (logical, formal, derived) ap-
pearance of a vicious circle. It is not a question of escaping from
it but on the contrary of engaging in it and going all round it:
"We must therefore complete the circle (*den Kreisgang vollzie-
hen*). It is neither a stopgap measure (*Notbehelf*) nor a lack
(*Mangel*). To engage upon such a road is the force of thought
and to remain on it is the feast of thought, it being admitted
that thinking is a craft (*Handwerk*)." Engaging on the circular
path appeals on the one hand to an artisanal, almost a manual,
value of the thinker's trade, on the other hand to an experience
of the feast [*fête*] as experience of the limit, of closure, of re-
sistance, of humility. The "it is necessary" [*il faut*] of this en-
gagement is on its way toward what, in *Unterwegs zur Sprache*,
gathers together, between propriation and dispropriation (*Ereig-
nis/Enteignis*), the step [*pas*], the road to be opened up (*einen
Weg bahnen, be-wegen*), the trait which opens (*Aufriss*), and
language (speech-language: *Sprache*), etc. That which, later in
the text, joins the whole play of the trait (*Riss, Grundriss, Um-
riss, Aufriss, Gezüge*) to that of the stela, of stature or instal-
lation (*thesis, Setzen, Besetzen, Gesetz, Einrichten, Gestalt, Ge-
stell*, so many words I will not attempt to translate here) belongs
to that law of the *pas* [not/step] which urges the circle to the
lemmatic opening of the *Origin*: "it being admitted that think-
ing is a craft. Not only the chief step (*Hauptschritt*) of the work
toward art, *qua* step of the work toward art, is a circle, but each

of the steps we attempt to take here circles in that circle (*kreist in diesem Kreise*)."

Feast of the whole body, from top to toe, engaged in this circling step [*pas de cercle*] (*Hauptschritt, Handwerk, Denken*). What you want to do—going against the feast—is not to mix genres but to extend metaphors. You can always try: question of style.

not break the circle violently (it would avenge itself), assume it resolutely, authentically (*Entschlossenheit, Eigentlichkeit*). The experience of the circular closure does not close anything, it suffers neither lack nor negativity. Affirmative experience without voluntarism, without a compulsion to transgression: not to transgress the law of circle and *pas de cercle* but *trust in them*. Of this trust would thought consist. The desire to accede, by this faithful repetition of the circle, to the not-yet-crossed, is not absent. The desire for a new step, albeit a backward one (*Schritt zurück*), *ties and unties* this procedure [*démarche*]. Tie without tie, get across [*franchir*] the circle without getting free [*s'affranchir*] of its law. *Pas sans pas* [step without step/step without not/ not without step/ not without not]

so I break off here, provisionally, the reading of *The Origin*.

The encirclement of the circle was dragging us to the abyss. But like all *production*, that of the abyss came to saturate what it hollows out.

It's enough to say: abyss and satire of the abyss.

The feast, the "feast of thought" (*Fest des Denkens*) which engages upon the *Kreisgang*, in the *pas de cercle:* what does it feed on [*de quoi jouit-elle*]? Opening and simultaneously filling the abyss. Accomplishing: *den Kreisgang vollziehen.*

Interrogate the comic effect of this. One never misses it if the abyss is never sufficient, if it must remain—undecided— between the bottom-less and the bottom of the bottom. The *operation* of the *mise en abyme* always occupies itself (activity, busy positing, mastery of the subject) with somewhere filling up, full of abyss, filling up the abyss ⎯

⎮

⎮⎯ "a third party" (*ein Drittes*) ensures the circulation, regulates the encirclement. The *Mitte,* third, element and milieu, watches over the entrance to the hermeneutic circle or the circle of speculative dialectic. Art plays this role. Every time philosophy determines art, masters it and encloses it in the history of meaning or in the ontological encyclopedia, it assigns it a job as medium.

Now this is not ambiguous, it is more or less than ambiguous. Between two opposites, the third can participate, it can touch the two edges. But the ambiguity of participation does not exhaust it. The very thing that makes—the believers—believe in its mediacy can also give up to neither of the two terms, nor even to the structure of opposition, nor perhaps to dialectic insofar as it needs a mediation.

Index of a discrepancy: in relation to all the machinery of the *pose* (position/opposition, *Setzung/Entgegensetzung*). By giving it the philosophical name *art*, one has, it would seem, domesticated it in onto-encyclopedic economy and the history of truth ⎯

⎮

⎮⎯ and the place which *The Origin of the Work of Art* accords to the *Lectures on Aesthetics* ("the

West's most comprehensive meditation on the essence of art") can only be determined, in a certain historical topography, on the basis of the *Critique of the Faculty of Judgment*. Heidegger does not name it here, but he defends it elsewhere against Nietzsche's reading. What holds of speculative dialectic in general is made rigorously clear in the *Lectures:* an essential affinity with the *Critique,* the only book—third book—which it can reflect and reappropriate almost at once. The first two critiques of pure (speculative and practical) reason had opened an apparently infinite gulf. The third could, should, should have, could have thought it: that is, filled it, fulfilled it in infinite reconciliation. "Already the Kantian philosophy not only felt the need for this junction-point (*Vereinigungspunkt*) but recognized it with precision and furnished a representation of it." The third *Critique* had the merit of identifying in art (in general) one of the middle terms (*Mitten*) for resolving (*auflösen*) the "opposition" between mind and nature, internal and external phenomena, the inside and the outside, etc. But it still suffered, according to Hegel, from a lacuna, a "lack" (*Mangel*), it remained a theory of subjectivity and of judgment (an analogous reservation of principle is expressed in *The Origin*). Confined, unilateral, the reconciliation is not yet effective. The *Lectures* must supplement this lack, the structure of which has, as always, the form of a representative anticipation. The reconciliation is only announced, represented in the third *Critique* in the form of a duty, a *Sollen* projected to infinity.

And so it indeed appears.

On the one hand, Kant declares that he "neither wants nor is able" (§ 22) to examine whether "common sense" (here reinterpreted as a nondetermined, nonconceptual, and nonintellectual norm) exists as a constitutive principle of the possibility of aesthetic experience or else whether, in a regulative capacity, reason commands us to produce it (*hervorbringen*) for more elevated purposes. This common sense is constantly presupposed by the *Critique,* which nevertheless holds back the analysis of it. It could be shown that this suspension ensures the complicity of a moral discourse and an empirical culturalism. This is a permanent necessity.

On the other hand, recalling the division of philosophy and all the irreducible oppositions which the first two *Critiques* had determined, Kant does indeed project the plan of a work which could reduce the "enigma" of aesthetic judgment and fill a crack, a cleavage, an abyss (*Kluft*): "If thus an abyss stretching out of

sight (*unübersehbare Kluft*) is established between the domain of
the concept of nature, that is, the sensible, and the domain of the
concept of freedom, that is, the suprasensible, such that no pas-
sage (Übergang) is possible from the one to the other (by means,
therefore, of the theoretical use of reason), as between worlds so
different that the first can have no influence (*Einfluss*) on the
second, the second *must* yet (*soll* doch) have an influence on the
former [. . .]. Consequently it must be (*muss es*) that there is a
foundation of *unity* (Grund der *Einheit*). . . ." Further on, we find
related metaphors or analogies: it is again a question of the im-
mense "abyss" which separates the two worlds and of the appar-
ent impossibility of throwing a bridge (*Brücke*) from one shore to
the other. To call this an *analogy* does not yet say anything. The
bridge is not *an* analogy. The recourse to analogy, the concept and
effect of analogy are or make *the bridge* itself—both in the *Cri-
tique* and in the whole powerful tradition to which it still belongs.
The analogy of the abyss and of the bridge over the abyss is an
analogy which says that there must surely be an analogy between
two absolutely heterogeneous worlds, a third term to cross the
abyss, to heal over the gaping wound and think the gap. In a word,
a *symbol*. The bridge is a symbol, it passes from one bank to the
other, and the symbol is a bridge.

The abyss calls for analogy—the active recourse of the whole
Critique—but analogy plunges endlessly into the abyss as soon
as a certain art is needed to describe analogically the play of
analogy

II. The Parergon

⎸——— economize on
the abyss: not only save oneself from falling into the bottomless
depths by weaving and folding back the cloth to infinity, textual
art of the reprise, multiplication of patches within patches, but
also establish the laws of reappropriation, formalize the rules which
constrain the logic of the abyss and which shuttle between the
economic *and* the aneconomic, the raising [*la relève*]³ *and* the
fall, the abyssal operation which can only work toward the *relève*
and that in it which regularly reproduces collapse ———⎹

⎸——— what then is the object of the third *Critique?* The critique
of pure theoretical reason assumes the exclusion (*Ausschliessung*)
of all that is not theoretical knowledge: the affect (*Gefühl*) in its
two principal values (pleasure/unpleasure) and the power to desire
(*Begehrungsvermögen*). It cuts out its field only by cutting itself
off from the interests of desire, by losing interest in desire. From
the moment that understanding alone can give constitutive prin-

3. *Relève*, from the verb *relever* (to stand up again, to raise, to re-
lieve), is also Derrida's translation of Hegel's *Aufhebung*.

ciples to knowledge, the exclusion bears simultaneously on rea-
son which transgresses the limits of possible knowledge of nature.
Now the *a priori* principles of reason, although regulative with
regard to the faculty of knowing, are constitutive with regard to
the faculty of desiring. The critique of pure theoretical reason
thus excludes both reason *and* desire, desire's reason and reason's
desire, the desire for reason.

What is it about, at bottom? The bottom.

The understanding and reason are not two disconnected fac-
ulties; they are articulated in a certain task and a certain number
of operations which involve, precisely, articulation, i.e., discourse.
For between the two faculties, an articulated member, a third
faculty comes into play. This intermediary member which Kant
names precisely *Mittelglied*, middle articulation, is judgment (*Ur-
teil*). But what will be the nature of the *a priori* principles of the
middle articulation? Will they be constitutive or regulative? Do
they give *a priori* rules to pleasure and unpleasure? What is at
stake in this question can be measured by the fact that regulative
principles would not allow the demarcation of a *proper domain*
(*eigenes Gebiet*).

Since the *Mittelglied* also forms the articulation of the the-
oretical and the practical (in the Kantian sense), we are plunging
into a place that is *neither* theoretical *nor* practical or else *both*
theoretical *and* practical. Art (in general), or rather the beautiful,
if it takes place, is inscribed here. But this *here*, this place is
announced as a place deprived of place. It runs the risk, in taking
place, of not having its own proper domain. But this does not
deprive it, for all that, of jurisdiction and foundation: what has
no domain (*Gebiet*) or field (*Feld*) of its own, no "field of objects"
defining its "domain," can have a "territory" and a "ground"
(*Boden*) possessing a "proper legality" (*Introduction*, III).

The *Mittelglied*, intermediary member, must in effect be
treated as a separable part, a particular part (*als ein besonderer
Theil*). But also as a nonparticular, nondetachable part, since it
forms the articulation between two others; one can even say,
anticipating Hegel, an originary part (*Ur-teil*). It is indeed a ques-
tion of judgment. The same paragraph recalls that a critique of
pure reason, i.e., of our faculty of judging according to *a priori*
principles, would be "incomplete" (*unvollständig*) if a theory of
judgment, of the *Mittelglied*, did not form a "particular part" of
it. But immediately after, in the following sentence, that in a pure
philosophy the principles of judgment would not form a *detached*

part, between the theoretical part and the practical part, but could be *attached, annexed* (*angeschlossen*) to each of the two. Kant thus seems to mean two contradictory things at the same time: that it is necessary to disengage the middle member as a detachable part, operate the partition of the part, but also that it is necessary to re-member the whole by re-forming the nexus, the connection, the reannexation of the part to the two major columns of the corpus. Let us not forget that it is here a question of judgment (*Urteil*), of the function of the copula: does it play a separable role, its own part, or does it work in the orchestra of reason, in the concert of the practical and the theoretical?

Let us look more closely at this paragraph in the preface to the third *Critique*. It does not involve any contradiction. The separation of the part is not prescribed and forbidden from the same point of view. Within a critique of pure reason, of our faculty of judging according to *a priori* principles, the part must be detached and examined separately. But in a pure philosophy, in a "system of pure philosophy," everything must be sewn back together. The critique detaches because it is itself only a moment and a part of the system. It is in the critique that, precisely, the critical suspension is produced, the *krinein*, the in-between, the question of knowing whether the theory of judgment is theoretical *or* practical, and whether it is then referred to a regulatory *or* constitutive instance. But the system of pure philosophy *will have had to* include the critical within itself, and construct a general discourse which will get the better of the detachable and account for it. This system of pure philosophy is what Kant calls *metaphysics*. It is not yet possible. Only the critique can have a program that is currently possible.

The question of desire, of pleasure and of unpleasure is thus also the question of a *detachment* (neither the word nor the concept appears *as such* in the *Critique*) which will itself be specified, dismembered or re-membered: *detachment*—separation of a member—, *detachment*—delegation of a representative, sign or symbol on assignment (the beautiful as *symbol* of morality, problems of the hypotyposis, of the trace (*Spur*), of "cipher-script" (*Chiffreschrift*), of the intermittent sign (*Wink*); see for example paragraphs 42 and 59), *detachment*—disinterested attitude as essence of aesthetic experience.

In order to express the relationship between the two possibles (the now-possible of the critique and the future-possible of metaphysics), Kant proposes another metaphor. He borrows it, already,

from art, which has not yet been discussed, from the technique
of architecture, architectonics: the pure philosopher, the meta-
physician, will have to operate *like* a good architect, like a good
tekhnitēs of edification. He will be a sort of artist. Now what
does a good architect do, according to Kant? He must first of all
be certain of the ground, the foundation, the fundament. "A Cri-
tique of pure reason, i.e., of our faculty of judging on *a priori*
principles, would be incomplete if the critical examination of
judgment, which is a faculty of knowledge, and, as such, lays
claim to independent principles, were not dealt with separately.
Still, however, its principles cannot, in a system of pure philos-
ophy, form a separate constituent part intermediate between the
theoretical and practical divisions, but may when needful (*im
Nothfalle*) be annexed (*angeschlossen*) to one or other as occasion
requires (*gelegentlich*). For if such a system is some day worked
out (*zu Stande kommen*) under the general name of Metaphysic
. . . , then the critical examination of the ground for this edifice
must have been previously carried down to the very depths of the
foundations (*Grundlage*) of the faculty of principles independent
of experience, lest in some quarter (*an irgend einem Theile*) it
might give way (collapse, *sinke*), and, sinking, inevitably bring
with it the ruin (*Einsturz*) of all" (Meredith, 4–5).
 The proper instance of the critique: the architect of reason
searches, probes, prepares the ground. In search of the bedrock,
the ultimate *Grund* on which to raise the whole of metaphysics.
But also in search of roots, of the common root which then divides
in the phenomenal light, and which never itself yields up to ex-
perience. Thus the critique as such attempts to descend to the
bythos, to the *bottom* of the abyss, without knowing whether it
exists.
 It is still too early to interrogate the general functioning of
metaphor and analogy in the third *Critique*. This functioning is
perhaps not simply reflected by the theory which, in the book,
both includes it and plunges into its abyss.
 We have just encountered the first "metaphor": beginning
of the preface (*Vorrede*). Now at the end of the introduction
which follows (*Einleitung*), and as if to frame the whole prole-
gomenon, will be the metaphor of the artificial work securing
the passage over the natural gulf, the bridge (*Brücke*) projected
over the great abyss (*grosse Kluft*). Philosophy, which in this
book has to think art through—art in general and fine art—as
a part of its field or of its edifice, is here *representing itself* as

a part of its part: philosophy as an art of architecture. It represents itself, it *detaches itself*, detaches from itself a proxy, a part of itself beside itself in order to think the whole, to saturate or heal over the whole that suffers from detachment. The philosophy of art presupposes an art of philosophizing, a major art, but also a miner's art in its critical preliminaries, an architect's art in its edifying erection. And if, as will be said further on, fine art is always an art of genius, then the *Anthropology from the Pragmatic Point of View* would for preference delegate a German to the post of critique: the German genius shows itself best on the side of the root, the Italian on that of the crown of leaves, the French on that of the flower and the English on that of the fruit. Finally, if this pure philosophy or fundamental metaphysics here proposes to account for, among other things, desire, pleasure and unpleasure, it exposes itself and represents itself first of all in its own desire. The desire of reason would be a fundamental desire, a desire for the fundamental, a desire to go to the *bythos*. Not an empirical desire since it leads toward the unconditioned, and that which yields itself up in the currency of a determinate metaphor ought, as a metaphor of reason, to account for [*rendre raison de*] all other metaphors. It would figure the being-desire of desire, the desire of/for reason as desire for a grounded structure. Edifying desire would be produced as an art of philosophizing, commanding all the others and accounting for [*rendant raison de*] all rhetoric.

"Great difficulties" arise. A theory of judgment as *Mittelglied* must be constructed. But there will be "great difficulties" (*grosse Schwierigkeiten*) in finding for judgment *a priori* principles which are proper to it and which would protect the theory from empiricism. One can find *a priori* concepts only in the understanding. The faculty of judgment uses them, it applies them, but it does not have at its disposal any concepts which belong to it or are specifically reserved for it. The only concept which it can produce is an empty concept, in a sense, and one which does not give anything to be known. By it, "nothing is properly known." It supplies a "rule" of usage which comprises no objectivity, no relation to the object, no knowledge. The rule is subjective, the faculty of judgment gives itself its own norms, and it must do so, failing which it would be necessary to call upon another faculty or arbitration, *ad infinitum*. And yet this *subjective* rule is applied to judgments, to statements which by their structure lay claim to universal objectivity.

Such would be the difficulty, the constraint, the confusion, the *Verlegenheit*. It seems to confirm a certain Hegelian and subsequently Heideggerian verdict: this discourse on the beautiful and on art, because it remains at the stage of a theory of judgment, gets tangled up in the—derived—opposition of subject and object.

Of the beautiful and of art it has not yet been question. Nothing, up to this point, suggested that it should be a question of these. And now here is Kant declaring that this "great difficulty" *of principle* (subjective *or* objective), "is found" (*findet sich*), that it is met with "principally" (*hauptsächlich*) in the judgments "which are called aesthetic." These could have constituted an example, however important, a major occurrence of the "difficulty." But in truth it is the principal example, the unique specimen which gives meaning and orients the multiplicity. The examination of this example, namely the aesthetic domain, forms the choice morsel, the "most important piece" (*das wichtigste Stück*) of the critique of the faculty of judgment. Although they bring *nothing* to knowledge, aesthetic judgments, insofar as they are judgments, come under the faculty of knowing alone, a faculty which they put in relation with pleasure or unpleasure according to an *a priori* principle. This relationship of knowledge to pleasure reveals itself here in its purity since there is nothing to know, but such is precisely the enigma, the enigmatic (*das Rätselhafte*) at the heart of judgment. It is why a "special section" (*besondere Abteilung*), a particular division, a cut-out sector, a detached part, form the object of the third *Critique.*

One must not expect from it what in principle it does not, in its declared intention, promise. This critique of taste does not concern production; it has in view neither "education" nor "culture," which can very well do without it. And as the *Critique* will show that one cannot assign conceptual rules to the beautiful, it will not be a question of constituting an *aesthetic*, even a general one, but of analyzing the formal conditions of possibility of an aesthetic judgment in general, hence an aesthetic objectivity in general.

With this transcendental aim, Kant demands to be read without indulgence. But for the rest, he admits the lacks, the lacunary character (*Mangelhaftigkeit*) of his work. This is the word Hegel uses too.

What does the lack depend on? What lack is it?

And what if it were the frame. What if the lack formed the frame of the theory. Not its accident but its frame. More or less

still: what if the lack were not only the lack of a theory of the frame but the place of the lack in a theory of the frame.

Edge [arête]/lack

The "lacunary character" of his work, according to Kant at least, hangs on the fact that nature has muddled up, complicated, tangled up (verwickelt) the problems. The author's excuses are limited to the first part of the work, to the critique of aesthetic judgment, and not to the critique of teleological judgment. It is only in the first part that the deduction will not have the clarity and distinctness (Deutlichkeit) which one would, however, be entitled to expect from a knowledge through concepts. After deploring that nature has mixed up the threads, at the moment when he is finishing his critical work (Hiemit endige ich also mein ganzes kritisches Geschäft), admitting the lacunae and projecting a bridge over the abyss of the other two critiques, Kant speaks of his age. He must gain time, not let the delay accumulate, hurry on toward the doctrine.

It's about pleasure. About thinking pure pleasure, the being-pleasure of pleasure. Starting out from pleasure, it was for pleasure that the third Critique was written, for pleasure that it should be read. A somewhat arid pleasure—without concept and without enjoyment—a somewhat strict pleasure, but one learns once more that there is no pleasure without stricture. In letting myself be guided by pleasure I recognize and simultaneously put astray an injunction. I follow it [je le suis]: the enigma of pleasure puts the whole book in movement. I seduce it [je le séduis]: in treating the third Critique as a work of art or a beautiful object, which it was not simply designed to be, I act as if the existence of the book were indifferent to me (which, as Kant explains, is a requirement of any aesthetic experience) and could be considered with an imperturbable detachment.

But what is the existence of a book?

1. I follow it. The possibility of pleasure is the question. Demonstration: the first two paragraphs of the "First moment of the

judgment of taste considered from the point of view of quality,"
book I ("Analytic of the Beautiful") of the first section ("Analytic
of Aesthetic Judgment") of the first part "Critique of Aesthetic
Judgment"). Why call a judgment of taste *aesthetic*? Because, in
order to distinguish whether a thing can be called beautiful, I do
not consult the relation of the representation to the *object*, with
a view to knowledge (the judgment of taste does not give us any
knowledge) but its relation to the *subject* and to its affect (pleasure
or unpleasure). The judgment of taste is not a judgment of knowl-
edge, it is not "logical" but subjective and therefore aesthetic:
relation to the affect (*aisthesis*). Any relation of representation
can potentially be objective, even a relation of the senses; but
pleasure and unpleasure never can. Aesthetic representations can
certainly give rise to logical judgments when they are related by
the judgment to the object, but when the judgment itself relates
to the subject, to the subjective affect—as is the case here—it is
and can only be an aesthetic one.

What is generally translated by subjective satisfaction, the
Wohlgefallen, the *pleasing* which determines aesthetic judgment,
must, we know, be disinterested. Interest (*Interesse*) always re-
lates us to the *existence* of an object. I am interested by an object
when its existence (*Existenz*) matters to me in one way or another.
Now the question of knowing whether I can say of a thing that
it is beautiful has, according to Kant, nothing to do with the
interest that I do or do not have in its existence. And my pleasure
(*Lust*), that species of *pleasing* which is called pleasure and which
I feel when faced with that which I judge to be beautiful, requires
an indifference or more rigorously an absolute lack of interest for
the existence of the thing.

This pure and disinterested pleasure (but not indifferent: Hei-
degger here reproaches Nietzsche with not having understood the
nonindifferent structure of this letting-be), this pleasure which
draws me toward a nonexistence or at least toward a thing (but
what is a thing? Need here to graft on the Heideggerian question)
the existence of which is indifferent to me, such a pleasure de-
termines the judgment of taste and the enigma of the bereaved
[*endeuillé*] relation—labor of mourning broached in advance—to
beauty. Like a sort of transcendental reduction, the *épochè* of a
thesis of existence the suspension of which liberates, in certain
formal conditions, the pure feeling of pleasure.

The example is familiar. I am in front of a palace. I am asked
if I find it beautiful, or rather if I can say "this is beautiful." It is

a question of judgment, of a judgment of universal validity and everything must therefore be able to be produced in the form of statements, questions, and answers. Although the aesthetic affect cannot be reduced, the instance of the judgment commands that I be able to *say* "this is beautiful" or "this is not beautiful."

Is the palace I'm speaking about beautiful? All kinds of answers can miss the point of the question. If I say, I don't like things made for idle gawpers, or else, like the Iroquois sachem, I prefer the pubs, or else, in the manner of Rousseau, what we have here is a sign of the vanity of the great who exploit the people in order to produce frivolous things, or else if I were on a desert island and if I had the means to do so, I would still not go to the trouble of having it imported, etc., none of these answers constitutes an intrinsically aesthetic judgment. I have evaluated this palace in fact in terms of *extrinsic* motives, in terms of empirical psychology, of economic relations of production, of political structures, of technical causality, etc.

Now you have to know what you're talking about, what *intrinsically* concerns the value "beauty" and what remains external to your immanent sense of beauty. This permanent requirement—to distinguish between the internal or proper sense and the circumstance of the object being talked about—organizes all philosophical discourses on art, the meaning of art and meaning as such, from Plato to Hegel, Husserl and Heidegger. This requirement presupposes a discourse on the limit between the inside and outside of the art object, here a *discourse on the frame.* Where is it to be found?

What they want to know, according to Kant, when they ask me if I find this palace beautiful, is if I find that it *is beautiful,* in other words if the mere representation of the object—in itself, within itself—pleases me, if it produces in me a pleasure, however indifferent (*gleichgültig*) I may remain to the existence of that object. "It is quite plain that in order to say that the object *is beautiful,* and to show that I have taste, everything turns on the meaning which I can give to this representation, and not on any factor which makes me dependent on the real existence of the object. Every one must allow that a judgement on the beautiful which is tinged with the slightest interest, is very partial and not a pure judgement of taste. One must not be in the least prepossessed in favour of the real existence of the thing (*Existenz der Sache*), but must preserve complete indifference in this respect, in order to play the part of judge in matters of taste.

"This proposition, which is of the utmost importance, cannot be better explained than by contrasting the pure disinterested delight (*uninteressirten Wohlgefallen*) which appears in the judgement of taste with that allied (*verbunden*) to an interest—especially if we can also assure ourselves that there are no other kinds of interest beyond those presently to be mentioned." These other kinds are the interest for the existence of the *agreeable* and for the existence of the *good* (Meredith, 43–44).

L──── a disinterested pleasure: the formula is too well known, too received, as is the refusal it has never ceased to provoke. Anger of Nietzsche and Artaud: disinterest or uninterestedness are supererogatory. Meditative murmur from Heidegger, at the end of *The Origin*: pleasure is superfluous or insufficient.

Don't be in too much of a hurry to conclude when it's a matter of pleasure. In this case, of a pleasure which would thus be pure and disinterested, which would in this way deliver itself up in the purity of its essence, without contamination from outside. It no longer depends on any phenomenal empiricity, of any determined *existence*, whether that of the object or that of the subject, my empiricity relating me precisely to the existence of the beautiful object, or to the existence of my sensory motivation. As such, and considered intrinsically (but how to delimit the intrinsic, that which runs along, *secus*, the internal limit?), the pleasure presupposes not the disappearance pure and simple, but the neutralization, not simply the putting to death but the *mise en crypte* [entombment/encrypting] of all that exists in as much as it exists. This pleasure is purely subjective: in the aesthetic judgment it does not designate (*bezeichnet*) anything about the object. But its subjectivity is not an existence, nor even a relation to existence. It is an inexistent or anexistent subjectivity arising on the crypt of the empirical subject and its whole world.

But a subjectivity which nevertheless enjoys. No, does not enjoy: Kant distinguishes pleasure (*Wohlgefallen, Lust*) from enjoyment (*Genuss*). Takes pleasure. No, for it *receives* it just as much. If the translation of *Wohlgefallen* by *pleasure* is not entirely rigorous, and that by *satisfaction* even less so, the *pleasing* risks leaning toward the agreeable and letting us think that

everything comes from the object which pleases. In truth, in the *Wohlgefallen* I *please myself*,[4] but without complaisance, I do not interest myself, especially not in myself insofar as I exist: I-please-myself-*in*. Not in any thing that exists, not in doing something or other. *I-please-myself-in pleasing-myself-in*—that which is beautiful. Insofar as it does not exist.

As this affect of the *pleasing-oneself-in* remains subjective through and through, one could here speak of an autoaffection. The role of imagination and hence of time in this whole discourse would confirm this. Nothing existent, as such, nothing in time or space can produce this affect which thus cathects itself with itself [*qui s'affecte donc lui-même de lui-même*]. And yet the *pleasing-oneself-in*, the *in* of the *pleasing-oneself* also indicates that this autoaffection immediately goes outside its inside: it is a pure heteroaffection. The purely subjective affect is provoked by what is called the beautiful, that which is said to be beautiful: *outside,* in the object and independently of its existence. Whence the critical and indispensable character of this recourse to judgment: the structure of autoaffection is such that it cathects itself with a pure objectivity of which one *must* say "it *is* beautiful" and "this statement has universal validity." Otherwise, there would be no problem—and no discourse on art. *The entirely-other cathects me with pure pleasure by depriving me both of concept and enjoyment.* Without this entirely-other, there would be no universality, no requirement of universality, but for the same reason, with respect to that entirely other, there is no enjoyment (singular, empirical, existent, interested) or determinant or knowledge concept. And nothing theoretical or practical yet. The most irreducible heteroaffection inhabits—intrinsically—the most closed autoaffection: that is the *"grosse Schwierigkeit"*: it does not hang on the comfortable setting-up of a very derivative subject/object couple, in a supervening judicative space. Nor from some well-oiled mechanism of *mimēsis, homoiosis, adaequatio.* We know that Kant rejects the notion of imitation, at least initially. As for *homoiosis* or *adaequatio,* the matter becomes, to say the least, complicated as soon as one is dealing no longer with a determinant judgment but with a reflective judgment, and as soon as the *res* in question does not exist, or in any case is not considered in its existence as a thing. It is at the end of a quite different itinerary that we

4. "I please myself" here *not* in the sense "I do as I like."

shall verify the efficacy of these values (*mimēsis, homoiosis, adaequatio*) in Kant's discourse [5] ▁▁

|

▁▁ almost nothing
remains (to me): neither the thing, nor its existence, nor mine,
neither the pure object nor the pure subject, no interest of any-
thing that is in anything that is. And yet I like: no, that's still
going too far, that's still taking an interest in existence, no doubt.
I do not like, but I take pleasure in what does not interest me,
in something of which it is at least a matter of indifference
whether I like it or not. I do not take this pleasure that I take,
it would seem rather that I return it, I return what I take, I
receive what I return, I do not take what I receive. And yet I
give it to myself. Can I say that I give it to myself? It is so
universally objective—in the claim made by my judgment and
by common sense—that it can only come from a pure outside.
Unassimilable. At a pinch, I do not even feel this pleasure which
I give myself or rather to which I give myself, by which I give
myself, if to feel [*éprouver*] means to experience [*ressentir*]: phe-
nomenally, empirically, in the space and time of my interested
or interesting existence. Pleasure which it is impossible to ex-
perience. I never take it, never receive it, never return it, never
give it, never give it to myself because *I* (me, existing subject)
never have access to the beautiful as such. I never have access
to pure pleasure inasmuch as I exist.

　　And yet *there is* pleasure, some still remains; *there is, es gibt,
it gives*, the pleasure is what *it gives*; to nobody but some remains
and it's the best, the purest. And it is this remainder which causes
talk, since it is, once again, primarily a question of *discourse* on
the beautiful, of discursivity *in* the structure of the beautiful and
not only of a discourse supposed to happen accidentally *to* the
beautiful.

　　5. "Economimesis," in *Mimesis* [*des articulations*] (in collaboration
with S. Agacinski, S. Kofman, Ph. Lacoue-Labarthe, J.-L. Nancy, B. Pau-
trat). In the collection "La Philosophie en effet" (Paris: Aubier-Flam-
marion, 1975) [pp. 55–93; English translation in *Diacritics* 11, no. 2
(1981):3–25].—J.D.

2. *I seduce it*: by treating the third critique as a work of art, I neutralize or encrypt its existence. But I will not be able to find out whether, in order to do this, I must find my authority in the *Critique*, so long as I don't know what the existence of a thing is, and consequently interest in the existence of a thing. What is it to exist, for Kant? To be present, according to space and time, as an individual thing: according to the conditions of the transcendental aesthetic. There is nothing less aesthetic in this sense than the beautiful object which must not interest us *qua aistheton*. But this aesthetic inexistence must affect me and that is why the retention of the word aesthetic is justified, from the start.

When the (beautiful) object is a book, what exists and what no longer exists? The book is not to be confused with the sensory multiplicity of its existing copies. The object *book* thus presents itself as such, in its intrinsic structure, as independent of its *copies*. But what one would then call its ideality is not pure; a very discriminating analysis must distinguish it from ideality in general, from the ideality of other types of object, and in the area of art, from that of other classes of books (novel, poetry, etc.) or of nondiscursive or nonbook art objects (painting, sculpture, music, theater, etc.). In each case the structure of exemplarity (unique or multiple) is original and therefore prescribes a different affect. And in each case there remains to be found out what importance one gives to the case [*le cas qu'on fait du cas*], to know whether one drops it as an extrinsic excrement, or retains it as an intrinsic ideality.

Here is an example, but an example *en abyme*: the third *Critique*. How to treat this book. Is it a book. What would make a book of it. What is it to read this book. How to take it. Have I the right to say that it is beautiful. And first of all the right to ask myself that

for example the question of order. A spatial, so-called plastic, art object does not necessarily prescribe an order of reading. I can move around in front of it, start from the top or the bottom, sometimes walk round it. No

doubt this possibility has an ideal limit. Let us say for the moment that the structure of this limit allows a greater play than in the case of temporal art objects (whether discursive or not), unless a certain fragmentation, a spatial *mise en scène*, precisely (an effective or virtual partition)[6] allows us to begin in various places, to vary direction or speed.

But a book. And a book of philosophy. If it is a book of metaphysics in the Kantian sense, hence a book of pure philosophy, one can in principle enter it from any point: it is a sort of architecture. In the third *Critique*, there is pure philosophy, there is talk of it and its plan is drawn. In terms of the analogy (but how to measure its terms) one ought to be able to begin anywhere and follow any order, although the quantity and the quality, the force of the reading may depend, as with a piece of architecture, on the point of view and on a certain relation to the ideal limit—which acts as a frame. There are only ever points of view: but the solidity, the existence, the structure of the edifice do not depend on them. Can one say the same, by analogy, of a book. One does not necessarily gain access to a piece of architecture by following the order of its production, starting at the foundations and arriving at the roofridge. And we must distinguish here between perception, analysis, penetration, utilization, even destruction. But does one read a book of pure philosophy if one does not begin with the foundations and follow the juridical order of its writing. What then is it to read philosophy and must one only read it. To be sure, the juridical order supported by the foundations does not coincide with the factual order: for example, Kant wrote his introduction after finishing the book and it is the most powerful effort to gather together the whole system of his philosophy, to give his whole discourse a *de jure* foundation, to articulate critique with philosophy. The introduction follows, the foundation comes after having come first. But even if it were established that in principle, in metaphysics in the Kantian sense, one must begin at the foundations, critique is not metaphysics: it is, *first, in search of* the foundation (and thus in fact comes *afterwards*), suspended like a crane or a dragline bucket above the pit, working to scrape, probe, clear, and open up a sure ground. In what order to read a critique. The *de facto* order or the *de jure* order. The *ordo inveniendi* or the *ordo exponendi*.

6. *Partition* here also has the meaning of "musical score."

All these questions differ/defer, each is subordinate to the others, and whatever their interminable breadth, they are valid in general for any critical text. ⎯

⎯|

|⎯ a supplementary complication constrains us to reconsider the way these questions fit together. The third *Critique* is not just one critique among others. Its specific object has the form of a certain type of judgment—the reflective judgment—which works (on) the example in a very singular way. The distinction between reflective and determinant judgment, a distinction that is both familiar and obscure, watches over all the internal divisions of the book. I recall it in its poorest generality. The faculty of judgment *in general* allows one to think the particular as contained under the general (rule, principle, law). When the generality is given first, the operation of judgment subsumes and *determines* the particular. It is determinant (*bestimmend*), it specifies, narrows down, comprehends, tightens. In the contrary hypothesis, the *reflective* judgment (*reflectirend*) has only the particular at its disposal and must climb back up to, return toward generality: the example (this is what matters to us here) is here given prior to the law and, in its very uniqueness as example, allows one to discover that law. Common scientific or logical discourse proceeds by determinant judgments, and the example follows in order to determine or, with a pedagogical intention, to illustrate. In art and in life, wherever one must, according to Kant, proceed to reflective judgments and assume (by analogy with art: we shall come to this rule further on) a finality⁷ the concept of which we do not have, the *example precedes*. There follows a singular historicity and (counting the simulacrum-time) a certain (regulated, relative) ficture of the theoretical ⎯

|

<hr/>

7. "Finality" translates *finalité*, the received French translation of Kant's *Zweckmässigkeit*, traditionally rendered into English as "purposiveness." See below, n. 11.

⎯⎯ on the authority of
this reflective hinge,[8] I begin my reading of the third *Critique*
with some examples.

Is this docility perverse. Nothing yet permits a decision.

So I begin with some examples: not with the introduction,
which gives the laws, nor with the beginning of the book (the
analytic of the beautiful). Nor with the middle nor the end, but
somewhere near the conclusion of the analytic of the beautiful,
paragraph 14. It is entitled "Clarification by Examples" (*Erlaü-
terung durch Beispiele*).

Its most obvious intention is to clarify the structure of "the
proper object of the pure judgment of taste" (*den eigentlichen
Gegenstand des reinen Geschmacksurtheils*). I shall not even cite
all the examples, but only some of them, and I shall provisionally
leave to one side the very complicated theory of colors and sounds,
of drawing and composition, which is unfolded between the two
fragments I translate here. Unless it be broached at the same time.
I shall in any case assume you have read it.

"Aesthetic, just like theoretical (logical) judgements, are divisi-
ble into empirical and pure. The first are those by which agreeable-
ness or disagreeableness, the second those by which beauty, is pred-
icated of an object or its mode of representation. The former are
judgements of sense (material aesthetic judgements), the latter (as
formal) alone judgements of taste proper (*allein eigentliche
Geschmacksurtheile*).

"A judgement of taste, therefore, is only pure so far as its deter-
mining ground (*Bestimmungsgrunde*) is tainted with no merely em-
pirical delight (*Wohlgefallen*). But such a taint is always present
where charm (*Reiz*) or emotion (*Rührung*) have a share in the judge-
ment (*einen Antheil an dem Urtheile haben*) by which something
is to be described as beautiful. . . .

"All form of objects of sense (both of external and also, me-
diately, of internal sense) is either *figure* (*Gestalt*) or *play* (*Spiel*). In
the latter case it is either play of figures (in space: mimic and dance),
or mere play of sensations (in time). The charm (*Reiz*) of colours, or
of the agreeable tones of instruments, may be added (*hinzukom-*

8. "Hinge" translates *brisure*, which carries connotations of both
breaking and joining; see *De la grammatologie* (Paris: Minuit, 1967), 96;
translated by Gayatri Chakravorty Spivak as (*Grammatology*) Baltimore:
Johns Hopkins University Press, 1976), 65ff.

men): but the *design* (*Zeichnung*) in the former and the composition (*Composition*) in the latter constitute the proper object of the pure judgement of taste. To say that the purity alike of colours and of tones, or their variety and contrast, seem to contribute (*beizutragen*) to beauty, is by no means to imply that, because in themselves agreeable, they therefore yield an addition (*einen . . . Zusatz*) to the delight in the form (*Wohlgefallen an der Form*) and one on a par with it (*gleichartigen*). The real meaning rather is that they make this form more clearly, definitely, and completely (*nur genauer, bestimmter und vollständiger*) intuitable (*anschaulich machen*), and besides stimulate the representation by their charm, as they excite and sustain the attention directed to the object itself.

"Even what is called *ornamentation* [*Zierathen*: decoration, adornment, embellishment] (*Parerga*) i.e., what is only an adjunct, and not an intrinsic constituent in the complete representation of the object (*was nicht in die ganze Vorstellung des Gegenstandes als Bestandstück innerlich, sondern nur äusserlich als Zuthat gehört*), in augmenting the delight of taste does so only by means of its form. Thus it is with the frames (*Einfassungen*) of pictures or the drapery on statues, or the colonnades of palaces. But if the ornamentation does not itself enter into the composition of the beautiful form—if it is introduced (*angebracht*: fixed on) like a gold frame (*goldene Rahmen*) merely to win approval for the picture by means of its charm—it is then called *finery* [*parure*] (*Schmuck*) and takes away from the genuine beauty" (Meredith, 65, 67–68).

a theory which would run along as if on wheels

the
clothes on statues—for example—would thus be ornaments: *parerga.*

Kant explains himself elsewhere on the necessity of having recourse to dead or scholarly languages. The Greek here confers a quasi-conceptual dignity to the notion of this *hors-d'oeuvre* which however does not stand simply outside the work [*hors d'oeuvre*], also acting alongside, right up against the work (*ergon*). Dictionaries most often give "hors-d'oeuvre," which is the strictest translation, but also "accessory, foreign or secondary object," "supplement," "aside," "remainder." It is what the principal subject *must not become*, by being separated from itself: the education of children in legislation (*Laws* 766a) or the definition of science (*Theaetetus* 184a) *must not* be treated as *parerga*. In the search for the cause or the knowledge of principles, *one must avoid* letting the *parerga* get the upper hand over the essentials (*Nicomachean Ethics* 1098a 30). Philosophical discourse will always have been *against* the *parergon*. But what about this *against*.

A parergon comes against, beside, and in addition to the *ergon*, the work done [*fait*], the fact [*le fait*], the work, but it does not fall to one side, it touches and cooperates within the operation, from a certain outside. Neither simply outside nor simply inside. Like an accessory that one is obliged to welcome on the border, on board [*au bord, à bord*]. It is first of all the on (the) bo(a)rd(er) [*Il est d'abord l'à-bord*].

If we wanted to play a little—for the sake of poetics—at etymology, the *à-bord* would refer us to the Middle High German *bort* (table, plank, deck of a vessel). "The *bord* is thus properly speaking a plank; and etymology allows us to grasp the way its meanings link together. The primary meaning is the deck of a vessel, i.e., a construction made of planks; then, by metonymy, that which borders, that which encloses, that which limits, that which is at the extremity." Says Littré.

But the *etymon* will always have had, for whoever knows how to read, its border-effects.

Boats are never far away when one is handling figures of rhetoric.[9] Brothel [*bordel*] has the same etymology; it's an easy one, at first a little hut made of wood.

The *bord* is made of wood, and apparently indifferent like the frame of a painting. Along with stone, better than stone, wood names matter (*hylē* means wood). These questions of wood, of

9. Perhaps referring to hackneyed examples of rhetorical figures, such as "forty sails" for "forty ships" in Dumarsais, Fontanier, etc. But *bateau* used adjectivally also *means* "hackneyed."

matter, of the frame, of the limit between inside and outside, must, somewhere in the margins, be constituted together.

The *parergon*, this supplement outside the work, must, if it is to have the status of a philosophical quasi-concept, designate a formal and general predicative structure, which one can transport *intact* or deformed and reformed *according to certain rules*, into other fields, to submit new contents to it. Now Kant does use the word *parergon* elsewhere: the context is very different but the structure is analogous and just as problematical. It is to be found in a very long note added to the second edition of *Religion within the Limits of Reason Alone*. This place, the form of this place, is of great import.

To what is the "Note" appended? To a "General Remark" which closes the second part.

Now what is the *parergon*? It is the concept of the remark, of this "General Remark," insofar as it defines what comes to be added to *Religion within the Limits of Reason Alone* without being a part of it and yet without being absolutely extrinsic to it. Each part of the book comprises a "General Remark" (*Allgemeine Anmerkung*), a *parergon* concerning a *parergon*. As there are four parts to *Religion*, then the book is in a manner of speaking *framed* [*cadrée*], but also squared up [*quadrillée*][10] by these four remarks on *parerga*, hors-d'oeuvres, "additives" which are neither inside nor outside.

The beginning of the note appended, in the second edition, to the first of the "General Remarks," defines the status of the remark as *parergon*: "This general Remark is the first of four which have been added [*angehängt*: appended, like appendixes] to each piece of this text (*jedem Stück dieser Schrift*) and which might have as titles: (1) Of the effects of grace; (2) Of miracles; (3) Of mysteries; (4) Of the means of grace. They are in some measure *parerga* of religion within the limits of pure reason; they are not integral parts of it (*sie gehören nicht innerhalb dieselben*) but they verge on it [*aber stossen doch an sie an*: they touch it, push it, press it, press against it, seek contact, exert a pressure at the frontier]. Reason, conscious of its impotence (*Unvermögens*) to satisfy its moral need [the only need which should ground or should have grounded religion within the limits of reason alone],

10. *Quadrillée* insists on the "squareness" implied in *cadre* (see also p. 77), but it also carries an important sense of coverage, control, surveillance.

reaches as far as these transcendent ideas which are potentially able to make good the lack (*die jenen Mangel ergänzen*), without however appropriating them (*sich zuzueignen*) as extension of its domain (*Besitz,* possession). It contests neither the possibility nor the reality of the objects of these ideas but it cannot admit them into its maxims for thought and action. It even holds that if, in the unfathomable field of the supernatural, there is something more (*noch etwas mehr*) than what it can render intelligible to itself and which would however be necessary to supply [Gibelin's translation of *Ergänzung*] its moral insufficiency, this thing, even though unknown, will come to the aid (*zu statten kommen*) of its good will, thanks to a faith which one could call (as regards its possibility) *reflective* (*reflectirenden*) because the dogmatic faith which declares that it *knows* seems to it presumptuous and not very sincere; for to remove difficulties with regard to what is in itself (in practical terms) well established is only a secondary task (*parergon*) when those difficulties concern transcendent questions."

What is translated as "secondary task" is *Nebengeschäfte*: incidental business or bustle, activity or operation which comes *beside* or *against.* The *parergon* inscribes something which comes as an extra, *exterior* to the proper field (here that of pure reason and of *Religion within the Limits of Reason Alone*) but whose transcendent exteriority comes to play, abut onto, brush against, rub, press against the limit itself and intervene in the inside only to the extent that the inside is lacking. It is lacking *in* something and it is lacking *from itself.* Because reason is "conscious of its impotence to satisfy its moral need," it has recourse to the *parergon,* to grace, to mystery, to miracles. It needs the supplementary work. This additive, to be sure, is threatening. Its use is critical. It involves a risk and exacts a price the theory of which is elaborated. To each *parergon* of *Religion* there is a corresponding damage, a detriment (*Nachteil*) and the four classes of dangers will correspond to the four types of *parergon*: (1) for the would-be internal experience (effects of grace), there is *fanaticism*; (2) for the would-be external experience (miracles), there is *super-stition*; (3) for the would-be insight of the understanding into the supernatural order there is *illuminism*; (4) for the would-be ac-tions on the supernatural (means of grace), there is *thaumaturgy.* These four aberrations or seductions of reason nevertheless also have in view a certain pleasing, pleasing-God (*gottgefälliger Absicht*).

So, as an example among examples, the clothing on statues (*Gewänder an Statuen*) would have the function of a *parergon* and an ornament. This means (*das heisst*), as Kant makes clear, that which is not internal or intrinsic (*innerlich*), as an integral part (*als Bestandstück*), to the total representation of the object (*in die ganze Vorstellung des Gegenstandes*) but which belongs to it only in an extrinsic way (*nur äusserlich*) as a surplus, an addition, an adjunct (*als Zuthat*), a supplement.

Hors-d'oeuvres, then, the clothes of statues, which both decorate and veil their nudity. Hors-d'oeuvres stuck onto the edging of the work nonetheless, and to the edging of the represented body to the extent that—such is the argument—they supposedly do not belong to the whole of the representation. What is represented in the representation would be the naked and natural body; the representative essence of the statue would be related to this, and the only beautiful thing in the statue would be that representation; it alone would be essentially, purely, and intrinsically beautiful, "the proper object of a pure judgment of taste."

This delimitation of the center and the integrity of the representation, of its inside and its outside, might already seem strange. One wonders, too, where to have clothing commence. Where does a *parergon* begin and end. Would any garment be a *parergon*. G-strings and the like. What to do with absolutely transparent veils. And how to transpose the statement to painting. For example, Cranach's Lucretia holds only a light band of transparent veil in front of her sex: where is the *parergon*? Should one regard as a *parergon* the dagger which is not part of her naked and natural body and whose point she holds turned toward herself, touching her skin (in that case only the point of the *parergon* would touch her body, in the middle of a triangle formed by her two breasts and her navel)? A *parergon*, the necklace that she wears around her neck? The question of the representative and objectivizing essence, of its outside and its inside, of the criteria engaged in this delimitation, of the value of naturalness which is presupposed in it, and, secondarily or primarily, of the place of the human body or of its privilege in this whole problematic. If any *parergon* is only added on by virtue of an internal lack in the system to which it is added (as was verified in *Religion*), what is it that is lacking in the representation of the body so that the garment should come

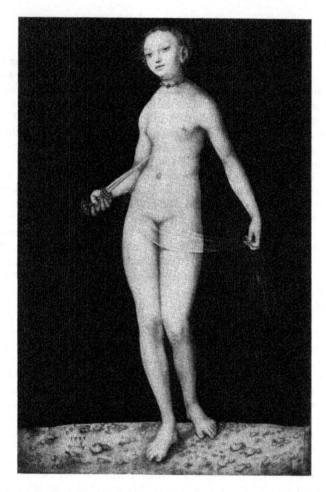

and supplement it? And what would art have to do with this?
What would it give to be seen? Cause to be seen? Let us see? Let
us cause to be seen? Or let itself be shown?

 We are only at the beginning of our astonishment at this
paragraph. (*Parergon* also means the exceptional, the strange, the
extraordinary.) I have torn the "garment" a little too hastily from
the middle of a series of three examples, of three parerga which
are no less strange. Each in itself, first of all, and then in their

association. The example immediately following is that of the
columns around sumptuous buildings (*Säulengänge um Pracht-
gebäude*). These columns are also, then, supplementary *parerga*.
After the garment, the column? Why would the column be ex-
ternal to the building? Where does the criterion, the critical organ,
the organum of discernment come from here? It is no less obscure
than in the previous case. It even presents an extra difficulty: the
parergon is added this time to a work which *does not represent
anything* and which is itself already *added to* nature. We think
we know what properly belongs or does not belong to the human
body, what is detached or not detached from it—even though the
parergon is precisely an ill-detachable detachment. But in a work
of architecture, the *Vorstellung*, the representation is not struc-
turally representational or else is so only through detours com-
plicated enough, no doubt, to disconcert anyone who tried to
discern, in a critical manner, the inside from the outside, the
integral part and the detachable part. So as not to add to these
complications, I shall leave to one side, provisionally, the case of
columns in the form of the human body, those that support or
represent the support of a window (and does a window form part
of the inside of a building or not? And what about the window
of a building in a painting?), and which can be naked or clothed,
can represent a man or a woman, a distinction to which Kant
makes no reference.

With this example of the columns is announced the whole
problematic of inscription in a milieu, of the marking out of the
work in a field of which it is always difficult to decide if it is
natural or artificial and, in this latter case, if it is *parergon* or
ergon. For not every milieu, even if it is contiguous with the work,
constitutes a *parergon* in the Kantian sense. The natural site cho-
sen for the erection of a temple is obviously not a *parergon*. Nor
is an artificial site: neither the crossroads, nor the church, nor
the museum, nor the other works around one or other. But the
garment or the column is. Why? It is not because they are detached
but on the contrary because they are more difficult to detach and
above all because without them, without their quasi-detachment,
the lack on the inside of the work would appear; or (which amounts
to the same thing for a lack) would not appear. What constitutes
them as *parerga* is not simply their exteriority as a surplus, it is
the internal structural link which rivets them to the lack in the
interior of the *ergon*. And this lack would be constitutive of the
very unity of the *ergon*. Without this lack, the *ergon* would have

no need of a *parergon*. The *ergon*'s lack is the lack of a *parergon*, of the garment or the column which nevertheless remains exterior to it. How to give *energeia* its due?

Can one attach the third example to this series of examples, to the question that they pose? It is in fact the first of the examples, and I have proceeded in reverse. In appearance it is difficult to associate it with the other two. It is to do with the frames for paintings (*Einfassungen der Gemälde*). The frame: a *parergon* like the others. The series might seem surprising. How can one assimilate the function of a frame to that of a garment on (in, around, or up against) a statue, and to that of columns around a building? And what about a frame framing a painting representing a building surrounded by columns in clothed human form? What is incomprehensible about the edge, about the *à-bord* appears not only at the internal limit, the one that passes between the frame and the painting, the clothing and the body, the column and the building, but also at the external limit. *Parerga* have a thickness,

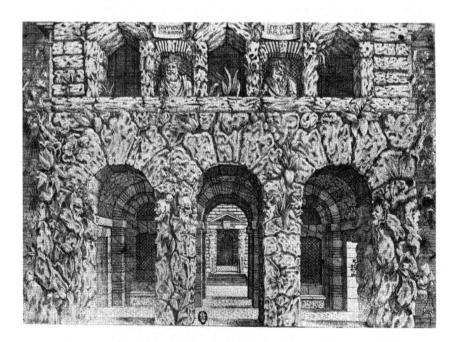

a surface which separates them not only (as Kant would have it) from the integral inside, from the body proper of the *ergon*, but also from the outside, from the wall on which the painting is hung, from the space in which statue or column is erected, then, step by step, from the whole field of historical, economic, political inscription in which the drive to signature is produced (an analogous problem, as we shall see further on). No "theory," no "practice," no "theoretical practice" can intervene effectively in this field if it does not weigh up and bear on the frame, which is the decisive structure of what is at stake, at the invisible limit to (between) the interiority of meaning (put under shelter by the whole hermeneuticist, semioticist, phenomenologicalist, and formalist tradition) *and* (to) all the empiricisms of the extrinsic which, incapable of either seeing or reading, miss the question completely.

The *parergon* stands out [*se détache*] both from the *ergon* (the work) and from the milieu, it stands out first of all like a figure on a ground. But it does not stand out in the same way as the work. The latter also stands out against a ground. But the parergonal frame stands out against two grounds [*fonds*], but with respect to each of those two grounds, it merges [*se fond*] into the other. With respect to the work which can serve as a ground for it, it merges into the wall, and then, gradually, into the general text. With respect to the background which the general text is, it merges into the work which stands out against the general background. There is always a form on a ground, but the *parergon* is a form which has as its traditional determination not that it stands out but that it disappears, buries itself, effaces itself, melts away at the moment it deploys its greatest energy. The frame is in no case a background in the way that the milieu or the work can be, but neither is its thickness as margin a figure. Or at least it is a figure which comes away of its own accord [*s'enlève d'elle-même*].

What would Kant have said about a frame framing a painting representing a building surrounded by columns (examples of this are numerous), columns in the form of clothed human bodies (the frescoes on the vault of the Sistine Chapel—what is its frame?—whose represented, painted object is a sculpted volume itself representing, for example to the right of Jonah, naked children forming a column which supports a ceiling, etc. Same implication around the Persian Sibyl or around Zachariah holding a book in his hand, or around Jeremiah, or the Libyan Sibyl; it is difficult

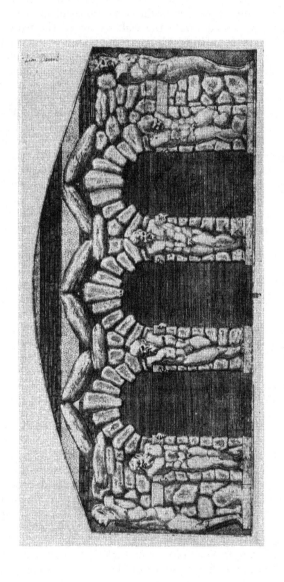

to say whether the children-columns are clothed or unclothed: they are *bearing* clothes), the whole frame being placed on the easel of a painter who is himself represented by another painting.

It may appear that I am taking unfair advantage by persisting with two or three possibly fortuitous examples from a secondary subchapter; and that it would be better to go to less marginal places in the work, nearer to the center and the heart of the matter [*le fond*]. To be sure. The objection presupposes that one already knows what is the center or the heart of the third *Critique*, that one has already located its frame and the limit of its field. But nothing seems more difficult to determine. The *Critique* presents itself as a work (*ergon*) with several sides, and as such it ought to allow itself to be centered and framed, to have its ground delimited by being marked out, with a frame, against a general background. But this frame is problematical. I do not know what is essential and what is accessory in a work. And above all I do not know what this thing is, that is neither essential nor accessory, neither proper nor improper, and that Kant calls *parergon*, for example the frame. Where does the frame take place. Does it take place. Where does it begin. Where does it end. What is its internal limit. Its external limit. And its surface between the two limits. I do not know whether the passage in the third *Critique* where the *parergon* is defined is itself a *parergon*. Before deciding what is parergonal in a text which poses the question of the *parergon*, one has to know what a *parergon* is—at least, if there is any such thing.

To the impatient objector, if s/he insists on seeing the thing itself at last: the whole analytic of aesthetic judgment forever assumes that one can distinguish rigorously between the intrinsic and the extrinsic. Aesthetic judgment *must* properly bear upon intrinsic beauty, not on finery and surrounds. Hence one must know—this is a fundamental presupposition, presupposing what is fundamental—how to determine the intrinsic—what is framed—and know what one is excluding as frame *and* outside-the-frame. We are thus *already* at the unlocatable center of the problem. And when Kant replies to our question "What is a frame?" by saying: it's a *parergon*, a hybrid of outside and inside, but a hybrid which is not a mixture or a half-measure, an outside which is called to the inside of the inside in order to constitute it as an inside; and when he gives as examples of the *parergon*, alongside the frame, clothing and column, we ask to see, we say to ourselves that there

are "great difficulties" here, and that the choice of examples, and their association, is not self-evident.

The more so because, according to the logic of the supplement, the parergon is divided in two. At the limit between work and absence of work, it divides in two. And this division gives rise to a sort of pathology of the *parergon*, the forms of which must be named and classified, just as *Religion* recognized four types of parergonal misdeeds or detriments. Kant is in the process of determining "the proper object of the pure judgment of taste." But he does not simply exclude from it the parergon as such and in general. Only in certain conditions. The criterion of exclusion is here a formality.

What must we understand by formality?

The *parergon* (frame, garment, column) can augment the pleasure of taste (*Wohlgefallen des Geschmacks*), contribute to the proper and intrinsically aesthetic representation if it intervenes *by its form* (*durch seine Form*) and only by its form. If it has a "beautiful form," it forms part of the judgment of taste properly speaking or in any case intervenes directly in it. This is, if you like, the normal *parergon*. But if on the other hand it is not beautiful, purely beautiful, i.e., of a formal beauty, it lapses into *adornment* (*Schmuck*) and harms the beauty of the work, it does it wrong and causes it detriment (*Abbruch*). This is analogous to the detriment or damage (*Nachteil*) of *Religion*.

Now the example of this degradation of the simple *parergon* into a seductive adornment is again a frame, this time the gilded frame (*goldene Rahmen*), the gilding of the frame done in order to recommend the painting to our attention by its attraction (*Reiz*). What is bad, external to the pure object of taste, is thus what seduces by an attraction; and the example of what leads astray by its force of attraction is a color, the gilding, in as much as it is nonform, content, or sensory matter. The deterioration of the *parergon*, the perversion, the adornment, is the attraction of sensory matter. As design, organization of lines, forming of angles, the frame is not at all an adornment and one cannot do without it. But in its purity, it ought to remain colorless, deprived of all empirical sensory materiality.

This opposition form/matter governs, as we know, the whole *Critique* and inscribes it within a powerful tradition. According to *The Origin of the Work of Art*, it is one of the three determinations (*hypokeimenon/symbebekos; aistheton/noeton, eidosmorphē/hylē*) which fall violently upon the thing. It procures a

"conceptual schema" (*Begriffsschema*) for any theory of art. It suffices to associate the rational with the formal, the irrational with matter, the irrational with the illogical, the rational with the logical, to couple the whole lot to the subject/object pair, in order to have at one's disposal a *Begriffsmechanik* that nothing can resist. But from what region does this determination of the thing as formed matter come? Its wholesale usage by aesthetics

allows us to conceive of it as a deportation from the domain of
art. In any case, Christian creationism would, according to Hei-
degger, have brought with it a "particular incitement," a supple-
mentary motivation for considering the form-matter complex as
the structure of every entity, the *ens creatum* as the unity of *forma*
and *materia*. Though faith has disappeared, the schemas of Chris-
tian philosophy remain effective. "Thus it is that the interpre-
tation of the thing in terms of matter and form, whether it remains
medieval or becomes transcendental in the Kantian sense, has
become common and self-evident. But this does not make it any
less than the other interpretations of the thingness of the thing
a superimposition fallen onto (*Überfall*) the being-thing of the
thing. This situation reveals itself already in the fact of naming
things properly speaking (*eigentlichen Dinge*) things pure and sim-
ple [*bloss Dinge*: naked things]. This 'naked' (*bloss*) does however
mean the stripping (*Entblössung*) of the character of usefulness
(*Dienlichkeit*) and of being made. The naked thing (*blosse Ding*)
is a sort of product (*Zeug*) but a product divested (*entkleidete*) of

its being-as-product. Being-thing then consists in what still re-
mains (*was noch übrigbleibt*). But this remainder (*Rest*) is not
properly (*eigens*) determined in itself. . . ." ⎯
 |

|
⎯ and what if the *Überfall* had the structure of the
parergon? The violent superimposition which falls aggressively
upon the thing, the "insult" as the French translator says for the
Überfall, strangely but not without pertinence, which enslaves
it and, literally, conjugates it, under matter/form—is this super-
imposition the contingency of a case, the fall of an accident, or
a necessity which remains to be examined? And what if, like the
parergon, it were neither the one nor the other? And what if the
remainder could never, in its structure as remainder, be deter-
mined "properly," what if we must no longer even expect or ques-
tion anything within that horizon ⎯
 |

|
⎯ the
word *parergon* intervenes, precisely (paragraphs 13 and 24) at the
moment when Kant has just distinguished between *material* and
formal judgments, the latter alone constituting judgments of taste
in the proper sense. It is not, of course, a matter of a formalist
aesthetic (we could show, from another point of view, that it is
the contrary) but of formality as the space of aesthetics in general,
of a "formalism" which, instead of representing a determinate
system, merges with the history of art and with aesthetics itself.
And the formality-effect is always tied to the possibility of a
framing system that is both imposed and erased.
 The question of the frame is already framed when it appears
at a certain detour of the *Critique.*
 Why framed?
 The "Clarification by Examples" (paragraph 14) belongs to
the "Analytic of the Beautiful," book 1 of the "Analytic of Aes-
thetic Judgment." This analytic of the beautiful comprises four
parts, four sides, four moments. The judgment of taste is exam-

ined from four sides: (1) according to *quality*; (2) according to *quantity*; (3) according to the *relation of the ends* (the *parergon* finds its lodgings here); (4) according to *modality*. The definition of the beautiful according to quality is the object of a disinterested *Wohlgefallen*; according to quantity, what pleases universally without concept; according to the relation of ends, the form of finality without the representation of an end (finality without end[11]); according to modality, that which is recognized without concept as the object of a necessary *Wohlgefallen*.

Such is the categorial frame of the analytic of the beautiful. Now where does this frame come from? Who supplies it? Who constructs it? Where is it imported from?

From the analytic of concepts in the *Critique of Pure* [speculative] *Reason*. A brief reminder: this analytic of concepts is one of the two parts of the transcendental analytic (transcendental analytic and dialectic, a division reproduced in the third *Critique*: analytic and dialectic of aesthetic judgment). The transcendental analytic comprises an analytic of concepts and an analytic of principles. The former breaks down the power of understanding in order to recognize in it the possibility of *a priori* concepts in their "country of birth," namely the understanding, where they lie dormant and in reserve. Since (receptive) intuition alone relates immediately to the object, the understanding does so by the intermediary, precisely, of judgments. Judgment is the mediate knowledge of an object. And we can "refer all the acts of the understanding back to judgments, in such a way that the understanding in general can be represented as a power to judge (*Urteilskraft*)." The power to think as power to judge. One will thus find the functions of the understanding by determining the functions of unity in judgment. Concepts relate, as predicates of possible judgments, to the representation of an object. Consequently, by considering the simple form of the understanding, by abstracting the content of judgments, one can establish the list of the forms of judgment under *four* headings and twelve moments (four times three: the four-times-three also constructs the table (*Tafel*)

11. We have preferred to translate Derrida's "finalité sans fin" literally as "finality without end," rather than revert to the standard "purposiveness without purpose": this allows us to preserve a certain sense of Derrida's exploitation of different senses of the word *fin* ("end"), and to avoid certain traditional assumptions about Kant which Derrida's essay suspends at the very least. "Purpose" would be more suitable for *but*, but we have tended to translate this as "goal" to avoid confusion.

of the superior faculties at the end of the introduction to the third *Critique*. Kant replies, in a note, to those who object to his "tripartite" (*dreiteilig*) divisions and to his taste for "trichotomy"; and the *three + one* informs the relationship of the faculties required by the fine arts—imagination, understanding, soul—with taste: "the first three faculties are united only thanks to the fourth," affirms the note to paragraph 50): *quantity* of the judgments (universal, particular, singular), *quality* (affirmative, negative, indefinite), *relation* (categorical, hypothetical, disjunctive), *modality* (problematic, assertoric, apodeictic). *Table of twelve*. Now there are as many pure concepts of the understanding, originary and nonderivable concepts, as there are logical functions in judgments. Whence the deduction of the table of categories (against the so-called grammatical empiricism of Aristotle) from the table of judgments.

Kant thus imports this table, this tableau (*Tafel*), this *board*[12] this *border* into the analytic of aesthetic judgment. This is a legitimate operation since it is a question of judgments. But it is a transportation which is not without its problems and artful violence: a *logical* frame is transposed and forced in to be imposed on a *nonlogical* structure, a structure which no longer essentially concerns a relation to the object as object of knowledge. The aesthetic judgment, as Kant insists, is not a knowledge-judgment.

The frame fits badly. The difficulty can be felt from the first paragraph of the book, from the "first moment of the judgment of taste considered from the point of view of quality." "The judgment of taste is aesthetic": in this single case, not foreseen by the analytic of concepts and judgments in the other *Critique*, the judgment is not a "knowledge-judgment." Hence it does not come under the transcendental logic whose *board* has been brought in.

The violence of the framing multiplies. It begins by enclosing the theory of the aesthetic in a theory of the beautiful, the latter in a theory of taste and the theory of taste in a theory of judgment. These are decisions which could be called external: the delimitation has enormous consequences, but a certain internal coherence can be saved at this cost. The same does not apply for another gesture of framing which, by introducing the *bord*, does violence to the inside of the system and twists its proper articulations out of shape. This must therefore be the gesture of primary interest to us if we are seeking a rigorously effective grip.

12. In English in the text.

In the course of the final delimitation (theory of taste as theory of judgment), Kant *applies*, then, an analytic of logical judgments to an analytic of aesthetic judgments at the very moment that he is insisting on the irreducibility of the one kind to the other. He never justifies this framing, nor the constraint it artificially imposes on a discourse constantly threatened with overflowing [*débordement*]. In the first note to the first page, Kant says that the *logical* functions of judgment served him as a guide (*Anleitung*). This note touches on a difficulty so decisive that one cannot see why it does not constitute the principal text of which it forms the ground bass, that is, the unwritten or underwritten space, the supposed range of the harmonics. Here it is: "The definition of taste which here serves as a foundation is the following: taste is the faculty of judging the beautiful. But what is then required in order to call an object beautiful must be discovered (*entdecken*) by the analysis of judgments of taste. I [intervention of the first person in a footnote] have looked for the moments (*Momente*) raised by this judgment in its reflection, taking as a guide the logical functions (for in judgments of taste there is still always (*immer noch*) a relation to the understanding. It is the moment of quality that I have examined first, because it is the one that the aesthetic judgment of the beautiful takes into consideration first."

This note is to the title, "First Moment of the Judgment of Taste Considered from the Point of View of Quality." The note thus precedes, in a certain way, the text of the exposition, it is relatively detached from it. The same goes for the parenthesis it includes: "(for in judgments of taste there is still always (*immer noch*) a relation to the understanding)." This parenthesis (inserted in a note which is neither inside nor outside the exposition, neither inside nor outside its content) attempts to justify—and it is the only such attempt—the frame of the exposition, namely the analytic of judgment whose *bord* has been hastily imported at the opening of the exposition.

Before the note and its parenthesis (before, if one looks at the space of the page from bottom to top, but after if one keeps to the order of the exposition which places the note at the top of the page, at the place of its reference), another, briefer parenthesis forms a pocket in the supposedly "main" text and is *invaginated* in it, in a sense: "In order to distinguish whether or not a thing is beautiful, we do not relate the representation to the object by means of the understanding, with a view to knowledge, but to

the subject and to its feeling of pleasure or unpleasure, by means of the imagination (united perhaps with the understanding, *vielleicht mit dem Verstande verbunden*)."

The two parentheses, *parerga* inside and outside the exposition, have the same object, the same finality: the justification (which is visibly very awkward) of the imported frame, of the analytic imposed—an ill-assured recourse, in order to get the table by and make the board fit—on a hypothetical "liaison" with the understanding, to which the judgment of taste, although there is nothing logical about it, supposedly "always still" has a relation.

Like an old liaison difficult to break off or a second-hand frame one is having trouble selling and that one wants to unload at any price.

The frame of this analytic of the beautiful, with its four moments, is thus furnished by the transcendental analytic, for the sole and bad reason that the imagination, the essential resource of the relation to beauty, is *perhaps* linked to the understanding, that there is perhaps and *still (vielleicht, noch)* some understanding in there. The relation to the understanding, which is neither certain nor essential, thus furnishes the frame of this whole discourse; and, within it, of the discourse on the frame. Without forcing things, but in any case in order to describe a certain forcing on Kant's part, we shall say that the whole frame of the analytic of the beautiful functions, with respect to that the content or internal structure of which is to be determined, like a *parergon*; it has all its characteristics: neither simply internal nor simply external, not falling to one side of the work as one could have said of an exergue, indispensable to *energeia* in order to liberate surplus value by enclosing labor (any market and first of all the picture market thus presupposes a process of framing: and an effective deconstructive labor cannot here do without a theory of the frame), it is called up and gathered together as a supplement from the lack—a certain "internal" indetermination—in the very thing that it comes to frame. This lack, which cannot be determined, localized, situated, *arrested* inside or outside *before the framing*, is simultaneously—still using concepts which belong, precisely, to the classical logic of the frame, here to Kant's discourse—both *product* and *production* of the frame. If one applies to it the rule defined in the "Clarification by Examples," and if it becomes in its turn an example of what it allows us to consider as an example (frame described in the frame), then one can act as though the content of the analytic of judgment were a work

of art, a picture whose frame, imported from the other *Critique,* would by virtue of its formal beauty play the role of *parergon.* And if it were simply an attractive, seductive, amusing exergue, not cooperating with what is proper to the work, a pure loss of value and waste of surplus value, then it would only be adornment. But it so happens that it is this analytic of judgment itself which, in its frame, allows us to define the requirement of formality, the opposition of the formal and the material, of the pure and the impure, of the proper and the improper, of the inside and the outside. It is the analytic which *determines* the frame as *parergon,* which both constitutes it and ruins it [*l'abîme*], makes it both hold (as that which causes to hold together, that which constitutes, mounts, inlays, sets, borders, gathers, trims—so many operations gathered together by the *Einfassung*) and collapse. A frame is essentially constructed and therefore fragile: such would be the essence or truth of the frame. If it had any. But this "truth" can no longer be a "truth," it no more defines the transcendentality than it does the accidentality of the frame, merely its *parergonality.*

Philosophy wants to arraign it and can't manage. But what has produced and manipulated the frame puts everything to work in order to efface the frame effect, most often by naturalizing it to infinity, in the hands of God (one can verify this in Kant). Deconstruction must neither reframe nor dream of the pure and simple absence of the frame. These two apparently contradictory gestures are the very ones—and they are systematically indissociable—of *what* is here deconstructed.[13]

If the operations engaged and the criteria proposed by the analytic of the beautiful depend on this parergonality; if all the value oppositions which dominate the philosophy of art (before and since Kant) depend on it in their pertinence, their rigor, their purity, their propriety, then they are affected by this logic of the *parergon* which is more powerful than that of the analytic. One could follow in detail the consequences of this infectious affection. They cannot be local. The reflective operation which we have just allowed to make itself writing on the frame or have itself written on the frame (this is—writing/written on the frame):[14] a general law which is no longer a mechanical or teleological law

13. "De *ce qui* se deconstruit": the French pronominal verb retains both passive and reflexive values.

14. "Ceci est—écrit sur le cadre": *écrit* can also be "a piece of writing."

of nature, of the accord or the harmony of the faculties (etc.), but a certain repeated dislocation, a regulated, irrepressible dislocation, which makes the frame in general crack, undoes it at the corners in its quoins and joints,[15] turns its internal limit into an external limit, takes its thickness into account, makes us see the picture from the side of the canvas or the wood, etc.

To note only the first consequence of the initial forcing, see the end of the first note (another *parergon* which frames both the text and, within it as within itself, the parenthesis). Just as Kant cannot justify in all rigor the importation of the analytic of judgment, he cannot justify the *order* he follows in the application of the frame, of the four categories of the analytic of concepts. No more than with the transport of the table (*Tafel*), i.e., the frame, does the order of exposition here manage to rationalize its interest philosophically. Its motivation hides behind the arbitrariness of philosophical decree. The exposition begins with the group of the two *mathematical* categories (*quantity and quality*). Why not begin with the two *dynamic* categories (*relation and modality*)? And why invert the order of the mathematical categories themselves, as it was followed in the original exposition (quantity before quality)? This latter reversal is explained, to be sure, by the fact that knowledge is neither the end nor the effect of the judgment of taste: quantity (here, universality) is not the *first* value of a judgment of taste. End of the note: "It is the moment of quality that I have examined first, because it is the one that the aesthetic judgment of the beautiful takes into consideration first." Why first (*zuerst*)? The priority is not prescribed by the table, by the order of judgment, by the logic proper to the frame. Nothing in the (logical) analytic as such can account for this priority. Now if a reversal of the logical order takes place here for reasons which are not logical, why should it not continue? What is the rule or critical limit here?

Quality (the disinterested character) is the very thing that determines the formality of the beautiful object: it must be pure of all attraction, of all seductive power, it must provoke no emotion, promise no enjoyment. The *opposition* between the formal and the material, design and color (at least insofar as it is nonformal), composition and sound (at least insofar as it is nonfor-

15. "L'abîme en coin dans ses angles et ses articulations": the translation loses a certain sense of slyness; cf. "un regard en coin," a sideways glance. Use of the idiom "on the side" would interfere too much with the insistence on corners.

mal), the formal *parergon* and the *parergon* for show or adorn-
ment, the opposition between the good and the bad *parergon*
(which in itself is neither good nor bad) thus depends on the
framing of this quality, of this frame effect called quality, value
of value, and with which, violently, everything seems to begin.
Position: opposition: frame.

Likewise, in the "Clarification," the discourse on sound and
on color is held in the angle of the two mathematical categories
(quality and quantity) even as the whole analytic of the beautiful
is undoing, ceaselessly and as if without wanting to, the labor of
the frame.

The frame labors [*travaille*] indeed. Place of labor, structur-
ally bordered origin of surplus value, i.e., overflowed [*débordée*]
on these two borders by what it overflows, it gives [*travaille*]
indeed.[16] Like wood. It creaks and cracks, breaks down and dis-
locates even as it cooperates in the production of the product,
overflows it and is deduc(t)ed from it. It never lets itself be
simply exposed.

The analytic of the beautiful thus gives, ceaselessly undoes
the labor of the frame to the extent that, while letting itself be
squared up by the analytic of concepts and by the doctrine of
judgment, it describes the absence of concept in the activity of
taste. "The beautiful is what is represented without concept as
object of a universal *Wohlgefallen.*" This definition (second mo-
ment, category of quantity) derives from the qualitative defini-
tion (disinterestedness). The object of a disinterested pleasure
does not depend on an empirical inclination, it therefore ad-
dresses itself to freedom and touches everyone—no matter who—
where everyone can be touched. It is therefore universal. Now
in explaining why this universality must be without concept,
Kant exhibits in a sense the forcing—imposing an analytic of
concepts on a process without concept—but he justifies his op-
eration by an argument that one can consider to be the *consti-
tution,* that which makes the whole edifice of the third *Critique*
hold-together-and-stand-upright in the middle of its two great
wings (the critique of aesthetic judgment and the critique of
teleological judgment). This argument is *analogy.* It operates

16. This sense of the verb *travailler* (i.e., to give or warp, of wood or
metal) communicates with an important sense of *jouer* (literally "to play,"
but also "to give" in the sense of there being "play" or "give" in a steering
wheel, for example); see here p. 81.

everywhere in the book, and one can systematically verify its effect. At the place where we are in the exposition—its cross-roads—it *gathers together* without-concept and concept, universality *without* concept and universality *with* concept, the *without* and the *with*; it thus legitimates the violence, the occupation of a nonconceptual field by the grid [*quadrillage*] of a conceptual force. Without and with at the same time (*ama*). By reason of its qualitative universality, the judgment of taste *resembles* the logical judgment which, nonetheless, it never is, in all rigor. The nonconceptual resembles the conceptual. A very strange resemblance, a singular proximity or affinity (*Ähnlichkeit*) which, somewhere (to be specified later)[17] draws out of *mimēsis* an interpretation of the beautiful which firmly rejects imitation. There is no contradiction here which is not reappropriated by the economy of *physis* as *mimēsis*.

He who takes a disinterested pleasure (without enjoyment and without concept) in the beautiful "will speak of the beautiful as if (*als ob*) beauty were a quality (*Beschaffenheit*) of the object and the judgment logical (forming a cognition of the Object by concepts of it); although it is only aesthetic, and contains merely a reference (*Beziehung*) of the representation of the object to the Subject—because it still bears this resemblance [*Ähnlichkeit*: affinity, proximity, family tie] to the logical judgment, that it may be presupposed to be valid for all men. But this universality cannot spring from concepts. For from concepts there is no transition to the feeling of pleasure or displeasure (save in the case of pure practical laws, which, however, carry an interest with them; and such an interest does not attach to the pure judgment of taste)" [Meredith, 51].

The discourse on color and sound belongs to the "Clarification by Examples," in the course of the exposition of the third category: the dynamic category of finality. The judgment of taste relates to a purely formal finality, without concept and without end, without a conceptual and determinant representation of an end. The two mathematical categories are nonetheless indispensable: sound and color are excluded as *attractions* only to the extent of their nonformality, their materiality. As pure forms, sound and color can give rise to a universal appreciation, in conformity with the quantity of a judgment of taste; they can procure a disinterested

17. Cf. "Economimesis."—J.D.

pleasure, conforming to the quality of a judgment of taste. The sensations of sound and color can "quite rightly" be held beautiful to the extent that they are "pure": this determination of purity concerns only the form, which alone can be "universally communicable with certainty." According to Kant, there are two ways of acceding to formal purity: by a nonsensory, nonsensual reflection, and by the regular play of impressions, "if one assumes with Euler" that colors are vibrations of the ether (*pulsus*) at regular intervals, and if (formal analogy between sounds and colors) sounds consist in a regular rhythm in the vibrations of the disturbed ether. Kant had a great deal of difficulty coming to a conclusion on this point. But the fact remains that on this hypothesis one would be dealing not with material contents of received sensations but with formal determinations. That is why simple color is pure color and can therefore belong inside the beautiful, giving rise to universally communicable appreciations. Mixed colors cannot do this. The empiricist motif (that simple color does not give rise to a transmissible perception) seems to have been inverted, but it is here not a question of determinant perception but only of pleasure or unpleasure.

This ambivalence of color (valorized as formal purity or as relation, devalorized as sensory matter, beauty on the one hand, attraction on the other, pure presence in both cases) is raised to the second power (squared) when it is a question of the color of the frame (*goldene Rahmen*, for example), when the parergonal equivocity of the color comes to intensify the parergonal equivocity of the frame. What would be the equivalent of this square for music

|

|___ it will be said that not all frames are, or have been, or will be square, rectangular, or quadrangular figures, nor even simply angular. Tables and tableaux (*Tafel*) likewise not. This is true: a critical and systematic and typological history of framing

seems possible and necessary.[18] But the angle in general, the quad-
rangular in particular will not be just one of its objects among
others. Everything that is written here is valid for the logic of
parergonal bordering in general, but the privilege of "cadre" [frame],
though it seems more fortunate in the Latin than in the Germanic
languages, is not fortuitous ⸻
 |

|
⸻ Kantian ques-
tion: the relation of the concept to the nonconcept (up/down,
left/right), to the body, to the signature which is placed "on"
the frame: in fact, sometimes; structurally, always. The pros-
thesis ⸻
 |

|
⸻ which does not run along as though
on wheels in the third Critique as soon as one looks a little
more closely at the example, that example of an example which
forms and is formed by the frame. If things run as though on
wheels, this is perhaps because things aren't going so well, by
reason of an internal infirmity in the thesis which demands to
be supplemented by a prosthesis or only ensures the progress
of the exposition with the aid of a wheelchair or a child's
pushchair. Thus one pushes forward something which cannot
stand up, does not erect itself by itself in its process. Framing

18. When "Parergon" was first published, I had not yet read Meyer
Schapiro, "Sur quelques problèmes de sémiotique de l'art visuel: champ et
véhicule dans les signes iconiques," translated into French by Jean-Claude
Lebensztejn, Critique 315–16 [(1973), 843–66; originally published in Se-
miotica 1, no. 3 (1969):223–42].
 The reader will find more than one indication concerning the "history"
of framing, its "late invention," the not very "natural" character of the
"rectangular frame," as well as "the frame that bends and turns inward into
the field of the picture to compress or entangle the figures (the trumeau of
Souillac, the Imago Hominis in the Echternach Gospels . . .)" (p. 228).
 I also refer, as goes without saying, to all of Lebensztejn's publica-
tions.—J.D.

always supports and contains that which, by itself, collapses
forthwith, exc ⎯⎯

|

|⎯ this is demonstrated
by example, by the problem of the example and the reflective judg-
ment. Now what does the *Critique of Pure Reason* tell us? That ex-
amples are the wheelchairs [*roulettes*] of judgment. The French trans-
lators sometimes say the "crutches" of judgment: but it really is
wheelchairs (*Gängelwagen*), not skateboards [*planches-à-roulettes*] but
the little wheeled cars in which children, the old, or the sick are pushed,
those who have not enough judgment, enough good sense, that faculty
of natural judgment, the best-shared thing (this is not the *sensus com-
munis* of the third *Critique*) that is called—this is Kant's word—*Mut-
terwitz*. Those who do not have enough of this maternal *Witz*, the sick,
imbeciles, need wheelchairs, examples. "Examples are thus the
wheelchairs of the faculty of judging (*Gängelwagen der Urteilskraft*)
and those who lack (*mangelt*) this natural talent will not be able to do
without them." The wheelchairs, however, do not replace judgment:
nothing can replace the *Mutterwitz*, the lack of which cannot be sup-
plied by any school (*dessen Mangel keine Schule ersetzen kann*). The
exemplary wheelchairs are thus prostheses which replace nothing. But
like all examples (*Beispielen*), as Hegel will have pointed out, they play,
there is play in them, they give room to play. To the essence, beside the
essence (*beiher*), Hegel goes on to make clear. Thus they can invert,
unbalance, incline the natural movement into a parergonal move-
ment, divert the energy of the *ergon*, introduce chance and the abyss
into the necessity of the *Mutterwitz*: not a contrary order but an alea-
tory sidestep which can make one lose one's head suddenly, a Russian
roulette if one puts into play pleasure without enjoyment, the death-
drive and the mourning of labor in the experience of the beautiful⎯⎯
 |

|⎯ of the parergon—get one's
mourning done. Like the entirely-other of hetero-affection, in the
pleasure without enjoyment and without concept, it provokes and
delimits the labor of mourning, labor *in general as* labor of

mourning �len

|___ *le travail à parer*[19] �len

|___ reserve, savings,
parsimony, stock—the self-protection *of* the work (*ergon*), energy
captured, hemmed (the "binding" (*Verbindung*) of energy, condition
for the "mastery" (*Herrschaft*) of the pleasure principle: the result
"is not simple"—to be continued) �len

|___ the self-protection-*of*-the-work,
of *energeia* which becomes *ergon* only as (from) *parergon*: not against
free and full and pure and unfettered energy (pure act and total
presence of *energeia*, the Aristotelian prime mover) but against what
is *lacking* in it; not against the lack as a posable or opposable neg-
ative, a substantial emptiness, a determinable and bordered absence
(still verifiable essence and presence) but against the impossibility
of *arresting différance* in its contour, of arraigning the heterogeneous
(*différance*) in a pose, of localizing, even in a meta-empirical way,
what metaphysics calls, as we have just seen, *lack*, of making it
come back, equal or similar to itself (*adaequatio-homoiosis*), to its
proper place, according to a proper trajectory, preferably circular
(castration as truth). Although apparently opposed—or because op-
posed—these two *bordering* determinations of what the parergon is
working against (the operation of free energy and of pure produc-

19. This syntagm is untranslatable as it stands: depending on the se-
quence into which it was inserted, it could mean, "(the) work to adorn,"
"(the) work to parry," "(the) work to be adorned," "(the) work to be parried,"
etc.

tivity or the operation of the essential lack) are *the same* (metaphysical).[20]

————|

|———— that which is outside the frame (putting-into-lethargy and absolute value of the frame): naturalization of the frame. There is no natural frame. *There is* frame, but the frame *does not exist.*

The parergon—apotrope (decoration, show, parry) *of the* primary processes, of free energy, i.e., of the "theoretical fiction" (*Ein psychischer Apparat, der nur den Primärvorgang besässe, existiert zwar unseres Wissens nicht und ist insoferne eine theoretische Fiktion*). So only a certain practice of theoretical fiction can work (against) the frame, (make or let it) play (it) (against) itself. Don't forget, nonetheless, that the *content*, the *object* of this theoretical fiction (the free energy of the originary process, its pure productivity) is metaphysics, onto-theology itself. The practice of fiction always runs the risk of believing in it or having us believe in it. The *practice* of fiction must therefore guard against having metaphysical truth palmed off on it once again under the label of fiction. There is fiction and fiction. Necessity here of the angle—diagonality—where things work and play and give, and of showing up the remnants of the angle in round frames (there are such things). Hegel: spirit linked to the appearance of the round form

————|

|———— everything will flower at the edge

20. "*Le même* (metaphysique)": also, "the (metaphysical) same," "the same (metaphysics)."

of a deconsecrated tomb: the flower with free or vague beauty (*pul-chritudo vaga*) and not adherent beauty (*pulchritudo adhaerens*). It will be, for (arbitrary) example, a colorless and scentless tulip (more surely than color, scent is lost to art and to the beautiful (paragraph 53): just try to frame a perfume) which Kant doubtless did not pick in Holland but in the book of a certain Saussure whom he read frequently at the time. "But a flower, *zum Beispiel eine Tulpe*, is held to be beautiful because in perceiving it one encounters a finality which, judged as we judge it, does not relate to any end" ⎯
 |

|⎯

 even

III. The *Sans* of the Pure Cut[21]

"La Façon de faner des tulipes

. . .
 Et je sais bien qu'il ne s'agit point ici d'une tête, mais
seulement de la tête du noeud (ou comme d'une rétroversion
de l'utérus), de la gourde séminale, et donc d'aucune autre
intelligence que celle d'un gland (ou rétroversion de l'utérus).
 Mais cela ne jette-t-il pas quelque jour, justement, sur
l'intelligence des autres têtes? des soi-disant véritables têtes?
. . .
lors donc de la fleur fanant ou fanée.
 Et peut-être suffirait-il d'avoir attiré l'attention, fixé un
moment les regards, porté le goût, fixé la mode sur ces
moments-là pour avoir un peu modifié la morale, peut-être;
peut-être la politique? L'opinion, du moins, de quelques
personnes.
. . .
 Nous aussi en avons fini de la 'beauté'; de la forme
parfaite: celle d'une coupe, pour les tulipes à leur éclosion
(classique).
. . .
 D'où la déformation et l'impropriété manifeste de nos
mots, de nos phrases;
 D'où la forme incongrue, baroque: ouverte enfin,—de nos
textes."

 PONGE, "L'opinion changée quant aux fleurs."[22]

21. Literally, "The without of the pure cut," but the homophony
with *sang* (blood) is important, as is the affinity with *sens* (sense[s],
direction[s]).

22. "And I know full well that we are not here dealing with a head,
but only the head of the prick [*noeud:* knot, node, as well as a vulgar

is picked at the end of a footnote. You recall: "But a flower, for example a tulip, is held to be beautiful because, in perceiving it, one encounters a finality which, judged as we judge it, does not relate to any end."

In the *Analytic of the Beautiful*, the note is appended to the definition of the beautiful concluded from the third moment: the judgment of taste examined as to the relation of finality. According to the framework of categories imported from the *Critique of Pure Reason*, the *Analytic* was constructed and bordered by the four categories: quality and quantity (mathematical categories), relation and modality (dynamic categories). The problem of the *parergon*, the general and abyssal question of the frame, had arisen in the course of the exposition of the category of relation (to finality). The example of the tulip is placed right at the very end of this exposition: the last word of the last footnote, itself appended to the last word of the main text. At the end of each exposition, Kant proposes a definition of the beautiful for the four categories: according to *quality* (the object of a disinterested *Wohlgefallen*), according to *quantity* (that which pleases universally *without* concept), according to *relation* (the form of finality perceived *without* the representation of an end). Just when he has extracted this third definition of the beautiful ("Beauty is the form of the finality—*Form der Zweckmässigkeit*—of an object inasmuch as it is perceived in that object without the representation of an end—*ohne Vorstellung eines Zwecks*—"), Kant adds a note to answer an objection.

Once again, for obvious reasons, I am going backwards, by a reflective route, from the example (if possible) toward the concept.

term for the penis: cf., too, the colloquial insult 'tete de noeud'] (or something like a retroversion of the uterus), with the seminal gourd, and hence with no other intelligence than that of a glans [*gland*: also 'acorn'] (or a retroversion of the uterus). / But does this not throw some light, precisely, on the intelligence of other heads? so-called real heads? ... / at the time, then, of the flower faded or fading. / And perhaps it would suffice to have called attention, fixed people's eyes for a moment, directed taste, fixed fashion onto those moments, in order to have modified morality a little, perhaps; perhaps politics? The opinion, at least, of some people. / ... We too have finished with 'beauty'; with the perfect form; that of a cup, for tulips at their (classical) opening. / ... Whence the deformation and the manifest impropriety of our words, our phrases; / Whence the incongruous, baroque—in a word, open—form of our texts" Ponge, "Changed Opinion as to Flowers."

So it's to do with a flower. Not just any flower: not the rose, not the sunflower, nor the broomflower [genêt]—the tulip. But there is every reason for presuming that it does not come from nature. From another text, rather. The example seems arbitrary until we notice that a certain Saussure is often cited by Kant in the third *Critique*. Now this Monsieur de Saussure, "a man as witty as he is profound," says Kant in the great "General Remark concerning the Exposition of Reflexive Aesthetic Judgments," was the author of a *Journey in the Alps*. There we read something that Kant did not quote: "I found, in the woods above the hermitage, the wild tulip, which I had never seen before" (1: 431).

Though it is taken from a book or an anthology, it is extremely important that Kant's tulip should nevertheless be natural, absolutely wild. A paradigmatics of the flower orients the third *Critique*. Kant always seeks in it the index of a natural beauty, utterly wild, in which the *without-end* or the *without-concept* of finality is revealed. At the moment when, much further on (§ 42, on "The Intellectual Interest of the Beautiful"), he wants to argue that the immediate interest taken in the beauties of nature, prior to any judgment of taste, is the index of a good soul, he has recourse to the example of "the beautiful form of a wildflower." This interest must of course be directed to the beauty of the forms and not to the attractions which would use these forms for purposes of empirical seduction. Someone who admires a beautiful wildflower, to the point of regretting its potential absence from nature, is "immediately and intellectually interested in the beauty of nature," without the intervention of any sensual seduction. And it is quite "remarkable" that if one substitutes an artificial (*künstliche*) flower (and, adds Kant, it is possible to make them entirely similar to natural ones), and if the trick is discovered, the interest disappears at once. Even if it is replaced by a perverse interest: using this artifical beauty, for example, to decorate one's apartment.

The example of finality without end must thus be wild. *Zweckmässigkeit ohne Zweck*—the phrase is just as faded as "disinterested pleasure," but remains none the less enigmatic for that. It seems to mean this: everything about the tulip, about its form, seems to be organized with a view to an end. Everything about it seems finalized, as if to correspond to a design (according to the analogical mode of the *as if* which governs this whole discourse on nature and on art), and yet there is something missing

from this aiming at a goal [*but*]—the end [*bout*]. The experience
of this absolute lack of end comes, according to Kant, to provoke
the feeling of the beautiful, its "disinterested pleasure." I leave
aside deliberately all the problems of etymology—of derivation
or affinity—which can be raised by this resemblance of *but* and
bout. Let us merely note that they have in common the sense of
the end [*fin*], the term-with-a-view-to-which, the extremity of a
line or an oriented movement, end of direction and sense of the
end [*fin du sens et sens de la fin*]. The feeling of beauty, attraction

without anything attracting, fascination without desire have to do with this "experience": of an oriented, finalized movement, harmoniously organized *in view* of an end which is never *in view*, seen, an end which is missing, or a *but en blanc.*[23] I divert this expression from the code of artillery: firing a *but en blanc* is to fire at a target [*blanc*] placed at such a distance that the bullet (or the shell) drops to intersect the prolongation of the line of sight. *But* refers here to the origin from which one fires *de but en blanc:* the gun barrel as origin of the drive. There must be finality, oriented movement, without which there would be no beauty, but the orient (the end which originates) must be lacking. Without finality, no beauty. But no more is there beauty if an end were to determine it.

The wild tulip is, then, seen as exemplary of this finality without end, of this useless organization, without goal, gratuitous, out of use. But we must insist on this: the being cut off from the goal only becomes beautiful if everything in it is straining toward the end [*bout*]. Only this absolute interruption, this cut which is pure because made with a single stroke, with a single *bout* (*bout* means blow: from *buter*, to bang or bump into something) produces the feeling of beauty. If this cut were not pure, if it could (at least virtually) be prolonged, completed, supplemented, there would be no beauty.

What justifies us perhaps in playing from *but* to *blanc*, in passing from *end* to *end [de bout en bout]* and from *but* to *bout*, is an association that appears strange at first approach. In Kant's footnote, the tulip appears to be placed, deposited on a tomb. In reply, then, to an objection.

The objection: there are final forms without end which are nevertheless not beautiful; so not every finality without end produces the feeling of beauty. Kant ascribes a curious example to the anonymous objector: in the course of excavating ancient tombs, there are often finds of stone utensils with a hole, an opening, a cavity (*Loche*), "as if for a handle (*Hefte*)". Does not their form clearly indicate a finality, and a finality whose end remains undetermined? The objection continues: this finality without end

23. Usually used figuratively in the sense of "suddenly, point blank, just like that" (Collins-Robert): but here "point blank" would be misleading, as its colloquial sense corresponds to the French "à bout portant." However, the *OED* defines "point-blank range" as "the distance the shot is carried before it drops appreciably below the horizontal plane of the bore."

does not provoke any feeling of beauty. No one says that they are beautiful, these tools equipped with a hole without a handle, these tools (*outils*), these utensils, these finalized useful objects that have no visible goal or end, no end that is determinable in a concept.

To be sure, replies Kant, but it is enough to consider them as artifacts (*Kunstwerke*) in order to relate them to a determinable goal. So when we intuit them, we have no immediate *Wohlge-fallen*. This reply is somewhat obscure. On the one hand, it opposes the *immediate* experience of finality in the tulip to the experience of the utensil, which is an experience mediated by a judgment. In both cases there is, supposedly, experience of beauty because the finality is without end both in art and in nature. On the other hand, if *Kunstwerk* designates a work of artifice in general and not the object of the fine arts, the experience of beauty would be absent from it to the extent that the supposed intention (*Absicht*) implies a determinable end and use: there would be not merely finality but end, because the pure cut could be bandaged.[24] The finalized gadget is not absolutely cut off from its end, one can mediately prolong it toward a goal, virtually supply it, replace the handle in its hole, rehandle the thing, give the finality its end back. If the gadget is not beautiful in this case, it is for want of being sufficiently cut off from its goal (*but*). It still adheres to it. There is an adherence—to be continued—between the detached end and the finalized organization of the organ, between the end and the form of finality. As long as there remains an adherence, even virtually or symbolically, as long as there is not a pure cut, there is no beauty. No pure beauty, at least.

As soon as he has closed the tomb again and covered over the place of the dig, Kant puts forward the example of the tulip: "But a flower, for example a tulip, is held to be beautiful because in perceiving it, one encounters a finality which, judged as we judge it, does not relate to any end."

The tulip is beautiful only on the edge of this cut without adherence. But in order for the cut to appear—and it can still do so only by its edging—the interrupted finality must show itself, both as finality and as interrupture—as edging. Finality alone is not beautiful, nor is the absence *of* goal, which we will here distinguish from the absence *of the* goal. It is finality-without-end which is *said to be* beautiful (*said to be* being here, as we

24. "La coupure pure y serait pansable": the homophony with *pens-able*, "thinkable," is important.

have seen, the essential thing). So it is the *without* that counts for beauty; neither the finality nor the end, neither the lacking goal nor the lack of a goal but the edging in *sans* of the pure cut [*la bordure en 'sans' de la coupure pure*], the *sans* of the finality-*sans*-end.

The tulip is exemplary of the *sans* of the pure cut

sans which is not a lack, science has nothing to say on this

the *sans* of the pure cut emerged in the disused utensil, defunct (*defunctum*), deprived of its functioning, in the hole without a handle of the gadget. Interrupting a finalized functioning but leaving a trace of it, death always has an essential relation to this cut, the hiatus of this abyss where beauty takes us by surprise. It announces it, but is not beautiful in itself. It gives rise to the beautiful only in the interrupture where it lets the *sans* appear. The example of the unearthed ax was thus at once necessary, nonfortuitous, and inadequate. A suture holds back the *sans* precisely inasmuch as the determinant discourse of science forms its object in it: I begin by inference to make judgments about what completes the tool, about the intention of its author, about its use, about the purpose and the end [*du but et du bout*] of the gadget, I construct a technology, a sociology, a history, a psychology, a political economy, etc.

Whereas science has nothing to say about the *without* of the pure cut. It remains open-mouthed. "There is no science of the beautiful, only a critique of the beautiful" (§ 44, "On the Fine Arts"). Not that one must be ignorant to have a relation with beauty. But in the predication of beauty, a nonknowledge intervenes in a decisive, concise, incisive way, in a determinate place and at a determinate moment, precisely at the end, more precisely with regard to the end. For the nonknowledge with regard to the end does not intervene at the end, precisely, but somewhere in the middle, dividing the field whose finality lends itself to knowledge but whose end is hidden from it. This point of view of non-

knowledge organizes the field of beauty. Of so-called natural beauty, let us not forget it. This point of view puts us in view of the fact that an end is in view, that there is the form of finality, but we do not see with a view to what the whole, the organized totality, is in view. We do not see its end. Such a point of view, suddenly [*de but en blanc*], bends the totality to be lacking to itself. But this lack does not deprive it of a part of itself. This lack does not deprive it of anything. It is not a lack. The beautiful object, the tulip, is a whole, and it is the feeling of its harmonious completeness which delivers up its beauty to us. The *without* of the pure cut is without lack, without lack of anything. And yet in my experience of the accomplished tulip, of the plenitude of its system, my knowledge is lacking in something and this is necessary for me to find this totality beautiful. This something is not some thing, it is not a thing, still less part of the thing, a fragment of the tulip, a bit [*bout*] of the system. And yet it is the end of the system. The system is entire and yet it is visibly lacking its end [*bout*], a bit [*bout*] which is not a piece like any other, a bit which cannot be totalized along with the others, which does not escape from the system any more than it adds itself on to it, and which alone can in any case, by its mere absence or rather by the trace of its absence (the trace—itself outside the thing and absent—of the absence of nothing), give me what one should hesitate to go on calling the *experience* of the beautiful. The mere absence of the goal would not give it to me, nor would its presence. But the trace of its absence (of nothing), inasmuch as it forms its *trait* in the totality in the guise of the *sans*, of the without-end, the trace of the *sans* which does not give itself to any perception and yet whose invisibility marks a full totality to which it does not belong and which has nothing to do with it as totality, the trace of the *sans* is the origin of beauty. It alone can be said to be beautiful on the basis of this trait. From this point of view beauty is never seen, neither in the totality nor outside it: the *sans* is not visible, sensible, perceptible, it does not exist. And yet *there is some of it* and it is beautiful. It *gives* [*ça* donne] the beautiful.

Is this *sans* translatable? Can its body be torn away from its tongue without thereby losing a remainder of life? *Sine! Ohne! Without! Aneu!* ("Hematographic Music" of "The Tympanum").[25] Beauty does not function without this *sans*, it *functions* only with *this* particular *sans*, it gives nothing to be seen,

25. "Tympan," in *Marges*, i–xxv; *Margins*, ix–xxix.

especially not itself, except with that *sans* and no other. And more-over it does not give (itself) to be seen with this *sans*, since it has nothing to do [*rien à voir*] with sight, as we have just said, or at least, in all rigor, with the visible. We have just written, a few lines up: "Beauty is never seen . . . the *sans* is not visible. . . ."

Of this trace of *sans* in the tulip, knowledge has nothing to say.

It does not have to know about it. Not that it breaks down in front of the tulip. One can know everything about the tulip, exhaustively, except for what it is beautiful. That for which it is beautiful is not something that might one day be known, such that progress in knowledge might later permit us to find it beautiful and to know why. Nonknowledge is the point of view whose irreducibility gives rise to the beautiful, to what is called the beautiful.

The beautiful of beauty pure and as such. It was necessary to insist on the *purity* in the trace of the *sans* of the pure cut [*Il fallait insister sur le 'pur' dans la trace du 'sans' de la coupure pure*]. I now return to it so as not to leave the wildflower.

Why does science have nothing to say about the tulip inas-much as it is beautiful?

If we go back from the appearance of the tulip (at the end of § 17, "Of the Ideal of Beauty," of which the tulip is thus the final example) to the preceding paragraph ("A judgment of taste by which an object is described as beautiful under the condition of a definite concept is not pure"), we already encounter the flower—first example—and the ruling out of account of the botanist as regards what the flower is beautiful for. "*Blumen sind freie Na-turschönheiten*": flowers are free beauties of nature, beauties of nature that are free. Why free?

Two kinds of beauty: free beauty (*freie Schönheit*) and merely adherent beauty (*bloss anhängende Schönheit*), literally, "merely suspended beauty, hung-on-to, de-pendent on." Only free (inde-pendent) beauty gives rise to a pure aesthetic judgment, to a pred-ication of pure beauty. That is the case with wildflowers. Kant gives the Latin equivalents of the expressions *free beauty* and *adherent beauty*. Free beauty, that of the tulip, is *pulchritudo vaga*, the other is *pulchritudo adhaerens*. Why these Latin words in brackets? Why this recourse to an erudite and dead language? It is a question that we must pose if we are to follow the labor of mourning in the discourse on beauty. In the first footnote to the following chapter, Kant analyzes the models of taste (para-

digm, paragon, pattern, *Muster des Geschmacks*). He prescribes
that, in the "speaking arts" at least, the models should be written
"in a dead and scholarly language." For two reasons, one lexical
and the other grammatical. So that these models should be spared
the transformations suffered by living languages and which have
to do first with the vocabulary: vulgarization of noble terms,
obsolescence of much-used terms, precariousness of new terms;
then with the grammar: the language which fixes the model of
taste must have a *Grammatik* which would not be subject to "the
capricious changes of fashion" and which would be held in "un-
alterable rules."

Whether or not the third *Critique* proposes models of taste
for the speaking arts, each time Kant has recourse to a scholarly
and dead language, it is in order to maintain the norms in the
state of utmost rigidity, to shelter them, in a hermetic vault, from
yielding or breaking up. When, digging in Kant's text, one comes
across these Latin words whose necessity one does not immedi-
ately (and sometimes not ever) understand, one has something of
the impression of those defunct utensils, endowed with a hole
but deprived of a handle, with the question remaining of whether
they are beautiful or not, with free beauty or adherent beauty.
Kant's answer is that their beauty in any case could not be vague
or free from the moment it was possible to complete it with a
knowledge, supplement it with a thesis or a hypothesis.

What does this opposition signify? Why the equivalence of
free and *vaga?* Free means free of all adherent attachment, of all
determination. Free means *detached.* It had been announced that
this discourse dealt with detachment in all senses, the sense [*sens*]
and the *sans* of detachment. *Free* means detached from all deter-
mination: not suspended from a concept determining the goal of
the object. *Pulchritudo vaga* or free beauty does not presuppose
any concept (*setzt keinen Begriff*, and for us the learned and dead
language is German, which we wear out, which we make use of
with all the plays on words and modes, with the grammatical
caprices that grow most quickly wrinkled) of what the object must
be (*von dem voraus, was der Gegenstand sein soll*). Thus *free*
means, in the concept which relates it to beauty, detached, free
of all adherence to the concept determining the end of the object.
We understand better the equivalence of *free* and *vague. Vaga* is
the *indefinite* thing, without determination and without desti-
nation (*Bestimmung*), without end [*fin*], without *bout*, without
limit. A piece of waste land [*terrain vague*] has no fixed limit.

Without edge, without any border marking property, without any nondecomposable frame that would not bear partition. *Vague* [i.e., "wanders, roams"—TRANS.] is a movement without its goal, not a movement without goal but without its goal. Vague beauty, the only kind that gives rise to an attribution of pure beauty, is an indefinite errance, without limit, stretching toward its orient but cutting itself off from it rather than depriving itself of it, absolutely. It does not arrive itself at its destination.[26]

Adherent beauty, on the contrary, is suspended by some attachment from the concept of what the object must be. It is there somewhere, however weak, tenuous, half-visible the ligament may be; it is hung, appended [*pendue, appendue*]. First consequence: cut off from the concept of its goal, vague beauty refers only to itself, to the singular existent which it qualifies and not to the concept under which it is comprehended. The tulip is not beautiful inasmuch as it belongs to a class, corresponding to such-and-such a concept of the veritable tulip, the perfect tulip. *This* tulip *here*, this one alone is beautiful ("a flower, for example a tulip"), it, the tulip of which I speak, of which I am saying here and now that it is beautiful, in front of me, unique, beautiful in any case in its singularity. Beauty is always beautiful *once*, even if judgment classifies it and drags that *once* into the series or into the objective generality of the concept. This is the paradox (the class which—immediately—sounds the death knell of uniqueness in beauty) of the third *Critique* and of any discourse on the beautiful: it must deal only with singularities which must give rise only to universalizable judgments. Whence the *parergon*, the importation of frames in general, those of the first *Critique* in particular.

Conversely, adherent beauty, from the moment it requires the determinant concept of an end, is not the unconditional beauty of a thing, but the hypothetical beauty of an object comprehended under the concept of a particular end. "The first [i.e., free beauty] presupposes no concept of what the object should be; the second does presuppose such a concept and, with it, an answering perfection (*Vollkommenheit*: the plenitude, the accomplishment) of the object. Those of the first kind are said to be (self-subsisting) (*für sich bestehende*, existing for themselves) beauties of this thing or that thing (*dieses oder jenes Dinges*); the other kind of beauty, being attached to a concept (*als einem Begriffe anhängend*,

26. "Elle ne s'arrive pas à sa destination": this pronominal form of the verb *arriver*, to arrive, to happen, is one of Derrida's neologisms.

appended to a concept) (conditioned beauty), is ascribed to Objects (*Objecten*) which come under the concept of a particular end" (Meredith, 72).

The beautiful *this* is thus beautiful for itself: it does without everything, it does without you (insofar as you exist), it does without its class. Envy, jealousy, mortification are at work within our affect, which would thus stem from this sort of quasi-narcissistic independence of the beautiful *this* (*this* rather than "object") which refers to nothing other than to itself, which signals toward nothing determinable, not even toward you who must renounce it, but like a voyeur, at the instant that the this gives itself, inasmuch as it gives itself, not signaling toward its end or rather, signing its end, cuts itself from it and removes itself from it absolutely. The tulip, if it is beautiful, this irreplaceable tulip of which I am speaking and which I replace in speaking but which remains irreplaceable insofar as it is beautiful, this tulip is beautiful because it is without end, complete because cut off, with a pure cut, from its end.

We must sharpen the points, the blades or the edges of a certain chiasmus. This tulip is beautiful because it is free or vague, that is, independent. It enjoys, of itself, a certain completeness. It lacks nothing. But it lacks nothing because it lacks an end (at least in the experience we have of it). It is in-dependent, for itself, inasmuch as it is ab-solute, absolved, cut—absolutely cut from its end (*"forme parfaite: celle d'une coupe"*): absolutely incomplete, then. Conversely, the unearthed gadget, a concavity deprived of its handle, seems incomplete and yet one connects it to the concept of a perfection. Inasmuch as it is incomplete it can be apprehended under the concept of its perfection. Its beauty, if it has any, remains adherent. The cut is not pure in this case [*La coupure n'y est pas pure*]. So we are dealing with two structures of completeness-incompleteness. The pierced gadget is complete because incomplete, this tulip is incomplete because complete. But the gadget remains incomplete because a concept can fill it up. This tulip is complete from the first because the concept cannot fill it in. The cut leaves it no skin, no tissue of adherence. A beautiful flower is in this sense an absolutely *coupable* [guilty, cuttable] flower that is absolutely absolved, innocent. Without debt. Not without law, but of a law without concept. And a concept always furnishes a supplement of adherence. It comes at least to stitch back up again, it teaches how to sew. We have not finished counting the effects of this chiasmus.

Because of the cut, science has nothing to say about the *vague*. Immediately after the distinction between the two beauties: "Flowers are free beauties of nature. What this thing, a flower, must be, almost no one knows, apart from the botanist; and even he, recognizing in it the plant's organ of fecundation (*Befruchtungsorgan*), takes no account of this natural end when he judges it according to taste."

As such, insofar as he inscribes his object in the cycle of natural finality, ascribes to it an objective function and end, the botanist cannot find the flower beautiful. At the very most he can conceive of an adherent beauty of the flower. If a botanist accedes to a vague beauty, it will not be insofar as he is a botanist. Scientific discourse will have become mute or impossible in him. He will no longer have at his disposal a supplementary concept, i.e., a concept, a concept as a saturating generality coming to drink up or efface the *sans* of the pure cut.

It is not insignificant—it is significance itself—that the discourse on the flower should become scientific, attach the flower to its end, efface the beauty of the *sans* by according the flower its place in the seminal cycle. The tulip is beautiful when cut off from fecundation. Not sterile: sterility is still determined from the end, or as the end of the end, the incompleteness of completeness, as imperfection. The tulip is in this regard potent and complete. It must be able to enter into the cycle of fecundation. But it is beautiful only by not entering it. The seed loses itself, but not—here the word loss is in danger at any moment of reconstructing adherence, as if a piece had been diverted from a circulation that must therefore be reconstituted—in order to be lost or to refinalize its loss by regulating the diversion according to turn or return, but otherwise. The seed wanders [*s'erre*]. What is beautiful is dissemination, the pure cut without negativity, a *sans* without negativity and without signification. Negativity is significant, working in the service of sense. The negativity of the gadget with the hole in it is significant. It is a signifier. The *without-goal*, the *without-why* of the tulip is not significant, is not a signifier, not even a signifier of lack. At least insofar as the tulip is beautiful, *this* tulip. As such, a signifier, even a signifier without signified, can do anything except be beautiful. Starting from a signifier, one can account for everything except beauty, that is at least what *seems* to envelop the Kantian or Saussurean tulip.

As always, the examples put forward by Kant have far-reaching implications. I proceed from his examples, by what path is now clear, but I insist here on reflexive wiliness: we are approaching two paragraphs defining what Kant calls *exemplary* and exemplary *without concept*. The necessity "thought" in an aesthetic judgment can only be called "exemplary" (*exemplarisch*). It is the necessity of the adhesion *of all* to a judgment as example (*Beispiel*) of a universal rule that one cannot enunciate (*angeben*) (§§ 37 and 38, in the course of passing from the third to the fourth category, from the moment of relation to that of modality). Such would be the effect of openmouthedness provoked by a unique exemplar whose beauty must be recognized in a judgment (mouth open), without conceptual discourse, without enunciation of rules (mouth mute, breath cut, *parole soufflée*).[27]

Two orders of examples: *natural* free beauties, analogous to that of the flower (wild animals, birds, the parrot, the humming-bird, the bird of paradise), but also *artificial* free beauties, alien to nature. Great difficulties are foreseen. How could productions of art appear to us as finalities without end? As nonsignifying? Cut from their goal?

And yet it must be that there are such things if free, vague, wandering, pure beauty touches us in art also. But what are these examples? What are the examples of productions of art which are beautiful without signifying anything by and for themselves (*bedeuten* [. . .] *für sich nichts*) and without representing anything? Without theme and even without text, if text retains its old meaning of "signifying organization, organization of signification"? Should we be surprised to encounter among them the frame or at least certain framing inscriptions?

"Flowers are free beauties of nature. Hardly any one but a botanist knows the true nature of a flower, and even he, while recognizing in the flower the reproductive organ of the plant, pays no attention to this natural end when using his taste to judge of its beauty. Hence no perfection of any kind—no internal finality, as something to which the arrangement (*Zusammensetzung*) of the manifold is related—underlies this judgement. Many birds (the parrot, the humming-bird, the bird of

27. *Soufflée* has the sense of whispered, prompted, but also stolen, ripped off, blown, blown away: see "La Parole soufflée," in *L'Ecriture et la différence* (Paris: Seuil, 1967), 253–92; translated by Alan Bass, in *Writing and Difference* (London and Henley: Routledge and Kegan Paul, 1978), 169–95.

paradise), and a number of crustacea, are self-subsisting beauties which are not appurtenant to any object defined with respect to its end, but please (gefallen) freely and on their own account." Now here is the other series of examples: free beauties in art, cutting off all adherence to concept and end, to the concept of end, are no longer significations or representations, nor signifiers or representers. In the rhetoric of the paragraph, this second type of example seems also to function as the insistent and metaphorical illustration of the first. The recourse to the example of art is made in order to make us better understand that of nature on a ground of analogy: "So designs à la grecque [straight-line designs in labyrinth form], foliage for framework (Laubwerk zu Einfassungen) or on wall-papers, &c., have no intrinsic meaning; they represent nothing (sie stellen nichts vor)—no Object under a definite concept—and are free beauties. We may also rank in the same class what in music are called fantasias [improvisation, free variation] (without a theme) (ohne Thema), and, indeed, all music that is not set to words (die ganze Musik ohne Text)" (Meredith, 72).

Hence, what is beautiful according to art and with a free or wandering beauty, thus giving rise to a judgment of pure taste, according to Kant, would be any finalized organization not signifying anything, not representing anything, deprived of theme and text (in the classical sense). These structures can also represent, show, signify, certainly, but they are freely wandering beauties only by not doing so: insofar as somewhere they apply themselves or bend themselves to not doing so. They apply themselves to this, for they must also be organizations of finalized form, otherwise they would not be beautiful. The without-theme and the without-text do indeed proceed from the sans of the pure cut. Not every nonsignifying thing is beautiful. The foliation on frames, for example, can represent leaves, but it deploys its beauty only without that representation. Its nonsignificance, its a-significance, rather, must have the form of finality, but without end.

One might be tempted, in exploiting this example (and nothing prohibits this by right), to conclude that contrary to what we were justified in thinking elsewhere, according to Kant the parergon constitutes the place and the structure of free beauty. Take away from a painting all representation, all signification, any theme and any text-as-meaning, removing from it also all the material (canvas, paint) which according to Kant

cannot be beautiful for itself, efface any design oriented by a determinable end, subtract the wall-background, its social, historical, economic, political supports, etc.; what is left? The frame, the framing, plays of forms and lines which are structurally homogeneous with the frame-structure. So it would be difficult, if not impossible, to reconcile what Kant said about the *parergon* two pages earlier and what he says here of the framing-foliation or the series of productions without theme and without text which are analogous to it. The difficulty allows us to sharpen up a cutting edge.

Like the framing-foliation, the framing *parergon* is a-signifying and a-representative. Another common trait is that the framing can also, as *parergon* (an addition external to the representation), participate in and add to the satisfaction of pure taste, provided that it does so by its form and not by sensory attraction (color) which would transform it into finery. So there can be a certain beauty of the parergon, even if it is, precisely, supplementary beauty. Now what separates the *parergon* from the framing-foliation and from other products of the same type? The foliation is here considered in itself, as object and not as accessory. If it does without signification and representation, this is no longer at all like the frame. The frame does not signify anything, and that's that, Kant seems to think. One sees in it no presentiment of any signification, nothing in it is finalized or finalizable. Whereas here the movement of signification and representation is broached: the foliation, pure musical improvisation, music without theme or without text seem to mean or to show something, they have the form of tending toward some end. But this tension, this vection, this rection is absolutely interrupted, with a clean blow. *It has to be* thus interrupted: by having to be, purely, absolutely, removing all adherence to what it cuts itself off from, it liberates beauty (free, wandering, and vague). By having to be interrupted, the *sans*-text and the *sans*-theme relate to the end in the mode of nonrelation. Absolute nonrelation. And by having to be so, this absolute nonrelation must also, if possible, be inscribed in the structure of the artifact. The *sans* of the *sans*-theme and the *sans*-text must be marked, without being either present or absent, in the thing to which it does not belong and which is no longer quite a thing, which one can no longer name, which is not, once charged with the mark, a material support or a form of what is to be found neither here nor there, and which one

Nouveaux Desseins
d'Ornemens
de Paneaux Lambris,
Carosse &c.

Inventés et Gravés par N. Pineau
A Paris.
Chez J. Mariette Rue. St Jacques à la Victoire,
aux Colonnes d'Hercules avec Privilege.

N° 45.

might indicate, given a certain displacement, by the name of text or trace ——

|

|
—— cut-
ting or cut it be, must not the apparently irreconcilable opposition between *pulchritudo vaga* and *pulchritudo adhaerens* find its limit somewhere? Absolute nonadherence should certainly have no contact, no common frontier, no exchange with adherence: no adherence is possible between adherence and nonadherence. And yet this break of contact, this very separation constitutes a limit, a blank, the thickness of a blank—a frame, if you like—which by suspending the relation, puts them in relation in the mode of nonrelation, reproducing here *at the same time* the freedom of vague beauty and the adherence of adherent beauty. *Pas* without relation from one to the other, once one keeps something of the other. This play of the limit is not an algebraic exercise. It appears very concretely in Kant's text. Primarily by the fact that the op-position of the errant and the adherent is a predicative opposition. *Errant* and *adherent* are predicates for the beautiful. So one can and must ask oneself what is beauty *in general* prior to being divided, plunged into its arborescent process, prior to being de-termined, from the basis of a common root, as adherent or as errant beauty. Must we not precomprehend what beauty is *itself*, the essence or the presence of the beautiful, in order to understand something of the distinction between errant and adherent? And in order that, despite the absolute heterogeneity which Kant re-calls, we might still be able to speak of beauty in both cases? So there must well be an adherence somewhere between the two beauties.

One can imagine that the logic of Kant's discourse refuses in advance the form of this question: there is no "common root" to the two beauties. We do not precomprehend the essence of beauty in what is common to the two types, but above all on the basis of free beauty giving rise to a pure aesthetic judgment. It is the pureness which gives us the sense of beauty in general, the pure

telos of beauty (as non-*telos*). It is the most beautiful which gives us a conception of essential beauty, and not the least beautiful, which remains a hesitant approximation to it in view of errancy. Adherence would be in view of errancy. That which is conceived according to its end (its determined *telos*) would be in movement toward what does without a *telos*. The *telos* of the two beauties would be the *sans:* the nonpresentation of the *telos*.

This is a first way of refusing the question of the common root. It seems very much in conformity with the logic of the discourse: the pure is worth more than the nonpure. And yet, from the moment that the contrary response seems just as pertinent and the dissymmetry can be inverted, the initial question of the common root (as adherence) forces us, by its irreducibility, to a reformulation. If errant beauty entertains a relation of non-relation to its end, its horizon is the announcement—charged with impossibility—of the end, exerting pressure, exercising a constraint from its very impossibility, of an end of which only *pulchritudo adhaerens* gives us the example. Hence adherent beauty is perhaps less pure but more beautiful and more perfect than vague beauty. It tells us more about beauty. It tells us more about what must be the accord between the imagination and the understanding which produces the idea of beauty. Adherent beauty would be more beautiful than pure beauty. And it would give us the principle of the analogy between the two beauties.

Each of them thus tells us more and less than the other what the beautiful must be. Is there a maximum of adherence? A maximum of freedom

the three questions: 1. The question of analogy as the question of man, of the place of man in this critique. It takes at least three forms. (A) What about the beauty of man and woman, of which Kant declares that it could not be other than adherent? (B) What about the place of man as "alone, of all the objects of the world, capable of an ideal of beauty"? And what relation is there between the adherent beauty

of man and the fact that he is the sole bearer of the ideal of beauty?
(C) Why are the system and the hierarchy of the fine arts consti-
tuted (§ 51) on the analogical model of human language, and of
language in its relation to the human body, and this not without
a certain embarrassment, once again indicated in a footnote, but
not without a rigorous internal necessity in the *Critique?*

2. The question of productive imagination and human pro-
ductivity. There is no experience of beauty without a "freedom
of play of the imagination." Here one does not conceive imagi-
nation first of all and solely as the faculty of the being called man
but on the basis of the *sans* of the pure cut (of vague beauty). Now
at the moment (the fourth *Moment*) that Kant proposes a General
Remark on the imagination, he distinguishes between a repro-
ductive imagination (the place of imitation and of a certain *mi-
mēsis*) and a productive spontaneous imagination (*productiv und
selbstthätig*), the one that is in play in the experience of vague
beauty and in pure aesthetic judgment. What must we understand
by this productivity and by this free play the value of which will
construct the opposition between mercenary art and liberal art,
the latter being the only one which is fine art inasmuch as it
plays and is not exchanged against any salary? It will be necessary
to put systematically in relation with *all* the preceding questions
the question of productivity, of salary and the market.[28]

3. Up until now, this whole discourse concerned the beautiful,
which relates, in the mode of determinacy or indeterminacy, to
an end and an accord, to a harmony, to an affinity of the imagi-
nation with nature or with art. The *sans* also cut out, in the mode
of the nonrelation, the anticipation of a final harmony. Whence
the pleasing, the positive pleasure in the experience of the beau-
tiful. And the indeterminacy, the indefiniteness, were always those
of the understanding faced with an essentially sensory experience.
Reason was not yet on the stage. What is excluded from this
discourse (and what is excluded from the inside forms that in-
ternal lack which always calls for the parergonal frame), is thus
not the *sans* of the without-end but the *counter* of the counter-
end. The question of counter-finality (*Zweckwidrigkeit*) making
use of violence and producing what Kant calls not a beyond of
pleasure or a pleasure of the beyond, but, in a formula which
could figure in *Beyond the Pleasure Principle*, a "negative plea-
sure" (*negative Lust*), is the question of the *sublime*. Kant explains

28. Cf. "Economimesis."—J. D.

that he must deal with it only in an appendix, a mere adherent appendix to the "Analytic of the Beautiful" (einen blossen Anhang). Whereas "the beautiful gives birth directly by itself to a feeling of intensification (Beförderung: also, acceleration) of life and can subsequently be united with the attractions and the play of the imagination [a more Nietzschean formulation than Nietzsche would have thought], the latter [the feeling of the sublime] is a pleasure which surges up (entspringt) only indirectly, i.e., in such a way that it is produced by the feeling of an instantaneous (augenblicklich) inhibition (Hemmung, an arrest, a retention) of the vital forces, followed at once by an outpouring (Ergiessung: unloading) of these same forces, an outpouring that is all the stronger for the inhibition."

What of this renewed force produced by a striction and a counter-striction? What relation does it entertain, in the appendix of the sublime, with the "negative pleasure"?

The scent of the tulip, of one that would be bright red, perhaps with shame, but still, it's not certain—

"The flower is one of the typical passions of the human spirit. One of the wheels of its contrivance. One of its routine metaphors.
 One of the involutions, the characteristic obsessions of that spirit.
 To liberate ourselves, let's liberate the flower.
 Let's change our minds about it.
 Outside this involucrum: The *concept* which it became, By some devolutive revolution, Let us return it, safe from all definition, to *what it is*.—But what, then?—Quite obviously: a *conceptacle*."
Changed Opinion as to Flowers

|‾

places man. His place
is quite difficult to recognize in the third *Critique*. It appears
mobile and multiple.

First we must explain why (1) man cannot be beautiful by
errancy, the object of a pure judgment of taste; (2) the ideal of the
beautiful can be found only in the human form. The linking of
these two propositions is perhaps surprising: no free or vague
beauty, no pure judgment of taste as to the human form, to which
ideal beauty, reserved for that form alone, nonetheless belongs.
Ideal beauty and the ideal of the beautiful are not, conceptually,
the same thing, but man is the name of what ensures their ex-
change: their necessary and immediate equivalence.

The conceptual determination of the end limits the free play
of the imagination. The *sans* opens play within beauty.

But the beauty of man cannot be free, errant, or vague like
that of the tulip. So it cannot be opened to the unlimited play of
productive imagination, which, however, belongs to man alone.
Man therefore eludes a power of errancy which he alone holds.

The example of the beauty of man is inscribed first of all in
a series. The common predicate is the relation to the concept of
an end which determines what the object must be, namely, its
perfection. The examples: man (in general: man, woman, child,
says Kant), the horse, the building (*Gebäude*). Man, the horse,
and the building presuppose a concept of the end and could not
be apprehended as free beauties.

How can we explain why the beauty of a horse can only be
adherent? Other animals (birds or crustaceans) had been classed
among the free beauties of nature. Conversely, why could certain
flowers not be determined according to the concept of their goal?
No doubt they are, from the point of view of the botanist, but
this point of view is not the point of view of beauty. One must
choose between not seeing pure beauty and not seeing the end.
But this possibility of varying the point of view, of abstracting or
not abstracting from the end, of considering or not considering
the fecundation (this was the criterion), is at our disposal in the
case of the flower, the birds, or the crustaceans, but never in the
case of the horse. Nor of man. We would have it at our disposal
in the case of designs *à la grecque*, framing-foliation, wallpapers,

pieces of music without theme or text, but never in the case of those other artifacts which are buildings (the church, the palace, the arsenal, the summer house). Why?

This question is more obscure than it seems. Nothing seems capable of answering it in the immediate context of Kant's argumentation. We must therefore recenter this whole critique of aesthetic judgment, recognizing to what extent it anticipates teleologically the critique of teleological judgment, and in that critique the propositions concerning the place of man in nature. Only the second part of the *Critique* can indeed justify, in the internal systematics of the book, what is said here about the two beauties and in particular this choice of examples. One could certainly have expected it and it's not much to discover— a book like this must be read from the other end. But it is rare in a discourse magnetized by its end for the median propositions to remain as suspended, lacking in immediate justification, or even unintelligible, as they do in the case occupying us.

The horse, especially, is bothersome. If one pushes things, one might admit that it is difficult or even impossible to disregard an end in the representation of man or his buildings. But what difference is there, from this point of view, between the horse, a bird, and a crustacean?

Now to answer the question of the horse, one must take account of the place of man: no longer as a beautiful object (of adherent beauty) but as the subject of aesthetic and teleological judgments. If the subject operating these judgments is not recognized as an anthropological unity, if the play of his functions (sensibility, imagination, understanding, reason) is not bound according to an organization finalized under the name of man occupying a privileged place in nature, nothing in all this is intelligible, and above all nothing in this opposition between the errant and the adherent. If on the other hand a determinate anthropology intervenes in this critique of aesthetic judgment, a whole theory of history, of society, and of culture makes the decision at what is the most formally critical moment. This theory weighs upon the frames with all its contents.

Kant had proposed two series of distinctions (§ 15). First between *objective finality* and *subjective finality*. The first relates an organization to its end, as this is determined by a concept, i.e., to its end as content and not simply as form. But the beautiful, judged in its formal finality, has no final content. Thus it has no

relation to what the object must be, to a perfection or to a good: formal and subjective finality.

Objective finality, determined in its content by a concept, can be—a second distinction—*internal* or *external.* External, it consists in utility (*Nützlichkeit*), for example that of a utensil with or without a handle. This utility is easy to determine from the point of view of man, so its anthropocentric determination is not surprising. But how can the human reference be introduced into internal finality, which Kant also calls perfection (*Vollkommenheit*)? Perfection has often been confused with beauty. Kant insists on breaking with that tradition. In no case does the judgment of taste bear on the perfection of the object, on its internal possibility of existence. To judge this latter, I must have at my disposal the concept of what, quantitatively and qualitatively, the object *must be.* If I do not have it at my disposal, I have only a formal representation of the object. This is even the definition of such a representation: the nonknowledge of what the object must be, of its objective finality, external or internal. There is of course a subjective finality of representations, "a certain ease of understanding a given form in the imagination," but without a concept of objective end. Errant beauty corresponds to subjective finality, without end, without content, without concept. On the one hand, subjective finality or finality without end; on the other, objective finality. The without-end of finality is contradictory only in the case of objective finality.

The three examples of adherent beauty (man, horse, buildings) presuppose not only the concept of an objective finality but that one cannot even disregard it in the experience of those objects. The *sans* of the *sans-fin* cannot be cut out in that experience, not even in a variation of point of view.

For despite their apparent diversity, these three examples are anthropological (the horse is also for man, for nature whose center is man) and man, subject of this critique, cannot think *himself without* (purpose or end), cannot be beautiful with a pure, vague, and free beauty, or at least appear to himself as such.

Let us take up the examples again in the inverse order. The building is understood on the basis of the concept of its end, the church with a view to religious ceremony, the palace with a view to habitation, the arsenal with a view to storing arms or munitions. If closed down, they still keep the sense of the purpose to which they had been destined. This was not the case for the

framing-foliation. The end of the building is determined by and
for the subject "man."

But what about the horse? What is the finality which one
cannot disregard, as in the case of the birds or crustaceans? And
does this finality have an essential relation to man?

One ought to be able to disregard the internal finality of the
horse and consider it—provided it is neither castrated nor sterile
but abstracted in perfect shape from the process of reproduction—
as a wild and errant beauty of nature. But it is its external finality
that Kant does not disregard. And it is in its external finality that
he identifies its internal finality: the horse is *for* man, in the
service of man, and perceived by man only in its adherent beauty.
Such is its internal destination: the external. For man, for a being
who can himself only hang on to his adherence. Subjectivity is
adherence.

To justify thus the choice of the example, one has to look at
what the second part of the book (notably in § 83) tells us about
man: man is, like all organized beings, an end of nature, but he
is also, here on earth, the final end of nature. The whole system
of ends is oriented by him and for him. This is in conformity with
the principles of reason. For *reflexive judgment*, of course, and
not for *determinant judgment*. Man is the final goal of nature. If
we have to look for what end he must himself attain in his relation
to nature, it must be an end made possible by the beneficence
(*Wohltätigkeit*) of nature. Kant has named the maternal earth
(§ 82), the maternal bosom of the sea (*Mutterboden [des Landes]
und der Mutterschoos [des Meeres]*): we can, from the point of
view of our understanding and our reason, conceive of beings only
according to final causes, i.e., subjectively, the antinomic oppo-
sition between subjective finalism and objective mechanism hav-
ing to be resolved in the suprasensible principle of nature ("out-
side us as it is in us"). The end which man must attain in nature
is thus made possible by the beneficence of nature—and this would
be *happiness*—or by the clever aptitude for all sorts of ends for
which nature "internally and externally" would be used—and this
would be the *culture (Cultur)* of man. Happiness and culture pre-
suppose that man puts to work what nature puts at his disposal.

To understand the example of the horse, its functioning per-
taining to the place where it occurs, we must bring in a theory
of culture, more precisely a pragmatic anthropology, into the the-
ory of the beautiful, into the formation of its founding concepts,

for example the opposition between the errant and the adherent. This is an irreducible architectonic necessity. The third *Critique* depends in an essential manner—these examples show it—on a pragmatic anthropology and on what would be called, in more than one sense, a reflexive humanism. This anthropologistic recourse, recognized in its juridical and formal agency, weighs massively, by its content, on this supposedly pure deduction of aesthetic judgment.

The example of the horse makes the thing clearer. For me to be unable to disregard the external finality of the horse at the moment when I ascribe to it a beauty of adherence, to be unable to disregard its objective finality which can only be external, the animal must first of all and solely be for man. This is confirmed later (§ 63, "Of Finality Relative to Nature, as Distinct from Internal Finality"), in the course of a very complex argumentation which it is not indispensable to reconstitute here: "This latter finality is called utility (for man), or also appropriateness (for any other creature), and it is merely relative whereas the first is an internal finality of the natural being. [. . .] Likewise if there was to be livestock in the world, cattle, sheep, horses, etc., it was necessary that grass grow on the earth, but also chenopods in the sand deserts so that camels might prosper. . . . And although among the examples cited the species of grass must be considered for themselves as organized products of nature, and thereby as effects of art (*kunstreich*), they are regarded nevertheless as mere raw matter (*blosse rohe Materie*) in relation to the animals which feed on them. But after all, if man, by the freedom of his causality, finds that the things of nature suit his intentions, often enough bizarre ones (the many-colored feathers of birds as decoration for his clothes, colored earth or plant juices for makeup), but sometimes also reasonable ones, the horse for riding, the ox, and in Minorca even the ass and the pig for ploughing, one cannot admit here a relative end of nature (for this use). For man's reason is able to give things a conformity with the arbitrary caprices of his invention, for which he was not himself predestined by nature. But if one admits that men had to live on earth, then at least the means without which they could not live as animals, even reasoning ones (on the lowest rung of the scale you like) had to be there; in this case the things of nature indispensable to this use had to be considered also as natural ends."

Hence the horse is for man and man for man. Neither the one nor the other can be beautiful with a free beauty, but their place

in the chain of examples is not the same. Neither suffers the *sans* of errancy. But the *sans* of the *sans* has different effects on the one and the other. The horse, just like the building moreover, is capable of adherent beauty. But no more. As well as the *sans*, man is capable, and is the only one capable, of an ideal of beauty. The adherence of human beauty is not separated from that capacity of which both the other adherent beauties and the errant beauties are deprived.

The bearer of an ideal of beauty, man is also endowed with ideal beauty.

What does *ideal* mean?

For all the reasons we now know, a rule of taste cannot be determined by concepts. And yet a universal communicability, an accord of the most perfect possible kind, conditions any evaluation. But by criteria that are necessarily empirical, as Kant concedes, and weak, scarcely sufficient to prop up the presumption of a common principle hidden deep in all men. In the absence of a general concept of rules, and given that universality remains a prerequisite, the value of the exemplary, of exemplary product of taste, becomes the sole or major reference. The exemplary (*exemplarisch*) is a singular product (*Produkt*)—since it is an example—which is immediately valid for all. Only certain exemplary products can have this effect of quasi-rules. Whence the historical, cultural, pragmatico-anthropological character of taste, which is constituted after the event [*après coup*], after the production, by means of example. The absence of concept thus liberates this horizon of historical productivity. But this historicity is that of an exemplar which gives itself as an example only to the extent that it signals, empirically, toward a structural and universal principle of accord, which is absolutely ahistorical.

Let us follow this schema of production. Not being conceptual, the exemplary cannot be imitated. One does not acquire taste by imitation. The judgment of taste, even if it refers to prototypical (exemplary) productions, must be autonomous and spontaneous. Hence the supreme model, the highest pattern (*das höchste Muster*), can be only an *idea*, a mere idea which everyone must *produce* (*hervorbringen*) in himself and according to which he must judge everything that is an object of taste. There must be a pattern but without imitation. Such is the logic of the exemplary, of the autoproduction of the exemplary, this metaphysical value of production having always the double effect of opening and closing historicity. Since everyone produces the idea of taste,

it is never pregiven by a concept: the production of the idea is
historical, a series of inaugurations without prescription. But as
this production is spontaneous, autonomous, free at the very mo-
ment when, by its freedom, it rejoins a universal fund, nothing
is less historical.

The autoproduction of the *Muster* (pattern, paradigm, para-
gon) is the production of what Kant calls first an *idea*, a notion
which he specifies at once by substituting for it that of *ideal*. The
idea is a concept of reason, the ideal is the representation of a
being or of a particular essence *adequate* to that idea. If we follow
here this value of *adequation*, we find the dwelling place of *mi-
mēsis* in the very place from which imitation seems excluded.
And at the same time, of truth as adequation in this theory of
the beautiful.

The paradigm of the beautiful rests, then, on the idea of rea-
son, on the absolutely indeterminate rational idea of a "maxi-
mum"—Kant's word—of accord between judgments. This max-
imum cannot be represented by concepts but only in a singular
presentation (*in einzelner Darstellung vorgestellt*). The paradigm
is not an idea but a singularity which we produce in ourselves in
conformity with that idea: Kant proposes to call it *ideal*. But this
ideal, to the extent that it is produced in the presentation of a
singular thing—an exemplar—can form only an ideal of the imag-
ination. Imagination is the faculty of presentation (*Darstellung*).
This value of *presentation* supports the whole discourse. Just as
one can (as we have seen) understand the faculty of imagination
only on the basis of the *sans* and free play, one cannot accede to
it without this value of presentation: free play of the *sans* in the
putting into presence.

The *sans* is nevertheless strictly compressed and oriented by
the economic instance of the *maximum*. The free play in the
presentation submits of itself to its regulation, to the regulatory
idea of a maximal consensus among men.

Only man would be capable of presentation, since only he is
capable of production—of exemplarity, of ideal, etc.

Here Kant poses a question and introduces a cleavage of great
consequence. He asks himself (1) whether one accedes *a priori* or
empirically to this ideal; and (2) what kind of beauty gives rise
to this ideal.

To the second question the answer is clear and prompt. Errant
beauty cannot give rise to any ideal. The beauty whose ideal one
seeks is necessarily "fixed" (*fixierte*) by the concept of an objective

finality. Consequently, contrary to what one might have thought, ideal beauty will never give rise to a pure judgment of taste but to a partly intellectualized judgment of taste, comprising an idea of reason which determines *a priori* the internal possibility of the object according to determinate concepts. So one cannot "think" an ideal of "beautiful flowers," nor of any "vague beauty." This is a first reply to the question: What is the beautiful in general, prior to the opposition between errancy and adherence? The oscillation is broken, the *pure* is opposed to the *ideal*. The ideal of beauty cannot give rise to a pure aesthetic judgment: the latter can concern only an errancy, whereas the ideal is of adherence. *Pure beauty and ideal beauty are incompatible.* So the *sans* of the pure cut here seems to interrupt the process of idealization. The yawning gap in the idealization would open onto errant beauty and to the event of a pure aesthetic judgment.

But where does this appear from? Whence does this opposition between the ideal (of the imagination) and the pure, between the *non-sans* and the *sans* appear?

From man. Man, equipped with a reason, an understanding, an imagination and a sensibility, is that X from which, with a view to which, the opposition is taken in view: the opposition of the pure and the ideal, the errant and the adherent, the *sans* and the *non-sans*, the without-end and the not-without-end, that is also the opposition of non-sense and sense. The subject of that opposition is man and he is the only subject of this *Critique* of judgment. Only he is capable of an ideal of beauty and, from this ideal, capable of letting the *sans* of the pure cut present itself. He is capable of this ideal of the imagination as to the things of nature because he is endowed with reason, which means, in Kantian language, able to fix his own ends. The only being in nature to give himself his own ends, to raise in himself the *sans*, to complete himself and think from his end; he is the only one to form an ideal of beauty, to apprehend the *sans* of others. He is not errant. He cannot conceive of himself without goal and that is why he is in the full center of this point of view, the full center of a field which is nonetheless decentered and dissymmetrical. Man is not between errancy and adherence as in a middle place from which he would see both of them. He is situated on one side only (adherence to self, to his own end) and from that side he puts errancy in perspective. "Only what has in itself the end of its real existence—only *man* that is able himself to determine his ends by reason, or, where he has to derive them from external perception,

can still compare them with essential and universal ends, and
then further pronounce aesthetically upon their accord with such
ends, only he, among all objects in the world, admits, therefore,
of an ideal of *beauty*, just as humanity in his person, as intelli-
gence, alone admits of the ideal of *perfection*" (§ 17; Meredith,
76–77).

A paradoxical but already obvious consequence: ideal beauty
and the ideal of beauty no longer come under a pure judgment of
taste. There is a cleavage between the beautiful and taste or, to
be precise, between the ideally beautiful and pure taste, between
a callistics and an aesthetics.

This comes from the fact that the subject of this discourse,
in his humanity, withdraws from his own discourse. There is no
place for an aesthetic of man, who escapes the pure judgment of
taste to the very extent that he is the bearer of the ideal of the
beautiful and himself represents, in his form, ideal beauty. He
carries himself away from himself, from his own aesthetic; he
prohibits a pure human aesthetic because, so that, insofar as the
sans of the pure cut is effaced in him. This is also what is at stake
in the "Copernican revolution."

How does man escape from a discourse on aesthetics of which
he is the central origin?

What then is the beauty of man? For the *non-sans* of the pure
cut to be possible, another division is necessary.

Kant distinguishes, with regard to the beauty of man, two
ideas. Two pieces, he says elsewhere (*zwei Stücke*). He cuts the
beauty of man into two pieces, effaces the cut of each in turn,
without asking himself whether the beauty of man, that pure,
errant, nonideal beauty, which he holds as it were in reserve and
which does not appear to him, never becoming an object for him,
does not stem from the possibility of this breakup without
negativity.

Each piece is fixed. The two pieces have in common that they
are fixed. There is first of all the aesthetic norm-idea (which is
not pure): *die esthetische Normalidee*. Man is presented here as
a finite, sensory being, belonging to an animal species. This idea
corresponds to a particular intuition of the imagination borrowing
its canons from experience. To see in nature what are the typical
elements in the form of a certain species (man or horse), one refers
to a certain "technique of nature" producing the general type. No
individual is adequate to it but one can construct a concrete image
of this type, precisely as an aesthetic idea and as an empirical

ideal. A product of the imagination, this type refers to a highly determinate concept. Here there is a parenthetical clause, which is very important for two reasons. Kant notes that the imagination, the faculty of signs, can sometimes lead us back to signs of ancient concepts, "even very ancient ones" (*selbst von langer Zeit*). On the one hand this is the first time signs are mentioned: yet a whole semiotics supports the third Critique. On the other hand the reference to something "very ancient" that is accessible only via signs communicates with a certain elliptical remark, hasarded as if in passing, in the introduction (VI): the pleasure (*Lust*) of knowing, which is no longer noticed now, "surely existed in its day."

And this pleasure is a pleasure of the same: it always stems from the mastery of the dissimilar, from the reduction of the heterogeneous. The agreement, conformity, coming together (*Zusammentreffen*) of perceptions and categories (general concepts of nature to which laws conform) apparently procure no pleasure. But the reduction of several "heterogeneous" empirical laws to one principle "causes a very remarkable pleasure." And although the intelligence of nature in its unity no longer necessarily procures for us such a pleasure, this pleasure "certainly existed in its day" (*aber sie ist gewiss zu ihrer Zeit gewesen*), otherwise "the commonest experience would not be possible." It's just that this pleasure gradually became confused with experience and was no longer noticed.

Thus, although the third *Critique* (the place of aesthetics) dissociates pleasure and knowledge, although it makes of this dissociation a rigorous juridical frontier between taste and knowledge, the aesthetic and the logical, it must be that the pleasure principle somewhere, in a time immemorial (a concept whose status remains highly uncertain in a *Critique*), governed knowledge, conditioned it and accompanied it everywhere that knowledge was possible, determined it as experience (in the Kantian sense), thus preceding the divergence between enjoying and knowing. How can one situate here the time of this arche-pleasure welding the imagination (aesthetic) to the understanding (logical)?

The aesthetic norm-idea—to which no individual is adequate—forms the empirical canon of human beauty: an average type analogous to the average height that would be derived from thousands of individual images in order to construct "the stature of a beautiful man." This type varies with empirical conditions, it differs for a "negro," a "white," or a "Chinese." The same applies

for the type of a "beautiful horse" or a "beautiful dog" of a determinate breed. This image which "floats" among the individuals of the species is an "archetype" (*Urbild*) regulating all the "productions" of nature for a given species. Not an archetype of beauty but the form and the condition of beauty for a species. In the case of the human face, this regulatory type, which is never beautiful in itself, ordinarily lacks expression and reveals a man of "mediocre inner value," if, that is, adds Kant, one admits that nature carries the internal proportions to the outside. And he is quite ready to admit it. What is more, in this system he cannot but admit it. We shall verify this. For example, if caricature corresponds to an exaggeration of the norm-idea, an extreme *within* the type, the genius, marks, for his part, in the face itself and in its expression, a divergence which deports the type.

The ideal of beauty—this is the other piece—is distinguished from this norm-idea. It can be encountered only in the human form. Man is never beautiful with a pure beauty but ideal beauty is reserved for him. Here for the first time absolute interiority and absolute morality intervene as conditions of the ideal of beauty: that which absorbs or resorbs the *sans* of the pure cut. If the human form and it alone has the right to ideal beauty, it is because it expresses the inside and this inside is a relation of reason to a pure moral end. This engages the whole theory of the sign and the symbol whose position will appear later, precisely at the pivot, at the center or the hinge of the book, in the famous paragraph 59: the last paragraph of the first part (the end of the critique of aesthetic judgment), which deals with the question of philosophical metaphor and bearing the title "Of Beauty as the Symbol of Morality." As early as paragraph 17, "Of the Ideal of Beauty," this symbolics is defined as the expression of the inside on the outside, presentative union of the inside and the outside. The expressivist and symbolic order of beauty takes place in man and for man:

> But the *ideal* of the beautiful is still something
> different from its *normal idea*. For reasons already
> stated it is only to be sought in the *human figure*. Here
> the ideal consists in the *expression of the moral* (*in
> dem Ausdrucke des Sittlichen*), apart from which the
> object would not please at once universally and
> positively (not merely negatively in a presentation
> academically correct). The visible *expression* (*der
> sichtbare Ausdruck*) of moral ideas that govern men
> inwardly can, of course, only be drawn from experience;

but their combination (*Verbindung*) with all that our reason connects with the morally good in the idea of the highest finality—benevolence, purity, strength, or equanimity—may be made, as it were, visible in *bodily manifestation* (*in körperlicher Äusserung*) (as effect of what is internal) (*als Wirkung des Innern*), and this embodiment involves a union of pure ideas of reason and great imaginative power, in one who would even form an estimate of it, not to speak of being the author of its *presentation* (*vielmehr noch wer sie darstellen will*). The correctness of such an ideal of beauty is evidenced by its not permitting any sensuous charm (*Sinnenreiz*) to mingle with the delight (*Wohlgefallen*) in its Object, in which it still allows us to take a great interest. This fact in turn shows that an estimate formed according to such a standard can never be purely aesthetic, and that one formed according to an ideal of beauty cannot be a simple judgement of taste. (§ 17: my emphasis on *expression, bodily manifestation, presentation*—J. D.) (Meredith, 79–80)

‾‾‾‾‾‾ this moral semiotics which ties *presentation* to the expression of an inside, and the beauty of man to his morality, thus forms a system with a fundamental humanism. This humanism justifies, at least surreptitiously, the intervention of pragmatic culture and anthropology in the deduction of judgments of taste. There we have the wherewithal to make sense of a sort of incoherence-effect, of an embarrassment or a suspended indecision in the functioning of the discourse. Two points of orientation:

1. In the fourth and last moment of the judgment of taste (modality), the value of exemplarity appeals to a common sense (*Gemeinsinn*). The rule of the exemplary judgment attracting universal adhesion must remain beyond all enunciation. So common sense does not have the common meaning [*sens*] of what we generally call common sense: it is not intellectual, not an understanding. What then is its status? Kant refuses to decide here, or even to examine ("we neither want nor are able to examine here") whether such a common sense exists (if "there is one") as a constitutive principle of the possibility of experience or else whether,

this time in a *regulatory* and not *constitutive* capacity, reason commands us to produce (*hervorbringen*) in ourselves a common sense for more elevated ends. What remains thus suspended is the question of whether the aesthetic principle of pure taste, inasmuch as it requires universal adhesion, has a specific place corresponding to a power of its own, or whether it is still an idea of (practical) reason, an idea of the unanimous universal community which orients its idealizing process. As always, so long as such an idea remains on the horizon, moral law allies itself with empirical culturalism to dominate the field.

2. The other significant indecision as to the principle concerns the division of the fine arts. This division comprises, as always, a hierarchy, going far into detail and also resting on an analogy: between art and human language. The three kinds of fine arts (talking art, figurative (*bildende*) art, the art of the play of sensations (*Spiel der Empfindungen*)) correspond to the forms of human expression referred to the body's means of expression (articulation, gesticulation, modulation: words, gestures, tones). This correspondence is analogical. But on two occasions, in footnotes, Kant shows that he does not absolutely hold to this principle of hierarchical classification and that he does not consider it to have an absolutely reliable theoretical value: "If then we wish to divide up the Fine Arts, we cannot, at least on a trial basis (*wenigstens zum Versuche*), choose a more convenient principle (*bequemeres Princip*) that the analogy of art with the kind of expression which men use in their language (*Sprechen*) in order to communicate to one another, as perfectly as possible, not only their concepts but also their sensations.*

"*The reader should not judge this sketch of a possible division of the fine arts as a theoretical project. It is but one of the many attempts than can and must still be tried" [Kant's footnote] (§ 51).

The redundancy of a second note, in the same paragraph, underlines the embarrassment: "The reader must in general consider this only as an attempt to tie together the fine arts under one principle, which this time must be that of the expression of aesthetic ideas (according to the analogy of a language (*nach der Analogie einer Sprache*)), and not a derivation held to be decisive."

Kant's scruple would only be the index of a critical vigilance if it bore upon a localizable, revisable, or detachable point of the system. But it is not clear how he would have been able to avoid,

without a complete recasting, such a classificatory and hierar-
chizing deduction, regulated according to the language and body
of man, the body of man interpreted as a language dominated by
speech and by the gaze. Humanism is implied by the whole func-
tioning of the system and no other deduction of the fine arts was
possible within it.

The principle of analogy is here indeed inseparable from an
anthropocentric principle. The human center also stands *in the
middle,* between nature (animate or inanimate) and God. It is
only on this condition that we can understand the analogy be-
tween determinant judgments and reflexive judgments, an essen-
tial part of the machine. Incapable as we are of determining ab-
solutely the particular empirical laws of nature (because the general
laws of nature, prescribed in our understanding, leave them un-
determined), we must act *as if* an understanding (not our own)
had been able to give them a unity, "as if some understanding
enclosed the foundation of the unity of the variety of empirical
laws" (Introduction, IV). From then on, natural finality, an *a priori*
concept deriving from a reflexive judgment, is conceived by anal-
ogy with human art which gives itself a goal before operating.
This analogy—giving oneself the goal of the operation, effacing *a
priori* its *sans*—thus puts the art of man in relation with the art
of the creator. The analogy with practical finality is its medium.
"For one cannot attribute to the productions of nature any such
thing as a relation of nature to ends, but one can use this concept
only to reflect (*reflectiren*) on nature from the point of view of
the linking of the phenomena in her, a linking given by empirical
laws. This concept is, moreover, quite distinct from practical fi-
nality (of human art or even of mores), although it is thought by
analogy with it."

The connection between anthropo-theologism and analogism
indicates, among other things, a certain course, the course being
steered.

This course seems to be *lacking* from *pulchritudo vaga,*
wandering without a determinable end, in the *sans* of the *but
en blanc,* without object-complement, without objective end.
But the whole system which has its sights on that beauty
supplies the course, determines the vagueness (as lack) and
gives sense and direction back to errancy: its destiny and its
destination. Analogism recapitulates or reheads it. It saturates
the *hiatus* by repetition: the *mise en abyme* resists the abyss

of collapse, reconstitutes the economy of mimesis. This latter is the same (economimesis), the law of the same and of the proper which always re-forms itself.

Against imitation but by analogy ⎯

 |

|
⎯⎯ economimesis—

4. The Colossal

That which always forms itself anew—economimesis—only to close up again, nonetheless leaves an embouchure each time. The end of "Economimesis" opened onto water "put in the mouth."

Let us leave the embouchure open. It is still a question here of knowing what happens [se passe] with or without what one leaves. And what happens with (or: what does without) [se passe de] leave, whether it is followed by a noun or a verb,[29] when it carries us at a stroke [coup], with a step [pas], beyond passivity and activity alike. Let us let be [laissons faire] or let us allow to be seen [laissons voir] what does without [happens with] the open embouchure.

What I shall try to recognize in it, in its vicinity, and moving around it a little, would look like a certain column.

A colossus, rather, a certain kolossos which erects itself as measure [en mesure].[30]

What is it to erect en mesure?

The column is not the same thing as the colossus. Unless they have in common only the fact that they are not things. In any case, if one wished to keep the word "word" and the word

29. Laisser + noun works more or less like English leave + noun; laisser + verb is roughly equivalent to English let + verb, with the important difference that some infinitives following laisser can have either active or passive value.

30. "S'érige en mesure": also, "rises up in time" (in the musical sense of "in time").

"thing," *colossus* and *column* are two indissociable words and two indissociable things which have nothing to do [*rien à voir*] together and which together have nothing to see: they see nothing and let nothing be seen, show nothing and cause nothing to be seen, display none of what one thinks.

And yet, between the Greek *kolossos* and the *columna* or *columen* of the Romans, a sort of semantic and formal affinity exerts an irresistible attraction. The trait of this double attraction is all the more interesting because it has to do with, precisely, the double, and the one, the colossus, as double.

Speaking only of the *kolossos*, Vernant declares: "Originally, the word has no implication of size [*taille*]."[31] "Has no implication of size": this apparently, visibly, means that a *kolossos* is not necessarily big, gigantic, out of proportion. Although the context, and consequently Vernant's manifest intention, does not invite this in the least, the "implication of size" carries us somewhere else. Before referring to size, and above all that of the human body, for example foot size, which is also called *pointure* in French, *taille* marked the line of a cut, the cutting edge of a sword, all the incisions which come to broach a surface or a thickness and open up a track, delimit a contour, a form or a quantity (a cut(ting) of wood or cloth).[32]

If, "originally, the word [*kolossos*] has no implication of size," it will come to have this implication later, adds Vernant, only *by accident*. What about the accident, this one in particular, which brings cise to the colossus, not the incisive cise which gives measure, not the moderating [*modératrice*] cise but the disproportionate [*démesurante*] cise? This accident is not, apparently, part of the program of Vernant's rich study; he is content to brush the question aside in his first few lines: "Originally the word has no implication of size. It does not designate, as it will later for accidental reasons, effigies of gigantic, 'colossal' dimensions. In Greek statue-vocabulary, which as Monsieur E. Benveniste has shown is very diverse and fairly fluctuating, the term *kolossos*, of the

31. "Figuration de l'invisible et categorie psychologique du double: le colossos," in *Mythe et pensée chez les Grecs* ((Paris: Maspéro, 1965; reprint in 2 vols., 1982), 2:65–78; English translation (London: Routledge and Kegan Paul, 1983), 305–20].—J.D.

32. To render this second sense of the French *taille*, and to preserve the uncertainty between the two senses which is vital in some of what follows, we shall use the word "cise," an obsolete spelling of "size" (see *OED*) and suggestive of cutting (cf. incision).

animate genre and of pre-Hellenic origin, is attached to a root
kol-, which can be connected to certain place names in Asia Minor
(Kolossai, Kolophon, Koloura) and which retains the idea of some-
thing erect, upright."

Through the *effigy*, precisely, and in the fictional space of
representation, the erection of the *kol-* perhaps ensures what I
have proposed elsewhere (*Glas*, +*R*), with regard precisely to the
colossal, to call the *detail* or the *détaille*, the movement from
cise, which is always small or measured, to the disproportion [*la
démesure*] of the without-cise, the immense. The dimension of
the effigy, the effigy itself would have the fictional effect of de-
measuring. It would de-cise, would liberate the excess of cise.
And the erection would indeed be, in its effigy, difference of cise.
Then *kol-* would also ensure, more or less in the effigy of a phan-
tasy, the passage between the colossus and the column, between
the *kolossos*, the *columen* and the *columna*.

I will take my stand in this passage.

Unlike other analogous "idols" (*bretas, xoanon*), the *kolossos*
cannot be moved around. There is nothing portable about it. It is
a stony, fixed immobility, a monument of impassivity which has
been stood up on the earth, after having been embedded a little
in it, and sometimes buried. Although philologists or archeolo-
gists, Vernant for example, don't look in this direction, even at
the very moment they are speaking of the Gorgon and of *lithinos
thanatos* (Pindar), one ought to link here the discourse on the
kol- to the whole Freudian problematic of the Medusa (erection/
castration/apotropaic) the reading of which I attempted to displace
in the "Hors livre" of *Dissemination*, as well as the problematic
of the *col* which ensures a great density of circulation in *Glas*
("And of the blink (—) between the two col (—)", p. 251). I shall
not do it here any more than I shall set off on the side of the
Heideggerian *trait* (*Riss, Zug*, and the whole "family" of their
crossings) or of the role played by broaching [*l'entame*] (*Aufriss*)
in this corpus. I shall come to it elsewhere and later. I prefer to
stay for the moment with the third *Critique*, which serves us as
a guide in this preliminary trajectory.

It's worth the detour. You come across columns in it, and the
colossal is not only encountered, it is a theme. But the column
and the colossal do not occupy the same place here. We have
already verified this: when it supports an edifice, the column was,
for example if not by chance, a *parergon*: a supplement to the
operation, neither work nor outside the work. One can find in

the *Analytic of the Sublime* a distinction and even an opposition between the column and the colossal. The column is of average, moderate, measurable, measured size. The measure of its erection can be taken. In this sense it would not be colossal, the column.

This opposition of the colossus and the column is not given to be immediately read as such in Kant's text. But it is none the less incontestable in the paragraph "Of the Evaluation of the Sizes of the Things of Nature, Necessary to the Idea of the Sublime" (§ 26). Here Kant is looking for an example of the sublime which would suit the critique of *pure* aesthetic judgment. It must therefore be distinct from teleological judgment insofar as this is rational judgment. So this example of the sublime will not be taken from the order of the "productions of art." For these are, one could say, on the scale of man, who determines their form and dimensions. The mastery of the human artist here operates with a view to an end, determining, defining, giving form. In deciding on contours, giving boundaries to the form and the cise, this mastery measures and dominates. But the sublime, if there is any sublime, exists only by overspilling: it exceeds cise and good measure, it is no longer proportioned according to man and his determinations. There is thus no good example, no "suitable" example of the sublime in the products of human art. But what examples present themselves to Kant as "bad" examples of the sublime? In what examples must one *not* seek the sublime, even if and especially if one is tempted to do so? Well, precisely (and in parentheses) in edifices and columns. "(*z.B. Gebäuden, Säulen u.s.w.*)." Elsewhere an example of a *parergon*, half-work and half-outside-the-work, neither work nor outside-the-work and arising in order to supplement it because of the lack within the work, the column here becomes exemplary of the work that can be dominated and given form, according to the cise of the artist, and *in this measure* incapable of giving the idea of the sublime.

Of course the things of nature, when their concept already contains a determinate end, are equally incapable of opening us up to the sublime: for example the horse whose natural destination is well known to us. Endowed with a determinable end and a definite size, they cannot produce the feeling of the sublime, or let us say the *superelevated. Erhaben*, the sublime, is not only high, elevated, nor even very elevated. Very high, absolutely high, higher than any comparable height, more than comparative, a size not measurable in height, the sublime is *superelevation* beyond itself. In language, the *super-* is no longer sufficient for it. Its

superelevation signifies beyond all elevation and not only a sup-
plementary elevation. (It has to do with what in *Glas* is called
the *élève.*).

So neither the natural object with a determinable destination
nor the art object (the column) can give an idea of sublime su-
perelevation. Superelevation cannot be announced, it cannot pro-
voke us to an idea of it, motivate us to it, or arouse that idea,
except by the spectacle of a nature, to be sure, but a nature which
has not been given form by the concept of any natural end. Su-
perelevation will be announced *at the level of raw nature: an der
rohen Natur,* a nature which no final or formal contour can frame,
which no limit can border, finish, or define in its cise. This raw
nature on which sublime superelevation would have to be "shown"
is raw in that it will not offer any "attraction" (*Reiz*) and will not
provoke any emotion of fear before a danger. But it will have to
comprise "grandeurs," vastnesses which nevertheless defy all
measure, exceed the domination of the hand or the gaze and do
not lend themselves to any finite manipulation. This is not the

case of natural objects provided with an end (which is accessible to us, in the concept, as a whole which the imagination can also comprehend), nor of objects of art which by definition come from the hands of man, of whom they then keep the measure — and this is the case of the column.

Not of the colossal.

What is the colossal?

By opposition to works of art and to finite and finalized things of nature, "raw nature" can offer or present the "prodigious," the *Ungeheuer* (the enormous, the immense, the excessive, the astonishing, the unheard-of, sometimes the monstrous). "Prodigious" things become sublime objects only if they remain foreign

both to fear and to seduction, to "attraction." An object is "pro-
digious" when, by its size (*Grösse*), it annihilates and reduces to
nothing (*vernichtet*) the end which constitutes its concept. The
prodigious exceeds the final limit, and puts an end to it. It over-
flows its end and its concept. *Prodigious*, or monstrous—let us
pay close attention to this—is the characteristic of an *object*, and
of an object in its relation to its end and to its concept. The
colossal, which is not the prodigious, nor the monstrous, qualifies
the "mere presentation" (*blosse Darstellung*) of a concept. But
not just any concept: the mere presentation of a concept which
is "almost too large for any presentation" (*der für alle Darstellung
beinahe zu gross ist*). A concept can be too big, *almost too* big
for presentation.

Colossal (*kolossalisch*) thus qualifies the presentation, the
putting on stage or into presence, the catching-sight, rather, of
some thing, but of something which is not a thing, since it is a
concept. And the presentation of this concept inasmuch as it is
not presentable. Nor simply unpresentable: *almost unpresenta-
ble*. And by reason of its size: it is "almost too large." This concept
is announced and then eludes presentation on the stage. One
would say, by reason of its almost excessive size, that it was
obscene.

How can the category of the "almost too" be arrested? The
pure and simple "too" would bring the colossal down: it would
render presentation impossible. The "without too" or the "not
too," the "enough" would have the same effect. How are we to
think, in the presence of a presentation, the standing-there-upright
(*Darstellen*) of an excess of size which remains merely *almost*
excessive, at the *barely* crossed edge of a limiting line [*trait*]? And
which is incised, so to speak, in excess?

The *almost too* thus forms the singular originality, without
edging or simple overspill, of the colossal. Although it has an
essential relation to approximation, to the approaching move-
ment of the approach (*beinahe zu gross*), although it names the
indecision of the approach, the concept of the "almost-too," as a
concept, has nothing of an empirical approximation about it. It
did not slip from Kant's pen. (I shall risk here the definition of
the *philosophos kolossos*, who is not the "great philosopher":
he's the one who calculates almost too well the approaches to
the "almost too" in his text.) The *almost too* retains a certain
categorical fixity. It is repeated regularly, and each time associated
with "big." Kant adds, in fact, immediately afterward, that the

presentation of a concept becomes difficult, in its "goal," when the intuition of the object is "almost too great" for our "power of apprehension" (*Auffassungsvermögen*). It "becomes difficult" (*erschwert wird*), progressively, by continuous approximation. But where, then, do we cut off? Where are we to delimit the trait of the *almost too?*

The "power of apprehension" seems to give the measure here. Let us not rush toward what would, by the slant of the metaphor, of (schematic or symbolic) hypotyposis, immediately put the *Auffassen* in our hands or under our noses. This problematic is necessary, and would lead just as well to the famous paragraph 59 of the third *Critique* as to the Hegelian treatment of the "Fassen" as a dead metaphor. I shall provisionally skirt around it, using other trajectories ("White Mythology" in *Margins*, and "Economimesis") to authorize this avoidance.

The "almost-too-large" of the colossal (if we were in a hurry, we'd translate this as: of the phallus which doubles the corpse; but never be in a hurry when it's a matter of erection, let the thing happen) is thus determined, if one can still say so, in its relative indetermination, as almost too large with regard, if one could still say so, to the grasp, to apprehension, to our power of apprehension. (I shall not abuse the word *apprehension:* at the limits of apprehension, the colossal is almost frightening, it worries by its relative indetermination: What's coming? What's going to happen? etc. But it must not cause fear, says Kant.)

The hold of apprehension is not that of comprehension. In this problematic, the question is always that of knowing if one can take hold of (apprehend or comprehend, which is not the same thing), how can we set about taking hold [*comment s'y prendre pour prendre*], and to what limits prehension can and must extend. How to deal with [*s'y prendre avec*] the *colossal?* Why is it almost too large for our *Auffassung*, for our apprehension, and decidedly too large for our *Zusammenfassung*, our comprehension? A little earlier [*Un peu plus haut*] in the same chapter, Kant had distinguished two powers of the imagination. When it relates intuitively to a *quantum* in order to use it as a measure or as a numerical unit of measure, it has at its disposal the *apprehensio* (*Auffassung*) or the *comprehensio aesthetica* (*Zusammenfassung*). The former can go to infinity, the latter has difficulty following and becomes harder and harder according as the apprehension progresses. It quickly attains its maximum: the fundamental aesthetic measure for the evaluation of magnitudes.

So what about the -prehend with respect to the colossal? Why does Kant call *colossal*, without apparent reference to the colossus, the presentation of a concept (of a *Begriff* whose *Begreifen* itself would not go without a taking hold and a taking sight of)? What is the presentation of a concept, if it may be sometimes colossal and, as such, unequal to the concept which, even while remaining too large for its own presentation, nonetheless never leaves off presenting itself, colossally? Finally, what would the sublime have to do with [*aurait à voir avec*] all these inadequations?

I have just excised the fragment of text in which the word "colossal" rose up. The contextual tissue belongs to the "Analytic of the Sublime" (part I, section I, book 2, after the "Analytic of the Beautiful"). The beautiful and the sublime present a number of traits in common: they please by themselves, they are independent of judgments of the senses and of determinant (logical) judgments, they also provide a pretension to universal validity, on the side of pleasure, to be sure, and not of knowledge. They both presuppose a reflexive judgment and appeal from their "pleasing" to concepts, but to indeterminate concepts, hence to "presentations," and to the faculty of presentation.

One can hardly speak of an *opposition* between the beautiful and the sublime. An opposition could only arise between two determinate objects, having their contours, their edges, their finitude. But if the difference between the beautiful and the sublime does not amount to an opposition, it is precisely because the presence of a limit is what gives form to the beautiful. The sublime is to be found, for its part, in an "object without form" and the "without-limit" is "represented" in it or on the occasion of it, and yet gives the totality of the without-limit to be *thought*. Thus the beautiful seems to present an indeterminate concept of the understanding, the sublime an indeterminate concept of reason.

From this definition—definition of the beautiful as definable in its contour and of the sublime de-fined as indefinable for the understanding—you already understand that the sublime is encountered in art less easily than the beautiful, and more easily in "raw nature." There can be sublime in art if it is submitted to the conditions of an "accord with nature." If art gives form by limiting, or even by framing, there can be a *parergon* of the beautiful, *parergon* of the column or *parergon* as column. But there cannot, it seems, be a *parergon* for the sublime.

The colossal excludes the *parergon*. First of all because it is not a work, an *ergon*, and then because the infinite is presented in it and the infinite cannot be bordered. The beautiful, on the contrary, in the finitude of its formal contours, requires the parergonal edging all the more because its limitation is not only external: the *parergon*, you will remember, is called in by the hollowing of a certain lacunary quality within the work.

In *presenting* an indeterminate concept, in one case of the understanding, in the other of reason, the beautiful and the sublime produce a "Wohlgefallen" which is often translated by "satisfaction," and which I have suggested transposing into "pleasing-oneself-in" for reasons already given and also to avoid the saturation of the "enough" which does not fit. In the case of the beautiful, the "pleasing-oneself-in" is "linked" to quality, in the case of the sublime, to quantity. Wherein one can already anticipate the question of the cise and the difference between the colossus and the column.

We had already recognized the other difference in another context: the pleasure (*Lust*) provoked by the sublime is negative. If we reread this sequence with a view to the *kolossos*, the logic of the cise, of the pure cut, of the without-cise, of the excess or of the almost-too-much-cise, imposes once more its necessity. In the experience of the beautiful, there is intensification and acceleration of life, feeling is easily united to the ludic force of the imagination and to its attractions (*Reizen*). In the feeling of the sublime, pleasure only "gushes indirectly." It comes after inhibition, arrest, suspension (*Hemmung*) which keep back the vital forces. This retention is followed by a brusque outpouring, an effusion (*Ergiessung*) that is all the more potent. The schema here is that of a dam. The sluice gate or floodgate interrupts a flow, the inhibition makes the waters swell, the accumulation presses on the limit. The maximum pressure lasts only an instant (*augenblicklich*), the time it takes to blink an eye, during which the passage is strictly closed and the stricture absolute. Then the dam bursts and there's a flood. A violent experience in which it is no longer a question of joking, of playing, of taking (positive) pleasure, nor of stopping at the "attractions" of seduction. No more *play* (*Spiel*) but seriousness (*Ernst*) in the occupation of the imagination. Pleasure is joined with attraction (*Reiz*), because the mind is not merely attracted (*angezogen*) but, conversely, always also repulsed (*abgestossen*). The *traction* [*trait*] of the attraction (the two families of *Reissen* and *Ziehen* whose crossings in *The Origin*

of the Work of Art and *Unterwegs zur Sprache* we must analyze elsewhere) is divided by the double meaning of traction, the "positive" and the "negative." What the "pleasing-oneself-in" of the sublime "contains" is less a "positive pleasure" than respect or admiration. That's why it "deserves to be called negative pleasure."

This negativity of the sublime is not only distinguished from the positivity of the beautiful. It also remains alien to the negativity which we had also recognized to be at work, a certain labor of mourning, in the experience of the beautiful. Such negativity was already singular, a negativity without negativity [*sans sans sans*], sans of the pure cut, *sans fin* of finality. The singular negativity of the *sans* here gives way to the *counter:* opposition, conflict, disharmony, counterforce. In natural beauty, formal finality appears to predetermine the object with a view to an accord with our faculty of judging. The sublime in art rediscovers this concordance (*Übereinstimmung*). But in the view of the faculty of judging, the natural sublime, the one which remains privileged by this analysis of the *colossal*, seems to be formally contrary to an end (*zweckwidrig*), inadequate and without suitability, inappropriate to our faculty of representation. It appears to do violence to the imagination. And to be all the more sublime for that. The measure of the sublime has the measure of this unmeasure, of this violent incommensurability. Still under the title of the *counter* and of contrary violence, paragraph 27 speaks of an emotion which, expecially in its *beginning* [*début*], can be compared to a shock (*Erschütterung*), to a tremor or a shaking due to the rapid alternation or even to the simultaneity of an attraction and a repulsion (*Anziehen/Abstossen*). Attraction/repulsion *of the same object.* Double bind.[33] There is an excess here, a surplus, a superabundance (*Überschwenglich*) which opens an abyss (*Abgrund*). The imagination is afraid of losing itself in this abyss, and we step back. The abyss—the concept of which, like that of the bridge, organized the architectonic considerations—would be the privileged presentation of the sublime. The example of the ocean does not come fortuitously in the last "General Remark on the Exposition of Reflective Aesthetic Judgment," not the ocean as the object of teleological judgments but the ocean of the poets, the spectacular ocean, limpid "mirror of water" limited by the sky when it is calm, "abyss threatening to swallow everything" when it unleashes itself. This spectacle is sublime. This same "Remark"

33. In English in the text.

distinguishes the "without-interest" (*ohne alles Interesse*) proper to the experience of the beautiful, from the "counterinterest" which opens up the experience of the sublime. "That is sublime which pleases immediately by its opposition (*Widerstand*) to the interest of the senses."

The "pleasing-oneself-in" of the sublime is purely or merely negative (*nur negativ*) to the extent that it suspends play and elevates to seriousness. In that measure it constitutes an occupation related to the moral law. It has an essential relation to morality (*Sittlichkeit*), which presupposes also violence done to the senses. But the violence is here done by the imagination, not

by reason. The imagination turns this violence against itself, it mutilates itself, ties itself, binds itself, sacrifices itself and conceals itself, gashes itself [*s'entaille*] and robs itself. This is the place where the notion of sacrifice operates thematically inside the third *Critique*—and we've been constantly on its tracks. But this mutilating and sacrificial violence organizes the expropriation within a calculation; and the exchange which ensues is precisely the law of the sublime as much as the sublimity of the law. The imagination gains by what it loses. It gains by losing. The imagination organizes the theft (*Beraubung*) of its own freedom, it lets itself be commanded by a law other than that of the empirical use which determines it with a view to an end. But by this violent renunciation, it gains in extension (*Erweiterung*) and in power (*Macht*). This potency is greater than what it sacrifices, and although the foundation remains hidden from it, the imagination has the feeling of sacrifice and theft at the same time as that of the cause (*Ursache*) to which it submits.

First consequence: if the sublime is announced in raw nature rather than in art, the counterfinality which constitutes it obliges us to say that the sublime cannot be merely a "natural object." One cannot say of a natural object, in its (beautiful or sublime) positive evaluation, that it is contrary to finality. All we can say is that the natural object in question can be proper, apt (*tauglich*) for the "presentation of a sublimity." Of a sublimity which, for its part, can be encountered as such only in the mind and on the side of the subject. The sublime cannot inhabit any sensible form. There are natural objects that are beautiful, but there cannot be a natural object that is sublime. The true sublime, the sublime proper and properly speaking (*das eigentliche Erhabene*) relates only to the ideas of reason. It therefore refuses all adequate presentation. But how can this unpresentable thing present itself? How could the benefit of the violent calculation be *announced* in the finite? We must ask ourselves this: if the sublime is not contained in a finite natural or artificial object, no more is it the infinite idea itself. It inadequately presents the infinite in the finite and delimits it violently therein. Inadequation (*Unange-messenheit*), excessiveness, incommensurability are presented, let themselves be presented, be stood up, set upright in front of (*darstellen*) as that inadequation itself. Presentation is inadequate to the idea of reason but it is presented in its very inadequation, adequate to its inadequation. The inadequation of presentation is presented. As inadequation, it does not belong to the natural sen-

sible order, nor to nature in general, but to the mind, which contents itself with *using* nature to give us a feeling of a finality independent of nature. Unlike that of the beautiful, the principle of the sublime must therefore be sought in ourselves who *project* (*hineinbringen*) the sublime into nature, ourselves as rational beings.

There is an effect of the colossal only from the point of view of reason. Such is the *reason of the colossal*, and such is its reason that no presentation could get the better of it [*en avoir raison*]. The feeling of the colossal, effect of a subjective projection, is the experience of an inadequation of presentation to itself, or rather, since every presentation is adequate to itself, of an inadequation of the presenter to the presented of presentation. An inadequate presentation of the infinite presents its own inadequation, an inadequation is presented as such in its own yawning gap, it is determined in its contour, it cises and incises itself as incommensurable with the without-cise: that is a first *approach* to the colossal in erection.

Because the sublime is not in nature but only in ourselves, because the colossal which derives from it proceeds only from us, the analytic of the sublime is only an appendix (*einen blossen Anhang*) to the aesthetic appreciation of natural finality. "This is a very necessary preliminary remark," notes Kant at the opening of the "Analytic of the Sublime," "which totally separates the ideas of the sublime from that of a finality of *nature* and makes of the theory of the sublime a mere appendix to the critical aesthetic evaluation (*Beurteilung*) of natural finality, for by that reason no particular form is represented [in nature]. . . ."

So, although the sublime is better presented by (raw) nature than by art, it is not in nature but in ourselves, projected by us because of the inadequation in us of several powers, of several faculties. The appendix will be the *place* of this inadequation. It will deal with it and will be affected by it. This place would be the *proper* place of the colossal were it not the inadequate emplacement of an inadequation.

It is this "subjective" determination of the sublime based on our faculties that Hegel will judge to be interesting and insufficient. He does this in the *Lectures on Aesthetics*, in the chapter "The Symbolism of the Sublime." In breaking with symbolism, the internal infinity becomes inaccessible and inexpressible. Its presentation can no longer be symbolic (in the Hegelian or Saussurean sense of the term, which implies participation or analogical

resemblance between the symbol and what it symbolizes). The content (the infinite idea, in the position of signified and no longer of symbolized) destroys the signifier or the representer. It expresses itself only by marking in its expression the annihilation of expression. It smashes to smithereens [*Il fait voler en éclats:* makes it fly (off) into pieces] the signifier which would presume to measure itself against its infinity. More precisely, form, the act of forming (*Gestalten*), is destroyed through what it expresses, explains, or interprets. Hence the exegetical interpretation (*Auslegung*) of the content is produced as sublation [*relève*] (*Aufhebung*) of the act of interpreting, of showing, of unfolding, of manifesting. That's the sublime: a sublation of the *Auslegen* in the *Auslegung* of the content. The content operates in it and commands the sublation of form. That's what Kant's "subjectivism" is supposed to have missed. If it is the content, infinity itself, what Hegel calls the one, substance, which itself operates this sublation of the form, if this is what renders the form inadequate, then one cannot explain this operation in terms of a finite subjectivity. We must on the contrary comprehend the sublime inasmuch as it is founded in the unique absolute substance, in the content to be presented (*als dem darzustellenden Inhalt*). In other words, starting from the presented of the presentation and not the presentation of the presented. If there is inadequation, we would say in a code that is scarcely different, between the signified and the signifier, this sublime inadequation must be *thought* on the basis of the more and not the less, the signified infinity and not the signifying finitude.

If—for example—a colossal presentation is without measure, what *is* without measure is the infinite idea, the presented which does not let itself be adequately presented. The form of the presentation, for its part, the *Darstellung*, has a measurable cise, however large. The cise of the colossal is not on the scale of what it presents, which *is* without cise. Hegel reproaches Kant with setting out from cise and not from without-cise. To which Kant replies in principle that in order to think the without-cise, it has to be presented, even if it is presented without presenting itself adequately, even if it is merely announced, and precisely in the *Aufhebung*. One must (one must and one cannot avoid it) set out from the colossal inasmuch as it cuts into itself [*s'entaille*], lifts its cise and cuts it out against the background of the without-cise: one must set out from the figure, and its cise.

Thus all this goes on around an infinite but truncated column, at the limit of the trunk, at the place of the truncation or the cutting edge, on the borderline, fine as a blade, which defines the cise. The question opens around knowing whether one must *think* a sublimity of the soul from one edge or the other, of the infinite or the finite, it being understood that the two are not opposed to each other but that each transgresses itself toward the other, the one in the other. More precisely, the question opens of *knowing*, or rather of *thinking*, whether one must first *think* (as Hegel thinks) sublimity, set out from the thought of sublimity, or on the contrary (as Kant figures) from presentation, inadequate to this thought, of the sublime, etc.

Kant and Hegel nevertheless reflect the line of cut or rather the *pas* crossing this line between finite and infinite as the proper place of the sublime and the interruption of symbolic beauty; it is not then surprising that they both consider a certain Judaism as the historical figure of the sublime irruption, the one, Kant, from the point of view of religion and morals, in the ban on iconic representation (neither *Bildnis* nor *Gleichnis*), the other, Hegel, in Hebraic poetry considered as the highest negative form of the sublime. The affirmative form of the same sublime would be found, he says, in pantheist art. |

|___ Like that of the beautiful, the analytic of the sublime proceeds within the frame of the analytic of judgment imported from the *Critique* of pure theoretical reason (quantity, quality, relation, modality). We have already recognized the problems posed by this importation at the moment of situating the *parergon*. Here taking account of the nonformed character of the sublime object, Kant proposes to begin with quantity and not with quality as he had in the analytic of the beautiful. So he commences with the mathematical sublime and not with the dynamic sublime. Now it is in the space of the mathematical sublime that the column and the colossal rise up. And the problem of cise.

"We call *sublime* that which is *absolutely large* (*schlechthin gross*)" (§ 25). The absolutely large is not a dimension,[34] in the quantitative sense. To be large and to be a dimension are two "totally different concepts (*magnitudo* and *quantitas*)." The absolutely large does not belong to dimension, it is not and does not have a dimension. It does not lend itself to any example (*absolute, non comparative magnum, über alle Vergleichung*). Not being equal or comparable to anything, this magnitude remains absolutely unequal, inadequate to anything measurable whatever. Absolute unmeasure [*Démesure absolue*] of this magnitude without dimension, the unequal can here only be, as unequal, equal to itself, can be equal only to itself. That is what we call sublime, "a dimension which is equal only to itself." From this it follows that the sublime is never encountered in the things of nature, only in ideas. Which ideas?, Kant then asks. It will be the object of a "deduction." ⎯

⎯

|⎯ What is the question, then? The question that Kant does not pose and yet which we can pose from inside his discourse. And if we can pose it from inside his discourse, this is because without being posed there, it is not without posing itself there. Questions can also be parergonal. Here it is.

Let us try to consider magnitude anew. This name translates the absolutely large, not absolute largeness (since this "large" is alien to and incommensurable with dimension), nor the large absolute (since one might be tempted to invert or permutate the two attributes and transform one or other into a substantive), but the absolutely large, an incorrect syntax to designate a value which is neither absolutely nominalizable (the largeness of the large) nor a mere modification of the noun (the large *as* largeness). It is because it is absolutely large that this large is no longer of the order or at the orders of largeness as dimension. It is larger than

34. "L'absolument grand n'est pas une grandeur"; in the exposition that follows, we have translated "grandeur" as "dimension" or "largeness" depending on context.

largeness, neither large nor largeness, but absolutely large. So what is the question? Here it is.

Why can magnitude, which is not a quantity, and not a comparable quantity in the order of phenomena, let itself be represented under the category of quantity rather than some other category? What does it have in common or analogous with that category even when it is incomparable with it? In other words, why call magnitude or "absolutely large" that which is no longer a quantity? Why this reference, still, to a cise in space? Then, another question, still the same, if phenomenalization is to be admitted, why would the sublime be the absolutely large and not the absolutely small? Why would the absolute excess of dimension, or rather of quantity, be schematized on the side of largeness and not of smallness? Why this valorization of the large which thus still intervenes in a comparison between incomparables? To be sure, the absolutely large is not compared with anything, not with any phenomenal dimension in any case, but it is *preferred* to the absolutely small. In short, why is the sublime large and not small? Why is the large (absolutely) sublime and not the small (absolutely)? Kant posits the fact of this preference, of this pleasure taken in the larger or of the greater pleasure taken in the large, of this economy which quasi-tautologically makes the more worth more than the less and the absolutely large more than the absolutely small, since the schema of preference (the more) leads into it as an analytical consequence. If indeed one asks oneself, as I have just done, why preference should go to the largest, one forgets naïvely that the more and hence largeness are inscribed in the movement and in the very concept of preference. So we have to displace the question: *Why should there be a preference?* And more strictly, why, if in phenomenality the excess of quantity is to announce itself, and likewise the movement beyond comparison, why should it do so on the side of the large and not the small, the largest and not the smallest, the less large or the absolutely small?

Kant posits that the preference can only be subjective but the very tautology of the proposition dispenses him from questioning it. If no mathematics can as such justify a preference, an advantage, a superiority, a privilege (*Vorzug*), it must be that an aesthetic judgment is implied in it, and a subjective measure coming to found reflective judgments. An object, even if it were to be indifferent to us in its existence, still pleases us by its mere largeness, even if one considers it as without form (*formlos*), and this

feeling is universally communicable. The relation to this large-
ness is not mathematical, nor is the "respect" which it inspires,
and no more is the "contempt" aroused by "what we call simply
small." Kant does not ask himself why this should go without
saying, naturally toward the largest and the highest. The question
is all the more inevitable because the nonphenomenal infinity of
the idea must always be presented in intuition. Now everything
that is "presented" in intuition and therefore "represented" aes-
thetically, every phenomenon is also a *quantum*. But what decides
that, in this *quantum*, the more is worth more than the less, and
the large more or better than the small? The agency of decision
or "preference" can as such be neither phenomenal nor noumenal,
neither sensible nor intelligible.

The question comes back to the origin of presentation. Why
does the large absolute (the sublime), which is not a *quantum*
since it exceeds all comparison, let itself be presented by a *quan-
tum* which does not manage to present it? And why does this
essentially inadequate *quantum* present it all the "better" for
being larger? The more or less (large) should no longer have any
meaning, any pertinence in the view of the large absolute, of
magnitude. But it has a meaning, notes Kant (and he describes
here what in fact happens) since positive evaluation moves toward
the absolute high or large, and not toward the small or medium.

Kant has introduced comparison where he says it should have
no place. He introduces it, he lets it introduce itself in an appar-
ently very subtle manner. Not by re-implying magnitude in the
comparable, but by comparing the comparable with the incom-
parable. The logic of the argument, it seems to me, and perhaps
the thing itself, are not without relation to the proof of the ex-
istence of God according to Saint Anselm (*aliquid quo nihil majus
cogitari potest*)

 ⌐
 └─ sublime that in comparison with which
all the rest is small. Kant in this way lets a comparison be
introduced, a *Vergleichung*, the site of all figures, analogies, met-
aphors, etc., between two orders that are absolutely irreducible
to each other, absolutely heterogeneous and without likeness.
He throws a bridge across the gulf, between the unpresentable
and presentation. In fact he claims not to throw it but to rec-
ognize it, to identify it: the bridge, like the symbol, throws itself.
Hence it is the whole of nature, the totality of presences and
dimensions which is and appears *as small* in the eyes of mag-
nitude. And that is the sublime. There is nothing in nature,
however large its phenomenon may be, which cannot be brought
down to the infinitely small. The telescope makes this affir-
mation very close to us. Conversely, there is nothing that, for
the imagination, cannot be extended to the dimensions of the
world, in comparisons with still smaller scales of measurement,
and this time it is the microscope which helps us. But as there
is in our imagination a tendency to infinite progress, and in our
reason a pretension to absolute totality as a real idea, the ex-
cessiveness (*Unangemessenheit*) of our power of phenomenal
evaluation of dimensions, its inadequation to the infinite idea
awakens in us the feeling of a suprasensible faculty. This awak-
ening is properly sublime, and it makes us say: "that is sublime
in comparison with which all the rest [all other, *alles andere*],
is small" ───
 │

⎸____ we had left the colossal to wait, and it rises up again here. We are in arrest before a sort of first and fundamental measure. According to Kant, there is a fundamental evaluation (*erstes oder Grundmass*) of size, and two ways of taking it: apprehending and comprehending. How is this to be understood?

In the phenomenal order, one evaluation of size proceeds mathematically, by concepts of number or by their algebraic signs; the other proceeds aesthetically by mere intuition, by eye. Now if we wanted to trust ourselves only to mathematical evaluation, we should be deprived of any primary or fundamental measure. In the series of numbers going to infinity, each unit would call for another unit of measurement. The evaluation of fundamental size (*Grundmass*) must therefore consist in an immediate and intuitive capacity for grasping (*Fassen*): the presentation of concepts of number by the imagination. Another way of repeating that the evaluation of sizes, for natural objects, is in the last instance aesthetic: "subjective and not objective."

A power related to what can be taken by eye, taken in view, that is the fundamental thing where the evaluation of sizes is concerned. The colossal will perhaps be something, or rather the presentation of something which can be taken without being able to be taken, in hand or eye, the *Fassen* looking first of all like the operation of the hand. Being taken without being able to be taken, and which from then on crushes you, throws you down while elevating you at the same time, since you can take it in view without taking it in your hand, without comprehending it, and since you can see it without seeing it completely. But not without pleasure, with a sublime pleasing-oneself-in-it.

Let us resume: the mathematical evaluation of size never reaches its maximum. The aesthetic evaluation, the primary and fundamental one, does reach it; and this *subjective* maximum constitutes the absolute reference which arouses the feeling of the sublime; no mathematical evaluation or comparativity is capable of this, unless—and this remark of Kant's dropped as if in passing, in brackets, is striking—the fundamental aesthetic mea-

sure remains alive, is kept alive (*lebendig erhalten wird*) in the imagination which presents the mathematical numbers. Which shows well that the fundamental evaluation of size in its maximum is subjective and living, however enigmatic this "life" remains, this vivacity or this aliveness [*vivance*] (*Lebendigkeit*).

This primary (subjective, sensory, immediate, living) measure proceeds from the body. And it takes the body as its primary object. We must now verify this. *It is the body which erects itself as a measure.* It provides the measuring and measured unit of measure: of the smallest and the largest possible, of the minimum and the maximum, and likewise of the passage from the one to the other.

The body, I was saying. The body of man, as is understood and goes without saying. It is *starting from* it that the erection of the largest is preferred.

Everything is measured here on the scale of [*à la taille de*] the body. Of man. It is to this fundamental measurer (*Grundmass*) that the colossal must be related, its excess of cise, its insufficient cise, the almost and the almost too much which holds it or raises or lowers it between two measures.

We have just glimpsed it: for the aesthetic evaluation to give rise to a mathematical measure, the intervention of the imagination is indispensable. The imagination takes hold of (*aufnimmt*) a sensory quantum in order to make an empirical estimation of it. Now the imagination, being intermediate between sensibility and understanding, is capable of *two operations*. And we rediscover here the two edges, the two faces of the trait, of the limit or of the cise. Imagination is the cise because it has two cises. The cise always has two cises: it de-limits. It has the cise of what it delimits and the cise of what it de-limits, of what it limits and of what is liberated in it of its limits. Two operations of the imagination, then, which are both *prehensions*. Apprehension (*apprehensio, Auffassung*) can go to the infinite *without difficulty*. The other operation, comprehension (*comprehensio, Zusammenfassung*) cannot follow, it is finite, subjected to the *intuitus derivatus* and to the sensory. It arrives very quickly at a maximum, which is then set up as a fundamental measure. This maximum of comprehension is "the fundamental measure, aesthetically the largest, of the evaluation of size." And if apprehension extends beyond this maximum, it lets go in comprehension what it gains in apprehension. Whence this apparently paradoxical conclusion: the right place, the ideal *topos* for the experience of the sublime,

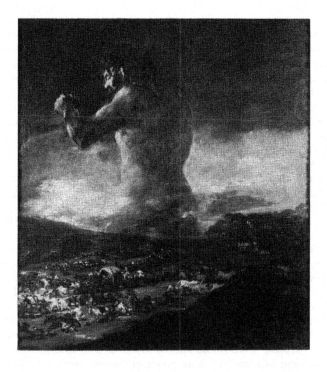

for the inadequation of presentation to the unpresentable, will be a median place, an average place of the body which would provide an aesthetic maximum without losing itself in the mathematical infinite. Things must come to a relationship of body to body: the "sublime" body (the one that provokes the feeling of the sublime) must be far enough away for the maximum size to appear and remain sensible, but close enough to be seen and "comprehended," not to lose itself in the mathematical indefinite. Regulated, measured dis-tance [é-loignement] between a too-close and a too-far.

In Kant's examples, this relationship of body to body is one of body to stone. Even before the colossal rises up, and you already sense that it will be of stone, stony, petrified or petrifying, the two examples are of stone.

First of all, once again, the pyramids. Kant refers to the Letters from Egypt. Savary explains: you have to be neither too close to nor too far from the pyramids in order to feel the

emotion proper to the thing. From far away, the apprehension of these stones gives rise only to an obscure representation without effect on the aesthetic judgment of the subject. From very close, it takes time to complete the visual apprehension from base to summit, the first perceptions "faint away" before the imagination reaches the last ones, and the "comprehension is never complete," accomplished. So one has to find a middle place, a correct distance for uniting the maximum of comprehension to the maximum of apprehension, to take sight of the maximum of what one cannot take and to imagine the maximum of what one cannot see. And when the imagination attains its maximum and experiences the feeling of its impotence, its inadequacy to present the idea of a whole, it falls back, it sinks, it founders into itself (in sich selbst zurück sinkt). And this abyssal fall-back does not leave it without a certain positive emotion: a certain transference gives it the wherewithal to feel pleased at this collapse which makes it come back to itself. There is a "pleasing-oneself-in" in this movement of the impotent imagination (in sich selbst zurück sinkt dadurch aber in ein rührendes Wohlgefallen versetzt wird). This is what happens (another place of stone in the name of the Rock, and it's the Church) when "the spectator enters for the first time into the Church of Saint Peter in Rome." He is "lost" or struck with "stupor." One would almost say turned to stone [médusé]: a moment ago outside, now inside the stony crypt.

This is at least what people say (wie man erzählt): Kant never went to have a closer look, neither to Rome nor to Egypt. And we must also reckon with the distance of a narrative, a written narrative in the case of Savary's Letters. But does not the distance required for the experience of the sublime open up perception to the space of narrative? Does not the divergence between apprehension and comprehension already appeal to a narrative voice? Does it not already call itself, with a narrative voice, the colossal?

We shall come back to it after having moved slowly round its site. In the previous paragraph, Kant has just named the pyramids and Saint Peter of Rome: "if the aesthetic judgement is to be pure (unmixed with any teleological judgement which, as such, belongs to reason), and if we are to give a suitable example of it for the Critique of aesthetic judgement, we must not point to the sublime in works of art, e.g. buildings, statues and the like, where a human end determines the form as well

as the magnitude, nor yet in things of nature, *that in their very concept import a definite end,* e.g. animals of a recognized natural order, but in rude nature merely as involving magnitude (and only in this so far as it does not convey any charm or any emotion arising from actual danger). For in a representation of this kind nature contains nothing monstrous (*ungeheuer*) (nor what is either magnificent or horrible)—the magnitude apprehended may be increased to any extent provided imagination is able to grasp it all in one whole. An object is *monstrous* where by its size it defeats the end that forms its concept. The *colossal* is the mere presentation of a concept which is almost too great for presentation, i.e. borders on the relatively monstrous; for the end to be attained by the presentation of a concept is made harder to realize by the intuition of the object being almost too great for our faculty of apprehension" (Meredith, 100–101). Apprehension and not comprehension, even though apprehension is defined by the power of progressing to the infinite; it runs out of breath less quickly than comprehension. We had insisted on this earlier, but to sharpen up the distinction and the proximity of *kolossalisch* and *ungeheuer,* we must again recall the virtual connotation which marks this latter value: the *monstrous.* A. Philonenko privileges it by systematically replacing "prodigious" (Gibelin's translation) by "monstrous."

The colossal seems to belong to the presentation of raw, rough, crude nature. But we know that the sublime takes only its presentations from nature. The sublime quality of the colossal, although it does not derive from art or culture, nevertheless has nothing natural about it. The cise of the colossus is neither culture nor nature, both culture and nature. It is perhaps, between the presentable and the unpresentable, the passage from the one to the other as much as the irreducibility of the one to the other. Cise, edging, cut edges, that which passes and happens, without passing, from one to the other. ̄|

|⎯⎯ *pas*-without-from-the-one-to-the-other [*pas-sans-de-l'une-à-l'autre:* the pun suggests "passing from one to the other"—Trans.]

|

|⎯⎯ Kant retouched his sentence several times, sharpening his quill on it. The "which" of the "which is almost too large" has as its antecedent, from one edition to another, the concept or the presentation. But does this not amount to the same thing? The presentation of something which is too large to be presented or the presentation, too large to be presented, of something—that always produces an inadequation of the presentation to itself. And this possible inequality of the present of presentation to itself is what opens the dimension of the colossal, of the colossal *Darstellen*, of the erection *there in front* [*là-devant*] of the colossus which cises itself.[35] It cises itself, rises up and rises up again in its immense cise, both limited since what is presented remains too large, almost too large for it, and unlimited by the very thing it presents or which presents *itself* in it. This double trait of a cise which limits and unlimits at one and the same time, the divided line upon which a colossus comes to cise itself, incise itself without cise, is the sublime. Kant also calls it "subjective": let us decipher in this the psychic ideality of what "is not in nature," the origin of the psyche as *kolossos*, the relation to the double of the *ci-devant*[36] who comes to erect himself *là-devant*. To superelevate himself, supposedly, beyond height. ⎯⎯

|

35. "Qui se taille"; also, in colloquial French, to beat it, to clear off.
36. As an adjective, *ci-devant* means "formerly"; as a noun, it refers specifically to a noble stripped of his title during the French Revolution.

|
‾‾‾‾ *ci-devant.* Colossal
Fort: Da. What comes-in-front[*devant*]-of-it-to-erect-itself. Hav-
ing to [*Devant*] erect itself in the excessive movement of its
own disappearance, of its unpresentable presentation. The ob-
scenity of its abyss. ‾‾‾
 |

|
‾‾‾‾ this double
cise is compared only with itself. For the limit does not exist. Even if
there is some, the cise of this broaching does not exist, it never begins,
anywhere. Neither originary nor derived, like the trace of each trait.
That's what is presented without cise. ‾‾‾
 |

|
‾‾‾‾ and if you consider the trunk of the present
which makes itself present here, you see double, you see that it
will have had to be double. The colossal is, in other words su-
perelevates itself, on both sides of its own cise, it is on both sides
its own cise, it is of its own cise on both sides. *A priori* and from
the start double colossus, if not double column. Whence its res-
onance. ‾‾‾
 |

|⎯⎯⎯ both potent and impotent, potent in its very
impotence, all potential in its unequalness to itself. Everything
here resounds and echoes in the dynamic sublime. The colossal
was dealt with in the chapter on the mathematical sublime. It
remains to be seen how the dynamic comes to the mathematical.

For aesthetic judgment, the *dynamic* sublime of nature is
given in the difference between force and potency, when force
(*Macht*) has not the force to exercise its potency or its violence
(*Gewalt*): on us. And force becomes potency only by winning out
over the resistance of another force ⎯⎯⎯
 |

|⎯⎯⎯ death knell [*glas*] and galactic
of the *kolossos*. In the interval between the mathematical sublime
and the dynamic sublime, a tree had been projected into the Milky
Way. There was the bridge over the abyss which threatens to
swallow everything, on the edge of which the analytic of the
sublime is broached. Now this whirlpool which tears up the tree
and throws it, immensely, into the milky dissemen [*la disse-
mence*]. The question is still, as we know now, the cipher writing
(*Chiffreschrift*) on the surface of nature. And an example: "We
get examples of the mathematically sublime of nature in mere
intuition in all those instances where our imagination is afforded,
not so much a greater numerical concept as a large unit as measure
(for shortening the numerical series). A tree judged by the height
of man gives, at all events, a standard for a mountain; and, sup-

posing this is, say, a mile high, it can serve as unit for the number
expressing the earth's diameter, so as to make it intuitable; sim-
ilarly the earth's diameter, for the known planetary system; this
again for the system of the Milky Way; and the immeasurable
host of such systems, which go by the name of nebulae, and most
likely in turn themselves form such a system, holds out no pros-
pect of a limit" (Meredith, 105).

+ R

(Into the Bargain)

First version published in 1975 in the series *Derrière le miroir* [Behind the mirror] (no. 214, May 1975, Editions Maeght). The occasion for the text was provided by an exhibition of the work of Valerio Adami, entitled *Le Voyage du dessin* [The journey of the drawing]. Among a hundred or so other drawings, it is worth recalling here two "Studies for a drawing after *Glas*." They were preparations for the two works which received their titles, ICH and CHI (CHIMERE for the whole), from the following text. This text was printed in 18 point type, without margin, border, or passe-partout of any kind. And is primarily concerned to explain this fact.

and what if, resonance in this other language still leading you astray, I liked words *in order to be-tray* (to treat, triturate, trice, in-trigue, trace, track).

For example, *in order to betray* Adami, to be a traitor to his travail, I would let myself be framed.

Shall I exhibit it without remainder? How to evaluate the economy of the means, the constraints of a deadline (so many days, but things are more complicated than that, I'm proceeding from an accumulation that is difficult to measure), of a format (so many signs, but I ply and multiply the tropes, overdetermine the codes, impregnate languages and margins, capitalize ellipsis, up to a certain point which concerns me [*qui me regarde*] but which I can't see very clearly), and then of what they call the conditions of reproduction, the painting market: but also the constraints of the signature, of writing, and even, taken into account here, of deletion [*rature*].

He used to draw with an eraser, now here he is deleting.
What does *he* make of the market, of frames and margins?

Evidently talking about them isn't enough for him. Nor is the statement of theses *on this subject*. Benjamin, portrayed here, urges *the author as producer:* that he not be content to take up a position, through discourse, *on the subject* of society and that he never, even with theses or revolutionary products, stock up an

apparatus of production without transforming the very structure of that apparatus, without twisting it, betraying it, attracting it out of its element. After trapping it, having taken it—a low trick— at its word or by the bit [*au mot ou au mors*].

In this very place, you see, he has forced a frame. He has stripped it and turned it, working relentlessly to dislocate its angles, rummaging in its corners. *A tergo*, letting you think that one could turn around it, go on a tour of the property, go behind specular reproduction.

But where the back faces up, the text was already: initial letters already [*déjà*] written in what you think is *his* hand by someone who here writes *me*, saying (what? read, look) here now, but since ever dragged into *Glas* by an incredible scene of seduction between Rembrandt and Genet. With acting out, of course, as seduction is understood in psychoanalysis.

Putting the frame forward, pushing it onstage, ill-treated, in the limelight, he has crossed out *margins*, he has written, and therefore deleted, what he was doing; he has drawn, line for line, what he was writing, or rather deleting: those *Margins* I could only try in vain to reappropriate for myself as a rent or a title.

For this double gesture, and this motive of a quotation, already [*déjà*], from the double engraving (record and drawing), *Concerto per un quadro di Adami*, he needed twice two hands. He composes, he decomposes: with, among other pieces, scores that I have pretended to sign, where the need to play with several hands, on more than one stave, had long been insistent ("Two texts, two hands, two looks," "Ousia and grammē" [in *Margins*]; "It [the beyond of the closure of the book] is there like the book's shadow, the third party between the two hands holding the book [*deux mains tenant le livre*], difference in the now [*le maintenant*] of writing," "Ellipsis" [in *Writing and Difference*]; "At least two hands are needed to make the apparatus function, and a system of gestures, an organized multiplicity of origins. One must be several in order to write and already to 'perceive.' The simple structure of nowness [*la maintenance*] and manuscripture is a myth, a 'fiction' as 'theoretical' as the idea of the primary process," "Freud and the Scene of Writing" [in *Writing and Difference*]).

Study for a Drawing after Glas (one of the two sides of what will be a double-sided serigraph).

The *Concerto a quattro mani* is played twice by inverting the direction of the hands: in front of a mirror, under a mirror, behind the mirror. The strange manufacture diverts [*détourne*] speculation, it presents what presents it, *behind the mirror*, on the cover. This latter is thus a part of itself, a piece of a display shelf which, because it is situated both inside and outside, manipulates in several registers an object which, however, exceeds it. And pretends to represent a nonrepresentational instrument (for example a piano).

Study for a Drawing after Glas (the other side).

But also, vaguely distracted by the smoke of a cigarette, of a surgical dance, fingers as chorus [*les doigts en choeur*]. In *Viaggio all'est*, it's the mouth shaped like a heart [*la bouche en coeur*].

By covering, right from its title, the whole of a series of which it is however only one piece, an ensemble of which it is only one instrument, does the concerto take possession of the very powerful *galerie* ["gallery" in all senses, also "audience"—Trans.] (a

word I pick out from another drawing)? Does it dislocate the sense
of march or market? We shall ask this question of every drawing,
every title, every *trait*. Everywhere the same stratagem. *Trait* for
trait, each stands for all the others but, by this fact, never leaves
the slightest chance to equivalence.

What happens when a surplus value places itself *en abyme*?

To what then will I have yielded? To whom [*A qui*].

As for painting, any discourse on it, beside it or above, always
strikes me as silly, both didactic and incantatory, programed,
worked by the compulsion of mastery, be it poetical or philo-
sophical, always, and the more so when it is pertinent, in the
position of chitchat, unequal and unproductive in the sight of
what, at a stroke [*d'un trait*], does without or goes beyond this
language, remaining heterogeneous to it or denying it any over-
view. And then, if I must simplify shamelessly. it is as if there

Concerto a quattro mani.

Concerto a quattro mani.

had been, for me, two paintings in painting. One, taking the breath
away, a stranger to all discourse, doomed to the presumed mutism
of "the-thing-itself," restores, in authoritarian silence, an order of
presence. It motivates or deploys, then, while totally denying it,
a poem or philosopheme whose code seems to me to be exhausted.
The other, therefore the same, voluble, inexhaustible, reproduces
virtually an old language, belated with respect to the thrusting
point of a text which interests me.

At the point of this text (general text, I'm not going to define
it again in all the cog wheels or energies of its apparatus), the
angular signature of Adami was waiting for me. A stupefying
advance, and one made simultaneously on all fronts (historical,
theoretical, formal, political, etc.).

So I yielded, even before knowing it, as if I were read in ad-
vance, written before writing, prescribed, seized, trapped, hooked.
And then it was my business [*ça me regardait*]. Making me speak,

it was putting me in the wrong but it was too late and that will have taught me a lesson.

For example in the fish drawing which I shall baptize *Ich:* without the author's authorization, in order to take it from him in turn and hold it at the end of my line, with an apparently simple line, without a reel, without the interposed machine turning and fishing all by itself under the wheels of the train, in *La meccanica dell'avventura* (which dates from one month later).

Ich, snatched fish body, foreign body of a word to involve *another language* (Adami often does it) in the play of signatures and the agonistic outbidding speculating on the *I.* Truncated body or overcharged matrix (there are so many in Adami), bait for the Christic phallus (*Ichthys*), track, graph or trace (*Ichnos*) of a voiceless bit.

I give the translation of *Ich.*

Glas (it will be demanded that I quote myself, patiently, I'm talking here of *Ich* and exhibiting it *as an other,* and all and sundry) tracks in all directions the operation of the baptismal desire which enters and leaves but never holds, like *Ich,* either in the water or out of the water.

Two pages (double column, double band) are here bound together by a fastener known as a spiral, like in an *exercise book* [*cahier*]. Codicarium? Quaternarium? four sides in any case, a support also cut in four according to an internal discrepancy of the binding and an oblique limit like the surface of the waters.
Fished out of *Glas,* pulled up above the sea, out of its element, a sentence seems to last, both continue and cut itself off: first of all in itself, from left to right, breaking its own movement and then reconstituting itself, with a leap above the binding, above the domestic margin or the articulation. Taking its call from its scarcely articulable *gl.* Everything is here marked *scarcely.* The statement is not only cut inside, but also on its two outside edges, by the guillotine. "What both cuts me off and prompts me [*me souffle*] with all the rest" is thus written and read, performs itself in cutting off and prompting all the rest, *in the process* of doing what it says it is doing, of drawing what it is *in the process* of writing. The framing borders are jumped, the margins saturated,

Study for a Drawing after Glass.

but *en abyme. Ich* plunged back in ("the consonant plunged back
in") at the very moment of the catch and the baptism, in a bot-
tomless element. Does the Christic phallus come out of the sea?
No shore, no more edge, certainly, but the edge is named: "the
angle is always for me the edge of a tomb."

My signature—who will attest to its authenticity in this re-
production of a reproduction? and what if Adami had imitated it,
like my writing? and what if I had forged his on the left? —my
signature is also cut off, before the *da.* What is detached—falls

overboard—is also a piece of the other's [i.e. Adami's] name (*da*) and one of the most obsessive motifs in *Glas*.

The *da* is not there, *hic et nunc*, but it is not lacking. Like color? We'll have to see later: what [*ce qui*] makes itself strong [*fort*] from the monumental fall—falls [*tombe:* also "tomb"] overboard.

Ich: this sketchbook turns to derision, in advance and forever, the dissertations with which one might be tempted to cover it with application, of the type "painting and/or writing," "the rhetoric of the *trait*," "history and function of the legend in Adami's semiotics," "the reinscription of the title," "the politico-synecdochic subversion of the comic strip," etc.

I-marks only the event of *Ich.* Although its structure is singular, no longer, however, coming under what consciousness or perception apprehends as singularity, each of Adami's drawings is cathected by an event. A "global" event, as Genet would say. I would add telescoped, dramaturgy depending on the violent intrusion of the optical apparatus which *from afar* gathers and upsets, makes the one collide with the other, as much as it depends on the event whose narrative it precipitates.

The sentence which crosses the heights of *Ich* allows itself, up to a certain point, to be deciphered, I mean in the system of a language. I abandon this reading to you: polysemia or even dissemination drags it far from any shore [*rive*], preventing what you call an event from ever arriving [*s'arriver*]. Let the net float, the infinitely tortuous play of knots and links which catches this sentence in its drawing.

I pull only one thread in order to attempt, but still in vain, to capture what's coming. I note first that each letter, each word shows itself, *appears*, then, *trait* or form, outside language. But without restricting itself to reproducing, by resemblance or analogy, the very thing that is *said* or *shown*. Doubtless, each letter has the arched, stretched form, the convulsive and slightly incurved rigidity, the supple flexion of an erect phallus or of the fish between life and death, still hanging on the hook (a sort of bit too), snatched from its element but still leaping, desire dancing for the first and last time with a start: (no) more air [*plus d'air;* cf. "plus *r*" (+R}—Trans.]. And doubtless, each letter, especially *gl*, re-marks what is shown *as* what is said: slippery surface, angular character, angled word, edge of tomb, hooked signature. Each letter, bit, or piece of a word is written with two hands, on each page, twice two hands: formal writing, discursive writing, picto-

ideo-phonogram for a single concerto, dominated by a single instrument.

But *gl?* Its *gl* [*son gl*]? The sound *gl* [*le son* gl], the *gl* of "angle," its *gl?* This barely pronounceable writing is not a morpheme, not a word if one restrains oneself (nothing authorizes this) from taking the step [*le pas*] of meaning. *Gl* does not belong to discourse, no more does it belong to space, and nothing certifies the past or future of such a belonging. What is suspended is not however an insignificant phoneme, the noise or shout naïvely opposed, as nature or animality, to speech. Resisting the fisher's discourse, it would represent painting in that discourse if it did not remain unrepresentable for it too: not the outburst of voice in painting, but the bursting of speech in drawing, or the patch of color in graphesis or the *trait* in color. A rebel to appeased commerce, to the regulated exchange of the two elements (lexical and pictural), close to piercing a hole in the *arthron* of discursive writing and representational painting, is this not a wild, almost unnarratable event?

Adami sticks it in near the fish's tail, not far from the articulated binding, in the lower corner of the quarter-page, at the place where the limit sags, above and below the sea. Survival movement, stay of death [*arrêt de mort*, also "death sentence"], final trance, arched leap held on the bit. Caught in the links or the angled scales of the *ichthys*, like Adami's signature, or rather his acronym, for if the letters make up a shoal of fish, a band of erections wandering at the point of death, on the other hand the dominant fish, the one that bites best and says *I* (I am dead) or *hoc est corpus meum*, takes from the sea a body of scaly writing, a literal surface, homogeneous with the signatory's initials.

As *gl* can be reduced neither to a spatial form (the glottic thrust of reading, toward an almost impossible bubble, snatches it from the surface with a single blow (*ictus*)), nor to a logogram (it's not even the former fragment of a word or the ex-tract [*extrait*] of a discourse), *Ich* splits with one blow [*d'un coup*], like the fish, both language and the picture.

I would say with a burst of music [*d'un coup de musique*] if there wasn't the risk of this word's still letting itself be arraigned in a system of analogy. With a dance then, death dance in the fish's tail, with a rhythm impressed on the tail. And by the scaly tale. *Rythmos*, as we know, has come to signify both the cadence of a writing and the undulation of the waves. Impressed here on the matricial sea—the fish-man sublimating unto death for (no)

more air—on the waves, on the wavy surface of a music beaten by the furious tail of *Ich*.

Ground or abyss of the picture: touching the bottom of the sea, a vivid, straight, native seaweed, or a shipwrecked galley, an immobile and monumental wreck, a line already "quoted" in *Glas*, here fished up from way back, in inverted commas, angles, crochets too without a stave [*des noires aussi sans portée*]. In the beginning it was the first line of a bad poem I published, aged seventeen, in a little Mediterranean review since gone under—I abandoned my only copy in an old trunk in El-Biar.

I only retain, wary of it [*Je ne garde, m'en gardant*] the memory of that first line, back of a stage [*au fond d'une scène*] where, since ever, I must have known how to put myself to death.

Glas emerges twice in it, in pieces, cut from itself, once in *glu*, within a single word, once inapparent or inaudible, detached from itself by the chasm between two words: it is read, seen written or drawn, held to silence (étang *l*ait [pond milk], entity [*étant*] become milk [*lait*] again, *étranglé* [strangled] without the *r*, etc.).

This is not in *Glas*; refer for example to page 219 [of the first French edition] and its vicinity.

The body of the word "noyée," the drowned woman [*la "noyée"*], floats between two waters, a little up from the bottom, a cord relaxed far from its anchorage in the sentence, magnified letters adrift, dilated image, flared limits through diver's goggles.

Two lines of stress work or dynamize this fishing picture (the record of a hunt), two death-drives cross in a χ, double diagonal to keep alive the whole of the invested surface, the twice two parts. One death pushes, attracts, or holds down toward the bottom right-hand corner (drowning and descending column). The other death, which is just as pitiless, sublime, raises to the opposite corner (asphyxia of the phallus extracted from the sea and ascending column). Saving from drowning by attracting the beast, alive, out of its milieu.

It is possible to describe ad infinitum the instantaneous capture [*prise*] of *Glas* by *Ich*, *Ich*'s hold [*prise*] over *Glas*. It would be total if the whole of the prey, already, did not pertain to the simulacrum. I prefer to mark why it can give rise to no illustrative representation. In neither sense. And whatever reevaluation can

be allowed such an illustration, it would be necessary, rather, to say lustration. The scene named *Ich* cannot be found in *Glas* and reproduces nothing from it. Of course it captures and draws to itself a whole piscicultural machination, rhythmed by the logic of the double band (*double bind*) or held by the so-called sheath argument. Thus, for example, as for giving name or title: "But gift of nothing, of no thing, such a gift violently appropriates, harpoons, arraigns what it seems to engender, it penetrates and paralyzes at a stroke the donee thus consecrated. By being magnified, this latter becomes to some extent the object of his namer or nicknamer," or again, "we do not comprehend here the text named as Genet's, it does not exhaust itself in the pocket I cut, sew, and bind. It is the text which pierces a hole in the pocket, harpoons it first, looks at it; but also sees it escape, carrying its arrow toward unknown neighborhoods," and, as for the necessity to elaborate under the sheath, "all that must stay under the sheath . . . there is more *jouissance* . . . in acting as if the fish remained entire, still alive, the more mobile, slippery, and fleeting for knowing itself to be threatened." And since there is the angle and the wave [*onde*], the indefatigable and worrying insistence of fingernails [*ongles*] in all Adami's drawings (except, well well, in the three congeneric *Glas* drawings; for once they are setups without hands, and nothing human appears in them as such: "juridical exhibits" and "scene of a crime," concludes Benjamin faced with the first empty streets photographed by Atget), go and read on one double page (274) the association of fish and fingernails. And then Gabrielle, Genet's mother, matrix-forename for the whole book, is a "moon-fish."

And yet *Ich* develops, without a negative, a scene which can under no circumstances be found in *Glas* or represent it on any account. At least for the following reason: *Ich* performs its own operation, the hooked, steely violence of a capture which takes possession of an unconscious (review the arms, the reel of *La meccanica*, the rows of fishhooks under the hand of *Freud in viaggio*; there is, yes, the work and the force, the incomparable skill, the aggressivity, the ruses or the desire of the fisher-analyst, and then that *X* in whose place the stroke of luck or the stroke of genius is named: the line is slack for a moment, like attention, then vibrates and suddenly [*d'un coup*] tightens, a bite. The beast also has to give up to it), makes its persecuted prey of a text, a

signature, an *Ich*, that pisciphallic trace, tracks it and trices it up outside itself, in order to show it something [*lui donner à voir*], *let it be seen* [*le laisser voir*], at last, dead, the death it can't give itself. Adami is here drawing that/what he's drawing, showing that/what he's showing while pretending to show something with his other hand, he shows what is passing or happening, forbidden to *Glas*, out of range of its signatory. *Ich* signs the absolute reverse of a text, its other scene, but also shows that it is showing, draws the gallery, the *monstration*, the *exhibition* or, if we no longer want to speak Adami's two other languages, exposes the exposition. Into the bargain [*par-dessus le marché:* literally, "over the market"]. Not above [*au-dessus*] the market, that would be the lure in which you would again let yourself be caught, but by putting into play or *en abyme* the destructive simulacra of surplus value. Without this self-exhibition (or the *Autobiografia*) reappropriating anything whatever, without its ever unveiling or equaling itself in some truth emerged from the water: sophistry, said Plato, as line fishing. In the rigor and joyous severity of the *trait*, the petrifying [*médusante*] impassivity of the line, disjunction works on any possible equality, it dislocates, dissociates, unhinges, shifts out of line, truncates, interrupts. But, on the other scene, with the other hand, the gathering force of an erotics repairs, props, joints, reconstitutes "integrity in dispersion" (Jacques Dupin). The same drive stretches and pulls to both sides. And connects directly, one onto the other, two unconsciousnesses.

The event is unnarratable but the narrative moves on [*s'enchaîne*]. Exhibit the reverse side of exhibition but without any possible resumption: this *Ich*-simulacrum shows itself again, raised to so many higher powers, in the drawn double band, the double drawing (recto/verso) around which you will attempt to go, since the support, a metallic plaque, will be placed on a base. But you'll never be able to gather it together so as to place it as the whole of a spectacle, in view. As is always the case with Adami, the artifact is also a tool, a machine, an automobile: here the wheel above the *Elegy for Young Lovers* (title quotation from Auden), the automatic water spray under the skirt, the locomotive or the reel of *La meccanica*, or even, for the machines are often arms, the catapult of *Autobiografia* or Stalin's murderous rifle. It goes or goes off almost on its own.

Drive or penetrating projection (catapult, rifle, but also the syringe of *Sequenza*), attraction, aspiring introjection (fishing weapons, the vacuum cleaner of *Scena domestica*, the syringe

Autobiografia.

again with sharpened point but disjointed from itself). The syringe is his instrument: drawing with an incisive point, penetrating the skin, sharp style/stylus removing and then, after mixing, injecting the colors, irrigating and revealing the unconscious body; it's done in music: Syrinx, panic.

On the back, the back of a picture is described, the other side of the frame, going back through the corners, the quoins, the angles. What one thinks one can read, "text" or pseudo-legend, does not occupy the center but is deported into the angle (bottom right), biting into the border, with a slight dislocation of the corner.

Elegy for Young Lovers.

On the border, on the *Margins* renamed/renowned and deleted. But announced, on this damaged [*abîmé*] frame, by a χ.

χ, the chiasmus letter, is *Chi*, in its normal transcription. This is what I call that other scene, following, if you like, the anagrammatical inversion of *Ich*, or of *Isch* (Hebrew man).

Pronounce it *qui* or *khi*, breathing out, groaning or scraping a little, with an extra *r* in your throat, almost *cri* [cry, shout]. But several languages can be tried, and all sexes (for example *she*).

χ signs this picture.

A crossing privileged by all the texts I've sold under my name and which, for the good reasons I've given, I no longer hesitate to bring to the surface, in word-bubbles or legendary bands. "We are in an unequal chiasmus. . . . According to the χ (the chiasmus) (which can always, hastily, be thought of as the thematic drawing of dissemination), the preface, as *semen*, can just as well *remain*, produce and lose itself as seminal difference, as let itself be reappropriated in the sublimity of the father"—"Hors livre" [in *Dissemination*]. "Everything passes through this chiasmus, all writing is caught in it—frequents it. The form of the chiasmus, the χ, interests me greatly, not as the symbol of the unknown but because there is here a sort of fork (the series *crossroads, quadrifurcum*, grid, grill, key, etc.) which is moreover unequal, one of its points extending its scope [*portée*] further than the other: a figure of the double gesture and the crossing we were talking about a moment ago"—*Positions.*

χ, the general intersection of *Glas*, of its beginnings or ends in twisted and spaced-out bands, also describes the demiurgic operation in the *Timaeus:* "Having thus obtained the systasis, he split it in two from one end to the other with a lengthwise slit; he fixed these two bands across one another at the center, in the form of a χ; then he plied them to make a circle of each one and joined up all the ends opposite the crossing-point. . . . He adjudged the movement of the outside circle to the nature of the Same, and that of the inside circle to the nature of the Other."

But as if to hang the thing in the exhibition gallery, holding it suspended from the top, again the clawed fishhook of *Ich*, he repeats the first letter, the X-hook of a quotation.

Cut out of *Glas*, this quotation describes in advance an escalation, the process of an outbidding speculating to infinity: Who signs? Who reads? Who looks at and de-picts the other?

One can then let oneself be caught considering that the simulacrum of a legend entitles, on the back as is sometimes done, the silent "front" of the hanging: double scale [*échelle*], double measure, and yet the same, one ladder [*échelle*] hauled above the other, as if to look over the frame, over the step [*par-dessus le cadre, par-dessus la marche*], the top step, and dominate the overview. Each ladder is a double column which glides or slides over the other. But as always with Adami, what is disarticulated, dis-

Study for a Drawing after Glas

sociated, dislocated, holds itself back, arrested at the same time as it is exhibited: the *dis-jointed* (now [*maintenant*] forms a work).

The disjointed now forms a work.

By the force of the *trait*, according to a systasis of powerful ligatures which come to bank, bind, hold [*maintenir*] the *disjecta membra* strictly. The double ladder is tightly garrotted, by cords and bands, in the complex scaffolding (pillars, columns, frames, capitals). A ladder is a scaffold, it was also a synonym of potence, one of the organizing figures of *Glas* ("What I wanted to write was POTENCE of the text." The other word, the only one to get

Study for a Drawing after Glas.

big letters and which I end up using as a title for the fable of the three drawings, was chimera: "The outlined word is perhaps CHIMERA").

All these motifs, the chimera coming halfway out of the water, the immobile ladder on the edge, the absence of any human figure, could be found gathered in *La piscina* (1966).

We know that the double ladder erected, riveted, shackled, never arrives. A series of marks ("the same word as margin and march," "The Double Session" [in *Dissemination*]) which lead nowhere, on the other side, to the deleted margins. "The staircase always leads to death: upwards and in stages, stopovers, with the support of an other. Oedipus and Christ met on a staircase." It is a question, need I repeat, of *steps* [. . .] as we have known, at least since Jacob, every time one dreams of a sexual act, it represents symbolically a climbing up or a tumbling down. "Staircases, ladders, the step on a staircase or a ladder, going up as well as coming down, are symbolic representations of the sexual act (*Traumdeutung*)"—*Glas*.

Color has not yet been named. At the moment of writing, I have not seen the color of *Chimera*. Why show drawings? What is Adami's drawing [design]? An explanation is necessary.

Before the finished quality of a production the power and insolence of whose chromatic unfurling is well known, is it that he might want to open his studio on *work in progress*, unveil the linear substratum, the intrigue under way, travail in train, the naked *trait*, the traject or stages of a "journey"? That would be a little simple.

Without too much arbitrariness, I have just piled up words in *tr:* travail in train, *trait*, traject, in-trigue. I could have said tressed, traced, trajectory, traversal, transformation, transcription, etc.

To transpose, in other words to be-tray the function or the phase of the *trait* in Adami, when he operates "by line," let *gl* drop, treat with *tr*.

La piscina (1966).

Let drawing = *tr.*

Don't read in this a formal programer for all the words which will come along, in broad bands or color washes to fill it in like color. It is not a material matrix but a system of *traits*, not a formal matrix since its content is already decided.

And yet *tr* does not remain entirely intact through all the transformations of the supposed contents or complements. The so-called whole words are different each time in their form and in their content. The treachery of this translation or transcription, the transpassing, the trance or the tragedy of *Ich*, the transpiercings, trunks, trepannings, the *tréma* or the ex-tra which interest Adami have apparently no linguistic or semantic affinity with what I say I'm doing when I try or trick on a hairbreadth, when I *tringle* (an operation which consists in "marking a straight line on wood with a stretched string rubbed with chalk which is raised in the middle and leaves a mark as it falls back onto the wood," *Littré*), when I travail, tremble or become troubled while writing, treading the floating body of a ferry crossing a river, tracking down the beast, trailing my metallic line in the water, fishing from a trawler, with a trammel net, a trellis.

But if *tr* is each time altered, transformed, displaced by what appears to complete it, it keeps a sort of self-sufficiency, not a self-identity, a proper meaning or body, but a strange and haughty independence. It does not get this from the semantic nucleus *trans* or *tra*. Neither whole nor piece, neither metaphor nor metonymy ("How to arrest the margins of a rhetoric?"). It takes, hardens, entrenches itself [*se retranche*], cutting, bony, a fishbone.

This truncated matrix is lacking nothing for affecting already [*déjà*]. For inciting to all transferences.

Something will come to accomplish it, unforeseeably, but because it was never missing from it.

And here is the paradox: because it's lacking in nothing, because its unchangeable program controls and constrains all that can come upon it, it's careful to take absolutely new itineraries each time. In its quasi-completion, each word, each sentence takes on a heterogeneous meaning, broaches a second traversal which is not however secondary, derived, servile with respect to the master *tr*: to drawing as practiced by Adami. Color is never an-

ticipated in it, it never arrives before the complete halt of the motor *trait*, but by that very fact it deploys, in broad contained bands, a force all the more unbridled for the graphic apparatus's remaining ready, calm, impassively ready for anything.

The rigor of the divide between *trait* and color becomes more trenchant, strict, severe, and jubilant as we move forward in the so-called recent period. Because the gush of color is held back, it mobilizes more violence, potentializes the double energy: first the full encircling ring, the black line, incisive, definitive, then the flood of broad chromatic scales in a wash of color.

The color then transforms the program, with a self-assurance all the more transgressive (perceptual consciousness would say "arbitrary") for leaving the law of the trait intact in its inky light. There is, to be sure, a contract: between the drawing which is no longer an outline or a sketch, and the differential apparatus of the colors. But it only binds by leaving the two agencies in their autonomy. As is said of grace, the "second navigation" of the drawing in color is a first voyage, an inaugural transference. It has, so to speak, no past, no yesterday, even though, and because, the graphic structure is finished: therefore open, *viable*.

One proof among others: *Freud in viaggio verso Londra*. What Adami calls "journey of the drawing" here complicates, in an invisible *abyme*, a drawing of a journey. There are others, follow here the *Viaggio all'est* (again the traves, the traversal, the train, like in *Casals is Coming Home to P.C.*), *La meccanica dell'avventura* (the walking shoes, the auto-mobile umbrella and locomotive, the word *film* which passes quickly, like a train, on the screen, or whose spool unwinds by itself, like the fishing reel), the cycle of *Sequenza*, the tachygraphic traject of the *Autobiografia*, Gorki's journey to Capri, the emigration of Mies Van der Rohe to Chicago, Benjamin's last exile. Transference, invasions, exile, mass migrations, nostalgia, erratic trail clearing, persecution, deportation, aggressions, regressions, Adami's drawing traverses the deflagrating museum—or the unconscious—of our time at the speed of a Transeurope Express: historico-pictorial, theoretico-political being-in-train.

In *Freud's journey*, a single drawing, once put on the rails, lends itself, without moving in itself, or almost, to a whole series of different readings, each time transformed through and through across the redistribution of the chromatic values and all the dif-

ferential versions proposed by Adami. And yet, "the drawing, here, has none of the characteristics of a foundation" (Hubert Damisch).

Thus works, in or outside language, a *tr*.

People will rush headlong toward the bait, they'll bite: here we go, another return to logocentrism, there he goes consecrating analogy, absorbing space in the voice, painting in the poem, the rheme or the philosopheme, he's structuring everything like a

La meccanica dell'avventura.

language, and worse, he's doing it according to a mimetic and hypercratylean theory of language.

Well, no. What's at stake here, on the contrary, is violence and the arbitrary. And putting forward what is unjustifiable for any consciousness, something that only holds together, as it enters effectively into relation with the events unleashed by Adami, by *having nothing to do* with them. And then *tr* represents, imitates nothing, only engraves a differential trace, therefore no longer a formless cry, it does not yet belong to the lexicon, it does not yet allow itself to be domesticated by an appeased verb, it initiates and breaches [*fraye*] an entirely different body.

So don't stop at that. Although it is not a transcendental (semantic or formal) element, *tr* gives itself up to analysis. Like any transformable conglomerate. Decompose the *tr*, vary its atoms, work substitutions or transfers, erase as Adami does when he's drawing. In a first picture, keep first of all the consonantal double, rub out the odd bar from the *t*, replace them with the traits of another consonant. For example, *f* (which is more or less the catastrophic reversal of the *t*) but, for another journey, it could be *b, c, d, g, p, v.* Keeping the same *r*, you will then, along with a variation in *fr*, have brought out a +*r effect.* Consonant plus *r.* And by drawing the +, you will have quoted along the way all Adami's crosses, especially the itinerary of the red crosses, the badges of nurses, of fantastic ambulance men marking simultaneously war and peace, undecidable neutrality in the topography of political Europe, moving around among surgical mutilations, bodies cut to pieces and restored, stumps, wooden legs, aggressive prostheses, dressed heads, bandaged members or eyes.

You could analyze this +*r* effect, like the +*l* effect in *Glas,* analyze it coldly and practically.

But you could also orchestrate it, for if we were here producing a discourse, he and I, it would be, rather, on music.

You have to play *fr* with four hands, and always, like Adami, be doing several things at once.

For example by nicknaming [*Surnommant:* "overnaming"— Trans.] the *Ritratto di Walter Benjamin.*

Once again this is the active interpretation of x-rayed fragments, the epic stenography of a European unconscious, the monumental telescoping of an enormous sequence. It is stratified but simultaneously biographical, historical, economic, technical, political, poetical, theoretical. An edgeless textuality destructures and reinscribes the metaphysical motif of the absolute referent, of the thing itself in its final instance: neither that formalist and nonfigurative scripturalism which would come to efface or deny the scene supporting it (a scene which is historical, theoretical, political, etc.), nor a "left-realism," the codified simplification or the politicist stereotype which would annul the scientific event, also squeezing out the layer of discourse, the thickness of culture, ideological efficacity.

To begin with one only of its possible partitions (for it is a montage of partitions, caesurae, limits), the *Portrait of Benjamin* puts on the "exact material scene" the theoretical corpus of the "subject." Violent, sober, and powerful quotation, in the Brechtian sense of the *gestus* broken off to suspend identification (Benjamin set great store by it): from the *Trauerspiel* and its analyses of hieroglyph or allegory, from *The Author as Producer,* etc. A quotation such as this telescopes, blocks, and reverses everything from afar. The Benjamin text becomes the legend, a dependent piece played, analyzed, interpreted by the *Portrait.*

Which, nonetheless, looks at the author.

The Work of Art in the Age of Mechanical Reproduction (1936) questions the political effects of photography and cinema. Don't forget that you have before your eyes, in a primary sense, a reproduction. It depends on a market (*par-dessus le marché* can only entitle a fictional disturbance), of a political, optical, technical apparatus. Benjamin insists on this: as soon as the technique of reproduction reaches the stage of photography, a break line and also a new front traverses the whole space of art. The presumed uniqueness of a production, the being-only-once of the exemplar, the value of authenticity is practically deconstructed. Religion, cult, ritual, the *aura,* stop hiding, in art, the political as such. As

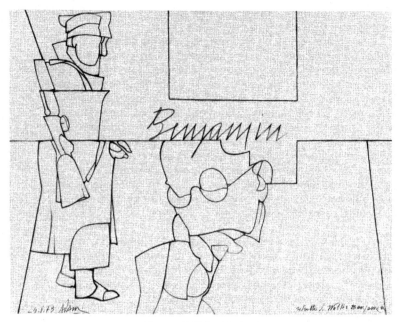

Ritratto di Walter Benjamin.

soon as one can reproduce, not only works of art which lent themselves, or so one thought, to the distinction production/ reproduction, but also others in which reproduction breaches the original structure (Adami always takes account of this effraction), "the function of art is no longer grounded in a ritual but on another praxis: it has its foundation in politics."

Although this crisis was contemporaneous with the origins of socialism (x-ray sequence in the *Ten Lessons on the Reich*— Nietzsche's typewriter, Liebknecht, Spartakusbund, etc.—but also in the portrait of Isaac Babel, Lenin's waistcoats, the battleship Potemkin, etc.), it must have begun earlier and it is far from being over. The reaction of artists often flees the negative theology of pure art in the art-for-art's-sake movement, and formalisms refuse to recognize any political role for themselves or to analyze the objective conditions of the market. In passing, Benjamin simpli- fies a little Mallarmé's role in this story. Along with all the abyssal effects that can be read in Mallarmé, the ambiguity of such a

position also marks Benjamin's text. On the one hand the theorist of the political stakes of the market in its technical and economical transformations, wary and demystifying with respect to reactionary ideologies and the fetishist ritual, Benjamin also appeared as a great aesthete, a lover of first editions which were above all not to be read, a collector of unique or rare copies; and this in the domain of literary publishing where uniqueness does not have the same value as in other arts. Painful irony of a self-portrait: "As the cultural value of the image becomes secularized, the substratum of its 'once only' (*Einmaligkeit*) is thought of in more indeterminate fashion. More and more, in the mind of the spectator, the once-only of the phenomena reigning in the cultural image is supplanted by the empirical once-only of the artist or his artistic operation. But never, of course, without remainder. The concept of authenticity (*Echtheit*) never stops tending toward something more than a simple attribution of origin (*authentischen Zuschreibung*). (The most significant example being that of the collector who always retains something of the character of the fetishist and who through the possession of the work of art participates in its ritual religious power)."

The figure of Benjamin retraces the ambiguity he declares here. He illustrates himself. On the two sides of a breakline.

The fetishist or dreamy aesthete is also a political theorist, an avant-garde militant, unassimilable on either side, rejected everywhere, with no place on the map of the European ideologies, a Marxist accused of not being the dialectician he always wanted to be, a political thinker reproached for his messianicism, his mysticism, his talmudism.

Poorly received in his country and his milieu, almost unknown in the land of exile—France first of all and still today— where he spent his life and killed himself. A critical man in a critical position, on the limits, a frontier man.

Killing oneself: the fact that his suicide (a more enigmatic sequence than is often allowed and whose dreadful simulacrum is perhaps better described in *Il gioco del suicidio*) should belong to a Franco-Spanish frontier scene should give rise not to symbolist reveries but to the analysis of an implacable historico-political apparatus.

The *Ritratto di Walter Benjamin* bears a citational, parodic title, part of the drawing, like the name *Benjamin*, written in

Adami's hand—you recognize his writing but he doesn't sign, and yet signs (who [*qui*] signs?), detaching, abandoning or remarking, in Benjamin's name, where the frontier sags (as it did under the *gl* in *Ich*), a piece of the body of his name. Apart from his writing, you identify the letters of his proper name which are sufficient for it to become available and common, *ami* [*friend*], sealing at the same stroke, by so many traits, the fraternity of the subjects. This is the body of my name (read Damisch too on this portrait, play a concerto for four names, not forgetting the tune of the forenames).

Benjamin had a theory of the portrait, which, according to him, played a transition role, on the frontier between "ritual religious art" and "technical reproducibility." The photographic representation of the face is the remainder, the last resistance of ritual. When the face begins to disappear or, as here, no longer to occupy the top or the center, the legend (*Beschriftung*) becomes necessary. "Its character is quite different from the title of a picture." *Ritratto di Walter Benjamin* is of a type as legendary as the name "Benjamin." Just about in the middle and on the subject's forehead [*front*], the name is also at the bottom of a frame. Title of one absent (picture): of one no more [*disparu*].

Disappeared [*disparu*] is the subject. What has disappeared *appears*, absent in the very place of the commemorative monument, returning to the empty place marked by his name. Art of the *cenotaph*.

Title, then, of one absent (picture): of one disappeared. Of an empty frame, like an optical apparatus, elsewhere binoculars or spectacles. They remain white in the painted picture: those of Freud or Babel too. In *Das Reich*, Liebknecht's pince-nez appears all alone, without a face, in the middle of a picture traversed by a diverted vertical line. Here by another frontier, like the Franco-Spanish frontier, above, under the gazeless vigilance of a sentry, Spanish or French, it matters little, the political force is the same on both sides. On both sides death (like in *Chimère*), on one side the German Benjamin hunted by the Nazis and repulsed by the Occupation forces (above the frontier the color will be close to gray-green), below it will be the red of a Benjamin (his head is caught in it) equally under surveillance, betrayed, repressed, like red Spain. Under his name the frontier traverses his head, strikes and cuts at forehead level.

When the "exhibition value" (*Austellungswert*) fractures the "cult value" (*Kultwert*), the latter retreats and entrenches itself

in the human face. "It is in no way by chance if the portrait is at the center of the first photograph. In the memory cult devoted to loved ones distant or dead, the cultural value of the image finds its last refuge. In the fugitive expression of a human face [here the barely human, barely living face of a refugee, a fugitive crossing the line, all lines] the first photographs make room for the *aura* for the last time." Reading Baudelaire, Benjamin had thought he could link the loss of the aura to the vacuity of the gaze. This portrait with white spectacles also exhibits the "scene of a crime" with "political significance," like the deserted streets of Atget's Paris. Juridical exhibits, *faits divers*, "route directions," "illustrated newspapers" (one picture bears this title), "the legend has become necessary for the first time, its character is quite different from the character of a picture."

Hieroglyph of a biography, of theory, of politics, allegory of the "subject"—of Benjamin in Benjamin's sense and name—a narrative fresco in a projection speeded up to the limit of instantaneity, synopsis of a film in which all the metonymic fragments, representations of words or things, hold as if in suspense an interrupted breaching force, the *gestus* of a blow seized by death. Scientific apparatus: products projected onto the film's support, band, or screen totally cathected or dynamized, the traits proceed in fits and starts, brief gaps, acute oscillations, sometimes spreading out long flat periods, the seismograph's point remaining continuously in contact with what it incises, more than sensitive and impassively objective.

Ça (quoi?) aura/marché [literally: "That (what?) will/have worked/walked": but *aura* = aura, *marché* = market—Trans.].

An underground legend is at work, a false title whose very repression would infallibly have joined the fragmentary lines, rearticulated the fragments in the linear continuum, organized the simulacra of fetishes: *Le Front Benjamin*.

I do indeed say simulacra of fetishes. The fetishism generalized by Adami turns to derision the classical logics of fetishism, the opposition of the fetishized bit and the thing itself, and God, and the original referent, and the transcendental phallus.

Benjamin's capital forehead [*front*], frontally cut by the Franco-Spanish frontier, the front of the wars which traversed him, divided him, opposed him to himself. And of which his name is

still the stake: was he, authentically, revolutionary or not, Marxist or not, dialectician or not, Jewish or not? Where did he stand with respect to what all the codes, those of the occupation too, call a line of demarcation? He crossed one, only to let himself be hit on the other.

The subject of this *Benjamin Front* will thus not have been Benjamin himself. In a sense that can be generalized, it was also the portrait of a photographic portrait all the lines of which can be recognized (it is reproduced on the cover of the English translation of *Illuminations*): the pose, the face on one side, without a full-face, the empty mounts—here twice split along an oblique line, above and below, inside and outside—the hand clasped, the fingers (again enlarged out of proportion, like those of the sentry) supporting the meditative face.

Here the historical compromise between painting and photography, the photographic portrait in the "age of mechanical reproduction," is denounced, placed *en abyme* in its reproduction, displaced because summoned to appear in an epic cycle [*une geste*] which deports referential naïveté, but this time without return.

It [*ça*] triturates, as often, photographs, but also a text, without any thing-itself border. Material thoughts, technical processes, war machines or political apparatuses, legends gorged with culture dragged along in an incessant eruption, a powerful mythographic wave draining all the strength of a revolutionary song. But no more abstraction or thing itself. For in this political cartography of Benjamin, the "passage affect" loses none of its violence, on the contrary, by happening on limits, on lines of fracture or confrontation, in places of effraction: frames and frames of frames. Here human features themselves draw only frames or mounts. And *Le Front Benjamin* never closes off again, its idiom is caught, as a differential *trait* in its turn, in a journey, the diagonal line of a fictive narration with which it exchanges or links all its fragments.

For example with *The Surrealist Map of the World* (the surrealists had erased Spain from it) and especially with *Freud's Journey* which dates from the same year, also operates from a photograph, accumulates, in the border crossing, the energy of a theoretico-political unfurling, the incredible epos of a Jewish hero,

of a revolutionary thinker that the dominant machine tried to repress, reject, sterilize. From these heroes, positive (Nietzsche, Freud, Gorki, Babel, Liebknecht, Lenin, Joyce) or negative (Bismarck, Hitler, Stalin, etc.), there is a *detailing* of extracts, fragments detachable as signatures (typewriter or red pen case, spectacles, umbrella, hat, waistcoat, chair, cigar, etc., but also helmets or rifles with telescope sights), artifacts, apparatuses for seeing, writing, killing, monumental fetishes or minuscule emblems.

Why de-tail [*dé-tailler:* cut out]? For whom [*Pour qui*].

Picking out the enlarged detail comes in any case from cinematographic and psychoanalytical technique. The two powers, the two techniques, the two situations, another of Benjamin's demonstrations, are indissociable. One and the same mutation.

Return now to the *Autobiografia* (among others, an index to the date of birth). Then to the epilogue to the *Work of Art . . .* , where Benjamin explains: if fascism "tends quite naturally to aestheticize political life," "the reply of communism is to politicize art." Legend for what I should have liked to draw here: another Adami portrait, a self-portrait

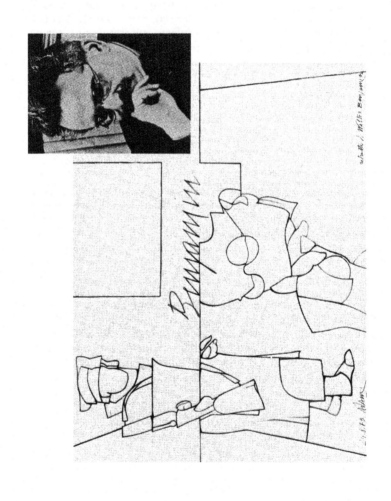

Cartouches

The first version of this chapter was published at the time of the exhibition by Gérard Titus-Carmel, *The Pocket Size Tlingit Coffin and the 61 Ensuing Drawings*, at the National Museum of Modern Art, Pompidou Center (1 March – 10 April 1978). The 127 "coffins" and their "model" were then reproduced in a catalog entitled *Gérard Titus-Carmel: The Pocket Size Tlingit Coffin*, which included *Cartouches* by Jacques Derrida.

30 November 1977
—and so for the rest,[1] without precedent.

2 December 1977
If I now write IT WILL HAVE REMAINED WITHOUT EXAMPLE, they will not read.

They will immediately turn aside, thinking that I'm giving in to the genre of traditional eloquence and, for once, to the code of the encomium: a funeral oration, the palls of idealization, the pomp of the future anterior above the mute coffin, both hermetic and transparent. Everything is indeed visible in it, shop-windowed under the plate of altuglass (what a word), accessible through all its surfaces, and yet closed, crypted, nailed, screwed down: impenetrable.

Scarcely reading at all, they will wonder what I'm talking about.

About this, about *this* singular, closed (impassive, taciturn, stubborn, *wooden*) "*coffin,*" in the absolute solitude of its princely title? But in that case, am I talking about the word or the thing?

1. "Cartouches," like *Glas,* plays persistently with the word and notion *reste(s):* the rest, the remainder, remains; and the verb *rester:* to stay, remain. Expressions involving the sequence *du reste,* as here (literally "of the rest/remainder"), also introduce the idiomatic expression *du reste:* "besides" or "moreover." We have tended to use "remainder" for the singular *reste* and "remains" for the plural *restes,* and to translate *du reste* literally or idiomatically according to immediate context.—TRANS.

Titus-Carmel designates the thing with a singular (definite article) which he calls "generic"("Under the generic title of *The Pocket Size Tlingit Coffin* are gathered quite a large number of drawings . . .").

Am I talking about the word or the thing? Or about *the rest* [the remains, *du reste*]? But then what? What remains? The remains to which a burial is supposed to give rise? Or the remainder of the series, the 127 coffins which the *incipit* of the little *princeps* coffin is thought to have engendered? Engendered or allowed to degenerate, depending on the case in question, with an air of family resemblance which removes none of them from itself, from the absolute secret, from this definitive detachment which isolates it and ab-solves it outside the series.

For they are all, and each, alone, unique, irreplacable: *The Coffin*, it, the other.

In any case, they defy repetition *in series*.

Whence my discouragement, today: I can only speak generally about them, or at best generically or genetically. I miss them [*je les manque*]. I miss them [*Ils me manquent*] too; where does this feeling come from, already? *It* must not be forgotten, *not one* must be forgotten (*not one*) [*pas un seul*] if one wants to see or touch something of this group in which a genealogy or even a reproduction is feigned.

Not forget a single one and let each one remain alone, if at least those not yet reading me want to follow this theory of coffins, the obsequence of this cortege in singular lineage, the series without model whose procession in a double band, on this wall, still fascinates them too much for them to listen to me saying IT WILL HAVE REMAINED WITHOUT EXAMPLE.

3 December 1977

Not one.

Why did the metaphor of family or genealogy force itself upon me yesterday? For I know that it lacks pertinence, and the word reproduction too. But I am also sure that the limit of this pertinence—the place where it no longer *touches*—is indeed also what is taking place here, what is happening, what he has set in place.

I reread. The word "altuglass" which he used himself. In decomposition: transparent mirror [*glace*], the cold of death, the passing bell [*le glas*], the ancestor in his foreign language, murder, the artificial or the synthetic (neither nature nor life, burial), all

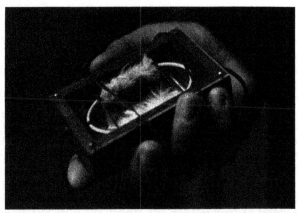

Photograph of the "real" "model" in the hand of the "author" who writes: "Under the generic title of *The Pocket Size Tlingit Coffin* are gathered quite a large number of drawings (one hundred and twenty-seven precisely) dealing with the same model: a mahogany box of modest dimensions (10 x 6.2 x 2.4 cm.). Care was taken in constructing this box: choice of wood, of color, of the different arrangements of grain, of the assembly (dovetails), proportions (golden number), etc. The bottom of the box is covered with a mirror, and two buttresses were placed (one at each end), to serve as rests for an oval piece of cane, wrapped along two portions of its perimeter with synthetic grey fur. The oval is, furthermore, held by a lacing whose bonds, penetrating the walls of the box at six places, then knotted around keys of a sort, fall freely all around this little coffin in island wood. The whole is closed by a thin pane of altuglass, fixed by four tiny brass screws." *The Pocket Size Tlingit Coffin (or: Of Lassitude Considered as a Surgical Instrument)*. Baudoin Lebon-SMI Paris, 1976.

the potencies of the syllable "tu" [you (thou), silent, killed]. I must give up this type of interminable analysis.

They're wondering how I could write that a coffin will have "engendered." The father's coffin? The coffin (in his foreign language) *as* father? The casket (sez Freud in *The Theme of the Three Caskets*—we'll have to come back to this) as female, or even maternal, belly. I will have to give up this type of interminable analysis.

The "without example" which forced itself upon me yesterday. And the not [*pas*] of the not-a-single-one. Difficult to make it heard, but I shan't insist. Don't deliver them from fascination just when they're falling into the abyss of the infinite—yet nil—

distance, the outsize space which separates the little *princeps* coffin from a whole resembling lineage, from a whole supposed descendance it does not recognize.

It must not be recognized.

It, entirely other, in relief, scale model retaining in reduction all its reliefs—*it does not belong to the lineage of which it immediately [derechef] forms part.* It remains itself (to itself), heterogeneous, immobile and indifferent, impassive and stubborn on a base, a stela, a throne or, still up to it, he the royal dwarf, on the rostrum of his catafalque. He risks his head on this hallucinatory scaffolding, he is exposed to height, smaller than the smallest of all but immensely grown, out of proportion, in his raised-up retrenchment. And yet fallen, destitute, neglected debris, *banished*, excluded from a family (tribe, people, *genos*) with which he no longer has any relationship. To tell the truth he will never have had any relationship with it, even though, in secret, in an immemorial time, a past which never was present, he will, presumptively, have engendered that family. If I am writing for the dumbstruck "spectators" whom this concerns [*que ça regarde*], I must not free them from fascination by my discourse. For I mean that discourse not to meddle with anything (the thing you're looking at is not my business or that of my discourse which it can very well do without), I mean it not to *touch* anything. It must, I would say to them, leave you alone with the thing that concerns you [*qui vous regarde*], leave it alone with you, remain silent when all is said and done [*au bout du compte*], pass to one side of it in silence, like another theory, another series, say nothing of what it represents for me, nor even for him.

And at the same stroke [*du même coup*] leave it, it, the thing, to the nameless crypt of its mutism.

It knows, and knows (how) to keep quiet.

4 December 1977

It will have been necessary to get down to it [*s'y mettre*].

Necessary for him first. For me following him. Order of sequences (consequences and obsequences of the series).

Get down to it: that means, first [*d'abord*] to accost [*aborder*], to begin, to undertake. And if it is *without example*, this is because the series will have *posed* a singular problem of *initiality*. I shall come to the initials later. Who began? When? How? At such and such a date, when THE little mahogany object was conceived and brought to light, constructed solidly, permanently?

Or else when it began to pester, or rather to *dog* him [*s'acharner sur lui*] (I prefer this word because of the reference to the trap, the hunt, the bait which gives dogs and birds of prey the taste of flesh), from 23 June 1975, from the first of the 127?

The 127 what?

He says "drawings," a "large number of drawings," but they are not solely drawings; there are watercolors, gouaches, engravings, and the set, including *the princeps, the coffin* itself, what is it a set of? What does set mean here?

For convenience I shall say the 127 *articles*. That remains sufficiently indeterminate, it will already have been sold on a certain *market*, it forms part of an *articulated* set, insists on the *articulations*, and reproduces singularly, each time inimitably, the (generic) *definite article* which seals the unicity of a prince (each time *the coffin*, the same and the other), it designates the *"part (numbered or not) which forms a division of a legal, juridical, religious, literary text"* (Robert), all of that inscribing itself at the *article of death.*

What then of the first article? I think that this *question of principle*, as to the *right of the prince*, is much more complicated, for him and for me following him. This is what for the moment I shall be content to suggest when I say "it will have remained without example," or "without precedent."

It is not something which will have remained without, etc. It is the remainder itself, in its structure as remainder, which will have been—this is moreover [*du reste*] quite odd—*without* (without example or without precedent).

It will have been necessary to get down to it. *I get down to it*, will they know how to hear this [*l'entendre*], this is what he says too, articulating well.

Get down to it [*s'y mettre*]: not only begin, undertake a piece of work, get working or commit oneself, give some commitment [*donner du gage*; also: a token, wages, a guarantee, proof, evidence, a wager], but also *put oneself in*, spread oneself out, lie down with slow gestures, sometimes impatient or discouraged, exalted or depressed, 127 times, plus one or without the other, in a coffin which one has built for oneself, or for the other, each time [*à chaque coup*] for the first and last time, at the article of death but without excluding another time, always the first and the last.

4 December 1977

Why did I say "prince" when I designated the principial article, the "first" coffin, the presumptive *incipit?* So as not to say father, king, or emperor. In this prince, I foresee already something of the heir, the offspring or the child, and perhaps of the stillborn child. I shall no doubt have to come back to this.

It's quite certain that I would not have agreed to produce a discourse above, to one side of or below these coffins without admitting my desire to put myself in them [*de m'y mettre*] in my turn, irrepressibly, compulsively, 127 times at least, to inscribe *my name on the cartouche*.

For the moment I'm interested in the masculine: *un cartouche*.

The cartouche sometimes has the relief of a sculpture, with scrolls (there is no cartouche in general without a card and a scroll) bearing inscriptions. They are sometimes the lines [*traits*] of a drawing around an official document (I'm thinking of a death certificate [*un acte de décès*]).

Littré suggests that *cartouche* is also the name of a sort of elliptical ring which, in hieroglyphic inscriptions, surrounds the proper names of gods and kings. The ellipsis of a ring would in that case name the alliance committing a genealogy in a proper name: something like a letter patent of nobility, a secret seal, a place of exile on the map [*carte*] (*cartuccio*), on a card [*carte*] played, given out to chance or to necessity, the encrypted geography of an *imperium*, another family, another tribe, very familiar and very foreign.

And yet I must not attempt to appropriate this series of *cenotaphs*.

The word would seem necessary if these funerary caskets were absolutely empty. A cenotaph is an empty tomb (*kenostaphos, kenotaphion*) for the departed body of one departed [*le corps disparu d'un disparu*], departed or stolen, pocketed by some experienced pickpocket picking his moment [*empoché à l'occasion—et à la tire—par quelque pickpocket exercé*].

Departed is the subject.

But the caskets are only empty—even after exhaustion—of the body proper [*le corps propre*]. Other reliefs, relics, leftovers remain in them: for example a ring I shall say some more about, some threads [*fils*] gathered around an empty place (a "focus" [*foyer*], he calls it) and above all this mirror right at the bottom. It is there for all speculations, all representations: the scene will begin by repeating itself [*se répéter;* also "to rehearse itself"]. You

need only lean over to put yourself in [*pour vous y mettre*], in pieces or entire, to hold on no longer to any of the edges and to fall in, see, as spectator or speculator, to the other side. I shall not attempt to steal, not even for the space of a signature on the cartouche, the lineage of these funerary marks.

I shall not speculate, let that be very clear forever. The little ligneous object does not belong to me. No more than all its apparent descendance cut off from it, no more than this derivation adrift [*cette dérivation en dérive*]. They are not mine. It's a family affair: they are his. To each his own.

And yet it's difficult to resist obsidional invasion [*investissement*]. There I am, like them now, like him, obsessed, besieged, *ça me regarde* from all sides, *ça me regarde* in all senses and from the bottom of the mirror, like a death already happened to me. Multiple and interminable, yet only one. What can one desire of a coffin if not to have it for one's own, to steal it, to put oneself inside and see oneself in it, lie or give birth in it [*y coucher ou accoucher*], preferably with the other, this being another way of neutralizing it, of calming one's own terror, of dealing with alterity, of thus wearing down alterity [*d'en user avec l'altérité, d'en user l'altérité*]? But what can one desire of a coffin except that it remain where it is, at a distance, to one side [*à l'écart*]— reproducing the *écart*, insisting to exhaustion—except that it remain the other's? The two desires are not contradictory, nor are the two gestures thus induced. They are always negotiating kenosis, they deal with each other for the dead man.

Without example, one has to get into it. One hundred and twenty-seven times, *with* and *without* the supplementary time about which you will never be able to decide—that's death—if it will have been the right one.

What is one time, this right time?

<div align="right">6 December 1977</div>

The day before yesterday, I wrote *à la tire.*

I was thinking of the pickpocket who practices stealing a coffin or a dead man from the other's pocket.

But the word *tirer* [to pull, to draw] could henceforth attract [*attirer*] to itself, in an ultimately impossible gathering, in an ill-closing glossary, all the features [*traits*] of this scene. The object is pulled [*se tire*] like a drawer [*tiroir*], it looks like a drawer one

would draw to oneself, as at the morgue, in order to recognize a still-anonymous corpse; this is the definition of the morgue or the medico-legal institute: "a place where the corpses of unknown persons are exhibited."

The other day I went with Titus-Carmel to see the 127 *drawings* at the institute called Beaubourg, the current holder of the 128 articles (in this case the holder occupies more than one place at once: those of owner, of powerful purchaser, of legatee, of simple depository, of the banker or solicitor appointed to guard, before opening, the will he will in any case have to manage, with utmost jealousy).

From the metallic cabinet, the large strongbox where they were laid, arranged one above the other, we *drew*, precisely, enormous black cardboard boxes shaped like drawers. They contained the *drawings*, the 127 drawings in the form of *drawers*. The thick black parallelepipeds were closed onto the drawings by black laces or ribbons. We untied them in order to draw out, one by one, the coffins which themselves, exhibiting their cords, etc. We talked about the morgue, and about the morgue in the morgue.

The glossary or array I'm dealing with at the moment (*tire, tirer, tiroir, tirage* [draw, to draw, drawer, drawing]) leads to that of the *trait*, it induces, precisely, *duction*, and even the *"ductus,"* the idiomatic *trait* by which one recognizes a draftsman even before he signs his name (it is this "ductus" I won't manage to talk about here). One draws a line [*trait*]: on the remains whose coffin one draws 127 times, then on the series one decides to "finish off." One draws out a coffin, for example in order to subtract it from the series. One draws (it) to oneself, on oneself. One draws drafts [*traites*] on a coffin. One draws out cartouches [*On tire des cartouches*; also "one fires cartridges"].

The question always returns, what is the attraction or the seduction of a drawer? Or of a coffin with drawers? What do you pull yourself out of in this way? [*De quoi se tire-t-on ainsi?*] I give up on all the drawings [*tirages*], on the market or the speculation retailing [*sous-traitant*] the luxury of offprints [*tirés-à-part*], on all the sealed contracts, but I wonder what's going on here. Seduce the haunting of a cenotaph, attract it to one side [*l'attirer à l'écart*], insist on the *écart*, lead the dead astray 127 times, give the sales patter and draw it aside 127 times [127 *fois faire l'article et le tirer à part*]. Withdrawing after the subtraction of a coffin: from

the other, from the series but only to put it back again as if nothing had happened, etc.

Coming back [*revenant*; also "ghost"]—127 times. I'm beginning to speculate on what of the remains is being put into figures [*chiffré*] in this way. For the moment, this figure—127—*says* nothing to me. T.-C. says nothing about it, he talks of wear [*usure*], erosion, etc. *Tirer*: to draw lots, to draw cards, to draw to one's end, etc.

There is an idiom—or rather an idiomatic effect—of the *tirer*. I understand it in two senses: the idiom of the line drawn but also the idiom of the word *tirer* and of all the ways it is treated in the language.

Later, elsewhere, draw all this discourse on lines drawn, draw it across toward where the two "families" cross—that of *Riss* (*Aufriss*, the broaching, *Umriss*, the contour, the frame, the sketch, *Grundriss*, the plan, the précis, etc.) and that of *Zug*, of *Ziehen*, *Entziehen*, *Gezüge* (*trait*, to draw, to attract, to withdraw [*tirer*, *attirer*, *retirer*], the contract gathering all the features [*traits*]: "Der Riss ist das einheitliche Gezüge von Aufriss und Grundriss, Durch—und Umriss"—Heidegger, *The Origin of the Work of Art*).

Later, elsewhere, go to the place where the crossing of these two "families," from *The Origin of the Work of Art* to *Unterwegs zur Sprache*, interlaces its necessity, that of difference, with the motif, precisely, of interlacing (*Geflecht*). How are these two families of idioms crossed with each other, etc.? And so on. And otherwise. The otherwise of the "and so on" then becomes my theme.

I will have been attracted, or rather seduced, by the word *ductus*, by the necessity of its meaning, of course, since *ductus* signifies the idiomatic *trait* of the draftsman coming along to sign all by itself, before even the undersigning of the proper name. The *ductus* makes a signature, or is as good as a signature, so they say. But I will also have been fascinated, close to Titus, by the affinity of the final syllables. They sign.

What, finally, *gives* Titus's signature? What does it give? Is there (*gibt es?*) some signature?

7 December 1977

I am not going to look for a precedent for this serial theory

of the 127 pocket coffins (I'm still naming it in French and in an approximate way). According to me, it remains, in a very singular sense, without example. It deals with [*traite*] the *without-example* according to the very structure—instructed by it—of a different relationship with the exemplar(y), the principial model, with what I shall prefer to call the *paradigm*.

Backwards, after the event [*après coup*] and in its own way, it *ejects* the paradigm.

Not that it loses it, annuls it, or gets rid of it purely and simply. That which it expels, discounts, or defalcates, it also keeps in its own way, and exhibits the remains of it, it *raises it up* onto this pedestal, the stela, throne, or rostrum of its catafalque (*ex cathedra*, once it has climbed up into the pulpit it keeps silent).

I call "paradigm" the "princeps" coffin, the little mahogany drawer or trap, this volume whose solid relief seems for the moment to be more "real" than the 127 drawings. These *seem* to "copy" a model (he himself writes the word "copy" in quotation marks in a "cartouche" on the *coffin* which I shall talk about later). They *seem* to follow on from it (consequence, obsequence) in order to lay it out flat and in perspective, thereby [*du coup*] losing relief, and making reference to it. Only this paradigm seems to have a name, a singular and therefore proper name, if that name were not also "generic": *The Pocket Size Tlingit Coffin*. It even seems to give its name—one is tempted to say its patronymic— to a reproductive lineage, lend its name, rather, cede it as a legacy, *on a reciprocal basis* [*à titre de revanche*].

But if the paradigm appears to be at the origin of a genealogy, the scandal of usurpation will not delay and the paradigm will have to withdraw (retreat, exile, retirement). The paradigm was not at the origin, it is itself neither producer nor generator. It is a *fac-simile* of a model, will first have been *produced*—and even, in all the senses of this word, as model, *reduced*. According to the undemonstrable, improbable, and inimitable *ductus* of Titus-Carmel, it is, then, indeed a matter of *duction* in series: neither induction, nor production, nor reproduction, nor reduction exhaust it with their modalities, nor even seduction which leads it astray [*le conduit à l'écart*].

The little *princeps* coffin is not *given*, that's the least one can say; it is not there, a prior given, belonging to a sort of nature, native and autochthonous, as are, most often, "models," "examples," "referents." The little mahogany coffin is itself a "prod-

uct." It has no absolute privilege with respect to a series of pro-
ductions or reproductions.

That's why I prefer to call it "paradigm."

The Greek word is right here. Most often it designates the
sort of artificial model which already proceeds from a *technē*. The
model, the example, is, then, an *artifact*, a referent constructed,
sometimes wholesale, instructed, a fabricated structure. This is
the case here. There will have been, in the past anterior and as if
at the *fac-simile* origin of that future anterior, "*production* of a
model" which would not have been found, any more than would
any sepulchre, already there, in nature. Nor even in any *given
society*. But I will constantly have to complicate these formulas,
these discursive models, I shall abandon them along the way like
the waste products of an insufficient consumption, the leftovers
of a supper interrupted in full enjoyment by an entombment, after
declarations which have nothing in common with the thing itself:
this is my body, this is my name. No word will have been ductile
enough, especially not the words "production," "reproduction,"
"seduction," "reduction." Duction is no longer sufficient for it.

And yet the paradigm, the little, solid, imperturbable, wooden
object, made to stand up to time [*temps;* also "weather"] and all
assaults, to tolerate in silence all manipulations, to exceed all
perspectives and all anamorphoses, to repel attacks from all sides
[*bords*] (for Titus-Carmel interferes with everything, he attacks
from all sides), to keep secret the priceless, unapproachable [*in-
abordable*], unfindable relief, the little paradigmatic coffin will
have been there, *as if* since always, *posed* (a theme, then, a thesis),
exposed, deposed then "reproduced" (but we must also say *with-
drawn*, to one side, subtracted, in the shelter of its withdrawal)
127 times offprinted on a fragile support, a paper vulnerable to
the strokes [*traits*] themselves, 127 times multiplied, described,
serialized, analyzed, detailed, displaced, turned about in all its
states (or almost) and from all its angles (or almost).

The little one (paradigm) will have been built like a crypt, so
as jealously to keep its secret at the moment of greatest exhibition.
Jealously, because everything here has, it seems to me, to do with
envy and excess *zeal*. For if it is offered to all contacts, to all
touches, at least before its purchase by a Center acting here on
authority, a national funeral company [*entreprise de Pompes Fu-
nèbres nationales*] for funerals of the same name, it remains ob-
stinately and, as they say, hermetically closed, recalling those

little portable temples the Greeks called *hermes*. It is mute, *closed* beneath its altuglassed transparency.

Private domain, capable of driving the attendant voyeur mad with jealousy, through these regular, more or less straight, lines—

Seduce the dead man, attract him to one side [*à l'écart*] (lure, hounding), lead him astray, make him lose the ghost's trail, make him come back a hundredfold, and more. *Except* (save [fors]) in that casket.

Lock oneself up with the whole family of the *paradigm*. *Paradeiknymi:* to show *to one side,* to place opposite, whence to compare (immediately, then, the idea of an analogical series), to show, to exhibit, to assign, to distribute, to attribute (the idea of *tribute* here seems to me to be indispensable).

The other operation in the same family, the other verb, would not be without its use if I had to write in Greek on this coffin; *paradeigmatizō:* to propose as a model or to give as an example, but also to make an example of, to condemn, to blame, to cover with infamy, to hound someone so as to dishonor him. Paradigmatism (*paradeigmatismos*) is an infamous punishment destined to make an example. Perhaps, in the (hi)story of the coffin, it's a question of a *condemned example* (one also says lead-sealed [*plombé, sous scellés*]), not of a sentencing with a view to making an example, or of an example of sentencing, but of an (exemplary) sentencing *of the example*: damned paradigm. To death! Or sentenced, at any rate, it's more tortuous (because the sentence can revert as the ghost can return [*la condamnation peut, comme le revenant, faire retour*]), sentenced to banishment. "Close the lists" [*"fermez le ban"*], he says.

They will notice that I like the word *paradigm*. It's the measure of my love, yes, it's the word that's needed, for the coffin, the word and the thing. The measure of all I *invest* in it: this last word is now too worn on all sides [*trop usé maintenant sur tous les bords;* also, possibly, "too much used on all sides"], but is in this case irreplaceable. The measure of what I invest of it, rather, after repeated assaults, the attacking waves whose siege it will have withstood, from capital, from interest as from usury, from all the investments of the other, to which it will have given rise and for which it will have called. I'm trying to get my bearings in all this. The word paradigm (in black and white [*en toutes lettres*]) is a nice proper [or clean] name with which to say the

thing in question, it is its measure for all sorts of reasons which accumulate in surplus value, but I'll only say one or two.

Thus, for example, the artifact does not expose itself only to sight. For the Greeks, it is not only the visible model of a painter or a draftsman, of a *zoographer* taking his inspiration, then, from a *constituted* example or even from a constitution (system, systasis, syntax) when the metaphor becomes political. Plato speaks of a state which will know happiness only if the constitutional "diagram" for it has been traced by "zoographers" working with their eyes fixed on the "divine paradigm."

But most often, then, a paradigm offers itself not only to sight, pre-posed like a precedent laid out flat, like a prior plan for the zoographer. It occupies a volume, it puts itself forward as a structure of reliefs belonging to the space of manipulatory construction, as the *model* of a building or of a monument, of a device or a machine, a boat for example. (The coffin is also a *floating* remainder, a hull or the coffer of a pirate adrift. T.-C speaks of it as a "wreck.") In short, a body not easily laid out flat and which one can try at most to move around, even though, for this very reason, you never get quite round it: the sketches do not exhaust it, they exhaust themselves in the mark [*à la tache*; cf. *la tâche*, the task] (*macchietta*) and must one day come to an end, one specific day, for reasons of fatigue, wear [*usure*], good or bad luck.

Now here the "initial" coffin, the coffin no. o (hello, it includes the form of the o at its heart, the oval between mirror and altuglass) or no. *1*, or − *1*, as you wish, this un(de)cipherable member of the series has indeed a voluminous, architectural, or sculptural status, even before being placed on high so as to be *dropped* [*mis bas*]: fallen, laid on a surface, given birth to on a support, delivered, or all that at once.

It is also itself which, before being dropped, seems to give birth, like a generator or a genitrix, the question remains open, to an improbable progeny, to an incalculable descendance.

They will be wondering how a coffin can give birth [*mettre bas*]. I shall try to explain. But also, how would it not do so?

The coffin no. o (1 or − 1) has not only this status as architecture or as sculpture, it *is*, laid out on its back like a recumbent statue on a tomb—here lies the *Tlingit Coffin*—a princely statue. We shall see its back, I think, only in the last drawing (11 July 1976), at the moment of the last turning, the 127th finally making up the (black) picture [*tableau (noir)*; also "blackboard"], a dark picture and shady affair of its underside. The back faces, like a

deathmask, hair falling vertically, empty eyelets (but it's still too early to talk about them). Its stature will indeed have been a paradigm in this sense, for architects, sculptors, obstetricians if you prefer, rather than a model for zoographers. It is not a zoographer's model because the model has been, in a sense which will have to be made more precise, *subtracted* [*soustrait*], but first of all because there is no longer a zoographer.

In effect: before the overturning of the paradigm, the o coffin is raised, lifted up [*monté, surélevé*] to the height of a sublime mount (we'll soon have to rise to the assault after having laid siege) and artfully arranged. The assembly [*montage*] is meticulous, like that of a watch—prepared for a delayed explosion or for the exhibition of all the internal cogs in the transparent case. The assembler [*monteur*]—author of seven *Démontages*—says somewhere that he has a "Swiss watch" side to him.

Now in the operation which raises only in order to drop [*mettre bas*], Titus-Carmel (just now I hear his name like that of an invader, the emperor come from the plebs who with one or several blows—coups d'état—overturns, destitutes, interrupts a royal genealogy in order to found another dynasty and instigate a new political age), Titus-Carmel does not calculate like a painter or a zoographic draftsman. He also behaves like a *thanatographer*. With respect to the paradigm, precisely. He is not content with dealing with [*traiter de*] sepulcher, dead man, and remains, and, to this end, with joining on their paradigm. No, it is the paradigm which he does down, and to death. His paradigm does not show a coffin, it shows itself in *its* coffin, last dwelling *of the* paradigm finally laid in earth.

Titus-Carmel cadaverizes the paradigm. Hounding its effigy, feigning the feigning of it in a series of simulated reproductions, he reduces it, he transforms it into a tiny piece of waste, *outside the series in the series*, and henceforth no longer in use.

He does without it ((*no*) more paradigm, (*no*) more coffin, one more or less), he puts an end to it.

He works, at mourning, without example and without precedent. He learns to go without [*se passer*].

8 December 1977
I give up. Discouragement. I'll never get to the end of it, I'll never be quits. I'll have to start again after treating as residues, more than once, all the words I've just used, I shall have to use

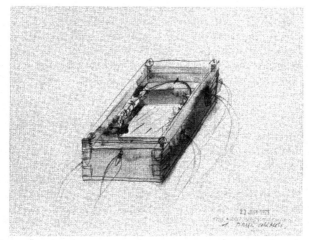

23 June 1975

The "first" and the "last" of the 127 drawings.

11 July 1976

a lot of them, consume them, gnaw them to the bone or wear them threadbare, put them back into perspective, turn them round in all directions through a series of deviations, variations, modulations, anamorphoses. And then stop at a given moment (twenty pages more or less), in an apparently arbitrary fashion, as he did at the end of the year, more or less, in the mode of contingency.

8 December 1977
Contingency: that's the word *which was looking for me.*
For it's a matter here of the *contingent*, of what touches on touch, on the tangible, on what touches, like perceiving things or collecting money [*comme on perçoit (des choses ou de l'argent)*], like manipulating on bare skin, setting up false contacts [*manigance(r) le faux-contact*], establishing the ploy [*manège*] of more or less discrete contiguities, in series; but a matter too of the contingent which is *attributed* (as an *adjective*) to the effects of chance or luck, the epithet of the uncalculable term [*échéance*], the use of the nonnecessary become fatal; and, finally, of the contingent, the *noun* this time: the rationed multiplicity of a serial set distributed, attributed (again), as a share, to the rightful receiver.

How to give a reason for this ration, the 127 for example?

The contingent is an attribute. We shall say the contingent of the 127 articles, as one says a contingent of arms, of soldiers, of provisions or medicaments in time of war (using the necessary). I shall therefore use the word *contingent*. Moreover, as I've failed in advance to account for [*rendre raison de*] the thing itself, for the idiom and this irreducible *ductus*, as I have accepted in advance to leave the coffin to look after itself, which it does better than anyone, I shall have been content to use a few words, to propose their usefulness or economic formality to others; the words *cartouche*, for example, *paradigm, article, duction, contingent*, and quite a few more, themselves aleatory *and* inevitable, which will form in their turn a parallel series, the fatality of a new idiom.

So we have to get back down to it and start afresh from this contingented term [*échéance*]. It will have remained without example; there's a ruse in which I have a premonition of some *blackguardly* [*scélérat*] stratagem.

I take this penultimate word in its Sadian register.

8/9 December 1977

Perhaps one day people will say, in legendary or mythical mode, "The 127 coffins of Titus-Carmel" (although there's only one of them, never forget it, *unique of its kind*) *like* they say, *for example*, "The 120 Days of Sodom or the School of Libertinage." The analogy, like the putting into series of series, can and must remain accidental. It belongs to the order of the contingent. It appeals neither to the model nor to the example—singularly that of Sade for Titus-Carmel, on opposite sides of several revolutions, republics, or empires.

And yet, if I have allowed myself to make this connection, this is because the trivial analogy (the contingent of the 120, with or without an extra week) carries another analogy, which touches on the heart of the matter: both contingents stage a work and a *jouissance with respect to the remainder. They put on stage, theater and theory, the rationing of the remainder.*

Disseminal remainder, perhaps, 120 and a few more jets or projects, but excremental after all.

The "first" project, the principal coffin, guardian of the remains, will become again, at the process's term, at the procession's end, the monumental waste product of the series.

Which it is already, at the articulation of each article.

To take on the waste product, such had been the contract by which Titus-Carmel had dealings with himself. He had decided to keep all the year's "drawings," even the least good. At the anniversary's turn, having reached the 127th version, he had, however, destroyed two of them, to which I shall return later, still saving the odd number or the prime.

To take on anal excretion, swallow it or have it swallowed, to reckon on its enjoyment [*jouissance*], such was the rhythmic operation, the regular cadence of the 120 Days. Each experimentation is meticulously noted, narrated, dated, and scrupulously accounted for. Arithmetic compulsion and (ac)countable narration are part of the fun, they procure a supplement of *jouissance* and leave writing no respite. Store must be set by excretion (oral or anal), it has to be taken into or onto oneself at the (secret) moment of its separation, and interiorized.

But the introjection of the piece [*morceau*], *in other words of the bit* [*mors*], is interminable, it always ends up by letting drop an absolutely heterogeneous remainder of incorporation.

Infinite analysis of mourning, between introjection and incorporation.

The bit is thus cut from its place of production or so-called originary reproduction, from its orifice, from its exit or its pit [*fosse;* also "grave"]. It comes out of its pit, follow it, follow this last word. Follow the word *fosse,* but follow too the word *mors.* When I said, "*of the piece, in other words of the bit,*" I was stressing the *words* as much as the *thing.* The bit is the piece in the mouth, whether or not it speaks there, whether it chats there [*y cause*] or forbids it [*qu'il y cause ou l'interdise;* also, "interdicts it"]. The reduction of the remainder, of that remainder, remains impossible; I'll tell how it resists. I'll report it so as to do justice to what requires narration in this contingent without precedent. For as soon as it touches on the series (127 *without one* [Eng.], outside the series in the series), one can no longer economize on narrative. If one has to get down to it and get back to it and lay it on thick [*s'y mettre et s'y remettre et en remettre*], this is because it's never done in one go [*ça ne se fait jamais d'un coup*]. By making an example of the *without-example,* he has shown in this exhibition that however much one multiplies [*il a montré . . . qu'on a beau, vraiment beau*] approaches, assaults, attacks, however much one multiples movements of appropriation, seduces the thing, tames it, domesticates it, tires it with one's advances, it remains, as remainder (really beautiful [*vraiment beau*]), indifferent, *cut off* from the world, from production as from reproduction.

(But we'll reconsider this *cut,* things always get complicated when the structure of a serial interlace [*entrelacs*] comes into play.)

Cut, for the moment, in other words truncated, *entirely* truncated. In short, a *turd,* in a series, in a rationed contingent, a piece, a bit [*mors*] cut (from *stronzare* or from *strunzen*) and well formed, a "solid and well-formed [piece of] fecal matter," says Littré, who adds for our benefit since we'll be taking interest again in the scrolls known as cartouches: "little cone which children make from gunpowder dampened and made into a paste, and which they light at the summit."

The *armament,* then, in this contingent of a funereal parade, in this expedition, that's what remains to be seen: fire. The *armament,* what words—

9 December 1977
A turd one would like to make one's own [s'approprier], without ever managing to do so, which one would like to take back into oneself *until* the end, *until* exhaustion.

The *until* (death ensues) is interminable, the termination of the analysis is apparently contingent.

Let them read for example the *until* at this point of the 120 Days.

I take it deliberately from the Twentieth Day. It's the end, we're about to overflow [*déborder*] into the twenty-first and it's a question of a "secret," of the "other secret" held under the tracing paper, the veil, or the shroud. ("As these gentlemen did not explain themselves further, we have been unable to find out what they meant. And, even if we were to know it, I think we should do well, out of modesty, to keep it under the veil, for there are very many things which must only be pointed to. . . . It would be to reveal secrets which must be buried for the happiness of humanity; to undertake the general corruption of mores, and precipitate one's brothers in Jesus Christ into all the deviations [*écarts*] such portraits could inspire.") And here is the dripping cascade of the untils in la Duclos's "Five Narratives":

Another had his buttocks, balls, and cock pricked with
a large cobbler's awl, and this with more or less the
same ceremonies, that is, until he had eaten a turd
which I presented to him in a chamber pot, without his
wishing to know whose turd it was.
 One cannot imagine, gentlemen, to what point men
carry their madness in the fire of their imagination. Did
I not see one who, still within the same principles,
would demand that I thrash him heartily on the
buttocks with a cane, until he had eaten the turd he
would have drawn before him from the very bottom of
the place's cesspit [*fosse*]? And his perfidious discharge
would spurt into my mouth at this dispatch only when
he had devoured this impure mire.

Draw, then, again, before one, from the very bottom of the place's cesspit.

Once [*un coup;* also "one blow"], then again, and again.

Extract the remainder and make it one's own.

The disseminal spurt of sperm does not emerge [*débouche*] into the other's mouth before the turd has been incorporated by

the mouth, his own. (Embouchure of the remainder, vomit in *economimesis.*)

Once the remainder has been consumed, one must, one more compulsive time, get back down to it. To make an *oeuvre* and a series.

What *makes an oeuvre* is the decisive decree, the separation of bodies, the secreting [*mise au secret*] of the turd: a series, itself a turd (generic unicity, *the coffin*), a truncated set, is arrested, fixed, cut out, at the end of a multiplicity of blows. For example at the 127th article of death.

Where does the decree which places in section [*en coupe*] and in crypt come from? From whom? From what?

Why the death sentence [*l'arrêt de mort*] at 127?

9 December 1977

I turn around this figure [*chiffre*], I speculate, I compare with the punctilious (others would say manic, or obsessional, or compulsive) accountancy of the other series, of the series of series, of series in number.

It partakes of accounts, apparently. It settles accounts, no doubt, with the paradigm. For what is it accountable? For whom? To whom?

Things won't stop computing in me, as if I wanted to account for [*rendre raison de*] the number, give a *pertinent* reason for the contingent *ration*, as if I hoped to *touch*, then, on the necessity of this contingency, to touch the side [*bord*], all the sides of this so numerous coffin.

I recapitulate: there are the *25 Variations on the Idea of Rupture* (already oblong parallelepipeds, hairy bands come along to dress, bind, grip the hidden caesura, the collapse of a hyphen [*trait d'union*]: but I won't produce the inventory of them, in each series—although all of them are unique and irreplaceable—are to be found the elements of another, and thus for the remainder [*et ainsi du reste*], which links to itself an open series of series), there are the *18 Mausoleums for 6 New York Taxi Drivers*, there are the *20 Variations on the Idea of Deterioration* (again the parallelepiped like a closed coffin with the angle of attack for decomposition, etc.), there are the *17 Examples of Alteration of a Sphere*, then there are the *VI Spheres*, the *7 Dismantlings*, the *15 Latin Incisions* (with cartouche, in a very strict sense, tombstone inscriptions of poets' names and "shroud impregnated with the image of a *remainder*"). (The number, then, is part of the title, it

comes to corrupt in the title the authority of the name, of the voice, of phonetic writing: in the very title. This is one of the functions of the series. But when the figure does not dislocate the nominal title, it intervenes again in the subtitles, in the numbering or dating—as is the case here—or in general in what plays the role of *cartouche*. A written text accompanies the series, inseparably. It is therefore inscribed in that series, even if it seems to present itself as outside the frame and outside the series. This coffin is not without its cartouche; I'll explain later.) Without a number incorporated into the title, there is also *Joaquin's Love Affair*, "a suite of 8 paving stones not immediately legible," the 19 drawings of *The Use of the Necessary*, the 34 drawings of *The Four Season Sticks*, etc. It had not gone beyond 34 (but $3 \times 4 = 12$, $3 + 4 = 7$, 12 and 7: 127). This time the increase seems enormous: 127. Long-distance run. The series is more *consequent*. If serial practice is pushing the putting-to-death of the paradigm or the downfall of the model, this latter seems this time to have been more resistant: more than 4 seasons. The 34 *Sticks* make an anniversary (21 June 1974/21 June 1975), the 127 coffins, begun 2 days after the last of the *Sticks* (23 June 1975), overrun the ring, elliptically (11 July 1976). The anniversary engagement is not kept.

Must we take into account the dates or the number of articles? What does it mean, beyond the apparently meaningless *ananke* of a chance, a term [*échéance*], a decline [*déchéance*]? What will this number—127—have satisfied to stop desire from going further? Why not one coffin more?

127: I tend first, by dissociated reading, to decompose thus: 12 + 7. Hello, that makes 19, as in *The Use of the Necessary*, and we know that in that case the number 19 had been obtained after the subtraction or destruction of one drawing; it had been stolen, subtracted or annulled, extracted from the series: it will have been necessary to reduce to 19.

12 + 7: 12 months, one year, plus an overrun, a comet's tail. And there are 12 drawings after the anniversary of the first, the 23rd of June, and they are spread over a little more than a week (seven days and an overrun) of the seventh month. He drew 12 engravings from the coffin (the reproductions of which are, precisely, accompanied by a piece of writing with a cartouche's import [*à portée de cartouche*; also "in cartridge range"], and to which I shall return). Twelve coffins, like *The Twelve Brothers*

29 August 1975

17 September 1975

4 October 1975

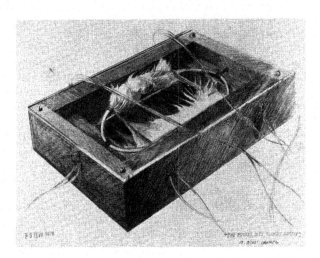

9 February 1976

by Grimm: the king threatens his twelve sons that he will kill them if the thirteenth child is a girl. From before the birth, the *twelve coffins* are ready. The sons flee and swear to kill any girl they happen to meet. Go and see what happens next, up to the *seven years* during which the girl was silent, remained mute as death in order to free her brothers who have become crows. Freud tells the story in *The Theme of the Three Caskets.*

9 December 1977

The theme of Titus-Carmel's 127 caskets. Will I have the time to reinscribe a whole reading of Freud in this cartouche?

127: 12 + 7. 12: 3 × 4 (hours, months, seasons, anything at all, you choose), 7 = 3 + 4 or again 1 + 2 + 3 + 4 = 10 and 1 + 2 + 7 = 10. Pythagorean tetractys (I talked about it too much in *Dissemination,* I let it drop, not without recalling that the proportions of the coffin no. 0 (--1 or +1) correspond to the golden number (10 × 6.2 × 2.4 cm) and therefore to the same register of arithmopoetic speculations).

This morning, on my table, I've a little "electronic pocketable calculator" (model Ur–300, serial no. 27932) next to the type-writer. I compute, with a somewhat distracted hand.

And here it is: 127 is a *prime number.*

That's not all, but it's very important. A prime number, by definition, is *only divisible by itself.* By no other whole number. The coffin, in its generic unicity, is thus entire, intact, invulner-able, divisible by nothing other than itself. Nothing will affect it again from outside. The odd is indivisible in this case. The re-mainder remains entire, on condition that you deduct one, the paradigmatic coffin which *belongs without belonging* to the series it makes possible. It inscribes itself in that series but also leaves on it the mark of its own subtraction, which defines the agency [*instance*] of the transcendental *bit:* an exceptional piece, *bitten* [*mordu*], torn off or held with the mouth, has a hard-on on its own [keeps aloof] [(*fait*) *bande à part*], but in order to make pos-sible the articulated chain, the series of articles with respect to which it is an exception (everything *except* it, *save* the bit [*fors le mors*]) and in which, however, it reinscribes itself regularly.

We shall say, indifferently, the transcendental *mors* or the transcendental *fors.*

But the putting-to-death of the paradigm is also the putting-to-death of the transcendental. T.-C.'s act will have forced the transcendental coffin—if you will be good enough to follow it—

to reenter the series or the cortege and to occupy any place in it, to which an avant-garde coffin must always be led [*s'entraîner;* also, perhaps, "must always be dragged"].

The prime number of the coffin thus resists all analysis, that's what it's for, it doesn't resolve itself into phantasies, it does not divide itself, it does not split. At least no decomposition come from outside can affect it, save its very own. Atomic armament. *The* coffin then becomes *itself,* indivisible in short, up to and including the dissemination of its lineage. Whole [*intègre*] outside the series, whole once reintegrated or *reinserted,* unattackable from one place to the next, impassive, splendidly autonomous: sufficient [*suffisant;* also "self-important"]. The sufficiency of this lineage even grants itself—this is its unique prerogative—the modesty, the measure, the moderation one can always hear when someone says, accepting the limit: *that's enough.* 127, that's enough, sufficient, I can't go on. T.-C. says of the mahogany box with the golden-number proportions that its dimensions are "modest." That's enough, sufficient, *satis* and "satire of the abyss."

Proud arrogance [*superbe morgue*]. The prime number had to be thought of, like the unconscious of course, and, consciously this time, in the proportions of the golden number! What arrogance [*quelle morgue*]. What refinement, finally.

In its foreign-language title, a mute coffin keeps the last word. *Quelle morgue.*

9 December 1977

Before coldly ditching this numerological thrust, I notice this: he destroyed two drawings. He told me so. He would have reached 129, another odd number, certainly (and $129 - 10 = 119 = 12(0) - 1$, etc.), *but an odd number which would no longer be a prime.* Two more and the paradigm is no longer prime [*premier,* first] in its lineage; it becomes divisible by an other than itself: disseminable, offered up to formless decomposition.

Those two fascinate me.

Excluded or destroyed, they leave the trace of an interruption in the contract he had wanted to make with himself, *entirely* with himself, if such an act is possible, for the formation of this contingent or the institution of the lineage: that of keeping all the drawings, even the (more or less) failures, the aborted ones, the debris, the rubbish. He seems then to have recognized that not all waste is of equal value.

We can say of the two banished drawings that he has not kept them, certainly, thus consigning them to a nameless and tombless loss; but also that in losing them in order to save the series in its prime number, he saved them from disaster or from funeral rites, from the communal grave [*fosse*] or the sinister exhibition of the cenotaphs.

Entire except for those two. It's the condition of the stillborn. Look closely at these coffins, there is something stillborn in this coffin's (hi)story and perhaps in the coffin itself. First, the annihilation of the two little ones was not without remainder. He remembers and talks about it. This cartouche keeps the memory of it. He has left them no tomb and no name but a date at least: born and died between 20 and 21 (!) August. Witnesses to this remain, the four black stains (or models), the barest, without laces ("pall cords"). Two of them, the first two, traced, and one only of them, the only one of the four, shows the tufts of hair on the sides, inside the coffin. In what I'm calling his cartouche, he describes them in passing as "two gray, beakless fledgelings." Nothing then prevents one from thinking that the two excluded ones, like everything that is excluded in general, have themselves represented within the enclosure.

Do the two form a pair? Or a couple? Are they or not part of the lineage? Do they carry its name, and what right have they to do so? Another day I'll ask the same question about the cartouche in general: does it belong to the *oeuvre* or not? Is it at work or not [*Est-il ou non à l'oeuvre*]?

Of the genealogical catastrophe, how to *know* if the two excluded ones or the double banished offspring were its victims or its beneficiaries? The question I pose is that of *knowledge* [*savoir*], and of a remainder-to-know [*reste-à-savoir*]. Those two are sublime, the most subtle, the most spirited away [*subtilisés*] of all in their out-of-series subtraction, we'll mourn them forever. The edges of this crypt are sealed by them.

Sealed by an out-of-series the exteriority of which both has and does not have the same, relative, function of the out-of-series-in-the-series which is that of the *princeps* coffin and, in its wake, of all the exemplars.

I had been put on the track of this series of out-of-series "out-of-series" by Gilbert Lascault's allusion to an analogous subtraction, in or out of *The Use of the Necessary:* "To the nineteen drawings is added, excluded from the series, produced just about

in the middle of the series, a twentieth work: we shall have to come back to this exclusion." And he comes back to it: "one of the necessaries has been excluded from the series. This necessary is entitled, 'Gaping, opening, elsewhere disclosed, read in its yawning: W. B. Yeats. . . .' " ("Remarques dispersées sur L'Usage du Nécessaire," *Revue d'esthétique*, March 1973. You must read Lascaut. I date my first thought for Titus-Carmel from this reference, and the feeling that this excluded necessary marked the necessary border of the Necessary itself, the necessary—the excepted, the contingent, "except," "save"—of the Necessary, the I'm-out-of-series [*le M'hors-serie*] or the *Fors*-series. The blow of fate, proper name: Lachésis. The name of this spinner, one of the three sisters, recalls "The Theme of the Three Caskets," designates "chance showing up within the laws ruling destiny." Lachésis, hello, that's the title of drawing 12 in *The Use of the Necessary!* That's enough.)

10 December 1977

Must do the impossible. Get back down to it today. To work, of course.

Of mourning. Make mourning *one's* mourning [or "do one's mourning of mourning"]. That's what I call doing the impossible.

For him first of all (but he's already succeeded, hasn't he?), and for me after him. Get back down to it, lie down at full length, lie out without fear, without modesty, on one's back (which then remains invisible though it exposes itself the more, more blindly, to the mirror), in the wooden box, make one's niche there—something like the opposite of digging one's grave—like burying one's head, in a few brief movements, in a slightly hard cushion, giving it one's mold and one's own form.

But in order to make it one's own, to be sure of one's own [*pour se l'approprier, pour être sûr de son bien*] (the hidden secret, the good precious above all, the treasure of the New World in the country of the fur traders, the Tlingit), one must, for a long time, since always, have been *preparing* the thing. For example, after many other analogous objects in their series (boxes, caskets, cases, parallelepipeds, ligaments, garrots, laces, bindings, dressings, cloths, synthetic furs, right angles and ovals, etc.), lots of elements differently joined together but analogous in their disjunction or in their partial rejointings, one must have designed and built, almost with one's hands, one's own coffin.

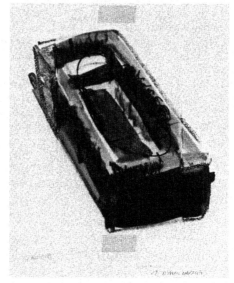

20 August 1975

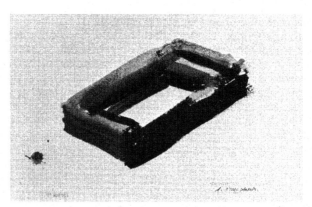

21 August 1975

Carpenter's work [*Travail de menuisier*]: it consists first in refining and polishing the coffin on all its surfaces, in slimming [*amenuisier*] it down, in *diminishing* its form and its content (reduced model and shrunken head, these are his words, so shrunken that the body of the departed [*le disparu*] has disappeared [*disparu*], all that remains of it is the word and the allusion to the funerary practices of the New World).

Let us suppose then that he got down to it. It must have been one day, before 23 June 1975, the date of the first drawing, a little while before our first meeting: he talked to me about the paradigm and the first drafts [*jets*] as of something already done, sketching out, if I remember rightly, the gesture of putting his hand into his pocket. Before 23 June, then, let us reconstitute the process, he would have conceived, that's the word, the paradigm of the paradigm. Did an archi-first drawing, a proto-coffin provide the *precedent* for the carpentered object? Its estimate [*son devis*]? Its motto [*sa devise*]? In any case, before 23 June, he has at his disposal what he calls a series "model." An essential first manipulation will have allowed him to raise himself above the object (which starts by being bigger than him since he approaches it with the intention of getting into it [*s'y mettre*]), until it is diminished enough for him to be able to handle it, to hold it in his hand. Always the colossal raising [*surélévation*]. First raising of the coffin (it will have been carried off more than 127 times).

Abductions at the coffin [*Enlèvements au cercueil*].

Thinking of all the ruses, all the artifices employed in the shade for this repeated abduction, I'd say that he is plotting to be well in with the dead man [*avoir le mort dans sa manche;* literally, "to have the dead man in his sleeve"], if not to contract alliance with him: sleight of hand, ploy and scheming [*jeux de mains, manège et manigances*].

Then pocket him in a trice [*d'un tournemain*].

That's what he calls "putting the model in one's pocket."

I'm here quoting a writing which has to be taken into account as precisely as possible. It is entitled "THE POCKET SIZE TLINGIT COFFIN (or, Of Lassitude Considered as a Surgical Instrument)." This document, reproduced at the time of the exhibition (of which it is therefore a part), was first published with the *twelve engravings* of the coffin (Baudouin Lebon, SMI, Paris, 1976) and consists in *twelve propositions* classified thus for your specula-

tion: 1.1, 1.2/ 2.1, 2.2, 2.3, 2.4, 2.5/ 3.1, 3.2, 3.3, 3.4, 3.5. Another *out-of-series series* which comes to inscribe itself, twice in twelve, *in* the series. The act of T.-C. is thus put forward here as an act of discursive writing, leaving an "act," in the sense of the archive or testamentary document. It commemorates, explains, describes, recounts the (hi)story and the structure of the coffin, but in a fashion sufficiently elliptical and put on [*jouée*], sufficiently fictive and little enough reproductive (it is one more text and not a replica) for the hors-d'oeuvre not to dominate [*surplombe(r)*] the coffin (the *chef-d'oeuvre*) and, on the contrary, for it to be part of the coffin. It is moreover written in the course of the operation, during the process. It can, then, be granted, in quite a strict sense, the value of a *cartouche*. It has all the features [*traits*] of one: card *(cartuccio)* or table as support for supplementary inscriptions, for example on the coffins of Egyptian emperors; a set of *traits* containing a *title* or a dedication; an elliptical ring around the proper names of gods or kings, with formulas or mottos, heraldry, coat of arms.

We will be able to read this cartouche both as a *title* and as a *signature*. It is not a stranger to the *cartellino* or the *cartel*, even if it cannot be reduced to that. This latter can *identify* and *sign* the picture, whether or not it is integrated into it, whether or not it is separated from the image in very diverse topological configurations. Jean-Claude Lebensztejn has offered a rich and rigorous analysis of the *cartel*, of its structure and of its historical function, in a section (1.4) of his "Esquisse d'une typologie" (in "L'art de la signature," *Revue de l'art* 26 (1974)).

The *cartel* which interests us here is not very far from being a signature, with log book [*journal de bord*] and visiting card. Read it attentively. For the moment I only pick up two *traits* from it. First, it is organized around the subtitle of *surgery*, the violence of the scalpel or the "syringe," and the play of hands. Follow in the text the relentless work on the body, in flesh and bone. Then the signatory of the *cartel*, Titus himself, notes in it, in capital letters, with the suddenness of a coup d'état or a *coup de théâtre*, between 2 and 3:

"THIS BEING THE CASE, PUT THE MODEL IN ONE'S POCKET."

This *coup de théâtre* is both that of a theorem and of a watchword [*mot d'ordre*].

It resounds on at least three surfaces.

11 December 1977

Leave the discourse on the three surfaces until tomorrow. Supposing the cartel "of lassitude . . ." to have been read at this stage, I extract from it the following:

"3.1 . . .—*scans* [*scande*] the day with its exits.)

'*Place it there and eat it in a single mouthful*' "

(Copro-necrophagy: for those who might have found forced or theatrical my curtain raising on the *120 Days* . . .)

Retrace one's steps, always, again, narrative/series [*récit/série*]. Funereal procession and palindrome. Return: the return on usury, the ghost [*le revenant*], the host, guest, ghost. The coffin as whore-hotel. Which is what T.-C. does in coming back to the attack [*revenant à la charge*] (surcharge and discharge of a juridical exhibit: how to get rid of it?) and returning to the scene of the crime. He is also tracking an exhumed body, following the wake of a "wreck." In the wake's wake, exultation too of a funeral vigil, *Finnegans Wake* again. Blackmail [*faire chanter*] the dead. Make the sarcophagus vibrate: under the *charm*.

And the words. This coffin is crawling with illegible words, whole or in many pieces. The many sleeps entire, exposed along its dimensions, played along its rhythms. Follow the cadences of the *trait*. The whole series of words in "or" [*mots en or*; or, "words of gold"] I've had to set store by (death [*mort*], body [*corps*], outside [*hors*], save [*fors*], bit [*mors*], corpse, chance [*sort*], edge [*bord*], tortuous [*retors*], and so on).

On the subject of the golden number and the tetractys (1 + 2 + 7 is 1 + 2 + 3 + 4), anecdote to lead back slowly toward the proper name, to induce it from afar: Jamblicus recounts that Pythagoras liked to retire to Mount Carmel to meditate. Reread too Kings.

So many narratives (in series) subcontracted in his cartouche's crypt. He follows more than one order there. And resounds on more than one surface. Work of the angle: he RECTIFIES in all senses: kills, makes a more or less right angle, then repairs, restores, recaptures, then once more, etc. Inexhaustible debt until the term of a dice throw ("at the bottom of a shipwreck"). An injustice must be redressed, a wrong repaired.

The English words in this network, their necessity, all that could be done with *corpse* or *rest* (residence, rest [*repos*] of the corpse) . . .

12 December 1977

In order to say these *three* possibilities, I exploit no more than he does an idiomatic expression very economical in its ellipsis. I describe an equivocal surgery.

It finds its chance in language and programs the gesture as much as it sees that gesture prescribed for it [*elle se le voit prescrire;* also "it sees itself prescribing it"].

1. He has not only put the model in his pocket. He has exposed, taught, shown by example (paradigm) how, in general and in particular, to "put the model in one's pocket." Dominate it, play it, undo it, foil it in the course of a simulacrum of negotiation, by a fool's deal, a scheme or a ploy. Put someone in one's pocket: make of that person one's submissive ally (alliance [the French *alliance* also means "wedding ring"]—both elliptical ring and subjection) after luring, by hounding, after placing the flesh in view, for the capture of another animal. Conquer its resistance by wearing it down [*à l'usure*], be stronger, or deader [*plus fort, ou plus mort*], than him, on occasion by playing dead.

Yes, put *someone,* in one's pocket, as much as *something:* who will decide if *the* coffin, if the Thing is someone or something, someone's or something's?

In this first sense, he has put the model in his pocket because he has finished with it (the late paradigm [*feu le paradigme*]), with its dignity or principial title as model.

He has finished with it in several ways. At least *four* (ABCD).

A. He has "produced" the paradigm, almost with his own hands. It was not there, in itself, before any operation. T.-C. is no longer in the position of the demiurge who, in the *Timaeus,* contemplates an unproduced and precedent paradigm, the program of its forms. T.-C.'s surgical operation is not a demiurgy. He lays his hand on the paradigm and even raises his hand against it. But in the same blow—whence the terrible equivocality of the (r)aid [*coup de main*], the impossible master stroke [*coup de maître*]— by "producing" the paradigm, by *giving himself* the model, by depriving it of its imperious transcendence, he runs the risk of raising himself up, himself, T.-C., as father of the "paternal" model put to death: father's father, son's grandfather, grandfather's grandson, ancestor of himself, etc. Simultaneously [*de même coup*], if one can say this, in killing the paradigm, the parricide kills his product, in other words his offspring, he makes it abort (127 times infanticide), and his own paternity along with it, thus under-

signed. Broken lineage, (no) more family, a series, a series of series
without commencement or command (or command *stick*), with-
out archy or hierarchy, and so on. (I should like to draw this
discourse into the purlieu of the *Chôra* in the *Timaeus* and of the
"bastardly" which is linked to it, but I must make it quick and
short.) Necessarily the dead takes his revenge. And the paradigm
returns, it gets its own back. The "model" is always the dreamed-
of ghost [*le revenant rêvé*]. Haunting does not befall it, but takes
the first step. At the end of *Das Unheimliche* (it would all need
to be quoted, as with the choice of the caskets), Freud recalls
Nestroy's *Der Zerrissene;* the man who takes himself to be a
murderer lifts up (*aufhebt*) the cover of each trap and sees rise up
each time the supposed ghost (*vermeintliche Gespenst*) of the
victim. He is scared: "but I only killed one of them!"

The paradigm, I was saying, "as revenge" [*à titre de revanche*].

B. One could compare (put into series) the coffin series with
all those preceding it, even though it can also do very well without
this. I shall limit myself to *The Great Cultural Banana Plantation*
(1969–70). Let us not rush headlong toward the "symbol," this
contingent of phallic victims, these victuals still erect on their
consoles: fifty-nine plastic bananas, pretending, impassively, to
copy the model provided by a sixtieth or a first (the "true," "nat-
ural" one) which rots slowly, distressing detumescence offered to
the starving coprophagist. Sixty in the contingent (half the 120)
or 59 (prime number) + 1, or (119 − 1)/2, etc. The "natural" fruit
(and father) of the series is in decomposition, in other words in
effective, practical *analysis.* The decomposition lasts as long as
the exhibition, which gives time for the remark, to re-mark the
difference between the "natural" fruit (which would also be the
father) and the fifty-nine "false fruits" (which are as alike as broth-
ers—false brothers [*faux-frères:* false friends]—or sisters or daugh-
ters, as you will).

What is thus remarked is the difference between the "model"
and the "copies" (but the model is already part of the exhibited
series), the "father" banana and its indistinct, indistinguishable,
more or less anonymous subsidiaries [*filiales*] (I'm writing on an-
other cartel here). But just when this difference (model/copy,
"father/offspring," Plato would say) is the most clearly marked,
the model (fruit or father, as you will) is totally rotten, decom-
posed, analyzed, fallen. It no longer functions: defunct (*defunctus*)
the "natural" model.

The subsidiaries are no longer copies, nor, moreover, originals. They would, rather, be *phantasmata* (copies of copies without example) if the force of a *ductus* did not carry *the remainder beyond any phantasy,* beyond the signature, the proper name, and even the nameable. It accounts, in its contingency, for the ideality of the model. Idealization always rises, like the fermentation of the spirit (*Geist*), like a gas, above an organic decomposition. Already in the *Banana Plantation* . . .

There is indeed something *analogous* in the contingent of the 127. This time the paradigm seems to escape disaster, it does not fall into decomposition. No rout [*débandade:* with a connotation of detumescence]. It even holds the presumed dead man in a state of constant rigidity, rigor stretched by strict bonds. The stricture is knotted within and without, it traverses the partition like a lace, a series of laces pulling in all directions [*dans tous les sens*]. (In all senses [*dans tous les sens*], the series will come back to interlacing, and already in the words *series,* lineage, linking [*enchaînement*] and in Greek *seira,* cord, chain, lasso, knotted cord.) But it indeed gives the example and the place of decomposition, of remains and reliefs; and it does indeed seem to have the same relationship with the 127 articles as the "living" banana has with the fifty-nine *false copies* in plastic, even though these are, precisely, in plastic, in relief, and the former drawn flat. And yet between the two series there is a pertinent dissimilarity. I mean one which touches. It touches, precisely, on the difference between the (natural) model and the (artificial) paradigm, in their relationship with production and decomposition. As "natural" model, the presumptively paternal banana has not been "produced" in the "technical" sense of the term. It decomposes "naturally." It is not made in order to survive its subsidiaries, its detumescence is the rout [*débandade*] of the model. As for the "artificial" paradigm, the genitor or generator coffin will have been "produced," apparently at least, and it lasts as long as its simulacra. Marking the place of "natural" decomposition, supposed to give it a place in itself (remains in it), it does not decompose. All its drawn perspectivizations (partial ones, unlike the bananas) do perhaps decompose it in(to) part(s), but it is made so as not to decompose, to exceed analysis in its prime number.

Now here is the paradox of the paradigm: by reason of its very prerogative, and of that other (hi)story which refers it to the "phantasmata," it is deposed from its privilege. From the moment it is

constructed, artificially built, it is automatically inscribed into
the series, no more and no less than an apparently out-of-series
cartouche. It *is part* of the contingent and it is even more ho-
mogeneous with the 127 than the exemplary banana with the
fifty-nine others. No doubt it remains heterogeneous by virtue of
its relief, its matter, its voluminous singularity, etc. But it is no
longer heterogeneous in so far as it is the product of a *technē,*
whereas the banana, natural model (fruit or father) *was* hetero-
geneous with respect to the fifty-nine simulacra.

Moreover—and this is what I want to get to today—who as-
sures us that the little coffin made of wood (*hylē,* wood or matter,
little beam) will have been *first,* if only in time?

With the banana, there's no doubt: it will have been in the
"natural" situation of preceding all the others, all the "copies."
One has no need of an inference, a judgment, or a narrative to be
sure of it. In the case of the coffin, we have to *believe* what the
presumed author, Titus-Carmel, *says* about it. Only the *story* he
tells us attests to it, and this narration, put forward in the car-
touche I was talking about above, in 1.1, i.e., that it is the little
wooden case which comes first in production and thus serves as
a "model" ("1.1. Under the generic title *The Pocket Size Tlingit
Coffin* are gathered quite a large number of drawings (one hundred
and twenty-seven precisely) relating to [*ayant trait à*] the same
model: a mahogany box . . .").

Now this declaration which *puts order* into the series, this
narrative which seals an irreversibility, belongs to the cartouche.
This is a cartouche: it puts to work and forms part of the work
by inscribing (itself) there (as) the title, the signature and the
autobiographical performative of the signatory (how I drew certain
of my coffins). He *recounts* that the father of the series (the "same
model"), by him produced, the one which gives its "generic" title,
namely a collective singular which, although it is singular, is none
the less valid for a genealogical set—he tells us, then, asking us
to believe him, that this father-son is the unique "mahogany box,"
etc.

But nothing, no structural and internal necessity in the series
of the 128 articles, prevents us from considering the mahogany
box as a simili-reproduction among others, the hyletic material-
ization of this or that drawing, in this or that place in the series,
or even, after all why not, after all of them, *in fine.* If I disregard
the order imposed (performed) by the signatory in his cartouche,
nothing prevents me from moving the articles around in the se-

ries, from considering that the mahogany box can occupy all the places, and any place, with the same authority [*au même titre*] as the other simulacra. What's more, it's tempting: why should he not have solidified the thing at the end of the trip, to complete the monument? Or just about in the middle, to spur on or stop the sketch? The out-of-series, in this case as in that of the 127, can run, it's a cursor, all along a series to which it belongs without belonging to it. It inhabits it without residing in it, it haunts it.

The apparition of the visitor is innumerable, he throws the arithmosophists off the trail.

<div align="right">13 December 1977</div>

The logic of the cartouche disconcerts you, like that of a narration the site of which would remain improbable.

If I place the cartouche *outside the work*, as the metalinguistic or metaoperational truth of the work, its untouchable truth falls to ruins: it becomes *external* and I can, considering the inside of the work, displace or reverse the order of the series, calmly *reinsert* the paradigm at any point. Even destroy it like the two stillborn, like the two excluded false copies.

If, conversely, I make room for the cartouche on the *inside*, or on the inside edge of a frame, it is no longer any more than a piece of the general performance, it no longer has a value of truth overbearing [*surplombante*]. The result is the same, the narrative is reinscribed, along with the paradigm, *in* the series.

Where has the cartouche gone? It steals itself. (No) more narrative, (no) more truth.

The primordial place of the presumed paradigm, of the presumptive "father," is thus not inscribed right on the thing. It depends on a cartouche-performance which takes away from it with one hand what is given with the other in this tortuous surgery. As soon as a paradigm is "produced," it can just as well descend from the "copies," from filial pseudo-"reproductions" which will thus have given birth to it. If the cartouche introduces the possibility of a perversion into the very order which it is alone in performing, it is no longer a question merely of temptation, as I just wrote. Everything is put to work so that catastrophic perversion or inversion become necessary. They are fatal. As product, the paradigm must have been *preceded by its following*, by some anterior drawing or design inscribing it in advance in a serial filiation without beginning or end, without any ordering other

than the phantasmatics of a *contingent remaining* (beyond hierarchy and beyond phantasy).

Whence the dynamic instability, or even the *double bind* which holds this coffin between its laces, binding the out-of-series to the series, and what I am going to say about the presumptive paradigm goes as well for each 127th or 128th of the first. Sometimes, however modest it may be in its presentation, it grows massively from its analogy with the 127 others. Colossal raising. Magnified, out of all proportion, incommensurable, it dominates, this tiny thing, the whole scene of the exhibition. I see it as bigger than Beaubourg, enormous. Bigger than any museum of classical and contemporary art. You are in it, you see nothing but it, you come back to it, you rebound from its walls. All the drawings are executed on order and to its glory. It radiates, the magnificent, it sparkles, it concentrates all potency, it has all powers. The political space is mobilized, dynamized, or hierarchized by the dead man's place [*la place du mort*] from which it extends its empire and governs hieratically, without a single gesture.

Sometimes, on the contrary (is it the contrary?) it is reduced to its modest appearance, almost ridiculous, infinitely small faced with [*au regard de*] the whole lineage, insignificant beside each mural and monumental drawing. Unobtrusive little carpentered remainder, outdated residue of an operation which has always been beyond it, a ligneous, lifeless shell, a fallen skin ("the little Tlingit coffin has left its skin(s) behind . . . ," concludes the cartouche), a father, if you insist, but as little, diminished, dwindled old man, anonymous ancestor forgotten in the great familial ceremony to the glory of the lost name. Abandoned [*délaissé*] (an old shoe, more or less unlaced [*delacée*]). Dream up a father who has just given birth after having been pregnant with all the others.

Or again, a third possibility in which the economy of the two others is regulated: an out-of-series (or outlaw) among others, in the law of the series, neither bigger nor smaller than each and every one, subtracted from all hierarchies, an effect of a series without family.

14 December 1977

The parergon. The topology of the cartouche would thus seem to come under what I have analyzed elsewhere as *parergon* (the *hors-d'oeuvre*'s supplement in the work). In short, a series which I truncate here: the *paradigmatic coffin*, the pattern [*le patron;*

also "the boss"], the *parricide* to which it gives rise, the *parergon*. *Tour de force*, force of the *trait*, in this case: reduce the paradigm, the model or the "paragon" (this word had long been awaiting its insertion around here), to the place of the *parergon*. In the same series, the *pharmakon* and bastardy.

The question returns: how to frame a cartouche? In *The parergon*, I lightly defied anyone to frame a scent. I did not then know *The Olfactive Reconstitution* . . .

Give its due to the cartouche, to this writing articulated onto the exhibition, which comes to attest to the fact that this, the little wooden object, is the father, the first and "same" model. As soon as it is a cartouche *put into play or put to work*, its irony can no longer be trusted [*ne fait plus foi*]. We are not obliged to believe it and nothing proves it or gives it to be perceived. We know—Freud recalled the fact in order to draw some consequences from it—that paternity (this is the father, says the cartouche) is always inferred from a sentence, a declaration in the form of a judgment. For paternity cannot be perceived and can never be touched. This is why it is in no case natural. *They say* it's a different matter for maternity.

In this sense the "natural" phallus of the decomposing banana would be, rather, in the place of the mother. To this extent at least, such a cartouche would not have been necessary in the case of the *Banana Plantation*, not necessary with respect to genealogical order. In principle no one would get the idea of refusing the natural, out-of-discourse banana a certain absolute anteriority, a role as incontestable precedent, with respect to the fifty-nine anonymous subsidiaries. The interest or capital of this (hi)story is not the fact that one can doubt a birth certificate [*acte de naissance*] or a recognition of paternity, nor the cartouche as T.-C.'s act. But this: as soon as the cartouche no longer lays down the law and can pretend to *recite* the truth only by giving *place* to the conditions of doubt, it enters the series, like a simulacrum among others. Forms part of the series without paradigm, without father, the little pocket diary, the log book [*journal de bord*] which still speaks of the model or the father. It transforms the paradigm into a *paradigm effect* (without destroying it, for there's always something of it). Supplementary, an effect itself added or cut off, 128th or 129th (we get another count), the cartouche narrative on the head [*le chef*] (the chief's discourse [*le discours du chef*]) is executed like a piece, a bit, a scene among all those that interlace here.

I call this the *chef-d'oeuvre* ["masterpiece," but literally "chief of (the) work" or "head of (the) work"], the effect of chiefing [*chefferie*] as remainder of a putting-to-work, in other words a putting-into-series, without model, without precedent.

It is only a *chef-d'oeuvre* (later they'll read these hyphens [*traits d'union*] differently; the whole thing would seem, in short, to work in the name of a hyphen, in his name), according to the genealogy of a perverted genitive, the chief born of the work. Is there any such thing as a born chief? Among the Tlingit?

What is it that rings a bell [*fait tilt*] when I say again this tribal name? It'll certainly reason later [*Ça raisonnera sûrement plus tard;* cf. *Ça résonnera:* it'll resound].

C. He has, therefore, circumvented the model, he has obliged it to stay in a series open/closed like a box. He has even out-played the very *eidos* of model, the paradigm of the model, the paradigm of the paradigm, in order to put it in his pocket. To this end—he has in the same stroke [*du même coup*] finished it (put the finishing touch, prepared, made up like a deceased for a last *funeral home* [Eng.] mascarade), finished off (put to death and led to its term, perfected), reduced (to almost nothing, to its end, to the insignificant, to the very small—shrunken head of a little chief).

He hasn't played this trick of spiriting away [*ce tour subtilisant*] on *this* paradigm but, exemplarily, on the paradigm (in) general. And he's played it on himself in giving it to himself for it is not easy to get rid of it. To put something in one's pocket is to keep it close to oneself better than ever (see alongside or above for the revenge of the dead paradigm).

This is why there is always ideality in a paradigm and in its mourning no less than anywhere else.

T.-C. has done his mourning for the paradigm and made mourning his paradigm. The coffin contains the remains of the coffin and the paradigm is the paradigm's grave, its own funerary monument which can no longer contain itself for holding itself so well in its remains. Ghost-effect. Nothing is stranger, more worrying: it is there without being there, neither full nor empty of itself, and it *looks at* itself. Without seeing itself: one looks at it and it looks at us but it does not see itself entire in its mirror or in any of its reproductions (T.-C. will have been unaware of the superstition obliging one to hide the mirrors under sheets in the rooms of the dead). And as there is no more model—its body has been spirited away—the (model) grave of the model is just

about empty. I think of the *Idea of a Parallelepiped Split in Two*
(*Large Cenotaph* no. 1) (1971).
 D. Like all coffins, this one *simultaneously* keeps *and* de-
stroys the keeping *and* the destruction of what it keeps *and*
destroys.
 Any oration about it must therefore remain in a reserve, and
on the reserve: irony, equivocation, the actor's mask, hypocrisy,
and half-mourning are in on it. T.-C., the more or less natural
father of the stillborn paradigm, puts the model "in his pocket,"
he monumentalizes the thing whose disappearance he then signs,
he marks the decline of what he institutes (both father and son).
T.-C.'s act ironizes. And as a model coffin can open and close onto
the remains of a model coffin, the exemplary irony boxes and
mocks itself [*se met en boîte;* lit. "puts itself in a box," but idi-
omatically "makes fun of itself"].
 I here quote Jean-Marc Tisserant. Before the *Coffin*, in 1974,
he wrote: "the same alters itself by coming to the same in a
deviation [*écart*] which is traced [*qui se trace*]—and *écart* is the
palindrome of *tracé*—by the play of a *distance* which is not only
a putting aside [*mise à l'ecart*] or *leg pull* [*mise en boîte*] of the
original Idea as transcendental principle—critique of the model
as intemporal and conceptual *substratum*—but also an *irony of
itself . . .*" (*G. T.-C. ou le Procès du modèle*). Read *Le Procès du
modèle* in order to understand the structure and the genealogy of
what is happening here, but also as a (parergonal) part of T.-C.'s
oeuvre, and not one of the lesser parts, and even as a serial set of
which the work in question would also be a part in a sort of
interlacing without beginning or end, the part always being able—
that's one lesson of this surgery—to comprehend the whole. For
example: it all happens as though the *mise en boîte* of the par-
adigm, the *mise en boîte* you think you have before your eyes or
in your hand, came to accomplish the formula prescribed in *Le
Procès du modèle*, to finish it off and also to materialize it—in
wood (*hylē*)—in an ultimate allegory. The ironical formula "*mise
en boîte*" would seem to have just been embodied or encorpsed,
in a different body or corpse; and once displaced, dragged off else-
where, of its own accord it puts itself *en boîte* in its allegory,
always in another coffin, the other's sepulcher. It had, in advance,
been *named*, designated in language (*mise en boîte*) by a royal
weaver (the weaver of the paradigm in Plato's *Statesman*, with
the interlace you can follow there in series). In the *mise en boîte*
as putting-to-death of the model, the body has disappeared but it

is not absent. Once pocketed or boxed, incorporated, it makes the labor of mourning impossible, it makes it do the impossible. And the ghost takes its revenge, multiples its apparitions. As early as the second day, the lid lifts (by levitation, a bit like all the others, flying, airborne): rigorous dismantling for a break-in, in proof, on 24 June 1975.

In what way is the allegory more consequent here? It had already begun: boxes, cassettes, caskets were not lacking and the "trial of the model" [procès du modèle] was well under way in all its discrete elements. The supplement of consequence hangs on this, which contains everything, up to and including the abyss: *the box itself is mise en boîte*. It *is* not, it remains, *mise en boîte*: a *remainder* and a mise *en boîte*.

What is the inboxing of a box [l'emboîtement d'une boîte]?

I must get going with another narrative in this cartouche, that of the matchbox.

15 December 1977

The (hi)story of the matchbox is indispensable to a proper understanding of the second sense of the motto "put the model in one's pocket." This second sense has been realized, incorporated. Consequently:

2. When we first met (but doubtless we already knew each other), T.-C., glass in hand, talked to me about the coffin. This was, I think, around June–July 1975. The thing must already have been carpentered, and the procession under way. I then alluded to *Funeral Rites* and to certain sequences from it that I had regularly grafted or turned around in *Glas*, from the beginning (page 18) to the penultimate page.

(Having explained why, at the point of death, modesty was no longer in season [de mise] for a cartouche, I quote: "At the moment of the *coup de théâtre* in *Funeral Rites*, when the coffin was 'slid' into the catafalque—'spiriting the bier away'—before its reduction, like the coffin of 'Sainte Osmose' (a fictitious letter on the Golden Legend, published in Italian) into a matchbox, 'Jean's death was doubled into another death.' The dead Jean whose body is *band*aged" and on the penultimate page of *Glas* between the "canopy of the upturned eye [dais de l'oeil révulsé]" and the "sealed milk of mourning [lait de deuil cacheté]": "How does he do it? He's ready. He has always had his dead body on him, in his pocket, in a matchbox. At hand. It lights up all by itself. It ought to. He feels himself obstructing his death, that is he, little crea-

ture, obstructing the sublime, measureless, sizeless upraising of
his colossus. He is only a detail of his double, unless it's the other
way round. There's always more, with a bit, than with the whole
of the other. Hunger of the drive [*pulsion*]."

The association coffin/matchbox appears to be quite neces-
sary to Titus-Carmel, since in his cartouche (on "surgery") he
quotes *Funeral Rites* in a note ("In my pocket, the matchbox, the
minute coffin").

Such a necessity, by him retained, obliges one to insist.

Apparently the coffin *is not* a matchbox, nor even a coffin
truly identifiable as such in the West, nor, without doubt, else-
where. It does not open, except by breaking in, and contains not
a single match, not one of those little wooden bodies lying side
by side, waiting to catch fire and flame between your fingers. And
yet. From the moment the cartouche on "surgery," on the first
page, associates in a note—cartouche of the cartouche—the coffin
and the matchbox, then this contiguity forms part of the serial
work. It belongs to that work at least as a *parergon*.

For what's a matchbox when all's said and done?

A parellelepiped like the coffin and of about the same size (if
it's designed for the kitchen), the matchbox has the peculiarity
that it does not open, like so many other caskets, along the ar-
ticulation of a hinge. See for example the role of the hinge in *The
Use of the Necessary*. Here, for once, *one* box opens or shuts by
sliding *into another*, which is none other than itself. A box open
on top fits into [*s'emboîte dans*] another box, the same box, open
on two sides, at its last extremities. The hermetic closure com-
poses the two openings, is composed by them both. The box
decomposes—into two independent boxes; and boxes itself in [*se
met en boîte*] in this decomposition. Now sliding the coffin into
the catafalque involves a boxing-in of this type. This *mise en
boîte* of the box does indeed, in *Funeral Rites*, form one of the
many movements which induce the *coup de théâtre*, after this
one, which prepared things from a greater distance:

"I wonder why Death, film stars, virtuosi abroad, queens in
exile, banished kings, have a body, a face, hands. Fascination for
them comes from something other than a human charm, and
Sarah Bernhardt, without disappointing the enthusiasm of the
peasant women who wanted to catch a glimpse of her at the door
of her railway carriage, could have appeared in the form of a little
box of Swedish matches. We hadn't come to see a face but Jean
D. dead. . . ."

For the scene also takes place "in the room at the Morgue," "when I went to see him at the Morgue." Literature's *morgue* this time.

Another inductor preceding "the comparison" with the matchbox, the fact that earlier the narrator, the other Jean, had "one hand closed deep in his pocket and the other leaning on a supple stick. . . ."

A third inductor, the closest and the most decisive no doubt, the *sliding* of one box into another, of the coffin into the catafalque:

"The coffin was slid into the catafalque through an opening made in one of its ends. This *coup de théâtre*, the spiriting away of the bier, amused me enormously."

The "comparison" doesn't keep us waiting much longer, and imposes itself in the following paragraph:

"Mechanically I put my hand in my jacket pocket and came across my little matchbox. It was empty. . . .—It's a little matchbox that I've got in my pocket.

"It was natural that I should recall at that moment the comparison made one day by a guy in prison, telling me about the parcels the prisoners were allowed:

"—You're allowed one parcel a week. It can be a coffin or a matchbox, it's all the same, it's a parcel."

Then, after the passage quoted by Titus-Carmel, the following which interests me because of the significant error that followed from it in my reading, and which was not induced by chance:

"In my pocket, on the box caressed by my hand, I was carrying out a reduced-size funeral ceremony. . . . My box was sacred. It did not contain a part of Jean's body, it contained the whole of Jean. His bones were the size of matches. . . . All the gravity of the ceremony was amassed in my pocket where the transfer had just taken place. Nonetheless, it is to be noted that the pocket never possessed any religious character . . . except when, talking to Erik, my gaze fixed onto his fly resting on the chair with the heaviness of those purses which contain the balls in Florentine costumes, my hand let go of the matchbox and came out of my pocket."

My error, then, the mechanism of which will quickly be understood, consisted in believing, for a long time, that the pocket was a trouser pocket.

<div align="center">16 December 1977</div>

Had I misread? Apparently so. The narrator says "in my jacket

pocket." But the writing drifts slowly toward "the heaviness of those purses" which comes to touch, in the sentence, the "match-box." Here is the written and published archive of my haste, this passage from *Fors* (which I quote again without shame, it's to do with the *pudenda*) where, with reference to the work of Nicolas Abraham and Maria Torok on mourning, ghosts, crypts, introjection, and incorporation, etc., I situated the pocket near the purses:

> The crypt is perhaps this contract with the dead man. The cryptophore undertakes a commitment toward the dead man, leaves him, a mortgage in self, a gage in the body, a cystic pocket at once visible (barefaced) and secret, the place of a thanatopoetic pleasure which can always flare up again. Whence the *double* desire, the mortal contradiction assigned by every crypt. In order to keep hold of life and put the dead man in one's pocket (in a "matchbox," as specified in Genet's *Funeral Rites*), one has to reserve for him this place sewn near the *pudenda*, this patch holding what is most precious, money, title, or high-interest share. This is also a hold for the other's blackmail, always leaving you without resource when, at night, at every turn, at every street corner, he comes to threaten a desire: your purse or your life.

17 December 1977

Met Genet. He tells me that it was in the first place a "real" event, that he really had that matchbox in his pocket at the Morgue, before the body of his friend, the other Jean, J.D. *Funeral Rites* is dedicated to Jean Decarnin. The dedication belongs to the book's cartouche. Like the title and the signature, the exergue, the epigraph, the epitaph. Where does a cartouche end?

Rereading the cartouche of the twelve engravings, I'm unable to situate the pocket, perhaps it's a third, the hip pocket [*poche-revolver*] (no, that's impossible, because of the cigarettes, but the idea of the weapon won't leave me alone): "omnipresent, this intolerable casket, at hand, lurking in the pocket between the packet of cigarettes and the little black notebook. . . ."

So, don't get the wrong pocket, in the choice between one's own and the other's.

18 December 1977
What is a box?
Come back to boxing [emboîtement]. The series: boxing and
unboxing [déboîtement; also "dislocation"]. The matchbox as se-
ries object [object de série: mass-produced object] par excellence,
pending something better. Other traits which are pertinent, but
contingent just as well, boxed in the same "comparison" coffin/
matchbox. The coffin, return of the revolver pocket, remains a
weapon as much as an ammunition case. Offensive and defensive
display [parade]. Titus's martial art. A "weapon bag" as much as
a travel grip. "Nécessaire d'armes autant que de voyage," he said
in L'Usage du Nécessaire. Here the box of matches is a firearm.
You can direct it against others, make use of the little wooden
cylinders, all ready to take fire and flame or to explode (near the
head, their head), cartridges [cartouches]. Or else against the box
itself which can explode in your hands, a powderkeg [poudrière].
 Not a powder compact [poudrier] (bone powder, makeup ac-
cessories for the dead man's toilet, the little mirror incorporated
into the case but a powderkeg: suicide, the suicide paradigm re-
trac(t)ing by blowing itself up. It scuppers. Fuit [in Latin, "it was";
in French, "flees" or "fled"] the former model. Feu (sur) le para-
digme [fire on the paradigm; the late paradigm]. Il-fût

19 December 1977
The late paradigm [Feu le paradigme]. Pyrotechnist's work. If
there are, in the contingent, firearms or stores of cartridges of all
shapes and sizes, subject to variable (more or less "fast" [Eng.])
rhythms and variable calibers, then move from the idea of con-
tingent to that of armory [panoplie].
 Then to the idea of can(n)on. All the can(n)ons, associated
here in regulated (canonic) fashion or not. Behave as if the coffin
was conducting, on a leash, a discourse on the word can(n)on,
salvoes in all directions of homonymy or synonymy. Music and
mathematics, liturgy, printing, paleography are in on it, and so
forth. On the other hand, all the senses of canon as piping (see
Littré's seven headings). De but en blanc, like in The Sans of the
Pure Cut, the salvo.
 Whom does he want to salute?

20 December 1977
Whom does he want to save? And who will pull out of this
operation safe and sound—him?

Armament. The art of ballistics. The cartridge. The tracer bullet. I had noted above: He "ejects the paradigm." Yes, like an empty cartridge, its case or, in free and slightly oblique fall, the first stage of a rocket (ground-ground or ground-air): it falls along the trajectory of a flight the film of which (negatives, colors, x-rays, etc.) it brings back with it. Or again: beforehand, it would have projected itself, into the air, catapulted through stacked stages, like the rocket of a female orgasm. The launching paradigm stays on the ground, on the pad.

Study the structure of the LEM.

<div align="right">21 December 1977</div>

The great exhibition on a black background: spotlight [*pleins feux*] on the thing. Titus-Carmel's arsenal. But that's not all. The armory touches still differently on fire, it *goes to it* in all manner of ways. T.-C. plays too, in his cartouche, with fire, with the fire of the hearth ("caesurae of flames, the hearth . . . heat [*feu*] of the action, of the drama. The mirror . . . as . . . central heating").

The family hearth [*foyer*] is not named, of course, but one can speculate freely, in the mirror, on a family (hi)story, a "(murky story)" [*sombre histoire*] in parentheses, as the last word of the business, right up against the signature.

Nothing less familiar (*unheimlich*) in this panoptic, than a hearth of hearths. Ashes and family vault. The hearth become crematorium, a whole cooking-up of incineration, for example for "this curved skewer with its two fledglings."

Mass production [*travail en série*]: wear and relentless consuming. The remainder is neither *produced* by it (by an art which would claim the originary presentation of the thing, the production of pure presence, with no trace of doubling and with no past) nor *reproduced* or represented (the former paradigm will have been removed [*enlevé*]: raising the coffin). What remains of a moribund evaluation or "classical" thought about the remainder will have been reduced to ashes and yet we retain more than one (at least 127) monumental proofs of this historical operation.

<div align="right">21 December 1977</div>

He has fired all his cartridges, until the ammunition is spent. (The little orphan in Andersen's fairy tale dies in the early dawn, in the cold, having spent the box of matches.)

There are remains of cartridge, because the dissemination of the cartridges or cartouches (in all senses/directions, in all genres/

genders) never exhausts a *total*. There is no total of meanings and genders (masculine/feminine). Always a box *in* the box, some supplementary cartridge, a *parergon*, that's what the coffin's mutism *says* to us, and, in it, the couple of beakless fledglings. Always a box *outside* the box. Save the box [*hors la boîte. Fors la boîte*]. Whence the necessity of stealing the coffin, each time and each time differently. This necessity is inscribed right on the "thing" and right on the cartouche.

I move on this morning to the third "sense" of the motto ("Put the model in one's pocket"). I call it a motto because it is read in a cartouche, but also because it's going to allow us to decipher, slowly, a coat of arms.

3. To put the model in one's pocket is to steal it. Appropriate it in a trice in illicit conditions. Question of the title: if he has inscribed "Pocket Size" in the title, beyond all sorts of *good-reasons*, the pickpocket's quick theft must spy on the reading from the corner.

Inimitable *ductus* of the pickpocket, his daily exercise, his expertise, the singular force, the furtive agility of his stroke (of genius), repeating (transgression must be repeated in order to begin) the worst and most fatal of villainies: robbery and violation of tombs.

In a determined phase of mourning, moments of (imperial) triumph, jubilation, libidinal explosion: I know someone who lived such a triumph by driving around, all night, in his car, with the freshly exhumed coffin of his mother—or despondency, when one gives up trying, lets the thing drop, the thing one takes up again in exaltation the following day in order to give it all colors or to restore it, decorate it [*la parer*], repair it [*la réparer*] in its invulnerable integrity.

All these moments, and others, write their history on the 127 drawings. They deploy its synoptic archive.

Who signs the theft?

And with what name, proper or common? And what if the name itself were what is at stake in the theft?

Cartouche, the name of the great robber. Proper or common name? Cartouche did indeed leave an institution, the commonizing of his proper name; but this name no doubt had common origins; and he paid for this heritage very dearly with his body. What does a Cartouche sign?

And a Titus-Carmel? He signs himself [crosses himself] before the other's procession. But there is always something of the other,

and one does not *attend* a funeral. A cortège of ghosts surrounds you on all sides, they provoke you, they press you, from the quattrocento Triumphs of Death to Shelley's *The Triumph of Life* ("here the true similitude / Of a triumphal pageant . . ." / "But mark, how chained to the triumphal chair / The mighty phantoms of an elder day . . .").

22 December 1977

The theft of 127 funerary caskets. On the fifth, dated 21/7/75, he left prints, the palms of his hands, and a visiting card that has to be deciphered backwards. Each casket situates the archive of a theft, it gives rise to a thief. Titus-Carmel and the 127 thieves. The second day he raises a lid. Revise, later, *Das Motiv der Kästchenwahl* (*The Theme of the Three Caskets*) from beginning to end. General reinterpretation. A different syntax. (Hi)story of alliance and inheritance. Which of the 127 contains the portrait? Gold, silver, lead: the seal of mute lead, of leading (lead-on-lead), and of pencil lead in the coffin.

23 December 1977

This is a cartouche. Says he. I not only have a cartouche, I am it. This is my cartouche, I'm the one who's stolen it. This is my body, the body of my name.

A title, a proper name, a signature are inscribed on a cartouche. For example "The Pocket Size Tlingit Coffin." How did he decide on it? Why and how did he stop at this contingency become necessary? A *nominal* utterance (a noun and three stacked [*emboîtés*] adjectives, each functioning differently) and a very singular one. Two of the attributes (*Pocket-Size*) are common nouns, the other a proper name (*Tlingit*). So it's a sort of a proper name (a generic and family singular), but a proper name enclosing a proper name (Tlingit), the name of a foreign family, the name of the other.

Supplementary and abyssal *emboîtement:* "Tlingit" does not only name the family or tribe of the other, it is also a foreign name in an already-foreign language, English, doubly foreign, for the Tlingit and for Titus-Carmel: double violent insertion, by colonization, in the title as in British Columbia. Doubly strange: a foreign language encrypted in another, itself also foreign, already, and the whole in a proper name.

Which ought to become very familiar: listen, repeat, caress the surfaces, the corners, the edges.

24 June 1975

The Pocket Size Tlingit Coffin: a tribute paid to a foreign tribe but strangely familiar too: Titus-Carmel knows their *customs* (the coffin compared to the amulet, this time, of the shaman) and their *masks.* And their fetishes.

The other day, I stopped short [*je suis tombé en arrêt*] in front of the crypt, that of his name. Gérard is French all right, but Titus-

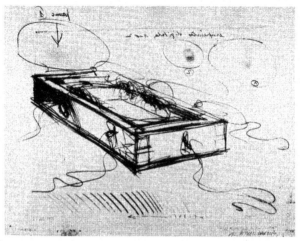

21 July 1975

Carmel links, with a fragile, breakable hyphen at work every-
where (in particular in his *Cryptiques* and his *Démontages*), two
strange-looking, if not foreign-looking names, and, as a supple-
ment, foreign the one to the other. The link [*cheville*; also "an-
kle"] is fragile. It could limp [*boîter*], or fit in badly [*mal s'em-
boîter*; also "fall badly in step"] in a hyphen which comes out of
it very well, what's more [*au reste*], when all's said and done [*en
fin de compte*; literally "at the end of the count"]: in the master-
piece.
 Furtive but stubborn games of the initials in cryptic nomi-
nation. T.-C.: the initials of *Tlingit Coffin*. And twice two syl-
lables around a precarious hyphen. The two names fit neatly
[*s'emboîtent bien*] into one another. The dimensions of the coffin
are right for the proper name ("modest" dimensions, he claims):
Tlingit Coffin, Titus-Carmel. The angular edges too: twice two
consonants (TS-CL, TT-CN) around the 2 × 2 syllables. The con-
sonants *last*. They supply the ligneous, bony framework, the bone
structure and the dead bones.
 I leave you now to speculate with all the letters (in particular
the T's, the CIGIT's [*ci-gît*, "here lies"]), which rest calmly in the
alphabetical cemetery of this title: twenty-six letters, neither more
nor less. Count the title, and take it into account, in tempo.

Meanwhile, I imagine him: for more than a year, he caresses the name in his pocket, the name of the other, his own, solid, squared, entire in its golden number, resistant, too, foreign, restive, whence the impatience, discouragement, sometimes, murder and reparation. Carnivorous or sarcophagous name, proper name in the other's language, with the arbitrariness of a genealogy, the nomination one can neither choose nor reappropriate. Recomposition or interminable recapitulation of a narrative in the act of T.-C. Palindrome, anagram, necrosis, and regeneration. Ashes. The fledglings are Phoenician.

<div align="right">24 December 1977</div>

Keep the account, take stock, in this logbook, of all the letters in his name, of the putting into play, *literally,* of the body of his name. In his pocket, he has put the coffin in the place of the "p*etit c*alepin noir" (little black notebook).

To what I said yesterday, add this: TlingIT sets off a palindrome, off to meet another more or less crucial *T.* In the *15 Latin Incisions,* under the article "Lucretius," the name *Titus* was read backwards as ꙅUTIT. Only an *S* will have suffered when the body of the name turns in its grave.

And then, again, the breakable hyphen, visible-invisible, in a fragility which would dis-mantle the whole work, both cursor and ruptor. It sets up and dismantles [*monte et démonte*], breaks up and patches together [*met en pièces et rapièce*] *around* a hyphen with which he signs: this is the body of my name. And my name has the same number of letters, again it's crucial, and it's framed by four consonants, of which the two central ones, around the hyphen, precisely, are the same (S-C), as those of JesUS Christ, (5-6). And one can also read $5 + 6 = 11$ or $5 - 6 = -1$.

The whole arithmetic of the coffin would be recapitulated here. Just before: "THAT BEING THE CASE, PUT THE MODEL IN ONE'S POCKET" (whose pocket, by the way?), his cartouche had invoked, apparently apropos of something quite different, the Isenheim Crucifixion by Matthias Grünewald.

If I say that the hyphen is not only *an* emblem, *a* motto, *a* coat of arms or *an* armorial crest but *the* symbol, this is so as to recall that *any* symbol is, *stricto sensu,* a hyphen, bringing together, according to the *symballein,* the two pieces of a body divided in contract, pact, or alliance. The ballistic resounds very close to the symbol in language.

The bit. It bites on the series—exemplarily. Which bites on it. Always a "this is my body" to get your teeth into, to "eat for breakfast." Or to let melt in the mouth if you don't like crunching like him: a job lot of 127 communion wafers. I take note on this date: a calendar can always be fictive; the chronology of the drawings is here on the touchlines, it's worth what the space of a cartel is worth. The principle of order is never untouchable.

 1 January 1978
 The *deposition* of his title—as of *cartouches.*

 The title—*Cartouches*—in the plural, in all its reaches [*portées*]. Thus, for example

 1. This—this text, if you like, this series already entitled *Cartouches* is (I prefer to say *remains*) itself a series of cartouches. The title describes the form, the nature, the structure, or the place of the text: here are cartouches, those that I *am* [*suis;* or "follow"].

 2. *Cartouches,* (the text thus entitled) deals, what's more, with *cartouches* in all senses and all genres/genders (masculine and/or feminine nouns, proper and/or common: it knots the interlace of the either/or). This title thus defines, as an extra, the *object* contained in the text, the irreducibly plural set of the objects *dealt with* [*traités*] and contained: here are cartouches, those I *show* or those with which I *am concerned* [*auxquels j'ai trait*].

 3. The objects (which are moreover abject) thus dealt with are not only the things named cartouches, but the names themselves, and as an extra, if you've been paying attention, many associated *words,* whole bodies or pieces of words, [*morceaux de mots*], reliefs of meaning or letter, those I *say* or *write* [*dis ou écris*].

 4. *Cartouches* allow the remark that every title is itself a cartouche, caught in the (parergonal) structure of a cartouche. That's where it takes place and it does not only mark it with a descriptive or definitional utterance, but rather with a performative, of a bizarre type, a *performance without presence,* without any self-production which isn't immediately dislocated [*qui ne se déboîte*] by a deviation [*écart*].

5. *Cartouches* is thus remarked [or "remarks itself"] in this performance: here, I am myself cartouche and cartouche(s) in the plural, I sign as soon as there's the title, I sign myself to death and reduce myself to the first heading, capital and shrunken head.

6. So *Cartouches* thus does not only remark the place of the title as place of the signature. Its *singular* performance (like the former paradigm, like the series, it is a *hapax*, it will have taken place only once) simultaneously entitles and signs: she/it, he/it, I sign(s), therefore we sign *Cartouche(s)*.

7. The six preceding traits can be further decomposed. The plural mark (s) remains, as an extra, among other things and supplementarily, a recall sign for the serial multiplicity 1, 2, 3, 4, 5, 6, and even 7. This latter, the 7, immediately increases itself, into the bargain, with a power of capitalization in abyss. It produces a bottomless surplus value. It can be remarked *almost* infinitely.

Perhaps I have just described the series entitled *The Pocket Size Tlingit Coffin*. At least in its generic structure, which is another way of saying that everything remains to be done [*reste à faire*]. Your business [*affaire*], and his, which he manages very well by himself [*dont il se tire;* literally, "from which he draws/ pulls himself".]

No cartouche without a "scrolling" onto itself, cylinder or spiral. What I have just schematically drawn, or decomposed, rather, is a movement of scrolling *and* stacking [*emboîtement*], of un-rolling and dislocating [*déboîtement*]. They have to be thought together, each closing and opening onto itself but deporting itself by this fact according to a deviation ceaselessly repeated, spoiling and deteriorating. The other, the double, the devil is in the box. Imagine a cylinder in an open cylinder, a manuscript or a drawing rolled in a cardboard box, a paralellepiped in a paralellepiped, then cartridges in an ammunition case, a matchbox. You open, close, open, find *this*.

The play of the supplement, the repetition of the deviation can go on *ad infinitum*, or *almost*, unless, with a "that's suffi-cient" you let the series stop one fine day, on such-and-such a

date, such-and-such an article, for example the 127th, in order to seal the crypt.

Which I leave intact for you, for I have decided not to touch it, truly.

<div align="right">2 January 1978</div>

They were expecting a *description:* of the late paradigm and all its retinue, article by article, and even of the series in *hiatus* which separates them forever one from another. Archipelago, absolute insularity, with the inlets of the sea between all these little coffins. But the contingent is made up, then exhibited, in its chance and its necessity, to do, haughtily (*quelle morgue*) without all discourse. How to explain the fact that on the market *and* in itself (if you were to insist on making this distinction), a masterpiece should not have been able to do without having itself a discursive cartouche, a *descriptive,* even one signed by the "author" in his privilege? How to explain it when it *remains,* through its function as defunct, what will have been able to do without it (no cartouche, (no) more cartouche) without ever being touched, understood, or even brushed by the assaults of eloquence, as impassive and invulnerable as it is to the houndings of the *trait?* The fact is perhaps that it was already in the grave, the cartouche.

And the descriptive. If I had wanted to describe, I should already have encountered, on top of the empirical difficulties you can imagine, the canonical difficulties of description in discourse on art. Now these are, in this unique case, affected by supplementary but essential complications. Here are half a dozen of them.

1. All the "arts" are put to work, sequential work, the arts of speech no less than the others and whatever their claims to nobility in the traditional classification (carpentry, sewing, locksmithery, sculpture, architecture, drawing, painting, literature, theater—a play in 127 acts—and I do not exclude music, and its canons, to the rhythm of a funeral march accompanying the procession). Try to describe.

2. The 127 articles are in themselves a sort of *described* movement, a journey from station to station, and describing (dis-scribing too). The coffin, the self-defining article. But this article, according to the exhibition's palindrome, only takes its value from the description which is emphatic, recommenced, insistent in its deviations. So it would be necessary to describe this singular description of an object which, in all certainty, does not exist

without description and outside it. Each description describes the object *and* itself, as much as its relation with another article; from that point on it always requires a descriptive supplement. No technical data card, no catalog will ever get the job done, as a matter of principle. No more than does the author himself, whose descriptive cartouche, exergue in the work, comes along to complicate the object with its associations, points of view, phantasmatic contingencies, etc. . . . , even if he intends to say "what matters . . . beyond phantasms." The author's debt, and my own, are also indescribable. No one will ever be quits faced with these remains.

That's enough for today. I notice, dating it, that the period during which I've been keeping this logbook coincides, two years on, with the period of his fasting, if one can put it like that: from 1 December 1975 to 9 January 1976, no drawing. Neither production nor reproduction. Complete abstinence. It's also the moment of the exhibition of a first lot, at Templon's. He gets back to it in January, with the fifty-ninth, (60 − 1: The Banana Plantation, 120/2).

Lot: nicely shared chance and necessity of this word which I should have used in order to gain a few signs. *Contingent* makes too long a procession merely to say just about the same thing, less well: no chance to share with the contingent.

As for "log book" [*carnet de bord*], I originally wanted to use it as a title, especially because of the silent *T* at the end, but one day in December I was lucky enough to read in a diary published by the Metropolitan Museum of Art the following description, for the picture of the week: "Box in the shape of a cartouche. Rising slightly above the gilded background of this wooden box are applied ebony and painted ivory hieroglyphs which render Tutankhamun's personal name and his regular epithet: 'Tut,' 'ankh,' 'Amun,' 'ruler of On of Upper Egypt.' "

<div align="right">7 January 1978</div>

When the date itself becomes the place of a crypt, when it stands in for it.

Will they ever know why I inscribe this at a given date? Throw of a *die*.

Le date [cf. *la date*, "the date"] has also been used [in French]: *le date* (the thing given, the *datum*). *There is* the date of today,

they'll never know anything about what was given to be lived in it—and taken away.

The date itself will stand in for a crypt, the only one that remains, save the heart.

In law, dating is said of the *place* of writing or signing for the engagement, the contract, the missive, the will. Who will ever know where I date this, today? There is the gift (*es gibt*) and there is also what, today, I will not have been able to give. And which, therefore, I want to keep better than ever.

8 January 1978
(Speed the process up today, finish before 9 January and then not one more sign. Phone call [*coup de fil*]: apparently the artwork of the casket, for the catalog and the reproductions, is already ready.)

3. Each descriptive assault, each 127th is entire. Unique, discrete, sufficient. I can't throw myself into the abyss of a patient analysis of each article. A unique series of unique objects: each time the *hiatus* maintains and *scores out* [*rature*], in the serial interlacing, the reference to the other (elsewhere I've suggested calling this *seriature*) and to the other's other. How to describe this *fold* of internal or citational reference? Of this transformational grammar?

4. Within the generic structure that I've tried to formalize (it's already not simple) the simulacrum of reference to the former model is affected with supplementary folds or deviations.

Four examples (ABCD).

A. One drawing takes as its "model" only another drawing, the one immediately preceding it, and *applies itself to copying it*, as if it were the only thing in the world and that was the only thing to do.

B. Another (5 October, the most fertile month, as if he were preparing for All Souls' Day, around his birthday) exhibits "real" cords: they do not belong to the element of the *trait* and, since they come from the skein used for the mahogany box, it's as if they were grafting, sewing, linking a piece of the paradigm, by a sort of synecdoche in relief, *onto* the body of the other; and, what's more, traversing a tracing! And even the support.

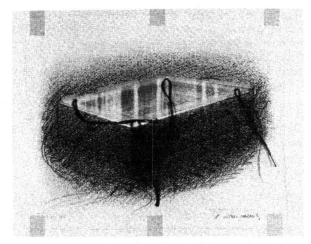

5 October 1975

27 March 1976

C. Others are made up of several drawings, or fragments of different drawings, readjusted or superimposed, casting into doubt even the unity of each article and broaching it in its very decomposition. In the superimposing of the reliefs—with effects which are each time singular—classify too the play of tracings (they are arranged above the altuglass, reframing or *rectifying* the angles of perspective, spread out, too, like a transparent shroud), the collages, the "real" staples, the palimpsestual overload of supports already covered with writing (27 March on headed notepaper from a hotel in Hammamet—the role of *opportunities* [and/or "occasions"] grasped in all that).

D. The broken [*morcelée;* or its homonym, *mort scellé(e)*— TRANS.], fragmented reference, not only to the elements (which can themselves always be decomposed) of *this* series, but of so many others. One example only: the wicker oval, the torture instrument for the two fledglings fallen from their nest and sacrificed on skewers, summons to appear, through its form, the O of the series H.I.O.X. ("O: encircle, surround. Nucleus of resistance. Maneuvre aimed at breaking the charm [magic circle]"). Etc.

I break off immediately a discourse called up by this "charm," by this word, and by this whole seduction of the dead in the name of Titus-Carmel.

I move from there to the cords (laces, bonds, tresses, ties, strings, threads) which multiply, dance, and sometimes rear up like the snakes above the Medusa's head, and go on to form elsewhere the most diverse figures (supple interlacings or stiff posture), to sketch out, break off, or call up all possible movements— or disappear, fall into the snare.

5. How to classify all the uses of these cords, all the senses in which they *take* or let themselves be taken? Their supple network [*filet*] structure puts you to the test. But not before already having shut you into a labyrinth. So many thongs, so many leashes.

Too much to say here, I give up. Like the rest, you can TAKE THEM OR LEAVE [*laisser*] THEM, in all ways.

They describe *in advance* all the movements by which your description might attempt to grasp hold of them and get its hands

on them. In vain would I try to *typify*, by their economy, the discourses I'm getting caught up in here, and which I've been getting caught up in elsewhere for a while. Three at least:

∝. A discourse on *stricture:* they are spread to bind the bit (or make it get a hard-on) [(*faire*) *bander le mors*], tightened *more or less* strictly, on both sides, in order to set up the ghost of a double bind or set it this trap involving "keys," which do not come without a *lock* [*serrure:* cf. too *serrer,* "to bind, to tighten"]. Same lacing in other series and, *within,* around the two bodies skewered *in mirror image.*

β. A discourse on the *lacs* [snare], lacing as stricture *interlacing* the inside and the outside, the above and the below, the right and the left. Once this *crossing* of the partition (at six points in this case) has been put to work, all the reassuring joints of discourse on art, all the limits authorizing framing, all the borders of prop(ri)e(r)ty are dislocated. I've attempted to ex-pose this elsewhere, apropos of another series of take-it-or-leave(lace)-it vehicles, vehicles to be returned, rather, full of undone laces and crossed eyelets, Van Gogh's shoes.

γ. A discourse on the *series:* not the series of cords, but the cord (*series* or *seira*) as eponymous figure of the serial interlace (I remember now that the eponym gives its name to a year). Before being carried off or put into the ground by the undertakers (cords hanging, then stretched to breaking point), before even being able to recognize anything in it ("fringes," "dribbles [*filets*] of slobber" or "palls," proposes the Master of the Works), it will have remained, crossing each *board* (each table, each picture [*tableau*]), the emblem of seriature. Supplementarity of interlacing (between the three discourses above just as well) allowing no respite to the *typos,* the paragon, description. The supplement *transforms* and *detaches.* Both at once.

6. *No repose either for a classification.* It will have been noticed that this coffin ensures no rest for the remainder. Not even the last rest, that of the last dwelling place. All genealogies come down to classifying and we know, of course, the author's taste for taxonomy. One could then be tempted to arrange all

the articles of the panoply and exhibit the panoptic in a tableau. With multiple entry points, with interlaced Ariadne threads. One would take one's bearings as follows, according to at least *six perspectives:*

1. According to the *techniques* (charcoal, more or less broad pencil, graphite lead, instruments for doing it yourself, for sticking, stapling, piercing, tracing, gouaches, watercolors, white pencil and eraser).

But these techniques cross over each other, overprint, *parasitize* each other, and they are also materials, and he uses the support as a technical means.

2. According to the *perspectives* (some angles are favored and form families of subtypes, profiles of profiles).

But the law of displacement is itself displaced. In terms of what "truth" are these angles to be ordered? There are only perspectives with no referent outside perspective. What is one to term "the front," "the profile," overview, top or bottom, left or right, of a cenotaph? The orientation of a body proper no longer holds sway here. At bottom, it's a coffin without *core* [Eng.], without a central, organizing nucleus.

3. According to the *supports* (a great variety of papers, they are of diverse size, value, thickness, and even color.

But there is not only paper, there are pieces borrowed from the skein of the ligneous paradigm (does this count as support or not?); and the support, which in principle is neither ground nor figure, often partakes of the one *and* the other; it is sometimes pierced, crossed, torn in its solidity as substratum, stove in like the coffin it supports and which can no longer be framed.

4. According to the *presence* or the *absence* of certain features (for example the caskets drawn (or made) with or without cords, with or without mirror, with or without tracing (veil one's face before the impossibility of deciding whether, in the first instance, [*au premier chef*], tracing is a trait, a ground, a figure, etc., or what element it belongs to), with or without writing (legible or not), etc.).

But the number of features cannot be delimited, each is the re-*trait* of all the others, it cites, classifies, describes *another* series, and above all *haunting* lays down the law, the absent

one insists more than an other, obsesses, besieges, *with* equals *without* (hyphen [*trait d'union*]: *with-out* [Eng.]).

5. According to *dimensions* (the frames can make them equal, but they're of all calibers).
But we have seen why the smallest is larger than the largest, thus *annulling* its own consequence.

6. According to the *rhythms* (the dates, the accelerations, the decelerations or the empty time segments, the grouping of the typified sub-sequences during such and such a period, etc.).
But this would involve relying on the order of a narrative whose trap has been situated by the logic of the cartouche. And the family-like gatherings also occur over long intervals. The unity of a period (of a detour) is indeterminable.
THE coffin will thus have remained *unclassifiable.* Each article opens a hand of *perforated* cards for the transformation of the other, which itself . . . and so forth.

8 January 1978
Tombe ["tomb" or "fall(s)"], in the snare.

8 January 1978
What will not be classified can no longer be framed. Elsewhere, since long ago, the play of the frame [*cadre*], the quarter, of cards and charter, in dissemination. And the *Spiegelspiel* of the "Quadriparti" or the "Cadran" (*Geviert*).

Put his proper name, beginning with the *quarter*, in my pocket, whole or part.

The play of three and four. Don't forget the tables, and the fact that you can't bank on [*tabler sur*] a cartouche, nor count on it or take it into account. I remember Kant's difficulties between the tables and the *parergon*. No more forget: $3 \times 4 = 12$, and $3 + 4 = 7$.

Offprinted [*tiré à part*], the announcement [*faire-part*] of mourning. One hundred and twenty-seven times like a salvo of black-edged missives.
It gets sent [*Ça s'envoie*], someone or something, sent to itself or oneself, to make oneself a party to [*se faire part*] the legacy which will have laid you all down, me too, and so on.

Send oneself [*s'envoyer;* also, "get landed with," "make it with"] the remainder, that's [the] desire, and its impossibility. The missile can always not come back, not arrive, nor the missive, nor even the emissary.

Study the structure of the LEM.

The flying coffin as means of transport, a *vehicle,* as the rhetoricians say, good for all conditions. We've checked this out: ship's hull (or "wreck"), rocket (when it buries itself a little after the fall), fire, water, air, earth, for in the end—

8 January 1978

A sort of lift, with or without a safety cable [*câble parachute*]. With or without an umbilical cord.

9 January 1978

IN WHICH THINGS HOT UP—DON'T PULL ALL THE STRINGS.

10 January 1978

And I shall add, and don't put your foot right down. Landing impossible today.

Uncompromising [*intraitable*]: the umbilicus of *this* coffin, this one here, of each one withdrawn in its crypt. Whip it as you will, the thongs leave [*laissent*] a mark but do nothing. So many leashes [*laisses*]. The block of the coffin, closed like a mute dictionary. Open at entry *laisse. Laisse,* it says: *voir* [allow to be seen], *faire* [allow to (be) do(ne)], *tomber* [let it drop], *pour compte* [reject], *en héritage* [leave as a legacy] (*lais* [an old French form of *legs,* legacy]). He holds all these words on a leash, more or less stretched, more or less loose, to each its chance and toward its end. I think of the Supper and the thirteenth at table.

11 January 1978

Unclassifiable. No burial without a classificatory arrangement, without an ordered series, without tabulation. Otherwise it's just a mass grave. The coffin circulates, cursor and ruptor, hyphen between the cemetery and the communal burial pit. Class is not lacking, that's the least one can say, it is at work (order, series, lineage, chronology, taxonomy, rank, row, arrangement, with and without hierarchy). But what no longer comes under class [*n'en relève plus*] and what it will never recover from [*dont elle ne se relève plus*], is perhaps *fate* [*le sort*]. The fate it suffers, the fate cast upon it, the fate cast of it.

It will no longer be possible to place it in a nomenclature, catalog, or classification table, I would at least have wanted to work at it. On an operating table, perhaps, and again, but without an anatomy lesson.

"No" should have been said, here, to exhibition in pictures. But in any case, will it have taken place? and so on, etc.

11 January 1978

Hear aright the chance and the necessity of a "that's sufficient." It's *enough,* but without satisfaction; and which does not saturate. Nothing to do with sufficiency or insufficiency. The verb *to suffice* will teach you nothing about such a "that's sufficient."

The coffin's unheard: on 11 July (he had made 111 little ones and 16 big ones), faced with the thing turned round into a blackboard, upside-down, feet in the air and eyelets wide open, Titus-Carmel must have murmured, if I hear aright, "that's sufficient."

11–12 January 1978

So for the remainder—and otherwise.

The author in front of *The Great Cultural Banana Plantation*. The "model": decomposing in the right-hand corner, above his head.

The Four Season Sticks. Here, a Summer Stick: Knotted at Both Ends.

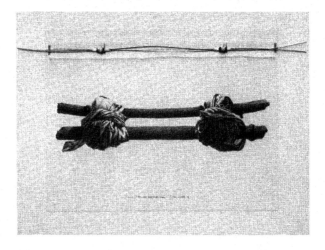

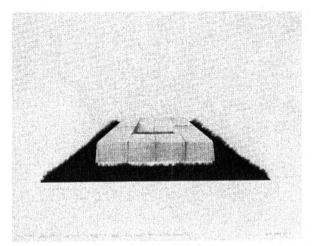

18 Mausoleums for 6 New York Taxi Drivers—Mausoleum Modesto Hernandez No. 3.

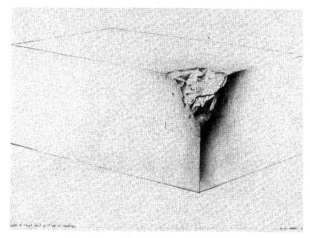

20 *Variations on the Idea of Deterioration*, Drawing 12.

17 *Examples of Alteration of a Sphere*—Ninth Alteration.

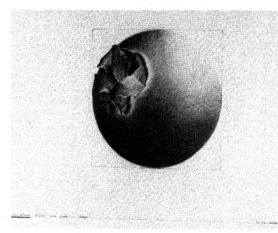

The Use of the Necessary—Lachesis 4.

The Use of the Necessary—*Léon, émir cornu d'un roc, rime Noël,*
1972. [Literally translated: "Leon, horned emir of a rock, rhymes Christmas";
but the point of the statement is that it is a palindrome.—TRANS.]

H.I.O.X.—O.

Dismantling—Dismantling 6.

15 Latin Incisions—Lucretius (detail).

Restitutions of the truth in pointing [*pointure*]

for J.C. sztejn

"POINTURE (Latin *punctura*), sb. fem. Old synonym of prick. Term in printing, small iron blade with a point, used to fix the page to be printed on to the tympan. The hole which it makes in the paper. Term in shoemaking, glovemaking: number of stitches in a shoe or glove."

Littré.

"I owe you the truth in painting, and I will tell it to you."

Cézanne

"But truth is so dear to me, and so is the *seeking to make true,* that indeed I believe, I believe I would still rather be a cobbler than a musician with colors."

Van Gogh

The first part of this "polylogue" (for $n + 1$—female—voices) was published in no. 3 of the journal *Macula*, as part of a group of articles entitled *Martin Heidegger and the Shoes of Van Gogh*. In it, I take my pretext from an essay by Meyer Shapiro published in the same issue of *Macula* under the title "The Still Life as a Personal Object." This is a critique of Heidegger, or more precisely of what he says about Van Gogh's shoes in *The Origin of the Work of Art*. Shapiro's article, dedicated to the memory of Kurt Goldstein ("who was the first," says the author, "to draw my attention to this essay [*The Origin of the Work of Art*] presented in a lecture-course in 1935 and 1936"), first appeared in 1968, in *The Reach of Mind: Essays in memory of Kurt Goldstein* (New York: Springer Publishing Company).

TRANSLATORS' NOTE.—Unless followed by the author's initials, all notes to "Restitutions" have been added by the translators. Translations from Heidegger take account of Derrida's French versions. The translators have however consulted the English translation of *The Origin of the Work of Art* by Albert Hofstadter, in Martin Heidegger, *Poetry, Language, Thought* (New York: Harper and Row, 1971).

— And yet. Who said—I can't remember—"there are no ghosts in Van Gogh's pictures"? Well, we've got a ghost story on our hands here all right. But we should wait until there are more than two of us before we start.

— Before we get going at the double [*pour appareiller*], you mean: we should wait until there are even more than three of us.

— Here they are. I'll begin. What of shoes? What, shoes? Whose are the shoes? What are they made of? And even, who are they? Here they are, the questions, that's all.

— Are they going to remain there, put down, left lying about, abandoned [*délaissées*]? Like these apparently empty, unlaced [*délacées*] shoes, waiting with a certain detachment for someone to come, and to say, to come and say what has to be done to tie them together again?

— What I mean is, there will have been something like the pairing of a correspondence between Meyer Schapiro and Martin Heidegger. And that if we take the trouble to formalize a little, that correspondence would return to the questions I've just laid down.

— It would return to them. *Returning* will have great scope [*portée*] in this debate (and so will *scope*), if, that is, it's a matter of knowing to whom and to what certain shoes, and perhaps shoes

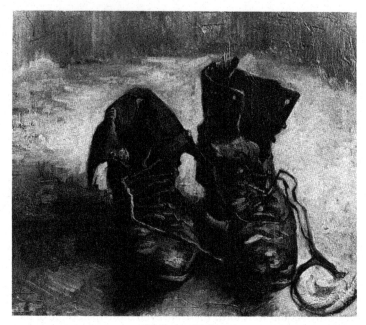

Old Shoes with Laces.

in general, *return*. To whom and to what, in consequence, one would have to *restitute* them, render them, to discharge a debt.

— Why always say of painting that it renders, that it restitutes?

— to discharge a more or less ghostly debt, restitute the shoes, render them to their rightful owner; if it's a matter of knowing from where they *return*, from the city (Schapiro) or the fields (Heidegger), like rats, which I suddenly have an idea they look like (then who is these rats' Rat Man?), unless it is rather that they look like snares [*pièges à lacets*] lying in wait for the stroller in the middle of the museum (will s/he be able to avoid being in too much of a hurry and catching his/her feet in them?); if it's a question of knowing what revenue is still produced by their out-of-service dereliction, what surplus value is unleashed by the annulment of their use value: *outside* the picture, inside the *picture*, and, third, as a picture, or to put it very equivocally, *in their*

painting truth; if it's a question of knowing what ghost's step [*quel pas de revenant*], city dweller or peasant, still comes to haunt them ("the ghost of my other I," the other I of Vincent the signatory, as Schapiro suggests quoting Knut Hamsun—but Heidegger also does this, elsewhere); if it's a question of knowing whether the shoes in question are haunted by some ghost or are ghosting/returning [*la revenance*] itself (but then what are, who are in truth, and whose and what's, these things?). In short, what does it all come down to [*ça revient à quoi*]? To whom? To whom and to what are we to restitute, to reattach, to readjust precisely

— to what shoe size exactly, made to measure, adequately

— and where from? How? If at least it's a question of knowing, returning will be from long range [*d'une longue portée*].

What I'm saying is that there will have been a correspondence between Meyer Schapiro and Martin Heidegger.

One of them says in 1935: that pair comes back to/belongs to/amounts to the peasant, and even the peasant woman

— what makes him so sure that they are a *pair of* shoes? What is a pair?

— I don't know yet. In any case, Heidegger has no doubt about it; it's a pair-of-peasant-shoes (*ein Paar Bauernschuhe*). And *ça revient*, this indissociable whole, this paired thing, from the fields and to the peasant, man or even woman. Thus Heidegger does not answer one question, he is sure of the thing before any other question. So it seems. The other one, not agreeing at all, says after mature reflection, thirty-three years later, exhibiting the juridical exhibits (but without asking himself any questions beyond this and without asking any other question): no, there's been an error and a projection, if not deception and perjury, *ça revient*, this pair, from the city

— what makes him so sure that it's a *pair of* shoes? What is a pair, in this case? Or in the case of gloves and other things like that?

— I don't know yet. In any case, Schapiro has no doubts about this and lets none show. And according to him, *ça revient*, this pair, from the city, to some city dweller and even to a particular

"man of the town and city," to the picture's signatory, to Vincent, bearer of the name Van Gogh as well as of the shoes which thus seem to complete/complement him, himself or his first name, just when he takes them back, with a "they're mine" [*"it's coming back to me": ça me revient*], these convex objects which he has pulled off his feet

— or these hollow objects from which he has withdrawn himself.

— It's only just beginning but already one has the impression that the pair in question, if it is a pair, might well not come back to anyone. The two things might then exasperate, even if they were not *made in order to* disappoint, the desire for attribution, for reattribution with surplus value, for restitution with all the profit of a retribution. Defying the *tribute*, they might well be made in order to remain-there.

— But what does *remain* mean in this case?

— Let us posit as an axiom that the desire for attribution is a desire for appropriation. In matters of art as it is everywhere else. To say: this (this painting or these shoes) is due to [*revient à*] X, comes down to [*revient à*] saying: it is due to me, via the detour of the "it is due to (a) me." Not only: it is properly due to such-and-such, man or woman, to the male or female wearer ("Die Bäuerin auf dem Acker *trägt* die Schuhe. . . . Die Bäuerin dagegen *trägt* einfach die Schuhe," says the one in 1935, "They are clearly pictures of the artist's *own* shoes, not the shoes of a peasant," replies the other in 1968, my emphasis), but it is properly due to *me*, via a short detour: the identification, among many other identifications, of Heidegger with the peasant and Schapiro with the city dweller, of the former with the rooted and the sedentary, the latter with the uprooted emigrant. A demonstration to be followed up, for let us have no doubt about this, in this restitution trial, it's also a question of the shoes, or even the clogs, and going only a little further back for the moment, of the feet of two illustrious Western professors, neither more nor less.

— It's certainly a question of feet and of many other things, always supposing that feet are something, and something identifiable with itself. Without even looking elsewhere or further

back, *restitution* reestablishes in rights or property by placing the subject upright again, in its stance, in its institution. "The erect body," writes Schapiro.

— Let us then consider the shoes as an institute, a monument. There is nothing natural in this product. In the analysis of this example, Heidegger is interested in the product (*Zeug*). (As a convenient simplification, let us retain the translation of *Zeug* as "product." It is used in the [French] translation of *Holzwege*, for the translation of *The Origin of the Work of Art*. *Zeug*, as we must specify and henceforth remember, is doubtless a "product," an artifact, but also a utensil, a generally useful product, whence Heidegger's first question on "usefulness.") Speaking of this artifact, the one says, before even asking himself or posing any other question: this pair is due to the one (male or female). To the other, replies the other, proof in hand but without further ado, and the one does not amount to the same thing as [*ne revient pas à*] the other. But in the two attributions it does perhaps amount to the same thing via a short detour, does perhaps come down to a subject who says me, to an identification.

— And these shoes concern them [*les regardent:* literally, "look at them"]. They concern us. Their detachment is obvious. Unlaced, abandoned, detached from the subject (wearer, holder or owner, or even author-signatory) and detached/untied in themselves (the laces are untied)

— detached from one another even if they are a pair, but with a supplement of detachment on the hypothesis that they don't form a pair. For where do they both—I mean Schapiro on one side, Heidegger on the other—get their certainty that it's a question here of a pair of shoes? What is a pair in this case? Are you going to make my question disappear? Is it in order not to hear it that you're speeding up the exchange of these voices, of these unequal tirades? Your stanzas disappear more or less rapidly, simultaneously intercut and interlaced, held together at the very crossing point of their interruptions. Caesuras that are only apparent, you won't deny it, and a purely faked multiplicity. Your periods remain without enumerable origin, without destination, but they have authority in common. And you keep me at a distance, me and my request, measuredly, I'm being avoided like a catastrophe. But inevitably I insist: *what is a pair in this case?*

— detached in any case, they concern us/look at us, mouth
agape, that is, mute, making or letting us chatter on, dumbstruck
before those who make them speak (*"Dieses hat gesprochen,"*
says one of the two great interlocutors) and who in reality are
made to speak by them. They become as if sensitive to the comic
aspect of the thing, sensitive to the point of imperturbably re-
strained hilarity. Faced with a procedure [*démarche*] that is so
sure of itself, that cannot in its certainty be dismantled, the thing,
pair or not, laughs.

— We should return to the thing itself. And I don't know yet
where to start from. I don't know if it must be talked or written
about. Producing a discourse/making a speech on the subject of
it, on the subject of anything at all, is perhaps the first thing to
avoid. I've been asked for a discourse. They've put a picture (but
which one exactly?) and two texts under my nose. I've just read,
for the first time, "The Still Life as a Personal Object: A Note on
Heidegger and Van Gogh." And reread, once again, *Der Ursprung
des Kunstwerkes.* I won't here write the chronicle of my previous
readings. I'll retain from them only this, in order to get going. I
have always been convinced of the strong necessity of Heidegger's
questioning, even if it *repeats* here, in the worst as well as the
best sense of the word, the traditional philosophy of art. And
convinced of its necessity, perhaps, to the very extent that it does
this. But each time I've seen the celebrated passage on "a famous
picture by Van Gogh" as a moment of pathetic collapse, derisory,
and symptomatic, significant.

— Significant of what?

— No hasty step here, no hurrying pace toward the answer.
Hurrying along [*la précipitation du pas*] is perhaps what no one
has ever been able to avoid when faced with the provocation of
this "famous picture." This collapse interests me. Schapiro also
detects it in his own way (which is also that of a detective) and
his analysis interests me thereby, even if it does not satisfy me.
In order to answer the question of what such a collapse signifies,
will we have to reduce it to a dispute over the attribution of the
shoes? Will it be necessary, in painting or in reality, to fight over
the shoes? Necessary to ask oneself only: who(se) are they? I
hadn't thought of this but I now find myself imagining that, de-

spite the apparent poverty of this quarrel over restitution or of
this trafficking in shoes, a certain deal done might well make
everything pass through it. In its enormity, the problem of the
origin of the work of art might well pass through these lace holes,
through the eyelets in the shoes (in a painting) by Van Gogh. Yes,
why not? But on condition that this treatment, of course, should
not be abandoned to the hands of Martin Heidegger or to the hands
of Meyer Schapiro. I do say "not be abandoned," for we intend to
make use of their hands, too, or even, what's more [au reste] of
their feet.

The choice of the procedure to adopt is difficult. It slides
around. What is certain is that there will have been correspon-
dence between Heidegger and Schapiro. And that there is here
something like a pairing-together in the difference of opinion, the
enigma of a complementary fitting-together of the two sides, of
one edge to the other. But I still don't know where to start from,
whether I must speak or write about it, nor, above all, in what
tone, following what code, with a view to what scene. And in
what rhythm, that of the peasant or that of the city dweller, in
the age of artisanal production or that of industrial technology?
Neither these questions nor these scruples are outside the debate
begun by Heidegger around the work of art.

But do I really want to undertake this procedure?

I shall begin by fixing a certainty that looks axiomatic. Set-
tling myself in it as though in a place where things appear not to
move, where things no longer slide around, I'll set off from there
(very quickly), having blocked one of my feet in that place, one
of my points, immobile and crouched before the starter's gun.
This place which I begin by occupying slowly, before the race,
can here only be a place of language.

Here it is. Questions about awkward gait (limping or shifty?),
questions of the type: "Where to put one's feet?" "How is it
going to work [marcher]?" "And what if it doesn't work?"
"What happens when it doesn't work (or when you hang up
your shoes or miss them with your feet)?" "When—and for
what reason—it stops working?" "Who is walking?" "With
whom?" "With what." "On whose feet?" "Who is pulling whose
leg? [qui fait marcher qui?]" "Who is making what go? [qui
fait marcher quoi?]" "What is making whom or what work?"
etc., all these idiomatic figures of the question seem to me,
right here, to be necessary.

Necessary: it's an attribute.

— So are the shoes. They're attributed to a subject, tied on to that subject by an operation the logico-grammatical equivalent of which is more or less relevant.

— *Necessary* remains an adjective which is still a little vague, loose, open, spreading. It would be better to say: question-idioms the form of which is very *fitting*. It fits. It adjusts, in a strict, tight, well-laced fashion, clinging tightly but flexibly, in vocabulary, letter, or figure to the very body of what you here wish to turn into an object, that is, feet. Both feet, that is of the first importance.

— But you don't say a pair of feet. You say a pair of shoes or gloves. What is a pair in this case, and where do they both get the idea that Van Gogh painted a pair? Nothing proves it.

— For my part, I've often dealt, in all senses, with *march* [*la marche:* "walking," "the step"] and with—it's just about the "same" word, the "same" sense—the mark and the *Margins* which I made into a title. Even "Pas" ["step(s)," "not(s)"] was another. Did I talk about feet then? I'm not sure (I'll have to look); nor am I sure of having talked about a certain necessity, that's the word, of walking, namely, closest to the ground, the lowest degree, the most subjective or underlying level of what's called culture or the institution, the shoe. More strictly, the pair of shoes

— "The Double Session" turns around the points of the ballerina, analyzes "the syntax of point [none] and step [not] [*la syntaxe du point et du pas*]," tells how "each pair, in this circuit, will always have referred to some other, signifying too the operation of signifying. . . ."

—But the point does not bring the foot into contact with a surface. It doesn't spread out on a surface. More strictly, the pair of shoes and even, to limit oneself to what supports the base of the feet above the ground—of towns or fields, it makes little difference—the pair of soles. Its external, and thus lower, surface goes lowest and that's what I think I've never talked about. It is lower than the foot.

I advance, then: what of shoes when it doesn't work/when they don't walk? When they are put on one side, remaining for a

greater or lesser period, or even forever, out of use? What do they
mean? What are they worth? More or less? And according to what
economy? What does their surplus (or minus) value signal toward?
What can they be exchanged for? In what sense (whom? what?)
do they *faire marcher?* and make speak?
There's the subject, announced.
It returns slowly. But always too quickly—precipitate step/
no hurry [*pas de précipitation*]—headfirst to occupy upright, in-
stantaneously, the abandoned places; to invest and appropriate
the out-of-use places as though they remained unoccupied only
by accident, and not by structure.
The subject having been announced, let's leave the shoes here
for a while. Something *happens*, something *takes place* when
shoes are abandoned, empty, out of use for a while or forever,
apparently detached from the feet, carried or carrying, untied in
themselves if they have laces, the one always untied from the
other but with this supplement of detachment on the hypothesis
that they do not make a pair.

— Yes, let us suppose for example two (laced) right shoes or
two left shoes. They no longer form a pair, but the whole thing
squints or limps, I don't know, in strange, worrying, perhaps
threatening and slightly diabolical fashion. I sometimes have this
impression with some of Van Gogh's shoes and I wonder whether
Schapiro and Heidegger aren't hastening to make them into a pair
in order to reassure themselves. Prior to all reflection you reassure
yourself with the pair.

— And then you know how to find your bearings in thought.[1]

— As soon as these abandoned shoes no longer have any strict
relationship with a subject borne or bearing/wearing, they become
the anonymous, lightened, voided support (but so much the heav-
ier for being abandoned to its opaque inertia) of an absent subject
whose name returns to haunt the open form.

— But precisely, it is never completely open. It retains a form,
the form of the foot. Informed by the foot, it is a form, it describes
the external surface or the envelope of what is called a "form,"

1. A reference to Kant's 1786 article "Was heisst: sich in Denken
orientiren," translated into French as *Qu'est-ce que s'orienter dans la
pensée*, trans. A. Philonenko, 4th ed. (Paris: Vrin, 1978).

that is, and I quote Littré again, a "piece of wood in the shape [*figure*] of a foot which is used to assemble a shoe." This form or figure of the foot

— Schapiro will see the "face" [*la figure*] of Van Gogh in "his" shoes.

— This wooden "form" or figure of the foot replaces the foot, like a prosthesis whose shoe remains ever informed. All these ghost-limbs come and go, go more or less well, don't always fit.

— So what is one doing when one attributes shoes? When one gives or restitutes them? What is one doing when one attributes a painting or when one identifies a signatory? And especially when one goes so far as to attribute painted shoes (in painting) to the presumed signatory of that painting? Or conversely when one contests his ownership of them?

— Perhaps this is where there will have been correspondence between Meyer Schapiro and Martin Heidegger. I've an interest in its having taken place. Apparently. But we don't yet know what this place is and what "to take place" signifies in this case, where, how, etc.

—The question's just been asked: what is one doing when one attributes (real) shoes to the presumed signatory of a painting which one presumes to represent these same shoes? Let's be more precise: *subject*-shoes (*support* destined to bear their wearer on the ground, of towns or fields, support which would here figure the first *substratum*, unless the wearer put them to a use other than that of walking, in which case the word "use" would, according to some, run the risk of perversion) but itself the subject of a canvas which in turn constitutes its subject or framed support. And it is this double *subject* (shoes in painting) that the two litigants want to see restituted to the true subject: the peasant man or woman on the one side, the city-dwelling painter on the other (a bit more of a subject through being the signatory of the picture supposed to represent his own shoes, or even himself in person: all the subjects are here as close as can be to themselves, apparently).

Where is the truth of this taking-place? *The Origin of the Work of Art* belongs to a great discourse on place and on truth.

Through everything just announced, it can be seen to commu-
nicate (without its "author" 's knowing it?) with the question of
fetishism, extended beyond its "political economy" or its "psy-
choanalysis" in the strict sense, or even beyond the simple and
traditional opposition of the fetish with the thing itself.
Everything points to a desire to speak the truth about the
fetish. Will we take the risk of trying to do so here?

— To do that we should have to let this debate between the
two great professors resonate with so many other texts. Marx,
Nietzsche, Freud

— who speaks more strictly of the fetishism of the shoe. In
the first part, or the first movement, of his 1927 essay on *Fetish-
ism*. The genealogy which he proposed at that time for the fetish
(as a substitute for the woman's or the mother's phallus) also,
according to him, accounts for the privilege accorded the foot or
shoe

— the shoes or the shoe?

— the shoe. This preference, according to Freud, hangs on the
fact that in the terrifying experience he has had of what he lives
as his mother's "castration," the "boy" looked "from below."
Slowly, he raised his eyes. From the ground.

— The shoe, as compromise or reassuring substitute, would
thus be a "form" of prosthesis, but always as a penis and a wom-
an's penis. Detachable and reattachable. How then do we explain
that in the *Introductory Lectures* ("Symbolism in Dreams" [lec-
ture 10]) the shoe and the slipper should be classified among the
symbols of the female genital organs? Ferenczi sometimes rec-
ognizes in it the vagina (*Sinnreiche Variante des Schuhsymbols
der Vagina*, 1916), but that is only an individual variant, and,
conversely, one would have to specify—

— Could it be that, like a glove turned inside out, the shoe
sometimes has the convex "form" of the foot (penis), and some-
times the concave form enveloping the foot (vagina)?

— In these later texts, it is not a question of fetishism (the
mother's phallus), and when it *is*, Freud does not say that the foot

(or the shoe) replaces what is supposed to be lacking *because of its form* but because of its *directional situation*, the syntax of a movement upwards, from the very-low, the most-low, a system of relationships in the alleged generation of the fetish. And Freud does not then designate something, a more or less detachable whole, for example "the foot" or "the shoe." He specifies: "or a part of these," the relatively detachable part of an always *divisible* ensemble.

— The big toe, for example? Doesn't the shoe by itself play the role of a detached big toe? In this market of sizes [*de la pointure*], the resonance of offers, demands, stocks rising or falling ought to have added to it a speculation on Bataille (*The Big Toe, Sacrificial Mutilation and Van Gogh's Severed Ear, Van Gogh as Prometheus*).

— In any case *the* shoe, for Freud, is no more the penis than it is the vagina. Of course he recalls, against Steckel, that certain symbols cannot be *at the same time* both masculine and feminine. Of course he specifies that long, firm objects (weapons, for example) could not symbolize female genital organs, nor hollow objects (cases, boxes, coffers) masculine organs. But he does so only to admit immediately afterwards that bisexual symbolization remains an irrepressible, archaic tendency, going back to childhood which is ignorant of the difference of the sexes (*Traumdeutung*, VI, V). "Let us add here that most dream-symbols are bisexual and can, according to the circumstances, be referred to the organs of both sexes" (*Über den Traum*). According to the circumstances, in other words also according to a syntax irreducible to any semantic or "symbolic" substantiality.

— So it is always necessary to hold in reserve a sort of excess of interpretation, a supplement of reading—which is decisive, to tell the truth—for the idiom of a syntactic variation. Even if absolute idiom is the name of a lure. The absolute "pas d'idiome" does not authorize us—quite the contrary—to be content with symbolic equivalences always ready-to-wear, or with off-the-peg universals. This is perhaps the sense of a little phrase in brackets and as if it were a postscript, at the end of Ferenczi's note, in which he distinguishes individual variants from universal symbols. This distinction depends on the wealth of associations (*"sich an sie reichlich Einfälle assoziiren"*) but this economic criterion

concerns variations which are also deviations [écarts], restructurations, general redistributions. And deviations *without* an essential *norm.* Network of differential traces. (I specify, also in parentheses, that the case evoked by Ferenczi does not bring shoes *stricto sensu* on stage, but in some sense overshoes, supplements, or overgarments (*Gummi-Überschuh* (*Galoschen*)) which fit not onto the feet but onto the shoes. When it's raining or snowing one leaves them in the hall while nonetheless retaining one's shoes. And—a trait which is important if not sufficient for the interpretation—this overshoe or surplus shoe is made of rubber. Whence, according to Ferenczi, the vagina symbolism. It remains to be discovered, and this is to be followed up, whether this sheath effect—

— Taking into account what has just been said of the "pas d'idiome" but also against symbolic universals, it goes without saying that we shall remain far, very far, from an idiomatic reading of Van Gogh, of his signature or *a fortiori* of a particular picture. It will only be a question, as with what was said and done with regard to Genet, Ponge, or Blanchot, of preliminaries to the posing of such a question. It is a question that has to be entirely reelaborated: we do agree about that, don't we?

— Agreed or not, I suggest putting this question off [*remettre*] until later. It is moreover made to be *put off,* since it concerns the putting-off until later, further on, if ever one gets there. I believe it to be a very scientific question but also one that is foreign to what is most often said *in the name of science,* that is, of a philosophy of science.

— There are two types of object and the "form" of the shoe has another privilege: it combines in a system the two types of object defined by Freud: elongated, solid or firm on one surface, hollow or concave on the other. It turns inside out

— like a pair of gloves. Van Gogh painted a pair (?) of gloves (in January 1889, in Arles) and in the note which he devotes to it, Schapiro again seems to consider them to be "personal objects." He reappropriates them, hastens to pair them up, and even to pair them with the cypresses which appear in the same still life ("The choice of objects is odd, but we recognize in it Van Gogh's spirit. In other still lives he has introduced objects that *belong to him*

(my emphasis—J.D.) in an intimate way—his hat and pipe and tobacco pouch. . . . His still lives are often personal subjects, little outer pieces of the self exposed with less personal but always significant things. Here the blue gloves, *joined like two hands* (my emphasis—J.D.) in a waiting passive mood, *are paired in diagonal symmetry* with a branch of cypress, a gesticulating tree that was deeply poetic to Van Gogh . . . the gloves and the branches *belong together . . ."* (my emphasis—J.D.)).[2]

— I suggest that we don't yet risk dealing directly with this question of fetishism, with the reversibility of gloves, or with directionality in the pair. For the moment I'm interested in the correspondence between Meyer Schapiro and Martin Heidegger.

— We're marking time. We're not even sliding around, we're floundering, rather, with a slightly indecent complacency. To what are we to relate this word "correspondence" which keeps on returning? To this exchange of letters in 1965?

Still Life (basket with oranges and lemons, branches, gloves).

2. Meyer Schapiro, *Van Gogh* (New York: Abrams, n.d.), 92.—J. D.

— I would be interested rather in a secret correspondence, obviously: obviously secret, encrypted in the ether of obviousness and truth, too obvious because in this case the cipher remains secret because it is not concealed.

In short, again entrusted to the purveyor of truth, this correspondence is a secret for no one. Its secret ought to be readable in black and white [à lettre ouverte]. The secret correspondence could be deciphered *right on the level of* the public correspondence. It does not take place anywhere else and is not inscribed elsewhere. Each of them says: I owe you the truth in painting and I will tell it to you. But the emphasis should be placed on the debt and on the *owe* [*doit: il doit* means "he must," "he ought," "he should," and also "he owes"], the truthless truth of truth. What do they both owe, and what must they discharge through this restitution of the shoes, the one striving to return them to the peasant woman, the other to the painter?

Yes, there was indeed that exchange of letters in 1965. Schapiro reveals it in "La nature morte," which is how one must translate into French "The Still Life," which you have just read. This "Dead Nature," the essay which bears this title, is a homage rendered, a present made to one dead, a gift dedicated to the memory of Kurt Goldstein, who had, during his lifetime, earned Schapiro's gratitude by this gesture at least: having given him *The Origin of the Work of Art* to read ("It was Kurt Goldstein who first called my attention to this essay . . ."). In a certain way, Schapiro discharges a debt and a duty of friendship by dedicating his "Dead Nature" to his dead friend. This fact is far from being indifferent or extrinsic (we shall return to it), or at least the extrinsic always intervenes, like the *parergon*, within the scene. Remember these facts and dates. Meanwhile, I shall pick out a few of them drily. Having emigrated when very young, Schapiro teaches at Columbia (New York) where Goldstein, fleeing Nazi Germany in 1933 (having been imprisoned there, and then freed on condition of leaving the country) himself taught from 1936 to 1940. He arrived there after a painful stay of one year in Amsterdam, precisely. He wrote *The Structure of the Organism* there. These are the very years in which Heidegger was giving his lectures on *The Origin of the Work of Art* and his *Introduction to Metaphysics* course (the two texts in which he refers to Van Gogh).

This last act happens, then, in New York, Columbia University, where, unless I'm mistaken, Schapiro was already living and

working when Goldstein arrived to teach from 1936 until his death, with a break during the war (Harvard and Boston from 1940 to 1945). This last act

— Is it the last?

— At the present date,[3] the last act is in New York, at this great university institution, Columbia, that has welcomed so many emigrant professors, but what a trip and what a story, for almost a century, for these shoes of Van Gogh's. They haven't moved, they haven't said anything, but how they've made people walk and talk! Goldstein, the aphasia-man, who died aphasic, said nothing about them. He simply indicated, pointed out Heidegger's text. But it all looks just as if Schapiro, from New York (where he also delivered Goldstein's funeral oration in 1965), was disputing possession of the shoes with Heidegger, was taking them back so as to restitute them, via Amsterdam and Paris (Van Gogh in Paris) to Van Gogh, but *at the same time [du même coup]* to Goldstein, who had drawn his attention to Heidegger's hijack. And Heidegger hangs onto them. And when both of them say, basically, "I owe you the truth" (for they both claim to be telling the truth, or even the truth of the truth—in painting and in shoes), they also say: I owe the shoes, I must return them to their rightful owner, to their proper belonging: to the peasant man or woman on the one side, to the city-dwelling painter and signatory of the painting on the other. But to whom in truth? And who is going to believe that this episode is merely a theoretical or philosophical dispute for the interpretation of a work or The Work of art? Or even a quarrel between experts for the attribution of a picture or a model? In order to restitute them, Schapiro bitterly disputes possession of the shoes with Heidegger, with "Professor Heidegger," who is seen then, all in all, to have tried to put them on his own feet, by peasant-proxy, to put them *back* onto his man-of-the-soil feet, with the pathos of the "call of the earth," of the *Feldweg* or the *Holzwege* which, in 1935–36, was not foreign to what drove Gold-

3. I reproduce here the editorial note proposed by *Macula:* "Since that date, and at a time when it was already in galley proofs, the fiction which we publish here was so to speak acted out or narrated by Jacques Derrida at the University of Columbia (Seminar on Theory of Literature) at the invitation of Marie-Rose Logan and Edward W. Said. This session took place on 6 October 1977. Meyer Schapiro took part in the debate which followed. Editors' Note."—J. D.

stein to undertake his long march toward New York, via Amsterdam. There is much to discharge, to return, to restitute, if not to expiate in all this. It all looks as though Schapiro, not content with thanking a dead man for what he gave him to read, was offering to the memory of his colleague, fellow man and friend, nomad, émigré, city dweller,

— a detached part, a severed ear, but detached or severed from whom?

— the pair taken back, whisked away, or even snatched from the common enemy, or at any rate the common discourse of the common enemy. For Schapiro, too, and in the name of the truth, it is a matter of finding his feet again [*reprendre pied*], of taking back [*reprendre*] the shoes so as to put the right feet back in them. First of all by alleging that these shoes were those of a migrant and city dweller, "the artist, by that time a man of town and city," things later to get dangerously complicated by the fact that this migrant never stopped uttering the discourse of rural, artisanal, and peasant ideology. All these great professors will, as they say, have invested a lot in these shoes which are out of use in more ways than one. They've piled it on [*Ils en ont remis*]. *Remettre* would carry a lot of weight in this debate. The snares [*rets*] of these shoes are formed of these *re*- prefixes in *revenir* "to return" and *remettre*. *Remise des chaussures* ["giving the shoes back"; "putting the shoes back on"; "handing the shoes over"; "shoe shed"]. They are, they can always be detached (in all the senses we have listed), abandoned, *à la remise*. A temptation, inscribed from that moment on the very object, to put it back, to put the shoes back on one's feet, to hand them over to the subject, to the authentic wearer or owner reestablished in his rights and reinstated in his being-upright. The structure of the thing and the trial obliges you, then, always, to keep adding to it. The measure here is one of *supplementary retortion*.

— Which is what this incredible reconstitution is now doing. It's a delirious dramaturgy that projects in its turn: a collective hallucination. These shoes are hallucinogenic.

— Yes, I'm going rather too quickly here. Let's say that all this is going on into the bargain, and give me credit for the moment. Allow me a slight advance and let's say that I'm espousing

what was, perhaps, on both sides, a delirium. There is persecution in this narrative, in this story of shoes to be identified, appropriated, and you know how many bodies, names, and anonymities, nameable and unnameable, this tale is made up of. We'll come back to it. What carries weight here, and what matters to me, is this correspondence between Meyer Schapiro and Martin Heidegger.

— Are we going to make them equivalent [*les renvoyer dos à dos*], setting up the pair again

— Is it really a pair?

— setting up the two shoes again in their "proper" abandonment, in their being-unlaced which, between them, slap in the middle

— in their restance?

— That would be impossible. Restance is never entirely restful, it is not substantial and insignificant presence. I've also got things to do with these shoes, giving them, maybe, even if I were content to say at the end: quite simply these shoes do not belong, they are neither present nor absent, *there are* [*il y a*] shoes, period.

— He tied [*il lia*] these shoes. And the twisted cable of our voices—

— *Es gibt*, it gives, these shoes,

— The literal correspondence, what you call the exchange of letters, is now (just about) a public phenomenon. Made public by Schapiro in his homage to the memory of Goldstein. This henceforth public exchange gave rise, apparently, to something like a disagreement. We could say that it resulted in a disagreement. At any rate, Schapiro who unveils and comments on this correspondence, thus hanging onto the last word, concludes on a disagreement. He claims to hold the truth of the shoes (of the picture) of Vincent (Van Gogh). And as he owes the truth, he restitutes it. He identifies (in all senses of this word) the painting and the shoes, assigns them their points or their proper size [*pointure*], names

the work and attributes the subject of the work (the shoes) to the subject of the work, that is, to its true subject, the painter, Van Gogh. According to him, Heidegger gets both the painting and the shoes wrong. By attributing them to some peasant man or woman, he remains in error ("the error lies . . ."), in imaginary projection, the very thing against which he claimed to put us on our guard ("He has indeed 'imagined everything and projected it into the painting' "). According to Schapiro, Heidegger has put the shoes back onto (male or female) peasants' feet. He has, in advance, laced them, bound them on to peasant ankles, those of a subject whose identity, in the very contour of its absence, appears quite strict. Such, according to Schapiro, is the error, the imagination, the precipitate projection. It has many causes, Schapiro detects more than one of them, but let's leave that aside for the moment.

— But what's the cause of this so-called public correspondence?

— Like all causes, and everything on trial [toute chose en procès], the proximate cause is a sort of trap. Schapiro lays it for Heidegger before catching his own feet in it.

— And yet. He knows all about traps. He has written most expertly about the trap in painting. For example about that mouse-trap that Joseph in that *Annunciation* by the Master of Flémalle[4]

— But that trap is set for the Devil (*Muscipula Diaboli*), its bait is Christ's flesh.

— All the more reason to be wary here. The diabolical is perhaps already caught, a supplementary bait, in the limping of these two shifty shoes which, if the double doesn't make a pair, nonetheless trap those who want to put their feet back into them, precisely because one cannot—must not—put one's feet in them and because that would be the strange trap. As for the Christic shade of the bait, we shall see that it is not entirely absent among all these ghosts. This strange trap—

4. Cf. Meyer Schapiro, "*Muscipula Diaboli*," the Symbolism of the *Mérode Altarpiece*, in *Renaissance Art*, ed. Creigton Gilbert (New York: Harper, 1970). French translation in *Symboles de la Renaissance*, recueil collectif published by Daniel Arasse (Paris: P.U.F., 1976).—J. D.

— Another type of trap and of what in "Pas" was named paralys [*la paralyse*].

— So Schapiro, insouciant, lays a trap for Heidegger. He already suspects the "error," "projection," "imagination" in Heidegger's text pointed out to him by his friend and colleague Goldstein. The hearing having begun thus, he writes to Professor Heidegger (that's what he calls him when speaking of the colleague and correspondent, and simply Heidegger for the famous thinker, author of *The Origin of the Work of Art*): which picture exactly were you referring to? The "kind" reply from Professor H. ("In reply to my question, Professor Heidegger has kindly written me that the picture to which he referred is one that he saw in a show at Amsterdam in March 1930. This is clearly de la Faille's no. 255 [see figure 1].") closes on its author like a trap. You can hear the noise: clear. It's clear, "clearly," understood, the case has been heard, de la Faille 255, that can't come down/back to peasanthood: "They are the shoes of the artist, by that time a man of the town and city." Hearing over, sentence decided: all that's required is to complete or refine the account of this trial which, all in all, was rapidly expedited. The professor is caught. Schapiro, confirmed in his suspicion, can now reconstitute one of the possible mechanisms of the mistake, a mistake which is itself in the service of an instinctual and political pathos (the rural, peasant "ideology"): a sort of resoling carried out with the aid of the sole from another picture seen at the same exhibition in 1930. That was the first mistake, the first trap, before the one set for the professor by Schapiro to make up the pair and leave him no chance. This by way of reply to the question put to me a moment ago: all the causes of this trial will have been traps (as if figured in advance by the apparent stake of the debate: to whom is the trap due?), pitfalls or, if you prefer, snares [*des lacets*], traps with laces. *Old Boots with Laces*, this is the title given by the large catalog of the Tuileries exhibition (1971–72) (collection of the Vincent Van Gogh National Museum in Amsterdam) to the picture which Professor Schapiro claims to identify on the basis of Professor Heidegger's unwary reply, and which he reproduces under the title *Old Shoes*. I do not yet know how much is due to Van Gogh in the choice of this title. But as a certain essential indeterminacy forms part of our problem which is also the problem of the title and the discourse produced (for example by the

author) *on the subject* of the picture, it is perhaps right to leave the thing some suspense. The authors of the catalog I just quoted took the de la Faille into account, the same de la Faille which is Schapiro's authority ("The titles given by Vincent in his correspondence, and commonly adopted, have been made more specific when they were not sufficiently explicit, whence some differences compared with either the titles usual in the past, or those of the new Catalogue Raisonné by J. Baart de la Faille . . ."). Whether named by Van Gogh or not, in a title or a letter, these laces (for tightening or slackening the grip, more or less strictly, on the bearing or borne subject) sketch out the very form of the trap. As fascinating as they are (by that very fact) negligible for the two professors who make not the slightest allusion to them. That's one of the causes: the lace. A thing whose name is, in French, also the name of a trap [*le lacet:* "snare"]. It does not only stand for what passes through the eyelets of shoes or corsets. Our voices, in this very place—

— I do indeed notice, now, that strange loop

— ready to strangle

— of the undone lace. The loop is open, more so still than the untied shoes, but after a sort of sketched-out knot

— it forms a circle at its end, an open circle, as though provisionally, ready to close, like pincers or a key ring. A *leash.* In the bottom right-hand corner where it faces, symmetrically, the signature "Vincent," *in red and underlined.* It occupies there a place very commonly reserved for the artist's signature. As though, on the other side, in the other corner, on the other edge, but symmetrically, (almost) on a level with it, it stood in place of the signature, as though it took the (empty, open) place of it . . .

— If the laces are loosened, the shoes are indeed detached from the feet and in themselves. But I return to my question: they are also detached, by this fact, one from the other and nothing proves that they form a pair. If I understand aright, no title says "pair of shoes" for this picture. Whereas elsewhere, in a letter which Schapiro quotes moreover, Van Gogh speaks of another picture, specifying *"a pair* of old shoes." Is it not the possibility

of this "unpairedness" (two shoes for the same foot, for example, are more the double of each other but this double simultaneously fudges both pair and identity, forbids complementarity, paralyzes directionality, causes things to squint toward the devil), is it not the logic of this false parity, rather than of this false identity, which constructs the trap? The more I look at this painting, the less it looks as though it could walk . . .

— Yes, but for that to be the case the "unpairedness" must remain a possibility which is, I shall say, a limit-possibility, improbable. And what's more, even if Van Gogh had given a title to the picture, and entitled it "pair of . . . ," that would change nothing in the effect produced, whether or not it is sought after consciously. A title does not simply define the picture it's attached to or which it's detached from according to numerous and sometimes overdetermined modes. It can form part of the picture and play more than one role in it, provide more than one figure of rhetoric in it. "Pair-of-," for example, can induce one to think of parity, the "truth of the pair," while showing unpairedness, or the peerless [*le hors-pair*]. And then, another argument, the "unpairedness" can say and show parity, the truth of the pair, with much greater force. Just as, as we shall see, the out-of-use exhibits utility or idleness exposes the work.

— I find this pair, if I may say so, gauche. Through and through. Look at the details, the inside lateral surface: you'd think it was two left feet. Of different shoes. And the more I look at them, the more they look at me, the less they look like an old pair. More like an old couple. Is it the same thing? If one let oneself slip to the facility of the symbolism you were talking about just now, the obvious bisexuality of this plural thing would stem from the inside-out passivity, open like a glove, more offered, more undressed, of the left shoe (I specify: on the left of the picture, since unpairedness can also affect the layout of a "real" pair, the left shoe facing us from the left, and the right from the right, of the picture)

— it's a peasant woman

— a potato eater or the *Peasant Woman of Brabant* (1885), the empty headdress of one or the other, while the other (left?) shoe, on the right of the picture (how should we orient ourselves

to talk about them?) is more right/straight, narrow, strict, less open. In short, what one would in the past have called more masculine, and that's the one that holds out the lace with the half-open circle, opposite the first name.

— If, as Schapiro suggests, the signatory is the owner or, an important nuance, the wearer of the shoes, shall we say that the half-open circle of the lace calls for a reattachment: of the painting to the signature (to the sharpness, the *pointure*, that pierces the canvas), of the shoes to their owner, or even of Vincent to Van Gogh, in short a complement, a general reattachment as truth in painting?

— That's moving far too fast. Whatever proof you claim to have in hand, the signatory of a picture cannot be identified with the nameable owner of an essentially detachable object represented in the picture. It is impossible to proceed to such an identification without an incredible ingenuousness, incredible in so authorized an expert. An identificatory ingenuousness with respect to the structure of a picture, and even to that of an imitative representation in the simplest sense of a "copy." Identificatory ingenuousness with respect to the structure of a detachable object in general and with respect to the logic of its belonging in general. What interestedness can have motivated such a faux-pas, that's the question I was trying to ask a while ago with reference to the strange three-person restitution scene, all three of them great European university professors. Why suddenly this blindness, this putting-to-sleep, all of a sudden, of all critical vigilance? Why does lucidity remain very active, hypercritical, *around* this macula, but only on its edges? Why this hasty compulsion, driving the one to give as homage to the second, the dead one, a still life/ dead nature snatched from (the no less hasty and compulsive interpretation of) the other, the third or the first as you wish, the fourth party as always remaining in exclusion? *Ça donne* the better to take back, *ça prend* as it gives, as soon as *there are* these laces/snares

— of the purse or the fetish, if I understand aright. If I understand aright, we don't yet know to what bearer the gawkiness [*dégaine*] of this object refers, but since you're interested in the bearer, for the moment I see in this lace a sort of check payable to the bearer. Checks payable to the bearer. The trap is that each

Peasant Woman of Brabant.

one jumps in to fill it in, with his name or the name of a Limited
Liability Company (SARL, *société à responsabilité limitée*) of
which he is more or less a stockholder or a bond bearer (Heidegger
for an agricultural, earthy, rural sedentary company, Schapiro for
an industrial, city-based, nomad or emigrant company), without
noticing that the check is crossed. Crossed, as is often the case,
with a double line, and perhaps still more: the line which frames
the picture, cutting it off from its outside, placing it in a severely
closed system [*régime*], and the line which, in the picture, de-
marcates the form of the shoes, and in particular that undone,
haunted, unlaced vacancy

— I'll add the line that separates one shoe from the other. For what proves that we're dealing with a pair?

— It's difficult, in these conditions, for any bearer to get to the cash desk. And for any giver to render homage.

And yet. *There is* homage. It gives. That's an *Es gibt* that Heidegger will have given us, better than any other, to think about. The *Es gibt* "before" being, the literal [*à la lettre*] Es gibt, the *Sein* starting from (and returning to) the *Es gibt Sein*.

— But we haven't yet opened the file of this correspondence between Meyer Schapiro and Martin Heidegger. Let's take our time. In any case, wherever they come from or come back from, these shoes won't come back safe and sound [*à bon port*].

— Nor cheaply [*à bon marché*]. Despite the incredible bargaining, or because of the interminable outbidding of an analysis which is never finished tying together, this time

— They will have traveled a lot, traversed all sorts of towns and territories at war. Several world wars and mass deportations. We can take our time. They *are there*, made for waiting. For leading up the garden path. The irony of their patience is infinite, it can be taken as nil. So, we had got to this public correspondence and I was saying that, sealing a disagreement, this sealed exchange was holding, under seals, another correspondence. Secret, this one, although it can be read right off the other. A symbolic correspondence, an accord, a harmonic. In this communication between two illustrious professors who have both of them a communication to make on "a famous picture by Van Gogh"

— one of the two is a specialist. Painting, and even Van Gogh, is, so to speak, his thing, he wants to keep it, he wants it returned—

— what do we notice? Through the mutual esteem, the civility of a reciprocal legitimation which appears to button the most deadly thrusts, one can feel the effects of a common code, of an analogous (identical, identifiable) desire, a resemblance in assiduity [*empressement*] (which is also an eagerness [*empressement*] in the direction of identificatory resemblance), in short, a common interest, and even a common debt, a shared duty. They

owe the truth in painting, the truth of painting and even painting as truth, or even as the truth of truth. (They must [*doivent*] speak the truth in painting. It is, of course, necessary to take into account the debt or duty—"I owe you"—but what does "speak" mean here? And speak *in painting:* truth spoken *itself,* as one says "in painting"? Or truth spoken about painting, in the domain of painting? Or truth spoken in painting, by the sole means of painting, no longer spoken but—"to speak" being only a manner of speaking, a figure—*painted,* truth silently painted, itself, in painting?) In order to do this, they both have an interest in *identifying,* in identifying the subject (bearer or borne) of these shoes, in tying up, tying back together *stricto sensu,* in their right sense, these objects which can't do anything about it—in identifying and reappropriating (for themselves), in using in their turn this strange out-of-use, this product productive of so much supplementary surplus value. At all costs its size/*pointure* must be found, even if this "subject" is not the same one for both parties. They are in agreement, that's the contract of this tacit institution, to seek for one, or to pretend to seek for one, given that both are certain in advance that they have found it. Since it is a pair, first of all, and neither of them doubts this fact, there must be a subject. So that in this shoe market [*marché;* also, "a deal"], the contract, the institution, is first of all the parity between the shoes, this very singularly dual relationship which fits together the two parts of a pair (identity and difference, total identity in the concept or in formal semantics, difference and non-overlap in the directionality of the traits). If there is a pair, then a contract is possible, you can look for the subject, hope is still permitted. A colloquy—and collocation—can take place, the dispute will be able to commence or commit. It will be possible to appropriate, expropriate, take, give, take back, offer, discharge, do homage or insult. Without which

— Why do you say that this correspondence is symbolic? Symbolic of what?

— Of the symbol. Of the *symbolon.* I said symbolic correspondence because of this prior, coded commitment, because of this colloquy contracted on the basis of a common interest (reattachment by a nexus, the annexation of the shoes or, and this is enough already, the mere formation of the statement "whose are the shoes" or, what just about comes down [*revient*] to the same

thing, in the infantry of this slightly military preparation, "whose or whats are the feet" which are here the object of the professors' constant care). This implies a sort of reciprocal recognition (of the pair), a diplomatic exchange (double and reciprocal) or in any case the law of nations presupposed by a declaration of war. In order to commemorate the mutual commitment, the shoes are shared, each party keeps one piece of the *symbolon*. And the same piece, or rather the similar and different piece of the same whole, the complementary piece. This is why the pair is the condition of the symbolic correspondence. There is no symbolic contract in the case of a double which does not form a pair. Which would not be one (selfsame) thing in two, but a two in identity.

— So, finally, this correspondence bears on what subject? On the subject of correspondence? On the subject of this parity of the pair?

— Ah, here we are. On what subject. The question "Whose are the feet?" to which they wanted to bring round [*faire revenir*] the question "Whose are the shoes?" assumes that the question "Of what" or "What are the feet?" has been resolved. Are they? Do they represent? Whom or what? With or without shoes? These shoes are more or less detached (in themselves, from each other and from the feet), and by that fact discharged: from a common task or function. *Both* because they are visibly detached and be-cause—never forget the invisible ether of this trivial self-evidence—they are *painted* objects (out-of-work because they're in a work) and the "subject" of a picture. Nonfunctioning, defunct, they are detached, in this double sense, and again in another double sense, that of being untied and that of the detachment/secondment of an emissary: diplomatic representation, if you like, by metonymy or synecdoche. And what is said of the shoes can also be said, although the operation is more delicate around the ankle, of the neck or the feet.

On what subject, then, this correspondence? On the subject of the subject of reattachment. They're in a hurry to tie up the thread with the subject. Detachment is intolerable. And the cor-respondence takes place on the subject of the true subject of the subject of a "famous picture." Not only on the subject of the subject of the picture, as they say, but of the subject (bearer or borne) of the shoes which seem to form the capital subject of the picture, of the feet of the subject whose feet, these shoes, and

then this picture itself seem here to be detached and as if adrift. That makes a lot of things. And it's very complicated. The structure of detachment—and therefore of the subjectivity of these different subjects—is different in each case. And we have to make clear that the correspondence we're interested in aims to efface all these differences. Among which I have not yet counted the one which determines the (underlying) subjectivity of the shoe in its most fundamental surface, the sole. Nor the still more or less fundamental subjectivity of the ground (on or without the support of the canvas) along with this *pas de contact* (this *pas de sujet*) which, rhythmically, raises the adhesion of a march/walk/step. The *pas* is not present or absent. And yet it works [*marche*] badly without a pair

— But I'm very surprised. It was indeed Heidegger's text that opened this debate. Now he leaves any problematic of subjectivity far behind him, doesn't he? Such a problematic in fact presupposes what is here, among other things, desedimented by him, that is, the determination of the thing as *hypokeimenon*, support, substratum, substance, etc.?

— That's one of the paradoxes of this exchange. Each discourse in it remains unequal, inadequate to itself. In *The Origin*, the passage on "a famous picture by Van Gogh" belongs to a chapter "Thing and Work." He is occupied in that chapter with removing (but removal is not enough) the thing from the metaphysical determinations which, according to Heidegger, have *set upon* it, covering it over and simultaneously assaulting it, doing it injury [*injure*] (Überfall), insulting [*insultant*], as the French translator has it, what is properly speaking the thing in the thing, the product in the product, the work in the work (*das Dinghafte des Dinges, das Zeughafte des Zeuges, das Werkhafte des Werkes*). These determinations of the *Überfall* go in pairs or couples. Among them is the determination of the thing as *underneath* (*hypokeimenon* or *hypostasis*) in opposition to the *symbebekota* which arise on top of it. This oppositional couple will be transformed, in Latin, into *subjectum* (*substantia*)/*accidens*. This is only one of the pairs of oppositions that *fall upon/attack* the thing. The other two are, according to Heidegger, that of *aisthēton/noēton* (sensible/intelligible) and that of *hylē/eidos-morphē* (matter/form-figure).

We must accompany for a while this Heideggerian procedure. It constitutes the context immediately *framing* the allusion to the "famous picture." And if Schapiro is right to reproach Heidegger for being so little attentive to the internal and external context of the picture as well as to the differential seriality of the eight shoe paintings, he ought himself to have avoided a rigorously corresponding, symmetrical, analogous precipitation: that of cutting out of Heidegger's long essay, without further precautions, twenty-odd lines, snatching them brutally from their frame which Schapiro doesn't want to know about, arresting their movement and then interpreting them with a tranquillity equal to that of Heidegger when he makes the "peasant's shoes" speak. Thus, getting ready to deal with shoes in painting and with *subjectum* in multiple senses, and with ground, background, support (the earth and the canvas, earth on the canvas, canvas on the earth, shoes on the earth, earth on and under the shoes, shod feet on the earth, the subject supposed to bear (or be borne by) the feet, the shoes, etc., the subject of the picture, its subject-object and its signatory subject, all this over again on a canvas with or without an underneath, etc.), in short, getting ready to deal with *being-underneath*, with ground and below ground, it is perhaps appropriate to mark a pause, before even beginning, around this *subjectum*. I reserve for another occasion a reading of clothes or tissues or veils, for example the stocking [*le bas*; also, "the low"], as what's underneath this text. As we shall see, this is not without its relationship with the underneath currently occupying us around the sole.

— Is it appropriate in order to give its rightful place to a sort of affinal assonance, as though to set the key before speaking of the subject (in all senses) of the "famous picture"? Or else must we consider the link between the two "subjects," the two problematic places of the subject, to be essential and necessary?

— I think it's appropriate for both reasons. The question of the underneath as ground, earth, then as sole, shoes, sock—stocking—foot, etc., cannot be foreign to the "great question" of the thing as *hypokeimenon*, then as *subjectum*. And then, if it is accepted that the procedure of *The Origin* intends to lead back beyond, upstream of or to the eve of the constitution of the *subjectum* in the apprehension of the thing (as such, as product or as work), then asking it the question of the "subject," of the

subject of this pair of shoes, would perhaps involve starting with a misapprehension, by an imaginary projective or erroneous reading. Unless Heidegger ignores (excludes? forecloses? denies? leaves implicit? unthought?) an *other* problematic of the subject, for example in a displacement or development of the value "fetish." Unless, therefore, this question of the *subjectum* is displaced *otherwise*, outside the problematic of truth and speech which governs *The Origin*. The least one can say is that Schapiro does not attempt to do this. He is caught in it and without even, apparently, having the least suspicion of this.

— And yet. If this "step backwards" (*Schritt zurück*) on the road of thought

— There is the insistence on questioning thought as *"Weg,"* as road or as traveling. It regulates everything in Heidegger. It is difficult and we should have to put it in accord with the "subject" which is occupying us in its proper place, with its countryside, its peasanthood, its "world," and this "thing" which is neither of the ground nor of the peasant but between them, the shoes. That would take us too far afield today, over toward the shoes or stockings with which thought makes its way, thinks, speaks, writes, with its language shod or as its roadway [*avec sa langue (comme)* chaussée]; and toward what takes place when the shoes of thought are not (are they ever?) laced absolutely strictly or when the stockings [*bas*] of language are a little undone. Suppose that Van Gogh's shoes are like those which, in the text, have just made their way along "the road which leads to what is properly product." (*Doch welcher Weg führt zum Zeughaften des Zeuges* is a sentence which occurs four lines before the evocation of the "famous picture" and the sentence which Schapiro quotes as he begins: "We are most easily insured against this if we simply describe a product without any philosophical theory. Let us take as an example a well-known product: a pair of peasant's shoes. . . ." It is not yet a question of a product as a work of art or in a work of art: a slim and equivocal articulation which we shall soon have to take account of, if, that is, we want to read this text.)

— If then, however, this "backward step" on the road of thought was supposed to go back behind any "*subjectum*," how do we explain this naïve, impulsive, precritical attribution of the shoes in a painting to such a determined "subject," the peasant, or rather

the peasant woman, this tight attribution and determination which direct this whole discourse on the picture and its "truth"? Would we all agree about calling this gesture naïve, impulsive, precritical, as I have just done?

— Yes, and on this precise point Schapiro's demonstration confirms what could very quickly be seen. But we still have to *demarcate* the place and function of this "attribution" in the text, trace the map of its effects in the long run of Heidegger's move, its apparent noncongruence with the dominant motifs of the essay: a climb back up behind the *subjectum*, indeed, but also a critique of representation, of expression, of reproduction, etc. We shall have to come back to this, and to the logic of the *Überfall*. On all these questions, and despite having a negative and punctual pertinence, Schapiro's demonstration seems to me to be soon exhausted. And its "impulsive or precritical naïveté" (I pick up these words) seems to me to be entirely symmetrical or complementary with the naïveté which he rightly denounces in Heidegger. The correspondence will forward these effects, right down to their details. In a moment.

We had agreed on a pause near the *subjectum*, if only to turn up the underside of this correspondence.

— In the museum of Baltimore there is a pair of shoes by Van Gogh (yes, perhaps a pair, this time), high-sided shoes, like these. Let's say half-boots. But on the left, one of them is overturned, showing its underside, its almost new sole, decorated with a hobnailed design. The picture dates from 1887 (F. 333).

— Let's go back to before the allusion to the "famous picture," to the point where the chapter "Thing and Work" names "the *fundamental* Greek experience of the Being of beings in general." I emphasize fundamental (*Grunderfahrung*). The interpretation of the thing as *hypokeimenon* and then as *subjectum* does not only produce (itself as) a slight linguistic phenomenon. The transforming translation of *hypokeimenon* as *subjectum* corresponds, according to Heidegger, to another "mode of thought" and of being-there. It translates, transports, transfers (Heidegger emphasizes the passage implied in *über*) over and beyond the aforementioned *fundamental* Greek experience: "Roman thought takes over (*übernimmt*) the Greek words (*Wörter*) without the corresponding co-originary experience of what they say, without the Greek word

(Wort). The absence-of-ground (Bodenlosigkeit) of Western thought opens with this translation."

The ground (of thought) comes then to be lacking when words lose speech [la parole]. The "same" words (Wörter) deprived of the speech (Wort) corresponding to the originarily Greek experience of the thing, the "same" words, which are therefore no longer exactly the same, the fantomatic doubles of themselves, their light simulacra, begin to walk above the void or in the void, bodenlos. Let's hang on for a long time to this difference between words and speech; it will help us in a moment, and again later, to understand, beyond the narrow debate on the attribution of these attributes, of these accidents that feet reputedly are, and that shoes are a fortiori, what the thing says. What one makes or lets it say, what it makes or allows to be said.

— Ought we to believe that there is some common topos between this deprivation of ground and the place of these shoes, their taking-place or their standing-in [leur avoir-lieu ou leur tenir-lieu]? They do indeed have an air of being a bit up in the air, whether they appear to have no contact with the surface, as if in levitation above what nevertheless supports them (the one on the right, the most visibly "gauche"/left of the two, seems a little lifted up, mobile, as if it were rising to take a step, while the other stuck more firmly to the ground), or whether, abandoned to their being-unlaced, they suspend all experience of the ground, since such experience presupposes walking, standing upright, and that a "subject" should be in full possession of his/her/its feet, or again whether, more radically, their status as represented object in the strict frame of a painted canvas, or even one hung on the wall of a museum, determines the Bodenlosigkeit itself, provokes or defines it, translates it, signifies it or, as you will, is it, there

— and the desire then to make them find their feet again on the ground of the fundamental experience

— no, no, or at least not so quickly. It's only a matter, for starters, of discovering a few cave-ins of the terrain, some abysses too in the field where advance so tranquilly

— Why no tranquillity? Why this persecution?

— the discourses of attribution, declarations of property, performances or investitures of the type: this is mine, these

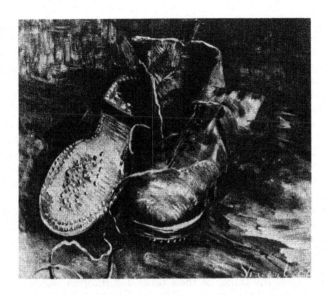

The Shoes.

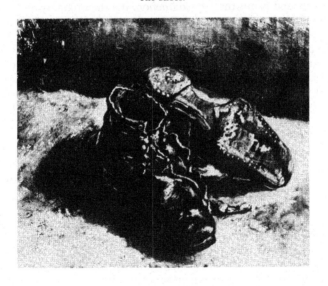

shoes or these feet belong to someone who says "me" and can thereby identify himself, belong to the domain of the nameable (common: the peasant man or woman, the man of the city; or proper: Vincent Van Gogh; and proper in both desires: Heidegger, Schapiro who demand restitution). These abysses are not the "last word" and above all do not consist simply in this *Bodenlosigkeit* about which we've just been talking. At the very moment when Heidegger is denouncing translation into Latin words, at the moment when, at any rate, he declares Greek speech to be lost, he also makes use of a "metaphor." Of at least one metaphor, that of the foundation and the ground. The ground of the Greek experience is, he says, lacking in this "translation." What I have just too hastily called "metaphor" concentrates all the difficulties to come: does one speak "metaphorically" of the ground for just anything? And of walking and shoes (clothing, the tool, the institution, even investiture) for thought, language, writing, painting and the rest.

What does Heidegger say? This: as soon as one no longer apprehends the things as the Greeks did, in other words as *hypokeimenon*, but instead as *substantia*, the ground falls away. But this ground is not the *hypokeimenon*, it's the originary and fundamental experience of the Greeks or of Greek speech which apprehends the things as being-underneath. This is the ground of the *hypokeimenon*. This (metaphorical?) doubling must be interrogated on its own account. And the underneath of the underneath leads to a thinking of the abyss, rather than of the *mise-en-abyme*, and the abyss would "here" be one of the places or nonplaces ready to bear the whole of this game [*un des lieux ou non-lieux prêts à tout porter de ce jeu;* also, "one of the off-the-peg, ready-made places or nonplaces of this game"].

— Which takes us far away from Schapiro's "Still Life . . ." and from what was a moment ago, if I remember rightly, called the offering to Goldstein of the severed ear.

— No, the offering of a pair (which perhaps never existed, which no one ever had) of things detached and tied back together again to make a present of them. A present [*cadeau*], as the [French] noun shows, in a *chain*. Has it gone away? What is it to go away [*s'éloigner*]? The *é-loignement ent-fernt*, he says, dis-tances the distant [*é-loigne le lointain*] . . .

— I'm not going away, I'm in the process, starting from here, of coming back to what the other says. For the thing is still more hidden away or wrapped up underneath its investiture than appears to be the case. At the very moment when he calls us back to the Greek ground and to the apprehension of the thing as *hypokeimenon*, Heidegger implies that this originary state *still* covers over something, falling upon or attacking it. The *hypokeimenon*, that underneath, hides another underneath. And so the Latin underneath (*substantia-subjectum*) causes to disappear, along with the Greek ground, the Greek underneath (*hypokeimenon*), but this latter still hides or veils (the figure of veiling, of veiling linen as over-under, will not take long to appear, and the hymen which will draw it into undecidability will not be unrelated to the sock, the socklet, or the *stocking* [*le bas*], between foot and shoe) a "more" originary thingliness. But as the "more" carries itself away, the thing no longer has the figure or value of an "underneath." Situated (or not) "under" the underneath, it would not only open an abyss, but would brusquely and discontinuously prescribe a change of direction, or rather a completely different topic.

— Perhaps that of this returning whose great scope, just now

— Perhaps. The topos of the abyss and *a fortiori* that of the *mise-en-abyme* could also hide, or in any case dampen a little the brusque and angular necessity of this other topics. And of this other *pas*. That's what interests me "underneath" this correspondence with respect to a "famous picture" of old unlaced walking shoes

— half-unlaced

— and when the question of its place is posed, if I can say that. How to take this correspondence and this transfer(ence), all these translations?

— I've arrived late. I've just heard the words "abyss," "offering," or "gift." *It gives* in the abyss, it gives—the abyss. There is, *es gibt*, the abyss. Now it seems to me that *The Origin* can also be read as an essay on the gift (*Schenkung*), on the offering: one of the three senses, precisely, in which truth is said to come

to its installation, its institution, or its investiture (*Stiftung*). One of the two other senses, the "founding" (*Gründen*), is not without its links with the ground. On the other hand, *The Origin* also says of this truth which is, Heidegger says, "nontruth" which "comes about (*geschieht*) in Van Gogh's picture" (a statement on which Schapiro exercises his irony), that its essence rather opens onto the "abyss." This has nothing to do with attributive certainty on the secure ground of (Cartesian-Hegelian) subjectivity. So? Before applying these "concepts" (gift or abyss, for example) to the debate, or even to such-and-such an "object," Heidegger's text, perhaps one would have to begin by deciphering them and restituting them *in* Heidegger's text which perhaps gets away in advance from the application we would like to make of them to it: perhaps it problematizes in advance all its instruments. In that case a malicious and agile application could easily turn out to be ingenuous, heavy, somnambulistic, and the detective trapped

— No doubt. We should then have to proceed in such a way that all the inequalities to itself of the discourse, meticulously—

— We had met, such was the convention among us, to talk about Schapiro's "The Still Life . . ." and about a certain correspondence the secret of which was promised to us at a given moment. I suggest that we finally come on to it. Otherwise we'll never get finished in the proposed limits. *Macula* defines the limits, that's what we've still got to look at and if it's the law as far as we're concerned, then we can't interfere with it.

— What interested me, was finally to see explained from a certain angle why I had always found this passage of Heidegger's on Van Gogh ridiculous and lamentable. So it really was the naïveté of what Schapiro rightly calls a "projection." One is not only disappointed when his academic high seriousness, his severity and rigor of tone give way to this "illustration" (*bildliche Darstellung*). One is not only disappointed by the consumerlike hurry toward the content of a representation, by the heaviness of the pathos, by the coded triviality of this description, which is both overloaded and impoverished, and one never knows if it's busying itself around a picture, "real" shoes, or shoes that are imaginary but outside painting; not only disappointed by the crudeness of the framing, the arbitrary and barbaric nature of the cutting-out,

the massive self-assurance of the identification: "a pair of peas-
ants' shoes," just like that! Where did he get that from? Where
does he explain himself on this matter? So one is not only dis-
appointed, one sniggers. The fall in tension is too great. One
follows step by step the moves of a "great thinker," as he returns
to the origin of the work of art and of truth, traversing the whole
history of the West and then suddenly, at a bend in a corridor,
here we are on a guided tour, as schoolchildren or tourists. Some-
one's gone to fetch the guide from the neighboring farm. Full of
goodwill. He loves the earth and a certain type of painting when
he can find himself in it [quand il s'y retrouve]. Giving up his
usual activity he goes off to get his key while the visitors wait,
slowly getting out of the coach. (There is a Japanese tourist among
them, who in a moment will ask a few questions of the guide, in
a stage whisper.) Then the tour begins. With his local (Swabian)
accent, he tries to get the visitors going (he sometimes manages
it and each time this happens he also trembles regularly, in time),
he piles up the associations and immediate projections. From time
to time he points out of the window to the fields and nobody
notices that he's no longer talking about painting. All right. And
one says to oneself that the scene, the choice of the example, the
procedure of the treatment, nothing in all this is fortuitous. This
casual guide is the very person who, before and after this incred-
ible tirade, carries on with his discourse on the origin of the work
of art and on truth. It's the same discourse, it has never been
interrupted by the slightest digression (what all these professorial
procedures with regard to the shoes are lacking in, moreover, is
the sense of digression: the shoes have to make a pair and walk
on the road, forwards or backwards, in a circle if pushed, but with
no digressions or sidesteps allowed; now there is a link between
the detachability of the step and the possibility of the digressive).
I see that you are shocked, in your deference, by the scene which
I have, how shall I put it

— projected.

— Then let's get back into the classroom. All that is classical,
class-business, the business of pedagogy and classicity. Professor
Heidegger, as Professor Schapiro says in homage to Professor Gold-
stein, projects a transparency. He wants to capture your interest,
through this illustration, right from the beginning of his lecture. For

The Origin was in the beginning, at a very significant date, a series of lectures delivered before a *kunstwissenschaftliche Gesellschaft* and then before a *freie deutsche Hochstift,* and shows it.

— The word "illustration" has just been uttered. And it had been several times previously. I suggest that that's where we should start, if we must begin and if we must read Schapiro's *Note* against which I intend to defend systematically, at least for the committee exercise, the cause of Heidegger (who, don't forget, also proffers, in this place where it is a question of the thing, an important discourse on the *causa*). A fair number of difficulties arise from what is translated by *illustration.* In his protocol, Schapiro uses this word which also translates [into French] *"bildliche Darstellung"* ("For this purpose an illustration suffices. We choose for this a famous picture by Van Gogh . . ."). Schapiro opens his text— and *The Origin*— at this point (by what right?) and he writes: "In his essay on *The Origin of the Work of Art,* Martin Heidegger interprets a painting by Van Gogh to illustrate the nature of art as a disclosure of truth.

"He comes to this picture in the course of distinguishing three modes of being: of useful artifacts [products], of natural things, and of works of fine art. He proposes to describe first, 'without any philosophical theory . . . a familiar sort of equipment [*Zeug:* product]—a pair of peasant shoes'; and 'to facilitate the visual realization [translating *Veranschaulichung,* intuitive sensory presentation] of them' he chooses 'a well-known painting by Van Gogh, who painted such shoes several times.' But to grasp the 'equipmental being of equipment,' we must know 'how shoes actually serve.' For the peasant woman they serve without her thinking about them or even looking at them. Standing and walking in the shoes, the peasant woman knows the serviceability [*Dienlichkeit*] in which 'the equipmental being of equipment consists.' But we . . ." [Schapiro, p. 203]. And Schapiro quotes these two paragraphs which you all find so ridiculous or so imprudent. Let's reread them first, in German, in French, in English.

. .
. .
. .

— It's done.

— Before going any further, I shall pick out from the cutting-out in Schapiro's protocol a certain number of simplifications, not to call them anything worse. They have effects on everything that follows. He simplifies matters by saying that Heidegger interprets a painting to illustrate the nature of art as the unveiling of truth. To prove this, one has no need to refer to what the following page says, i.e., (in translation first): "the work in no way served (diente gar nicht), as it may have seemed at first, to illustrate more clearly what a product is." What has here been translated as "illustrate" is Veranschaulichung this time, and not Darstellung, which was also translated above as illustration. Veranschaulichung, intuitive presentation, as it were, is what had to be facilitated by invoking the example of the picture. But it is also what was not done, although it seemed as though that's what was happening. Heidegger makes this quite clear: the work did not serve us to do that, did not do us this service which, all in all, we pretended to expect from it. It did better than illustrating or presenting something to sensory intuition— or worse, depending on the point of view— it showed, it made appear. Heidegger has just recalled that the work did not "serve" as Veranschaulichung or Darstellung, and he goes on to specify: "Much more is it the being-product of the product which arrives, properly (eigens) and only through the work, at its appearing." This appearing of the being-product does not, according to Heidegger, take place in an elsewhere which the work of art could illustrate by referring to it. It takes place properly (and only) in the work. In its very truth. This might seem to aggravate the illusion denounced by Schapiro and to place under the heading of presentation what was marked down only in the name of representation, as if Heidegger thought he could see still more directly what Schapiro reproaches him for inferring too hastily. But things are not yet so simple and we shall have to return to this.

First of all: it is not as peasant shoes, but as product (Zeug) or as shoes-as-product that the being-product manifested itself. The manifestation is that of the being-product of the product and not of this or that species of product, such as shoes. Such was the function of the Darstellung. It must be carefully demarcated in this passage and its stages differentiated. Heidegger is not simply, as Schapiro claims, in the process of distinguishing between three modes of being of the thing.

— Then what *is* going on when the so-called illustration intervenes?

— Heidegger has just analyzed the system of the three couples of determinations superimposed on the thing. They are connected, associated in a sort of "conceptual mechanism" (*Begriffsmechanik*) which nothing resists. Among the effects of this system, the matter/form couple and the concept of thing as informed matter have long dominated every theory of art and every aesthetics. And still do so today. From the moment he is interested here in the work of art, Heidegger insists and makes his question more precise: does this (dominant) form-matter complex have its origin in the being-thing of the thing or else in the being-work of the work and in the being-product (with the participation of man, it is understood, whence the temptation to take this matter-form complex to be the immediate structure of the thing) of the product? In other words, would it not be on the basis of the thing *as* work or as product that this *general* interpretation (or rather one that is claimed to be general) of the thing as informed matter was secretly constituted? Now reread the chapter: in the course of this questioning about the product as informed matter, the example of the pair of shoes appears at least three times *before and in the absence of the least reference to a work of art*, be it pictorial or otherwise. Twice associated with the example of the ax and the pitcher.

— There's a lot that needs to be said about these examples and about the discourse on the pitcher in Heidegger, with reference to the thing, precisely.

— Yes, in Heidegger and others before him, in his tradition, or after him: Ponge, for example. But let's not let ourselves get sidetracked. Another time. Having been twice associated with the pitcher and the ax, the pair of shoes (the third time it is mentioned but still before there is any question of the picture) detaches itself from the other examples. Suddenly it is alone. No doubt it is responding to a particular need, but Heidegger will never thematize this. Perhaps it is because, unlike the ax and the pitcher, this useful product is also an article of clothing (*Fussbekleidung*) whose mode of attachment to the body of the subject—let's say, more rigorously, to its *Dasein*—involves an element of originality

from which more can be got in this context. But let's leave that. In any case this example manages very well, for many pages, to do without any aesthetic or pictorial reference. And it is during its last occurrence before the allusion to the "famous picture" that an essential schema is set in place. Without it we would understand nothing of the passage about such-and-such a work by Van Gogh, nothing of its differential function, and nothing of its irreducible equivocality either. I called it a schema: basically, and in a barely displaced Kantian sense, it's a hybrid, a mediation or a double belonging or double articulation. The product (*Zeug*) seems to be situated between the thing and the work of art (the work is always a work *of art* in this context: *Werk*). It shares in both, even though the work resembles (*gleicht*) the "simple thing" more than does the product. The example of the shoes guides the analysis of this schematism when it is first set in place. It is only three pages later, in order to take a further step [*un pas de plus*] in this question of the being-product, that Heidegger will take up the same example again: this time "inside" a work of art; we shall see why and how this "inside" turns itself inside out, and is crossed with a single step [*d'un seul pas franchi*]. For the moment, the pair of shoes is a paradigm

— in its status as paradigm, it has a very noble philosophical genealogy, going back to Plato. So we can hear at this point a sort of quotation, as encrypted as it is conventional, in a long discursive chain.

— it is here a paradigm of the thing as "product." It is not yet "painted" or "painting" and it occupies, in an exemplary way, that "intermediate place [*Zwischenstellung;* place of the between, the inter-stela or, as Lacoue-Labarthe might say, the inter-posture: see his "Typographie," in *Mimesis*]⁵ between the mere thing (*blossen Ding*) and the work (*Werk*)." When the "product" is the subject of a "work," when the thing-as-product (shoes) is the "subject" presented or represented by a thing-as-work (a picture by Van Gogh), the thing will be too complicated to be treated as lightly and simply as Schapiro does. For then one will have to deal with a work (which resembles a mere thing more than it does a product, and resembles a mere thing more than a product does), with a work presenting or representing a product the status of which is

5. See *Mimesis des articulations,* collective work (Paris: Aubier-Flammarion, 1975), 165–270.

intermediary between the thing and the work, etc. The inter-
mediate mode is *in the middle* of the other two, which it gathers
and divides in itself according to a structure of envelopment which
is difficult to spread out. Here, first of all, is the schematism of
the product. For example: shoes *in general*. I pick out and em-
phasize a few words: "The product (*Zeug*), for example the shoe-
product (*Schuhzeug*) rests, as ready (*fertig*, finished) in itself as
the thing pure and simple, but it does not have, as does the block
of granite, this *Eigenwüchsige* [difficult to translate: not "spon-
taneity," as the French translation has it, but compact self-
sufficiency, dense propriety referring only to itself, stubborn]. On
the other hand the product also shows an affinity (Verwandtschaft)
with the work of art, inasmuch as it is produced (hervorgebracht)
by the hand of man. In spite of this, the work of art in its turn,
by its self-sufficient presence (*in seinem selbstgenügsamen An-
wesen*), resembles (*gleicht*) the thing pure and simple, referring
only to itself (*eigenwüchsige*) and constrained to nothing (*zu nichts
gedrängten*)] [. . .]. Thus the product is half a thing, because de-
termined by thingliness, and yet more than that; at the same time
it is half work of art, and yet less than that

— so a work like the shoe picture *represents* half of itself and
yet less than that

— and yet less than that, because it lacks the self-sufficiency
of the work of art.

— so a work like the shoe-picture exhibits what something
lacks in order to be a work, it exhibits—in shoes—its lack of itself,
one could almost say its own lack. And that is how it's supposed
to be self-sufficient? Accomplished? Does it complete itself then?
Unless it overflows (itself), into inadequation, excess, the
supplement?

— Heidegger continues. "The product thus has its proper in-
termediate place (*Zwischenstellung*) *between* the thing and the
work, always supposing that it is permissible to give in to such
an accountant-like classification."

What, to Heidegger's own eyes, limits the legitimacy of this
arithmetical triplicity (the one by which Schapiro boldly sums
up the whole context: "in the course of distinguishing three modes
of things . . ."), is that if thing 2 (the product) is between thing 1

(naked, pure and simple thing) and thing 3 (the work of art), thus participating in both of them, the fact nonetheless remains that thing 3 is more like thing 1: also, further on, the picture will be presented *as* a thing and it will be allowed a privilege in the presentation made *in it* (in presence and self-sufficient) of thing 2 (shoes as product). These "three" "modes" do not entertain among themselves a relationship of distinction, as Schapiro thinks. (Tight interlacing, but one which can always be *analyzed*, untied *up to a certain point*. Like a lace, each "thing," each mode of being of the thing, passes inside then outside the other. From right to left, from left to right. We shall articulate this *strophe* of the lace: in its rewinding passing and repassing through the eyelet of the thing, from outside to inside, from inside to outside, *on* the external surface and *under* the internal surface (and vice versa when this surface is turned inside out like the top of the left-hand shoe), it remains the "same" right through, between right and left, shows itself and disappears (*fort/da*) in its regular traversing of the eyelet, it makes the thing sure of its gathering, the underneath tied up on top, the inside bound on the outside, by a law of stricture. Hard and flexible at one and the same time). Thus the work, which is more like the thing pure and simple than a product is (shoes, for example), is *also* a product. The shoe picture is a product (of art) which is like a thing, presenting (and not representing, we shall come to this) a product (shoes), etc.

The recourse to the "famous picture" is in the first place justified by a question on the being-product and not on the work of art. The work of art as such will be talked about, it seems, only as if in passing and after the event. At the moment when Heidegger proposes to turn toward the picture, he is thus *not* interested in the work, but only in the being-product of which some shoes—any shoes—provide an example. If what matters to him and what he describes at this point are not shoes in painting, one cannot legitimately expect from him a description of the picture *for itself*, nor, in consequence, criticize its appositeness. So what is he up to and why does he insist so much on the being-product? He, too, has a suspicion, and a hypothesis: has not the thing pure and simple, thing 1, been secretly determined on the basis of thing 2, of the product *as* informed matter? Must we not try to think the being-product "before," "outside," "under" this supervening determination? "Thus it is that the interpretation of the thing in terms of matter and form, whether it remains medieval or becomes transcendental in the Kantian sense, has become current

and self-evident. But this does not make it any less a superimposition fallen upon (*Überfall*) the being-thing of the thing, than the other interpretations. This situation reveals itself already in the fact of naming things properly speaking (*eigentlichen Dinge*) things pure and simple (*blosse Dinge*, naked things). This 'naked' (*Das 'bloss'*) does however mean the stripping (*Entblössung*, the denuding which strips of -) away of the character of usefulness (*Dienlichkeit*) and of being made

— If I understand rightly: not the denuding of the foot, for example, but the denuding of the shoes that have become naked things again, without usefulness, stripped of their use-value? Presenting the shoes as things (1 or 3, without 2) would involve exhibiting a certain nudity, or even an obscenity

— obscenity, that's already laying it on a bit thick [*en remettre*]; let's say nudity, yes. Heidegger goes on: "and of being made. The naked thing (*blosse Ding*) is a sort of product (*Zeug*) but a product divested (*entkleidete*) of its being-as-product. Being-thing then consists in what still remains (*was noch übrigbleibt*). But this remainder (*Rest*) is not properly (*eigens*) determined in itself. . . ."

— The remainder: these naked shoes, these things of uncertain use, returned to their abandonment as things for doing nothing.

— Perhaps saying that still involves thinking of them too much in terms of their use-value. In order to think this "remainder" and "properly" (*eigens*) otherwise, Heidegger then takes another step. He wants to interpret the being-product *without* or before the matter-form couple, convinced that this remainder will not be reached by subtraction of the "product" but by opening up *another* road toward what is properly product in the product, toward the "Zeughaften des Zeuges." The reference to Van Gogh is inscribed in this movement, in whatever makes it very strictly singular. That said, *inside* this movement, Heidegger's gesture, with all the craftsmanlike subtlety of a cobbler with a short awl, going quickly from inside to outside, speaks *now of the picture, in it, now of something quite different, outside it*. In a first movement and most importantly, the question which provokes the reference to the picture in no way concerns a work of art. In a manner of speaking the primary motivation of the passage does

not concern painting. And yet, through this lacing movement we were talking about (from inside to outside, from outside to inside, his iron point passing through the surface of the leather or the canvas in both directions, pricking and pointing [*par piqûre et pointure*]), the trajectory of the reference is divided and multiplied. In a way which is doubtless both wily and naïve, but following a necessity which Schapiro's lawsuit seems to me to overlook.

— Is it a matter of rendering justice to Heidegger, of restituting what is his due, his truth, the possibility of his own gait and progress?

— This question comes a little too early. I'm only starting.

— Let me interrupt for a moment to recall, in "Parergon," the blank formed by the open-cornered frame separating the passage just quoted—on the "nudity," the "unclothed product" and the "remainder"—from a series of questions I should like to quote: "and what if the *Überfall* had the structure of the *parergon?* The violent superimposition which falls aggressively upon the thing, the 'insult,' as the French translator says for the *Überfall,* strangely but not without pertinence, which enslaves it and, literally, conjugates it under matter/form—is this superimposition the contingency of a case, the fall of an accident, or a necessity which remains to be examined? And what if, like the *parergon,* it were neither the one nor the other? And what if the *remainder* could never, in its structure as remainder, be determined 'properly,' what if we must no longer even expect or question anything within that horizon. . . ." Will it be said that we are here in the same problematic space, that of the edge, the frame, the place of the signature, and, in general, of the parergonal structure, as it is described "starting from" a certain reading of the *Critique of the Faculty of Judgment?*

— Yes ("starting from" and thus also outside it), yes, in a strictly necessary way, it seems to me. Let us inscribe all this— all that is being exchanged here on the subject of a picture and a correspondence—in this blank space with its dislocated frame. We cannot, even if I wanted to, analyze all the motifs which made one expect it at this place. It was prescribed there in all rigor but with that flexibility of chance, with that wager which could have

left the place empty. We should have to reread everything and other things besides.

— Should one translate *ergon* by product or work? And *parergon* by *hors-d'oeuvre*?

— "Parergon" replies to that question. What interests me here is not the necessity of returning toward "Parergon," but what is now added to it. In parergonal fashion, of course, as an outside assigned in the inside and yet irreducible.

— What, for example?

— Well, if, along with the frame and the column, clothing is for Kant an example of a *parergon*, in its aesthetic representation, and if then what is proper to representation is the "nude," then where shall we classify certain "old shoes with laces"? Do they not have as their "principal" subject this time *the parergon*, all by itself, with all the consequences that follow from that? A *parergon* without *ergon*? A "pure" supplement? An article of clothing as a "naked" supplement to the "naked"? A supplement with nothing to supplement, calling, on the contrary, for what it supplements, to be its own supplement? How would the shoes relate to the "naked" thing, to the "nude" and the "remainder" we've just been talking about? And yet, in another sense, we just said that they were "naked," we saw them quite naked. Is it by chance that the vestimentary "metaphor" comes so easily to Heidegger, when he wants to speak of the thing "pure and simple"? "This 'naked' (*bloss*) does however mean the stripping (*Entblössung*) of the character of usefulness (*Dienlichkeit*) and of being made. The naked thing (*blosse Ding*) is a sort of product (*Zeug*) but a product divested (*entkleidete*) of its being-as-product. Being-thing then consists in what still remains. But this remainder (*Rest*) is not properly determined in itself. It remains doubtful (*Es bleibt fraglich*) whether it is along the road (*auf dem Wege*) of a subtraction of all product-like characteristics (*alles Zeughaften*) that the being-thing of the thing comes in general to appear." A subtraction (of the being-product) will not restitute the "remainder" to us as a "naked" thing. The remainder is not a naked thing. We have to "think" the remainder otherwise.

— I always get the impression that in commenting on Hei-
degger, in restituting him in an apparently very strict way, one
makes him say something quite other; all the accents are changed,
his language is no longer recognizable. The commentary becomes
obscene and thinking otherwise becomes thinking otherwise than
he, who wants to think the remainder "properly." Here, "other-
wise" would be otherwise than properly. But then what would be
proper to this other?

— Let us rather return to the "famous picture." A product-
thing, some shoes, is there as if represented (Heidegger will, more-
over, say that it is not *re*presented, re-produced, but let's leave
these questions for the moment, we shall pick them up again).
This "product" has at least the following singular characteristics
that we can point out immediately: it belongs to the genus "cloth-
ing" (and is in this sense parergonal), and this is not the case with
all products. It hints at a movement of return to the thing that
is said, by metaphor or transference, to be "naked": insofar as it
is a useless product, not in current use, abandoned, unlaced, of-
fered, as thing (1 and 3) and as product (thing 2) in a sort of idleness
[*désoeuvrement*]. And yet, insofar as it is a usable product, and
especially insofar as it is a product of the genus clothing, it is
invested, inhabited, informed

— haunted

— by the "form" of another naked thing from which it is
(partially and provisionally?) detached

— "the *parergon* is detached . . ."

— and to which it seems to be waiting (seems to make us
wait for it) to be reattached, reappropriated. It seems to be made
to be retied. But the line of detachment (and thus of the out-of-
use and the idleness alike) is not only the one which goes around
the shoes and thus gives them form, cuts them out. This first line
is already a tracing of coming and going between the outside and
the inside, notably when it follows the movement of the lace. It
is therefore not simple; it has an internal border and an external
border which is incessantly turned back in. But there is another
line, another system of detaching *traits:* this is the work *qua*

picture in its frame. The frame makes a work of supplementary *désoeuvrement*. It cuts out but also sews back together. By an invisible lace which pierces the canvas (as the *pointure* "pierces the paper"), passes into it then out of it in order to sew it back onto its milieu, onto its internal and external worlds. From then on, if these shoes are no longer useful, it is of course because they are detached from naked feet and from their subject of reattachment (their owner, usual holder, the one who wears them and whom they bear). It is also because they are painted: within the limits of a picture, but limits that have to be thought in laces. Hors-d'oeuvre in the *oeuvre*, hors-d'oeuvre as *oeuvre:* the laces go through the eyelets (which also go in pairs) and pass on to the invisible side. And when they come back from it, do they emerge from the other side of the leather or the other side of the canvas? The prick of their iron point, through the metal-edged eyelets, pierces the leather and the canvas simultaneously. How can we distinguish the two textures of invisibility from each other? Piercing them with a single *pointure*

— So there'd be a *pointure* of the laces, in this other sense—

— piercing them with a single *pointure*

— does the *pointure* belong to the picture? I'm thinking of the points that nail the canvas onto the stretcher. When nails are painted (as they are by Klee in his *Constructif-impressionnant* of 1927), as figure on a ground, what is their place? To what system do they belong?

— the nails do not form part of the "principal" figure, as the laces do. The functioning of their *pointure* requires another analysis—

— piercing them with a single *pointure*, the figure of the laces will have sewn the leather onto the canvas. If the two textures are traversed by a single doubled blow, then they are henceforth indiscernible. Everything is painted on leather, the canvas is both shod [*chaussée*] and unshod, etc. That is how it appears, at least, in this play of appearance/disappearance.

In short, to precipitate the ellipsis of "Parergon" and "The *Sans* of the Pure Cut" which I give up here: what (and who) remains of a naked foot? Do these questions make sense? Would

the naked foot (which is more or less bound, underhandedly, whether or not it makes [up] the pair) here be the thing? Not the thing itself, but the other? And what has this got to do with aesthetics? With the word "beautiful"?

— A "beautiful" foot, a sublime foot like in Balzac's *Le Chef-d'oeuvre inconnu?*

— I said, in a shadier and lamer way, a word.

— What of the remainder, of feet or shoes: that's too open a question. I suggest that we tighten it up and come back more precisely to the object of the debate, an object which has been transfigured, it would seem, by the two correspondents: the figure of the peasant, for the one, and of the painter, for the other, who makes it into a portrait of the artist. The object of the debate

— The abject of the debate: shoes are also what you let fall. Particularly old shoes. The instance of the fall, the fallen, or the downfallen [*de la chute, du chu ou du déchu*]. You let something fall like an old shoe, an old slipper, an old sock. The remainder is also this lowness.

— "Make oneself a present of the remainder" (*Glas*), that is perhaps, following a syntax which neither stops nor works—not at all—that is Van Gogh's scene

— and that of the three eminent colleagues. But let's get back to the object of the debate. Why and by what right does Heidegger, talking about the "famous picture," authorize himself to say "peasants' shoes"? Why should the feet or the shoes belong to or come back to a peasant? Is Schapiro right or wrong to make his very pointed [*ponctuelle*] objection to this?

— I'll sharpen up the question: to a peasant or a peasant woman? It's the limen of this debate, let's remain there a little longer: why does Heidegger sometimes say "a pair of peasants' shoes (*ein Paar Bauernschuhe*) and nothing else (*und nichts weiter*)," without determination of sex or allowing the masculine to gain a footing thanks to this neutrality, and sometimes—more often, in fact—"the peasant woman" (*die Bäuerin*), when designating the "subject"? He never explains himself on this point,

and Schapiro, for his part, never pays the slightest attention to it. To which sex are these shoes due? This is not exactly the same question as that posed earlier, when we were wondering whether or not there was a symbolic equivalence between the supposed "symbol" "shoe" and such-and-such a genital organ, or whether only a differential and idiomatic syntax could arrest bisexuality, confer on it some particular leading or dominant value, etc. Here it is not the same question and yet the attribution of shoes (in painting) to a subject-wearer (bearer)

— of shoes and of a sex

— a masculine or feminine sex, this attribution is not without its resonance with the first question. Let us not forget that *The Origin* deals with the essence of truth, the truth of essence and the abyss (*Abgrund*) which plays itself out there like the "veiled" destiny (*fatum*) which transfixes being.

Graft of sex onto the shoes. This graft is not arrested by *The Origin*: sometimes the indeterminacy slips by force of language toward the masculine, sometimes the feminine wins out. There is *some* peasant(liness) and *the* peasant woman, but never a peasant man. For Schapiro, it comes down without any possible argument on the side of the masculine ("a man of the town and city"), Vincent Van Gogh's sex being in no doubt for the signatory of the "Still Life . . ."

— It is true that neither Heidegger nor Schapiro seems to give thematic attention to the sex of reattachment. The one reattaches, prior to any examination of the question, to peasantry, but passes without warning from peasantry to the peasant woman. The other, having examined the question, reattaches to some city-dwelling painter, but never asks himself why they should be man's shoes nor why the other, not content with saying "peasantry," sometimes adds "the peasant woman." Sometimes, and even most often.

— But what is thematic attention? And does what it seems to exclude (the implicit? the foreclosed? the denied? the unthought? the encrypted? the "incorporated"? — so many different functions) allow itself to be excluded from the field?

— From what field? Fenced by whom? By what? By peasantry or peasant-womanry?

— Yet there is something like a rule to the peasant woman's appearance on the scene. Heidegger designates in this way the (female) wearer of the shoes outside the picture, if one can put it that way, when the lace of discourse passes outside the edging of the frame, into that *hors-d'oeuvre* which he claims to see presenting itself in the work itself. But each time he speaks of the exemplary product in the picture, he says, in neutral, generic fashion—that is, according to a grammar, masculine fashion: "*ein Paar Bauernschuhe*," a pair of peasants' shoes. Why are the feet of the thing, in this case of some shoes, then posited as the feet of a woman, a peasant woman? The induction of a gesture such as this is all the more overdetermined because of the fact that in these passages the painting is no longer what lays down the law. This induction was without a doubt aided by so many other "peasant women" by Van Gogh, which is a step on the way to the contamination incriminated by Schapiro. According to him, several pictures came to make up Heidegger's imaginary model. We shall have to reexamine this complaint later. Elsewhere I shall also suggest placing in series, in a gallery, all the figures of women which rhythm, with their discreet, furtive, almost unnoticed appearances, Heidegger's discourse on The Thing: the peasant woman, the Thracian servant girl, the woman museum attendant, the "young girl" as "too young a thing" in the saying quoted at the beginning of our chapter and met with, like the first examples, on the road, *am Weg*: "*Der Stein am Weg ist ein Ding und die Erdscholle auf dem Acker. Der Krug ist ein Ding und der Brunnen am Weg. . . .* The stone on the road is a thing and the clod of earth in the field. The pitcher is a thing, as is the well beside the road. Man (*Mensch*) is not a thing. It is true that we speak of a young girl who undertakes a task that is beyond her as 'too young a thing' (*ein zu junges Ding*) but only because in this case we omit, in a certain sense, the being-human (*Menschsein*), thinking that we find here rather what precisely constitutes the being-thing of things (*das Dinghafte der Dinge*). . . ."

—The snare, gin, or pitfall of a moment ago are starting to look like a G-string, maybe a girdle [*gaine*].

—No, no, of course it's a matter of those things that must go on (the) foot. And which Heidegger pulling in one direction, and Schapiro pulling in the other, the one before examining the question, the other after a cursory examination, both want with the same amount of compulsive violence and trickery, to try on, to make fit

—to sharpen to a point: give in

—by forcing things, at all costs. Here, it's the foot of a city dweller who is not very far from him; there, the foot of a peasant woman close at hand. Speculation in mirrors to make sure of the thing. Which is used and used again, here a woman, there a man, in a duel to the death, of course, implacable and cruel despite the academic courtesy, the mutual esteem of the two men, the rules of honor and all the witnesses gathered together on the field. The chosen weapon, since you have to strain at the parergon, is the shoehorn. As for the state of the ground: a duelling field full of traps for clerks, they may well both end up being slain. Surviving witness: the shoes in painting remain, looking at them with the detachment of an imperturbable irony.

—What I asked was, is Schapiro right?

—A bit too right, in my opinion. Here we have to go into details, word by word. Everything in this deal is an affair of detachment and of de-tailing.[6] Schapiro extracted this long passage, rhythmed by a strange "And yet (*Und dennoch*)." Then he writes: "Professor Heidegger is aware that van Gogh painted such shoes several times, but he does not identify the picture he has in mind, as if the different versions are interchangeable, all presenting the same truth" [Schapiro, p. 205]. Schapiro is right; he's only too right. Heidegger does not try to specify which picture is in question. He hurries into the reference, and such a vague reference ("a famous picture"), as though the thing were so sure and clear, paying no attention to the differential series which not only discriminates between possible references, but also makes of each picture a latent, lateral, and differential reference to the others. One can even find something like an index of this seriality in one

6. *Détaille*, one of Derrida's neologisms, suggesting both "cutting (something) up into pieces" and "taking away the size or measure from (something)."

of the pictures (*Three Pairs of Shoes,* F. 332). On the far left, the shoe with undone laces has its "collar," so to speak, open and turned inside out, like the one on the left of F. 255, the picture identified by Schapiro as the one mentioned in *The Origin.* In the center, another "turn-up," one shoe exhibits its sole. I say "collar" because of the neck (from head to foot)

—or the cervix [in French: *col de l'uterus*].

—All this aggravates Heidegger's referentialist, monoreferential naïveté. This must be emphasized with respect to a discourse on *The Origin of the Work of Art.* It can't not have some relationship with the whole undertaking. And yet:

a. Heidegger "is well aware," and Schapiro knows that he is well aware: "Van Gogh painted such shoes more than once" (*solches Schuhzeug mehrmals gemalt hat*). Why did he not take this into account? Is his error more serious or less serious for this? Has he arrived by induction at a sort of "general picture," retaining, by abstraction or subtraction, the common or supposedly common traits of a whole series? This hypothesis—the least favorable—is ruled out by everything of Heidegger's one can read. He was always very severe on this conceptualism, which would here be doubled by an empiricist barbarity. So?

Heidegger's defence, mitigating circumstances: his "intention" was not that of concentrating on a given painting, of describing and interrogating its singularity as an art critic would do. So let's read once more the opening of this passage. It is indeed a question of "simply describing" (*einfach beschreiben*) not a picture but "a product," "without philosophical theory." "We choose as an example a common sort of product: a pair of peasants' shoes." *Not yet a picture, not a work of art, but a product.* Let's go on. "In order to describe them, we do not need to have in front of us real samples of useful objects of this type. Everyone is familiar with them. But since it is a matter here of an immediate description, it may be as well to facilitate intuitive presentation (*Veranschaulichung*). By way of an accessory aid (*Für diese Nachhilfe;* omitted in the French [and English] translation), a pictorial representation (*bildliche Darstellung*) suffices. For this purpose we choose a famous picture by Van Gogh who painted such shoes more than once."

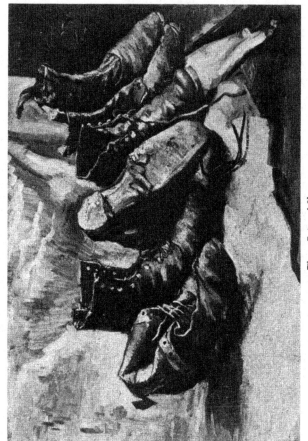

Three Pairs of Shoes.

—It's clear, the picture is, *for the moment*, as a hypothesis, an intuitive accessory. One can reproach Heidegger for this illustrative procedure, but that would be a different matter from behaving as though he were trying to describe the picture for itself, and then, in this hypothesis which for the moment is not his, reproaching him for mistakes in the reading. *For the moment*, the object to be described, to be interpreted, is not the picture or even the object insofar as it is painted ([re]presented), but a familiar product well known to everyone. None of what follows concerns, or pretends to delimit, the pictorial specificity of the shoes or even their specificity insofar as they may be different from other shoes. With a picture in front of you to keep up attention and facilitate intuition, a picture of a pair of shoes, whatever pair it may be, peasants' shoes or not, painted or not, you could bring out the same features: the being-product, the usefulness, the belonging to the world and to the earth, in the very definite sense that Heidegger accords to these two words which do not interest Schapiro and to which we shall have to return. But in that case, you'll say, why choose a painting? Why explicate so heavily what stems from the problematical identification of these shoes as peasants' shoes? At the stage where we are at the moment, and Heidegger says so, some real shoes (peasants' or not) or shoes drawn vaguely in chalk on the blackboard would have rendered the same service. The blackboard would have sufficed.

—That's what Schapiro reproaches Heidegger with.

—But Heidegger says it ("But what more is there to see there? Everybody knows what belongs to shoes"), and you can only reproach him for it by assuming that he was *primarily* interested in a picture, that he was trying to analyze it as such, which is not the case. For the use to which he wanted to put it at first, the various canvases were indeed interchangeable, with no harm done. If his attribution of the thing to peasantry is indeed (and we shall still have to examine to what point it *is*) imprudent and precipitate, we do at least know that he could have produced, for what mattered to the analysis of the being-product, the same discourse on town shoes: the relationship of the wearer to this strange product (very close to, and yet detachable from, his body), the relationship with walking, with work, with the ground, the earth, and the world. Everything that comes down to the "peasant" world is in this respect an accessory variable even if it does come

massively under "projection" and answers to Heidegger's pa-
thetic-fantasmatic-ideological-political investments.

b. The "same truth," that "presented" by the picture, is not
for Heidegger "peasant" truth, a truth the essential content of
which would depend on the attribution (however imprudent) of
the shoes to peasantry. The "peasant" characteristic remains sec-
ondary here. The "same truth" could be "presented" by any shoe
painting, or even by any experience of shoes and even of any
"product" in general: the truth being that of a being-product com-
ing back from "further away" than the matter-form couple, further
away even than a "distinction between the two." This truth is
due to a "more distant origin." It is not the truth of a *relationship*
(of adequation or attribution) between such-and-such a product
and such-and-such an owner, user, holder, bearer/wearer-borne.
The belonging of the product "shoes" does not relate to a given
subjectum, or even to a given world. What is said of belonging
to the world and the earth is valid for the town and for the fields.
Not indifferently, but equally.

Thus Schapiro is mistaken about the primary function of the
pictorial reference. He also gets wrong a Heideggerian argument
which should ruin in advance his own restitution of the shoes to
Van Gogh: art as "putting to work of truth" is neither an "imi-
tation," nor a "description" copying the "real," nor a "reproduc-
tion," whether it represents a singular thing or a general essence.
For the whole of Schapiro's case, on the other hand, calls on real
shoes: the picture is supposed to imitate them, represent them,
reproduce them. Their belonging has then to be determined as a
belonging to a real or supposedly real subject, to an individual
whose extremities, outside the picture, should not remain bare
[*déchaussées;* also, "loose" (of teeth)] for long

— loose like old teeth. But he won't be able to avoid the bridge.
He doesn't know that the shoe already forms a prosthesis. And
perhaps the foot does too. It can always be someone else's. So
many sayings pass through here to speak of the dislocation of the
inadequate, like when one is "*à côté de ses pompes*" [literally,
"beside one's shoes (with fatigue)"], or the usurper's abuse: "to
be in someone's shoes."[7] Thrown into the abyss, the sphynx, from
the moment the turgidity

7. In English in original.

— Schapiro tightens the picture's laces around "real" feet. I underline: "*They are clearly* pictures of the artist's *own* shoes, not the shoes of a peasant. . . . Later in Arles he *represented*, as he wrote in a letter of August 1888 to his brother, 'une paire de vieux souliers,' which are *evidently his own*. . . ." *They are:* the lace passes here, in the copula, it couples the painted shoes and the painter's feet. It is drawn out of the picture, which presupposes a hole in the canvas.

— And besides, did we have to wait for Heidegger before being on our guard? Before we could avoid considering a painted object as a copy? Worse, before we could avoid attributing it an adequate model (real shoes) and what's more attributing to this model an adequate subject (Van Gogh), which makes two capitalized attributions? Then there is the word *evidently*, the word *clearly* which comes in again later, when a picture is identified in a catalog, the words *his own* which several times so calmly declare property, propositions of the type "this is that" in which the copula ties a "real" predicate to a "painted" object. One is surprised that an expert should use all this dogmatic and precritical language. It all looks as though the hammering of the notions of self-evidence, clarity, and property was meant to resound very loudly to prevent us from hearing that nothing here is clear, or self-evident, or proper to anyone or anything whatsoever. And doubtless Schapiro knows this or says it to himself more or less clearly. But it is only at this price that he can have the shoes, acquire them with a view to a restitution, snatch them from the one to give them to the other. That other to whom he believes he is no stranger. To slip them on, then. On his own feet and on the other's feet. Like a garment or an object that one puts on [*qu'on se passe*]. The *se passer* of this thrust [*cette passe*] is also what the shoes in *restance* are doing. That's what's happening here.[8]

— I would distinguish three dogmas in Schapiro's credo, when he speculates in this way on the occasion of these old shoes. Three dogmas with structures that are distinct from one another but analogous in their functional finality. 1. Painted shoes can belong really and really be restituted to a real, identifiable, and nameable subject. This illusion is facilitated by the closest identification

8. *Voilà ce qui se passe ici:* this plays on three senses of *se passer:* to happen, to put on (a garment), to do without (something).

between the alleged holder of the shoes and the so-called signatory of the picture. 2. Shoes are shoes, be they painted or "real," solely and simply shoes which are what they are, adequate to themselves and in the first place fittable onto feet. Shoes belong properly. In their structure as replaceable product, in the standard nature of their size, in the detachability of this clothing-type instrument, they do not have what it would take to make all *strict* belonging and propriety drift. 3. Feet (painted, ghostly, or real) belong to a body proper. They are not detachable from it. These three assurances can't stand up to the slightest question. They are in any case immediately dismantled by what *happens* [*se passe*], by what *there is* in this painting.

— Although they bear on three distinct articulations, these three assurances tend to efface them in the interests of one and the same continuum. To reattach the detachables according to an absolute stricture.

— No more laces, what, no longer even a knot to be seen, or holes or eyelets, but full shoes, absolutely adherent to the foot.

— Like in Magritte's *Le Modèle rouge*. But there, too, one must take into account an effect of series and citationality. Magritte painted several of them. There, not counting *La Philosophie dans le boudoir* (1947) or *Le Puits de vérité* (1963), there is incontestably a pair, you can see the disposition of the toes which form one and the same body with the boots. They form both the pair and the join.

— *Le Modèle rouge* also mimics this lure and mocks it. It also cuts off the shoe-foot at the ankle, at the neck, indicating by this trait or stroke, added to the horizontal and regular lines of the wooden background, then added to the lines of the frame, that this pair of rising-sided (rising toward what?) shoes, now out of use, with empty unlaced neck (unlaced differently from one model to another), then summoning Van Gogh's witnesses to appear, are still deferring their supplement of property, the revenue on their usury [*usure*; also "wear"]. Their silence makes the expert speak, and he will not take long to say, like Heidegger speaking of Van Gogh's picture: "it has spoken." Two psychoanalysts—from London, of course, that sort of thing would never get across the English Channel—said to Magritte: "*The Red Model* is a case

The Red Model.

of castration." The painter then sent them "a real psycho-analytical drawing" which inspired the same discourse from them.

— But why so cutting in this verdict against Schapiro? If he were so credulous in the identification of this picture

— I haven't demonstrated that yet, I've stuck to the general premises. Later, with respect to this picture

— all right, let's say credulous in the attribution, in general, of painted shoes to a determinable subject and, which is indeed more serious, to one that is determinable *in reality:* isn't Heidegger's naïveté still more massive? He also attributes the painted

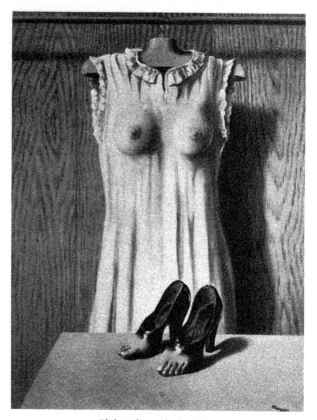

Philosophy in the Boudoir.

shoes, without the slightest examination, to peasantry, or even
to the peasant woman. This attribution appears to be incompat-
ible with what he says further on against imitation, copy, repre-
sentative reproduction, etc., against the notion of adequation or
homoiosis. For example: "Or else would the proposition according
to which art is the putting-itself-to-work of truth give new life
to a fortunately outdated opinion according to which art is an
imitation or a descriptive copy of the real? The replica of the
given doubtless demands conformity with being, a regulated mea-
suring against it; *adaequatio,* say the Middles ages, ὁμοίωσις said
Aristotle already. For a long time, conformity with being has been

The Well of Truth.

considered to be equivalent to the essence of truth. But do we really believe that this picture by Van Gogh copies (*male ab*, depicts) a given (present, *vorhandenes*) pair of peasants' shoes, and that it is a work because it has succeeded in doing so? Do we wish to say that the picture has taken a copy of the real and that it has transformed the real into a product (*Produkt*) of artistic production? Nowise." This reply ("Nowise") also holds, in the next paragraph, for the reproduction of a general essence which some tried to substitute for the singular given, keeping the same schema. Now I understand well enough how that hits Schapiro's

preoccupations and disqualifies his assurances (Schapiro who seems to believe in the reproduction of "given" shoes, those of Van Gogh and even of a "given" Van Gogh, in a *given* time and place, "by that time a man of the town and city"!), and I also understand well enough how the proof itself is in this case *a priori* irrelevant. But what I do not understand is why Heidegger should escape from the same suspicion, from his own suspicion basically, from the moment he says, without proof this time, without even looking for a proof: they are peasants' shoes. He does not even say *they are* in order to reply to a possible question; he names them, *"Ein Paar Bauernschuhe,"* without even imagining the first murmur of a question.

— That's the whole dissymmetry, the innocent outbidding, of this correspondence. One claim is more naïve, more excessive, if one can say that, than the other. One attribution exceeds the other. Imagine an auctioneer who is both an expert and a buyer, pushing up the bidding in the empty room. Bidding for second-hand, more or less unmatched shoes on a framed canvas. On the one hand, Schapiro's attribution remains in the aesthetics of representation, and even of the most empiricist kind: either short of (precritical), or going beyond (excessive), the movement carried out by *The Origin* in the passage just translated. But on his side, by saying *"Bauernschuhe"* without asking himself any questions about this, Heidegger falls short of his discourse on the truth in painting, and is even more naïve than Schapiro. Excessive to the extent of talking about peasants' shoes even before any question of "representation," and already in the order of a "presentative" truth. The fact is that the step backwards from a truth of adequation to a truth of unveiling, whatever its necessity and its "critical" force, can also leave one practically disarmed in the face of the ingenuous, the precritical, the dogmatic, in the face of any "preinvestment" (be it "fantasmatic," "ideological," etc., or whatever name you call it). There's a law here. This is perhaps one of the secrets of this correspondence, of its dissymmetry or its excessive symmetry: in the contract of truth ("I owe you the truth in painting"), between truth as adequation (of a representation, here an attributive one, on Schapiro's side) and the truth of unveiled presence (Heidegger's side). For the moment let us leave this truth contract, between the two truths. (What is *doing* the *contracting* there has to do with a *trait* (*Riss*) and an attraction [*attrait*] (*Zug*) of the work, with a *Gezüge,* which will draw us

much further into Heidegger's text.) The truth of the shoes as
things due (the object of the subject) constrains this correspon-
dence and we ought (supposing one ever has to ought) to reex-
amine its terms later. One of the innumerable difficulties in read-
ing *The Origin* and especially this passage, is that of grasping the
furtive moment when a certain line is crossed, and of grasping
too the step with which it is crossed.

— In the sense of *über die Linie* (*trans lineam* or *de linea?*)
and of the topology of being in *Zur Seinsfrage?*

— No. Well, yes. But this connection passes through detours
we don't have time for here. Or space. I was simply designating,
close at hand here, the crossing of certain lines, of certain *traits*
in the picture (the outline of the "product," for example the line
of the collar or the line of the lace). And above all, first of all, the
crossing of the lines of framing, the *traits* which detach the picture
from the real milieu. Where, at what moment, in what direction
[*sens*] does this transgression take place? And is this crossing a
transgression? Transgression of what law? Which comes down to
wondering notably whether and within what limits Heidegger
intended to speak of the "famous picture."

— Which one?

— We don't know yet. We have verified that at the precise
moment when in this chapter he takes the example of a pair of
peasants' shoes, no picture has yet been necessary. None has even
been invoked. And it's been going on like that for several pages.
Now even at the moment when the "famous picture" provides
what is basically an example of an example, its status leaves us
in a definitive uncertainty. We can always say, challenging proof
to be produced, that Heidegger does not intend to speak of the
picture, does not describe it *as such*, and passes regularly from
an example of a product (peasants' shoes) to the example of the
example (some particular shoes in some particular picture), in
both directions, then from exemplarity to the being-product, pick-
ing out the predicates of the being-product and letting the others
drop

— like old shoes

— more or less attentively, even if he does devote an abundant pathetico-pedagogical discourse to them. Even if he invests, in this investiture of vestimentary products, some values that one can take an interest in elsewhere.

— You're trying to justify him at any price.

— No. One can see *clearly, evidently,* that all that is said first in the first three paragraphs (up to the "And yet" (*Und dennoch*), an articulation or rhetorical suspension which is very unusual in Heidegger; it must be rigorously taken into account) does not claim to say anything about the picture *itself.* The only object in view is this pair of peasants' shoes mentioned earlier. No trait specific to the picture. After the "And yet" (followed by a period and a new paragraph), the pathetic tirade (what else can you call it?) has the form of an escaping meditation. But escaping from a picture which has only been evoked and into which neither gaze nor discourse has yet penetrated, which they have not even approached or brushed with a description. Nothing has yet been said which strictly concerns the content of the picture and scarcely does it come to be named a second time than it is left again in an evasive discourse which goes beyond it. Look at it attentively: each paragraph is a new wave that pretends to brush against the object and which pulls back immediately. And yet: a light touch, a very brief contact, indeterminate enough to generate just about any discourse going beyond bounds, has left the mark of its passage in the text. So Schapiro's objection will be as light as this, and he will find only this touch to support him in his identification of the picture which he thinks Heidegger is talking about. This touch is "*Aus der dunkeln Öffnung des ausgetretenen Inwendigen des Schuhzeuges,*" "From the dark opening of the worn inside. . . ." It's vague enough, open, loose enough, for one to be able to say it, more or less, about any pair of shoes, real or not, of peasant or city dweller, and in any event, as Schapiro rightly remarks, of three paintings of shoes signed by Van Gogh. But once more one can only make this into an objection by attributing to Heidegger an intention, which nothing in his text shows to be there, of describing and referring only to painted shoes, particular painted shoes, within the limits of a frame which can only be crossed in one direction: from the outside to the inside. If one ceases to attribute this intention to Heidegger, on the grounds that this question of the frame is not settled in all its implications

[*portées*], then the argument can be turned around against the objector. (Let us not forget that henceforth we shall have to ask again this question of the frame, the question of this frame, following the figure or trajectory of the *lace:* a stricture by alternate and reversible passage from inside to outside, from under to over. These laces which rise toward the collar "in" the picture or "in" the frame also form the *outline* [*le tour*] of the picture and the frame.) When Schapiro writes a little further on: "I find nothing in Heidegger's fanciful description that could not have been imagined in looking at a real pair of peasants' shoes" [Schapiro, p. 206], one can agree with him. But one can also see in this a confirmation of the fact that Heidegger was not trying to describe a picture. At least not simply, for we are still lacking even the premises of the debate, as well as the frame of the debate and the debate on the frame, on the structure (or the stricture, as we shall soon be saying) of its double limit, internal and external, its double edge.

For Schapiro did indeed pass over in silence, jumping it in his long quotation, what was inscribed on the lower edge of the "pathetic" paragraph (the third paragraph of this passage around the picture). Heidegger begins a new paragraph, as he had after "*Und dennoch*", and he writes: "But perhaps we see all this only on the shoes in the picture (*im Bilde*, or in image)," as a picture, as an image, etc. The fact that he says "perhaps," that he pretends, at least hypothetically, to see a limit in a description constrained or contained by pictorial determinations, this simple fact clarifies the possibility of crossing the frame in both directions. So in the previous paragraph *there was a claim* to see or read *something other than or beyond* the framed picture, something other than an "image" and this picture. By saying: but perhaps we remained shut up in it as if in a projection or a subjective hallucination, Heidegger confirms fully that his project was to go beyond the picture as representation. The allusion to Van Gogh did not therefore have the function attributed to it by Schapiro. The pathetic evasion

— Heidegger would not accept these words. He would no doubt have more than one question to ask about what Schapiro calls his "pathos." That would take us too far. And then he doesn't escape, he remains, digs himself in, stays . . .

— I meant "escape" by overflowing a pictorial limit with its collar flared out or half-turned inside out, by the crossing of the

framed representation, of visible immediacy, if any such thing exists, *in* the picture. Is this overflowing the discursive operation itself, from the first word, the first articulation? Or else does it have its internal reason, in some way, *in* the pictorial structure? The question which interests me is one of those which are not thematically posed by either of the correspondents. It concerns the structure of this limit, of being-in or being-out. With regard both to the product and to the work. This is in effect the question of the supplement of *parergon* which relays or pulls along with it a certain number of other questions which I do not have the time to enumerate. From the moment that the evasion makes its takeoff[9] from such an impoverished and indeterminate descriptive touch, any other descriptive trait (there are, so to speak, no others) would no longer concern a painting. For example (but there is no other example): "On the leather lies the rich damp earth. Under the soles. . . ." And even this "under" would push down to the underside of the canvas

 — which would be the sole?

 — if the canvas alone were designated. For these reasons alone, already, one cannot reproach Heidegger with getting the wrong picture, with muddling up several pictures, with describing badly or projecting into an imaginary space. He does not claim in all rigor to refer to a picture in general, or to some particular picture. This reference

 — But what is it to refer? What is reference in painting?

 — whatever this reference is, it's not essential to what he's saying. What's more, he's interested here in the truth of truth, which is an indispensable condition for knowing what reference means. And does not the notion of reference, like that of referent, belong to a semio-linguistics still dominated today, whether we like it or not and whether we know it or not, by the matter-form couple? By that interpretation of the thing as "product" which this very passage of *The Origin* is in process of putting into question or on trial?

9. *Prendre son appel sur:* a metaphor from athletics, suggesting a runner taking off from starting blocks.

— All right. But then how do you explain that further on, at the other end, all this discourse on the shoes, on this example of a product, should be put down to the picture *itself?* No longer merely as a discourse *on* the picture but a discourse *of* the picture, a discourse produced by it, or even by the pair of shoes? That's more serious, and more serious than what Schapiro reproaches him with.

— Oh, for both of them it's quite certain that the thing speaks. Look at what Heidegger says elsewhere about the *causa*, it would be essential to our debate.

— I return to my question. It all looks, in the end, as though Heidegger had indeed not spoken of the picture. But far from evading it, he would, in this hypothesis, not have spoken *of* it in order to let *it* speak *itself.* Not made to speak but allowed to speak. (Once they are painted,) these shoes talk, this thing produced by and detached from its subject begins to talk (about it), that's what Heidegger says a little later. He does not say it himself, but let's say that it is said and in any case here is what we read: "The being-product of the product has been found. But how? Not through a description or explanation (*Erklärung*) of a pair of shoes (*Schuhzeuges:* translated as *pair* once *Zeug* determines the *useful* product, an important nuance which will be of interest to us later on) actually present; not through a report on the process of making shoes; and no more was it through the observation of the way in which shoes are actually used here and there. But—but only by placing ourselves before Van Gogh's painting (*wir uns vor das Gemälde van Goghs brachten*). It spoke (*Dieses hat gesprochen*). In the proximity of the work we were suddenly somewhere other than where we are accustomed to be. The work of art has given us to know what the pair of shoes (*Schuhzeug*) is in truth. It would be the worst of illusions if we were to want to think that it was our description as subjective activity which had thus depicted everything and then introduced it into the picture. If something here is problematical, it is only the fact that we have learned only too little in proximity with the work and that we have stated this learning (*Erfahren:* to feel, to experience, to traverse) only too coarsely and immediately. But above all the work has in no way served, as it may have appeared at first, the interests of a better intuitive presentation (*Veranschaulichung*), and only that, of what

a product is. It is much rather through the work and only in the work that the being-product of the product properly (*eigens*) comes to its appearing (*Vorschein*). What is happening here? What is at work in the work? (*Was ist im Werk am Werk?*: at work in the sense of 'working, laboring,' of course, if not 'ready to get down to the job,' but one can also, by playing scarcely at all on the German, translate it as 'right on the work,' 'belonging to the work, working in the work,' which brings together numerous questions.) Van Gogh's painting is the disclosure of what the product, the pair of peasants' shoes, *is* in truth (*was das Zeug, das Paar Bauern-schuhe, in Wahrheit ist;* let's be attentive to the syntax of this sentence). This being comes into the unconcealedness (*Unver-borgenheit*) of its Being. The Greeks called this unconcealing of being ἀλήθεια."

— Isn't that the worst of all? Worse than the subjectivist "illusion" denounced by Heidegger? Worse than the "projection" incriminated by Schapiro? Here the painting now unveils by speaking, in the immediate proximity of its presence, which it would be enough to place oneself or find oneself in front of. That seems to me to contradict what was said a while ago about the example of the example.

— This exemplarity had to be thought of *in laces*.[10]

— The laces are being misused; everyone's playing with them—

— Yes, it seems "worse" than the readequation or reattribu-tion of a representation in the course of a laborious reattachment. It would be worse if *"Dieses hat gesprochen"* had the usual sense of discourse, and thus of human discourse attributed to a painting, to a shoe in painting. When I come on later to the problem of the *trait* (*Riss*), the *attrait* [attraction] (*Zug*), of the system that con-tracts the traits (*Gezüge*) in their relationship to speech and lan-guage, I shall try to show that it is more complicated than that. For the moment, it would indeed be "worse," if the "truth" were that of the "peasanthood," so to speak, of the shoes and not merely of their "being-product." But we did read: "Van Gogh's painting is the disclosure of what the product, the pair of peasants' shoes, *is* in truth." The syntax of the sentence, identical in German and

10. *En lacet:* literally, in (shoe-)laces, but this is also an idiom used to describe, for example, a winding road.

in French [and also in English] clearly marks the place of the subject. It is a matter of the truth of the product, of the being-product and not of the example, i.e., some particular pair of shoes squeezed into their determination as peasants' shoes. And this is quite in conformity with the demonstrative aim of this sequence. The word "example" would lend itself to confusion if it indicated only a determinant relationship of individual to conceptual generality or merely a specific (species/genus) narrowing of the concept of being-product to that of shoes (clogs, old slippers, boots, points, etc.) and then to that of peasants' shoes (which ones?), then to this pair here.

— But is one shoe by itself an individual of the group "pair"? And is a pair an individual of the set "shoes"? I came here [as a woman] to ask this question which nobody, since a moment ago, seems to have heard.

— If the word "example" lends itself to the confusion I was suggesting, things must be made clearer: the whole sequence appears to exclude this relationship of conceptual articulation (genus, species, individual, pair or not). It is indeed *this* pair in *this* painting which opens to the truth of the being-product. But which opens to it in its unveiled-unveiling presence, letting itself be traversed

— like an eyelet, like the leather, like the canvas of the shoes, traversed by the lace?

— toward truth. And in this case, even if there were an error of attribution or a projection of peasanthood, the margin of aberration would be very narrow. It is the truth of the being-product as such which carries weight. If there is projection, the haul is a meager one for the picture police, for this discourse of order and of property/propriety in painting.

— If police there is (and isn't there always?) it would here be operating against another police, against another ideological arraignment, and

— What does *ideological* mean in this case? *The Origin* suggests in passing a few interpretive schemas with respect to the formation and limits of this concept of ideology or of its field.

— Your refinement around the syntax of "the product, the pair of shoes" seemed incredible to me. So everything would be played out in the suspense of this apposition, on the point of a comma between "the product" and "the pair," this pause setting down the pair a little to one side of the product, of a slightly longer interval between two words

— what is the size [*pointure*] of a comma?

— It isn't a matter of temporal interval between two, of which one is "pair," but of this syntactic fact that "the pair" is in apposition, doubling the product, with a doubling which is nonetheless narrowing, stricter, straiter (the product, *here for example* the pair). So the space of *this* painting is assigned by the *pointure* of the comma which *itself*, as comma, like a shoe, never says anything.

— So everything comes down again to one of those "*explications de texte*" . . . Are we reading? Are we looking?

— You think people would accept that, that they'd receive it as an *explication de texte* or as a "close reading"?[11]

— Everything comes down to one of those reading exercises with magnifying glass which calmly claim to lay down the law, in police fashion indeed.

— It can always, more or less calmly, become police-like. It depends how, with a view to what, in what situation it operates. It can also arm you against that other (secret) police which, on the pretext of delivering you from the chains of writing and reading (chains which are always, illiterately, reduced to the alphabet), hastily lock you up in a supposed outside of the text: the pre-text of perception, of living speech, of bare hands, of living creation, of real history, etc. Pretext indeed to bash on with the most hackneyed, crude, and tired of discourses. And it's also with supposed nontext, naked pre-text, the immediate, that they try to intimidate you, to subject you to the oldest, most dogmatic, most sinisterly authoritarian of programs, to the most massive mediatizing

11. In English in original.

machines. But we can't here get into this debate about barbarities. I suggest we come back to the passage in which, with the frame playing discreetly (inaudible movement of the lace), the event, which is keeping us here with its police, political, historical, psychoanalytical stakes, happens. The border between this text (in the usual and supposedly strict sense of a thing printed in a book) and a general textuality (with no absolute edge) here comes away [s'y enlève].

— Comes away: in the sense of the *Gestalt* appearing against a background? Or else of something being effaced and lost?

— Perhaps both: both can be "at work" as we were saying earlier. Before returning to Schapiro's indictment and its cause, I'd like to explain very quickly an apparent reversal of perspective in *The Origin* (which can and must also be treated in painting [or: "as a painting"]). Having placed in a secondary position an example of an example and without there being any question of referring to a picture for itself, in its picture system

— does that exist, picture for *itself* in its picture system?

— having placed such a "system" in a secondary position, Heidegger has come, in stages, to entrust the whole truth to the picture, to restitute it entirely to the painting which "has spoken," ending up by doing something quite different from illustrating or rendering present to intuition. How and why? All that is difficult. Tiny and minutely regulated. As in the fetishism trial, everything is a business and an economy of detail, of de-tailing/unsizing [*la détaille*]; you can't do without detail. Not here, any more than you can anywhere else. We have to unlace *The Origin* with slow gestures, attentive to the slightest fold, with risky gestures, too, and from time to time a sudden deviation and a tug.

Heidegger chooses a picture, he decides on, posits, and produces a convention: "For this purpose we choose a famous picture by Van Gogh who often painted shoes like these. . . ." He does not identify it in its singularity. He gives it no title, no catalog number. He doesn't care at all about its differential or citational inscription in a series (by Van Gogh or others, Millet for example). But we know that he knows: there are others. What, for the moment, could authorize his insouciance? This: immediately afterwards and on several occasions, he calls on this painting only in

order to note—and have us note—that it is *useless*. There's nothing to be done with it and nothing to learn from it. He's going to put this uselessness to good use, to the use which we shall see. He's going to exploit it, speculate on it, make it *pay*.[12] So we shall have to refine on and differentiate the detail of this value of uselessness, of uselessness *itself*. But we can immediately guarantee the pertinence of this proposition: *to the extent that* Heidegger has clearly dismissed the picture to its uselessness for what matters here, insofar as and so long as he does so, we have the right to say that Heidegger does not make use of the picture for his demonstration and that in a certain way it isn't about the picture. Reference is suspended (or traversed).

— Shall we say then that he quickly let the picture drop like an old shoe, like a useless object, out of use? Like something abject? That would still involve considering it itself.

— Let's say that he puts it to one side, puts it down beside the present discourse. In any case, letting things drop takes time. The trajectory is twisted enough for more than one thing to happen in it. The moment he has "chosen" *the* picture, without choosing *among* the pictures in a series the existence of which he knows about, he abandons it. He begins, from the next sentence, to let it, if you like, drop: "But what is there to see here that's so important? (*Aber was ist da viel zu sehen?*)" What more is there, what is there that's so important, to see in this painting? The reply comes quickly and is clear-cut: *nothing*. Nothing that we didn't know already—outside the picture (by implication). This reply is never contradicted, but merely meditated on in the course of a winding road [*chemin en lacet*]. There will never appear a single content about which one could decide that, *qua* content, it belongs to the picture, is disclosed, defined, described, read *in* it. In these conditions, how could there be any confusion or projection with regard to the nature or property of painted things?
Having asked, "But what is there to see that's so important?" and replied, nothing, "everybody knows what is proper to shoes," Heidegger proposes a banal and minimal description of "what we already know" (*was wir schon wissen*) prior to any painting. A description, precisely, in terms of matter and form, these categories that at some moment or other are to be abandoned. But

12. *Rendre:* also, give up, return, vomit.

this description itself lets drop, abandons the picture immediately after its first evocation ("we choose . . .")

— But what is it to abandon a picture?

— What carries weight, in these few descriptive lines, is perhaps the fact that they exclude (wooden) clogs or bast shoes: "But what is there to see here that's so important? Everybody knows what is proper to shoes. If they are not clogs or bast shoes (*Holz- oder Bastschuhe*), we find the leather sole, the upper, the one joined to the other by stitching and nails. Such a product serves to clothe the foot (*dient zur Fussbekleidung*). As a function of this usefulness (*Dienlichkeit*), depending on whether it's a matter of work in the fields or of dancing, matter and form vary."

— He has just excluded clogs or wooden shoes. Why, if it is not because he's talking about a picture? Doesn't this make Schapiro right? Most of the peasants and especially the peasant women in Van Gogh's paintings or drawings wear clogs. I'm thinking especially of that *Intérieur de ferme* (1885, F. 168), of the *Ecosseuse de pois* (1885, F. 214), of a *Paysanne arrachant des pommes de terre* (1885, F. 251), of the *Femme à la bêche vue de dos* (1885, F. 255), of the *Paysan fauchant* (1885, F. 318), of *Le bûcheron* (1885, F. 1327), of the *Paysan à la bêche* (1890, F. 1587), of the *Paysans au travail* (1890, F. 1602), and of so many other clogs in scenes, groups of figures, or "still lives" the background of which remains visibly the peasant world. If clogs are excluded in Heidegger's very example, a simple internal reading ought to suffice to conclude that there is no space left for peasants' shoes representable by Van Gogh. We should thus be dispensed from these external conjectures concerning dates, places, the wearer or real subject of the shoes. The discussion would be shortened and would be none the worse for that. It's tiring, this point of detail or this detail of *pointure*. There are other, more urgent things at stake. The internal description would spare us these interminable circumstantial, police-like, anecdotal investigations.

— But an army of ghosts are demanding their shoes. Ghosts up in arms, an immense tide of deportees searching for their names. If you want to go to this theatre, here's the road of affect: the bottomless memory of a dispossession, an expropriation, a

Still Life (bottles, vases, clogs).

Still Life (cabbages, clogs, etc.).

despoilment. And there are tons of shoes piled up there, pairs mixed up and lost.

— All of you seem too sure of what you call internal description. And the external never remains outside. What's at stake here is a decision about the frame, about what separates the internal from the external, with a border which is itself double in its trait, and joins together what it splits. At stake are all the interests caught up in the trial of this split. The logic of the *parergon* at work here removes all security in this regard. All the more so in that the *parergon* has here perhaps the form of this lace that attaches the inside to the outside, so that the lace (inside-outside), half undone *in* the picture, also figures the relationship of the picture with its outside. The picture is caught in the lace which it yet seems to include as its part. As for the police investigations, it has already been suggested that beyond its importance as representative of the law, the police was always more and other than what one might want to limit under this name. Police agents are not only in their stations, their armored cars, or in their usual places of intervention. The investigation that interests us here is also an inquiry *into* the police. It is a police enquiry in this sense. As for the anecdotal, we must, precisely, see what *is given* as anecdotal. I too thought that such an internal reading would make the decision. But no. There are peasants' shoes which are not clogs. And above all, Van Gogh painted some whose "peasanthood" appears unquestionable. For example, *Le Semeur* of 1881. At least one of the two pictures which, dating from the same year, are painted "after Millet" under this same title, shows the detail of shoes—we can say shoes now since there are no more clogs—of the same type as those described by Heidegger and recklessly attributed by Schapiro to Van Gogh, "by that time a man of the town and city" (I keep on repeating to myself this little sententious allegation, we'll never get tired of it)! In any case, at the moment Heidegger is putting clogs aside, he is still not speaking of the picture, even if it is a given picture in view that drives him to tighten the example around shoes, like two shoes that make a pair. The same thing will hold when the shoe hypothesis is confirmed by the allusion to leather, which again excludes clogs. Describing what belongs to and certainly is due to the thing as product, describing in terms of matter and form, he wants, still without the aid of the painting, to pose the

question of *Dienlichkeit,* of that usefulness in which, for the tradition, the being-product of the product seems to reside.

Shoes are used. *Das Zeugsein des Zeuges besteht in seiner Dienlichkeit,* "the being-product of the product resides in its usefulness," that's "what we know already."

— But when it comes to the usefulness proper to the shoes, Heidegger lets equivocality lie and in truth will never lift it, even when he claims to be recalling it in its most banal obviousness. He has said first of all that shoes *are used* to shoe the foot, to clothe it, to cover it *(dient zur Fussbekleidung).* Referred to a given part of the body which is exposed (especially in its undersides) and which it is a matter of protecting, hiding (but why?), binding if not adorning (Heidegger is interested in this garment only by virtue of its *usefulness,* and in its usefulness only by virtue of walking and working, which will not be without its consequences), the shoe is not yet, in this first phase, posited as an instrument. Only as a *useful* garment. On the other hand, in the following paragraph, the peasant woman appears on the scene, and utilization is referred to the step, to walking, to upright station, and to work, in short, to feet in movement. As though a shoe without movement or contact with the ground, touching (in short) only the feet, lost its meaning and *all* usefulness. That isn't a contradiction, but by not insisting on the garment or at least on the garment outside work, on adornment, the postiche, on travesty or display investiture, on uses *other than* walking, or on using what is useless, one can be immobilized before two limits that are at least virtual. First, that of not understanding how the uselessness which will soon be in question can be "useful" (uselessness of the empty shoes, more or less loosened, out of step *[hors de marche]*; and the picture itself out of use, taken out like the shoes it exhibits, the out-of-use here showing both out-of-use and use, the suspended use of the shoes "in" the suspended (hung) picture, and vice versa). Second, the so-called process of fetishization of the produced *and* the worked, of the shoes and the painting, cannot be *thematically* questioned in its already coded problematical zones (coded if only for the sake of criticizing them): the "sexual" and the "economic." *This* is where I would situate the stake of the pair, of the parity or the pairedness of the shoes. A pair of shoes is more easily treated as a *utility* than a single shoe or two shoes which aren't a pair. The pair inhibits at least, if it does not prevent, the "fetishizing" movement; it rivets things

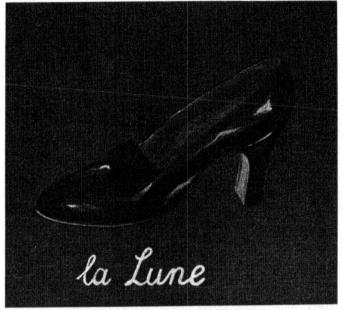

The Key of Dreams. The Moon (detail).

to use, to "normal" use; it shoes better and makes things walk according to the law. It is perhaps in order to exclude the question of a certain uselessness, or of a so-called perverse usage, that Heidegger and Schapiro denied themselves the slightest doubt as to the parity or pairedness of these two shoes. They bound them together in order to bind them to the law of normal usage. They *bound*, chained, repressed the diabolical, that which would be diabolical about a duplicity without parity, a double without a pair. They ligatured a worrying dismemberment in order to limit it. This was a condition of their doing justice to the truth they thought they owed in painting. What would they have done, try to imagine it, with two shoes for the same foot, or with a shoe even more solitary than these two here? Would they have been able to produce the same discourse taking as their example certain shoes by Adami (especially that woman's shoe, you can't tell whether it's on or off, the heel remaining—though apparently uncovered—veiled by a stocking or rather by what, between stocking and shoe, like another undie, a supplementary undergarment

in this striptease . . .) or Miró's *Nature morte au vieux soulier* (1973)? Or that (dead?) woman's shoe that Magritte entitles *La Lune?* Or *The Shoe* by Lindner? When you assure yourself of the thing as of a pair, when you forget that detachment also goes from one shoe to the other and divides the pair, you repress all these questions, you force them back into order.

— It has been said that all this could no longer be thematically questioned. But is this necessarily an inadequacy? What if Heidegger were already questioning beyond this already coded thematics? What if he were also wary of the concept of fetishism according to Marx or according to Freud? And what if he wanted to take the whole of this problem up again, and the whole question of the thing in truth which exercises the notion of fetishism? You all seem quite sure of being able to determine as excluded, misrecognized, unthought, denied, too implicit—so many possibilities which are moreover distinct—what you don't find *inside, inside* what you hastily demarcate as the *framable inside* of a text, of a unit detachable from the corpus.

— No, precisely, I was going to say, putting the word "fetishization" in quotation marks, and speaking of at least virtual limits, that it is necessary to be attentive to that problem: what looks like a process of fetishization (the uselessness of the work and the product, the uselessness of the product at work in the work) is described by Heidegger as a strange movement of *alētheia*. It can be pulled in various directions, all of which are open. Perhaps there are, in this lace trajectory, the resources with which to knot or unknot differently the whole aforementioned question of fetishism and the symbolic.

— Shall we speak from now on of an *argument-of-the-two-shoes* like the argument-of-the girdle [*gaine*] spoken of in *Glas?* An argument of the two-shoes, rather than of the pair, rather than of the couple (homo- or heterosexual). Bisexuality of the double in two shoes. The argument-of-the-girdle also intervened, *starting from* Freud, but from beyond the Freudian principle, in order to displace: the philosophico-psychoanalytical concept of fetishism, the opposition between the fetish and the thing itself which it became, sexual decidability (peasant man or woman? Van Gogh or the peasant woman?), castration as the truth of truth, etc. Two-

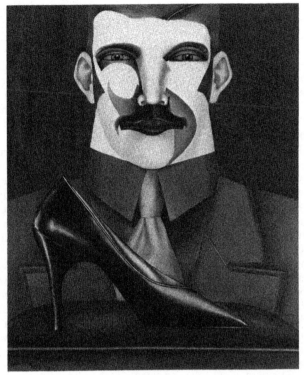

The Shoe.

shoes also sheath [*gainent*], but what, with a view to what profit, and what sex? They bind more or less tightly, more or less strictly. And the more or less undone stricture of the laces, those of the girdle too, would perhaps allow to be seen

— the "torso of some Venus in Paros marble rising from the rubble of a burned-out city"! It is thus that they "perceived in one corner of the canvas the end of a naked foot which came out of that chaos of colors, tones, undefined nuances, kinds of form-less fog; but a delightful foot, a living foot!" In *Le Chef-d'oeuvre inconnu* ("Yes, yes, it is indeed a canvas," said one. "You are standing before a woman and you look for a picture," said the

painter) the visitors are then dumbfounded [*médusés*, turned to stone], "petrified with admiration." "—There is a woman underneath. . . ."

— would perhaps allow to be seen what the corset, the bound underneath of the girdle or the shoe holds captive in a greater or lesser stricture, always, and that is indeed what matters to me, but let's not go too quickly, like an exit with no dénouement. The argument of the girdle is that things are always played out on both levels [*sur les deux tableaux*].

I take a step backwards, at the moment when Heidegger recalls that the being-product consists in its "usefulness." He is still not dealing with Van Gogh's picture. He is now going to operate in several moments and according to a very strange procedure.

First moment: this usefulness can only allow itself to be apprehended in use, during use, by use. So no painting is ever at all useful to us for the apprehension of the usefulness of a product. Evocation of the peasant woman, then, outside the picture: "The being-product of the product consists in its usefulness. But what about this usefulness? Do we already seize along with it what is properly product in the product (*das Zeughafte des Zeuges*)? In order to succeed in this, must we not go in search of the useful product in the course of its use (*in seinem Dienste*)? The peasant woman in the fields wears the shoes. Only there are they what they are. They are all the more authentically so (*echter*) the less the peasant woman at work thinks about her shoes, or the less she looks at them, or even the less she feels them. She stands and walks in them. This is how the shoes are actually of service. Through the process of using the product the properly product of the product must come to meet us."

Still within this first phase, Heidegger pretends—it's a rhetorical procedure—to draw a consequence from what has just been said: if usefulness, the essence of the being-product, can only appear in the course of use, by use, if use can only, as he thinks, be actual, actuality itself, then the picture *is of no use* for acceding to what serves, to the usefulness of the product. It is useless for the apprehension of the useful. But why?

Apparently for a single reason. But this reason doubles up and this doubling interests me. Again it is a movement of *interlacing* by the lace. Let us understand at least three things by this word: (1) the interlacing of the lace with itself; (2) the fact that it is also incompletely laced (*entre-lacé*, as you say *entrouvert* [half-open]

for what is not completely open); and (3) finally the fact that the figurer of the interlacing is here interlaced with the figured, the lacer with the laced. Heidegger does not thematize interlacing here, but under the name *Geflecht* it will later occupy his discourse, from 1950. I'll translate a few lines up to the "And yet" which will mark a turning: "Through the process of using the product the properly produced of the product must come to meet us. On the other hand as long as we are content to imagine (*vergegenwärtigen*) in general a pair of shoes or look at the image of the shoes which are simply there empty, unused, we shall never apprehend what the being-product of the product is in truth. From Van Gogh's painting we cannot even tell where these shoes are situated. Around this pair of peasants' shoes there is nothing to which they might belong (*wozu und wohin sie gehören könnten, to what and from what they might be owing or come back, and with a view to what*), only an undetermined space. There does not even remain stuck to them a clod from the glebe of the field or the field path, which could at least hint at their usefulness. A pair of peasants' shoes and nothing more. And yet."

In this moment of the argumentation, the uselessness of the picture hangs on two reasons which cross each other, double each other, and interlace according to a mode

— A moment ago you were saying, on the contrary, *one* reason which doubles

— You can also say that, what matters is the *remarkable* mode of interlacing of one reason which is remarked in the other or in itself.

— I cut in again. One thing is certain now, if not two, following these few lines. Even while declaring that the picture is useless, Heidegger says at least this about it: "this pair of peasants' shoes." It is unquestionably to do with the painting, with a reference, even if it is said to be useless, to this painting here, to a "this painting here." It is no longer possible to say that reference is suspended or the painting put to one side. He does not let it drop, he describes a picture, however little he does so.

— That is indeed unquestionable. And if there is any sense in saying "they're not shoes of X but shoes of Y," then Heidegger has committed himself heavily. Without however attributing them

to a real subject, exterior or anterior to the picture, he has loaded
these shoes, invested them, arraigned them, compulsively laced
them around peasant ankles, when nothing in the picture ex-
pressly authorized this.

— Nor forbade it.

— Whence the symptom, the symptomatic interest of the
investiture, on both side alike. But in Heidegger's case, it does
not suffice to say that it was illegitimate, imprudent, or arbitrary
(arbitrary with respect to the picture, but very necessary to Hei-
degger's investing procedure). It does not suffice to analyze the
motivations of all sorts (metaphysical, "ideological," political,
idiophantasmatic, all knotted together) which drove him in 1935,
almost half a century after their production and entry onto the
market, to annex these shoes, on the pretext of repatriating them
back to their authentic rural landscape, back to their native place.
It is necessary to emphasize the symptomatic contradiction, in
the same sentence, between the alleged indeterminacy of the pic-
ture which is supposed to teach us nothing about the shoes, about
their belonging, their place, their social "field" and, elsewhere,
this attribution of peasanthood. The contradiction is all the more
serious in that the attribution claims to be internal, grounded in
the picture and not in a conjecture or a reconstruction as it is in
Schapiro's "Note." And it clings to the shoes before any other
examination, more tenacious and adherent even than clods of
earth

— more incorrigible[13]

— this word [*indécrottable*] also connotes city and bourgeois
vulgarity, the vulgarity that sticks to town shoes. There are too
many political insults in this correspondence, too many low blows
for us to add any more here.

— But this correspondence has lowness [*le bas*] as its subject

— Which lowness?

— The other one, always the supplement of lowness.

13. *Indécrottable:* literally, impossible to clean up.

— I return to the symptomatic contradiction. At what moment does it appear? The picture is *doubly* useless to Heidegger. Useless because it "shows" us, "exhibits" or "represents" to us, it's all the same here, depicts object-products, useless, "empty and unused." They can teach us nothing about the usefulness which interests us. There they are out of service, without any current use-value. On the edge of this void we follow the line, the system of traits which cut out this "out of service," we follow them on the edge, the edges, the multiple edge which detaches the being-product from what I shall call its *subjective scope*. It is a linear and quite simple edge around the neck of the foot or the ankle de-picted *in absentia*. Simple enough when the upper is straight, less simple when it falls back like a glove half turned inside-out (the one on the left). Without the least simplicity when we come to the lace, interlacing the inside and the outside, the underneath and the top, the right and the left, or *a fortiori* these lined, hemmed holes, the eyelets as crossing point. All this system of interlacing edges detaches the being-product from its *subjective scope* whilst simultaneously baiting (inducing and luring) the reattachment of the said *subjective scope*. Take these last words as you will: the determinate content of the subjectivity of the subject, of the subject of the shoes, of whomever is supposed to fill the shoes; or again the subject bearer or borne, wearer or worn, if not the subject-owner. Into this subjective scope, cut off from its heel[14] like a blank check, will come [*se porter*: bring themselves] the subjects in a hurry to get their feet in, Martin Heidegger or Meyer Schapiro, with their own investiture. For example.

— In order to make ghosts come back? Or on the contrary to stop them from coming back? These shoes are also starting to look like a phantom limb. They are becoming sensitive, nervous, almost talkative where the thing apparently feels and says nothing, objectively.

—So Heidegger says: the shoes are useless, in this state, to anyone wanting to reach the usefulness of the useful, the presumed essence of the product. This uselessness of the useless when it comes to thinking about the useful, this—already—double uselessness only stems for the moment from the being-detached

14. *Talon:* also, the stub of a cheque.

of the shoes, from their being abandoned, unlaced. Heidegger does not speak directly of the exhibiting of the half-loosened laces, but that's what matters here and it belongs to the system of traits which mark the cut.

— I'm bothered by this word "cut." First of all it sets things up too quickly, it arraigns and maintains in a problematic of castration truth (remember the psychoanalysts just now when they were teaching Magritte castration

— in London?

— yes, in London). This problematic is a bit simplistic—a case or an effect at the very most—if you take into account the argument-of-the-girdle or of the two-shoes. And then these laces, precisely, these loosened bonds do not seem to me to play in a logic of the cut. Rather in the logic of stricture, in the interlacing of *différance* of (or as) stricture. The loosening of the laces is not absolute, it does not absolve, unbind, cut. It keeps an organized stricture. Not a more or less of stricture but a determined (structured) form of stricture: of the outside and the inside, the underneath and the top. The logic of detachment as cut leads to opposition, it is a logic or even a dialectic of opposition. I have shown elsewhere that it has the effect of sublating difference. And thus of suturing. The logic of detachment as stricture is *entirely other*. Deferring: it never sutures. Here it permits us to take account of this fact: that these shoes are neither attached nor detached, neither full nor empty. A double bind is here as though suspended and imposed simultaneously, a double bind which I shall not here attempt to attach strictly to another discourse on the double bind. But this shifty, limping, more or less paired pair, like the in-between band, ajar, is neither empty nor full. A certain haunting, which will return in a moment, cannot accommodate any of these couples of oppositions, of these oppositional cuts [*coupes*; also, "cups"]. If I say of the ghost in this leasing-out of shoes, that *le, la, les double(s) band-*[15]

— Yes, so let's say stricture or destricturation.

— Any stricture is *simultaneously* stricturation and destricturation.

15. For a gesture toward a translation of this "expression", (most extensively exploited by Derrida in *Glas*), see below, p. 377.

— Is that what this "pair" of shoes by Van Gogh says?

— It doesn't say that, but it doesn't say anything different. That's what is said that does without a *restance*, if you'd be kind enough to follow the interminable analysis of this lace. An analysis always wants to unbind.

— It's in considering the unboundness, the destricturation, the being-loosened of the laces, the out-of-service of the two shoes that Heidegger declares the picture to be useless for his search. But, and this is the second reason interlaced with the first, he says it is useless in *what* it thus represents and frames, and that it is also useless in *that* it represents and frames. Useless for *what* it gives in painting *and* because it gives *in painting*. Useless in the useless shoes (the product) but useless too for being a picture disinserted, detached from its milieu by the artifice of its reattachment, the line of the frame. It is not only a useless product showing a useless product, it is useless in that it is a work (*Werk*), a product abstracted from its milieu and showing a product abstracted from its milieu. Its milieu of belonging (the museum wall, for example) is as abstract as is that of the shoes. When Heidegger talks of the "indeterminate space" around the shoes, he could also have said it of what surrounds the picture.

In this phase of the argumentation, Heidegger puts the emphasis on the un-; the un-laced, the unstrictured, detachment, abstraction. Later, the process of reattachment, the always already begun restricturation will come, after the "And yet," to put this double uselessness to work, to make use and surplus value of it in a certain way

— this *triple uselessness*, since the double uselessness (that of the product and that of the work) is useless for grasping usefulness.

— In any case the interlacing correspondence between these two abstract detachments, that of the shoes and that of the picture, has nothing fortuitous about it. It does not bring together again *two* detachments, *two* terms, two *detachable* identities, twice detachable, two "things" or two products of which one is produced in the strict sense and the other a work, neither of them being natural. It does not bring together again *two* according to

a law that would be external to them. The detachment of the one marks, re-marks or overmarks that of the other. In itself interlacing it. I suggest this word *mark* (march, margin) for reasons explained elsewhere but it suffices to say here that I do so in order to avoid saying "say," "show," "represent," "paint," so many words that this system works to deconstruct. So the being-detached (unlaced or unstrictured, abandoned or abstracted) of the one interlaces with its remark the being-detached of the other: the shoes with their laces (a little) undone give painting to be *re*marked.

— They give?

— It gives, there is, *es gibt.* There is that, the two painted shoes . . .

— In obsolete language, one would say

— Is there any obsolete language? Like old outworn shoes, out of use or out of date, in a word—painted language? You see where that would lead . . .

— Let's leave the obsolete language. Others would say: the shoes produce a discourse on painting, on the frame, on the *traits.* These shoes are an allegory of painting, a figure of pictorial detachment. They say: we are painting in painting. Or again: one could entitle this picture "the origin of painting." It makes a picture of the picture and invites you not to forget the very thing it makes you forget: you have painting and not shoes under your nose (just try putting them on, on your own feet or someone else's!), painting is originarily this detachment which loses its footing. But detachment must also be understood

— No, no, no, it says nothing of the sort, it gives nothing to be understood, especially not, yet again, that *mise-en-abyme* of painting in painting which has been clearly shown still to tend toward such a restituting saturation, such a representative readequation. No, no.

— Yes it does—the detachment must also be understood as a representative mission to be reattached to its origin of emission. A reattachment is already, always, in the process of retightening the unstrictured. In this sense the shoes cause to be marked (they

make it work or walk, they pull its leg, they make a deal or a market of it)[16] something that would be translated by the following statement: this is a picture, we are painting in painting, this is drawn by the *traits*, the edges, the laces of the empty shoes which detach us from the full-length [*en pied*] subject. From then on these lace traits form the "frame" of the picture which appeared to frame them. We, the shoes, are bigger than the frame and the incorporated signature. The picture is in the shoes that we are

— They've suddenly grown much bigger, you can put anything in them. Everything (or -body) is able to want, wants to be able to borrow or steal them, like Tom Thumb or Puss-in-Boots. Who is the ogre? But these seven-league boots would also be the *text* of the narrative, *Tom Thumb, Puss-in-Boots, Cinderella*. The text is a shoe bigger than that which it stages and which is nonetheless bigger than it. And the discourse attributed just now to the shoe is also a shoe. The same law holds for these old shoes as for *The Emperor's New Clothes* in "The Purveyor of Truth."

— The law of the *parergon* which comprehends everything without comprehending and perverts all the links between part and whole. For conversely the framing painting, that which gives itself as painting as a first obviousness—for Heidegger, Schapiro, and a few others—remarks itself as a (more or less shifty) pair of shoes. Detached in the course of reattachment, in the process of (un-re-)stricturation. If the picture could speak in its turn (it has spoken, says Heidegger), a hypothesis to be worked on later, would it not say: I, like all paintings, am a shoe, a sort of shoe, and even perhaps (one possible version) a pair of shoes. As a picture, and as a given picture, a particular pair (possible version) of shoes.

— The least one can say is that such a discourse translating the *remark* of painting in painting is not a very usual version of Heidegger. It doesn't look much like what can be read in *The Origin* when truth takes the floor: "The picture has spoken. . . . The work of art has given us to know (*gab zu wissen*) what the shoe is in truth."

— Apparently not. It would certainly involve transforming, if not perverting, the way this text is read "in general," and perhaps

16. *Les souliers font marquer (font marcher, font marché-de) ce qu'on traduirait par l'énoncé suivant. . . .*

by Martin Heidegger himself. No one has ever seen a painting or
a shoe in it. And yet. I like it like that.

— It remains that the figure of this interlaced correspondence
(for a long time we have no longer known who is talking in it
and if there is talk) does not come under any established rhetoric.
Because it is not simply a discourse, of course, but also because
even if transported, by rhetoric, outside of discursive rhetoric,
tropes and figures would not work here. This interlacing corre-
spondence, for example the interminable overflowing of the whole
by the part which explodes the frame or makes us jump over it
[*qui fait sauter (par-dessus) le cadre*] is not produced inside a
framing or framed element, like the figures of rhetoric *in* language
or discourse, like the figures of "pictorial" "rhetoric" *in* the sys-
tem of painting. Here the outbidding in surplus value of the de-
bordering (overbordering) correspondence takes place *between* the
element that is called general (discourse, writing, painting) and
some particular determinate element in it. This element is worth
more than the whole. Metonymy or synecdoche are no longer
simply what they are. The more so because it operates in both
directions, the "whole" always playing metonymically, on both
levels,[17] and part of the part [of the part].[18] The play is there, and
it does not go without a strange contract between more traits than
one. And Heidegger says more about this, perhaps, and something
more singular, than he seems to in this passage. To understand
it, you have to go further than the passage on the shoes of Van
Gogh.

The figure without figure of this correspondence is glimpsed.
What pertinence is then left to the classical questions of identi-
fication, description, attribution? What sense is there in knowing
of whom, of what, exactly, most exactly, one speaks in adjusting.
And above all what sense is there in asking whether it happens
in the painting or outside the frame? There is naïveté in ignoring
the rights of these questions. There is no less naïveté in confining
oneself to them.

17. *Jouer sur les deux tableaux* also has the colloquial sense of "to
have it both ways."
18. *Jouer . . . la partie de la partie* presupposes a *jouer [le rôle de]
la partie de la partie*, which in its full English formulation gives "playing
the part [i.e., role] of the part of the part."

Second moment. Only the possibility of this overflowing interlacing permits Heidegger to cross the line in both directions, now in the frame, now outside the frame. Whether or not he does it *knowingly.*

The "And yet" forms the most apparent scansion in this crossing of the line. We've just stated the whole *uselessness.* We will now exploit the surplus value of the out-of-service. It is in the uselessness—of the shoes: of the painting—that we will "read" (says the French translator), "see" (says Heidegger) the usefulness of the product, the being-product of the product *as* usefulness. And then comes the incriminated paragraph, the pathetic paragraph, the one that seems to you so ridiculous, so loaded with "ideological" "projections." Let's reread it. In the three languages.

. .
. .
. .

— It is so coded, too, by the poetics of the soil, by traditional models, so stereotyped in the affectation of its pathos that it can also be read as an exercise miming scholarly application and saying in sum: this is what one could always feel, this is what one can say in the genre

— the essential point being to show up the overflowing (of what is strictly visible) by the "earth," by the "world" and by the "protected belonging" of the shoes.

If one could speak here, if not of fetishization, at least of the conditions of a fetishization, both of the product and of the work, both of the shoes and of the painting, one would have to take hold of them again at the moment when the detached (relatively unstrictured) out-of-service gives rise, in its very detachment, in its dereliction or its separation, to a sort of abyssal surplus value. To a bottomless outbidding. In the form of what one might call a truth-effect. The useless gives way to a speculative exploitation. It escapes from the space of production and tends toward absolute rarity, irreplaceable uniqueness. In itself and insofar as it gives to be read the law of the sought-after usefulness. It becomes more than useful: useful for grasping the usefulness of the useful. It allows us to think the being-product of the product and the being-work of the work. For from the moment when the detached *calls for* reattachment, a discourse is sketched, and a whole maneuver, to call for adherence.

— Here you are picking up on what was started in "The *Sans* of the Pure Cut" concerning artificial and "defunct" products (utensils dislocated from their functions, and having a hole, an opening, a cavity, *Loche*, "as for a handle," but without handle— empty shoes in short), concerning works of art, *pulchritudo vaga* and *pulchritudo adhaerens*.

— In *uselessness* (the uselessness of painting giving (itself) to be read (in) that of the shoes, the uselessness of the work (in) that of the product, and vice versa) *the truth of the useful appears*. It appears in the putting to work of the useless production. The putting to work of truth, Heidegger will say later. The truth of the useful, in other words the being-product of the product (at first sight) *appears* in the instance of the out-of-service, in the unlacing and destricturation. So these are used, in that, for that. This movement of truth passes via the *possibility* of fetishization but ends up, if one can say that, only confirming the very thing it seems to efface. The truth of presentation, in its *appearing*, overloads uselessness with value, augments it with surplus value in attaching it symbolically to its belonging. The latter, a *capital* difference since it concerns the head of the subject, is not that of a proprietor-subject, the holder or wearer of the shoes. It is not even that of some particular world, *for example* that of the peasant woman who is, precisely, only an example. It is, for any product and any usefulness, *the* earth and *the* world. *The* earth and *the* world, even if one must each time think them otherwise and in a singularly determinate way, in an opposition, a conflict or a war (of the earth and the world). Heidegger will later relate to this his thinking concerning the *trait* and *attraction* [*l'attrait*].

The "truth" of the useful is not useful, the "truth" of the product is not a product. The truth of the product "shoe" is not a shoe—

— But one could think the difference between being [*l'être*] and the existent [*l'étant*] like the shoe, through it, in its step. And likewise the ontological difference: shod in painting [*chaussée en peinture*; also, "roadway in painting"].

— For example.

— But Heidegger does not stop (that is what counts) at the usefulness of the being-product which he has just "seen" in the shoes in painting. Which he has "perhaps" just seen, "perhaps only" in painting, "in image," *im Bilde.* This "perhaps only" should have suspended all of Schapiro's assurance. "But perhaps," says Heidegger at the end of the tirade, "perhaps we see all that only on the shoes in the picture." The consequence of this is equivocal. Heidegger is at least affecting to be unsure: what he has just pathetically evoked comes perhaps from the power of evocation of the painting or from the subjectivity of the spectator, and he prudently lets a doubt hover about as to the rigor of the (re-)attachment. Paradox: Schapiro's objection falls at the very moment when it would find itself reinforced by Heidegger's implicit affirmation (this is at least in the painting, if not beyond it). But if it is *only* in the painting, it is also not there, the painting stepping over its own threshold in the reference it constitutes right from the start.

Third moment. But once again that is only a movement made in order to go further. Usefulness does not really interest Heidegger, in the last instance, therefore the useless does not either. As the being-product of the product, usefulness is still only that value derived from the matter-form couple, from what has "fallen-upon" the thing as product. In considering the shoes only as utensil ("useful artifact"), Schapiro seems to stop at what is only one stage of *The Origin.*

One must go further. Does the next paragraph definitively leave behind a picture of which we do not yet clearly know whether it was ever approached? It is difficult to decide. It is indispensable to recognize this movement if one is to comprehend this passing via (through) the picture. Even if, like Schapiro, one brutally cuts off and disarticulates the procedure of *The Origin,* one will still understand a little better the reference to the "famous picture" by reading one paragraph more. The one that begins with "But perhaps we see all that only. . . ." It will lead us to think that the usefulness of the product comes from further away still. Even the usefulness, which the double or triple uselessness of the shoes in painting will have shown up, comes from farther away. For usefulness was still thought in terms of formed matter, and to accede to the "authentic being-product," one must go further back than this oppositional pair: matter-form.

— Is the painting—this one—required for this return toward a still more distant, more hidden origin? For this further step in thought [ce pas de plus dans la pensée]?

— When you're present at a "step backwards," you see the shoes face-on. I say that for a joke, but also as an echo of Schapiro's precision, further on: certain peasant shoes are seen from the back, but these ones (his own!) Van Gogh has "rendered" face-on ("he has rendered them as if facing us"), and they are looking at us, in short, like the painter himself.

— Is the painting—this one—required for this other step? You can't decide, still for the same reasons. The traits delimiting both the object and the frame remove a priori all pertinence from this question and from the "decision" which it calls for. They (these traits) disqualify them by stricture. By interlacing. Of course, Heidegger still seems to put the picture aside (to "put aside" [mettre de côté] was once upon a time a bizarre—but here, interesting— translation for Aufheben). He does so with more spectacular rhetoric. After the new paragraph and the concession ("But perhaps we see all that . . ."), he will no longer speak of the picture, he will follow the peasant woman, he will analyze what, in the usefulness of the product, comes from farther away than the matter-form couple. But it will be in order to jump better, in conclusion: it is the picture "that has spoken," Dieses hat gesprochen. And in the interval, "beneath" usefulness, "beneath" the (re-)attach-ment of its utilizatory "belonging," he will name that "thanks to which," by the "force" of which, "in virtue of which" (Kraft) the usefulness of the product is possible: the condition of usefulness, Verlässlichkeit.

Verlässlichkeit. The word is difficult to translate. I have la-boriously specified "thanks to which," "by the force of which," "in virtue of which" because the relation (Kraft) is not that of a formal condition of possibility to its conditioned object or of a more profound foundation to what it founds, but of a sort of experience. An experience, let us say for the moment, of reli-ability: you can count on the product. The product is reliable. It is useful only if we can trust in its reliability. From the moment when Heidegger names reliability, he is no longer interested in the basically derived or conditioned value of usefulness. The site of the argumentation—that of the debate opened by Schapiro—is displaced.

That which is *verlässig* deserves confidence, faith, or credit.
In this case, the credit is anterior to any symbolic contract forming
the object of an agreement signed (explicitly or not) by a nameable
subject. It is not cultural any more than it is natural. It goes back
to [*revient à*] an engagement or commitment—

— Shall we associate fidelity with reliability? Faithful is that
on which, the one on whom, one can also count. And this notion
of fidelity would agree with all that was said about restitution:
about shoes that you give back, about the truth that you owe,
that you restitute or that restitutes, of what painting "renders"
faithfully, if it gives it to be seen "in painting." And the protag-
onists of the correspondence want in truth to give back the shoes
faithfully: from painting—and to the rightful owner. They want
to do this out of fidelity to an engagement anterior to all the social
contracts to which one can bear witness in public law. The shoes
are here parties to it, its secret witnesses: no longer only as "use-
ful" products, but as reliable things—

— Are the shoes parties to it or excluded from it in the portrait
of the Arnolfinis, that extraordinary contract of marriage without
any witness other than the painter, leaving above a mirror facing
him the inscription "*Johannes de Eyck fuit hic, 1434,*" thus trans-
forming into an attestation of marriage a painting representing a
wedding *per fidem* (not requiring witnesses), in a scene whose
pictural text should constitute a major test for new analyses?
Elsewhere, later. I note only that the shoes of those who are con-
tracting the marriage *according to the Faith* are deposited, aban-
doned, on the side, on the left of the painting, and as for the other
pair, between the two spouses, in the background and in the center
of the painting, under the table, under the mirror, and under the
painter's inscription. Panofsky's explanation is that they are there,
like other typical symbols of faith, to mark the imprint of the
sacred. When Moses approaches to see the burning bush better,
Yahweh says to him, "Take off your sandals from your feet, for
the place on which you tread is a holy place" (Exodus 3:5). So are
they, these shoes, excluded from the sacred space, or on the con-
trary hypercathected in the painting by this sacralization of the
hymen? Or both at once, according to the double function of a
pharmakon, and the double function of a *parergon?* Are they
"products"? And in what sense reliable? Heidegger and Schapiro
also resacralized the shoes in painting, each in a different but

The Arnolfini Marriage.

equally ambivalent way: because detached (excluded from every-
thing in a sense) but in process of being reattached. Their be-
longing is sacred, but (there is always a *but* in this case) you have
to detach the abject, reattach the sacred, sacralize the thing in
reattaching it. But by the same token the nudity of the foot can
be *either* more pure, more sacred (unbound from the abject) *or*
more impoverished, fallen, deprived of the sacred object, without
reattachment. Hence, at the same time, the ambivalence of their
worn state: good/bad, clean/dirty, familiar/abject. Moses: "I have

led you forty years in the wilderness ... and your sandals have not worn off your feet" (Deuteronomy 29:5). And the prodigal son was given shoes at once, as well as a robe and a ring (Luke 15:22). But besides, the Mishnah forbids the wearing of shoes on the sabbath day. You take off your shoes to enter a sacred place or simply to go into the house of your host, who must offer you something to wash your feet with (Luke 7:38, 44). Conversely, the nakedness of the foot becomes a negative mark of indignity (captivity) or a sign of mourning.

— The notion of reliability is here anterior to the opposition between the useful and the sacred. Without reliability there would be no usable product, but nor would there be any symbolic object. The ring, the "words and deeds" required for a hymen *per fidem*, must offer a minimum reliability for the commitment to take place, for the slightest exchange to be possible. This elementary reliability, this fidelity that predates everything, is a sort of ring (*Ring*, in the German), a sort of originary wedding ring ...

— We should read what Heidegger says elsewhere about this ring (*Ring*). Do the shoes, does the pair of shoes—

— In the context of *The Origin*, reliability (*Verlässlichkeit*) comes back to [*revient à*] a commitment (debt, duty, restitution, truth) whose concept cannot but precede all the notions which make a system with those of matter/form: the symbolic, the semio-linguistic, etc. The *Verlässlichkeit* of the product, "before" its usefulness but as the condition of this usefulness, engages in the belonging to the earth and to the world. This belonging is no longer that of the shoes to the wearer or user, but of both to the world and to the earth, which are given to be thought in their very "combat," according to this engagement and no longer on the basis of the philosophical concepts to which we alluded above. "Thanks to" this reliability, and thanks to the product which presupposes it, the peasant woman is "entrusted" (says the French translation for *eingelassen*: received, welcomed, admitted into), accorded to the silent call of the earth, to that language without language of correspondence with the earth and the world. Without the *silent* call (here it is rising up from the shoes as a faithful thing

— or descending from them, why not

— in Schapiro it would descend, rather, for he sees a face in them), without the absolute prerequisite of this commitment, in this preoriginary reliability, no symbolic contract, no production, no utilization would be possible, nor any of the concepts which serve to dominate all of that, in particular those of matter and form

— hence also those of sign, linguistic or otherwise, of subject, of object, of reality, of phantasy, of knowledge, etc. Where shall we stop? What is it to stop?

— For example the moment of taking off one's shoes and being separated from them, for a variable time or forever.

— I said that there was a preoriginary contract there with the reliable thing but the silent appeal which is heard through the *Verlässlichkeit* does not come from nature, such at least as it is conceived in the philosophical tradition. But from the combat of the earth and the world. And of its *trait*. It can be said very summarily: there is no chance of understanding anything in these pages on "the famous picture," no chance of making the slightest objection that could be pertinently measured against them, unless you follow, at least in principle, Heidegger's trajectory for thinking the earth, the world and the four-part (*Geviert*), the ring (*Ring*), and the circuit (*Gering*), *otherwise.*

— Can the lace lead there, or the interlacing?

— Certainly, if you take enough time. Read *The Thing.* Thinking *otherwise* does not imply that one thinks without relation or in a relation merely of altering and transformation to common or philosophical thought, but rather according to another relation of interlacing which is neither one of reproduction nor one of transformative production of a given material.

— We cannot here set out upon the long track—

— True. I wanted only to mark or situate a connection, a necessity of principle. And to insist on what interests us here in the narrow context of our debate. In a few points.

First: none of the "correspondences" whose modalities we have distinguished up to now can be deciphered without an at least problematic recourse to *the* correspondence which has just been brought out under the name of *Verlässlichkeit,* at the moment when *The Origin* crosses this step: "The being-product of the product consists indeed in its usefulness (*Dienlichkeit*). But this in turn resides in the plenitude of an essential being of the product. We call it *Verlässlichkeit.*" This nomination, this giving of the name is also a complex "act": it presupposes, in its very performance, a reliability of language and discourse; but it produces it at the same time, it commits itself to it. We cannot analyze this structure here but it would be necessary to do so. It is a "work" and a "product" at the same time, the only space in which discourse *on* the picture and the discourse *of* the picture can let themselves be understood. The least one could say is that Schapiro did not go there [*ne s'y est pas rendu*], to that space. Along with the shoes he claimed authority over a domain (discourse on painting, a specialism) whose frontiers he thought were determinable: beyond these frontiers lies, for example, the "philosophical" context

— But precisely not.

— of *The Origin,* a more or less chatty philosophical context. The competences are divided up. On this side, on the side of painting ("we all know what that is"), are the shoes of Van Gogh.

Second: in the logic of this procedure, "reliability" is the first or ultimate condition of concrete possibility of any *reattachment:* of the product to its usefulness, to its use, to its subject whether wearer or borne, to its belonging in *general.* These reattachments are attached to *Verlässlichkeit,* to this preoriginary gift [*don*] or abandon—

— to THE-MOTHER then, or from THE-MOTHER, and the two-shoes are—

— how can you go past what is said with these words without thinking first, in its approach, *Verlässlichkeit!* Then don't be in a hurry to recognize schemas that are too useful. Don't play utilities.

— But Heidegger has nothing against the useful; he does not develop an antiutilitarian "ideology."

— No. This preoriginary gift or abandon leads the reattachment back to before all the instances or categories of production, of matter-form or usefulness, law, contract, symbolic exchange or debt, oath, subject or object (total or partial), etc. Heidegger does not attach the shoes to a wearing (the wearer or the worn/borne) as subject, especially not as a real subject outside the painting. But he can be absolved of this accusation (as Schapiro cannot be) only through having tied things up much more surely and much more "profoundly," preoriginarily: in the belonging (corresponding) to the silent discourse of the earth. To this precontractual or precontracted marriage with the earth.

— with THE-MOTHER, and this trusting peasant woman who hears the silent call, and who answers it in silence—

— Don't play utilities. All the traits of detachment over which we have passed, those which mark the contour of the unlaced shoes, in the picture, those which delimit the picture itself, are effaced in the belonging of this *Verässlichkeit* and in this wedding with the earth. So that the pictural instance or rather restance seems to be omitted, made secondary and instrumental in its turn. One forgets about painting. Exactly as the progress·from re-presentation to presentation also effaced the obstinate specificity of the text or the pictural remainder. But we shall see later that nothing is appeased in the apparent effacement. And after reading that "the work lets the earth be the earth," we will see how the *trait*, the *broaching (Aufriss)*, the *attraction* and the system of *traits* play in the combat between the world and the earth.

Third: if *Verlässlichkeit* ensures "in the first or last instance" the interlacing tightening of the shoes, if it laces and lets loose at the same time, if the truth of the product appears on the level of (*an,* in the German) this reliability which appears on the level of the painting which "has spoken," it is indeed the most strict tightening-up (supple and rigorous at the same time, like the *Gering* in *The Thing*) of all these powers of attachment. This essential and "full" reliability makes possible—restitutes—not only the most "critical," the "profoundest" going-back behind the philosophemes of matter-form, of usefulness, of production, of subjectivity, of objectivity, of symbol and law, etc., but also the

most naïvely archaic regression into the element of ingenuous trust, the kind that can let itself be "had" [se laisser prendre], can abandon itself to the crudest trap, to the primary trap, to the trap from before all traps. To the possibility of a lure constituted by the mirror play of the world, its Spiegelspiel.

Fourth: the possibility of tightening in general is illuminated here by a translation difficulty which cannot be treated as incidental. I have not yet translated Verlässlichkeit. Reliability is a more or less strict, more or less loose approximation. The French translator of Holzwege proposes a word which is both unacceptable and yet pertinent in a subterranean way. Unacceptable at first sight: solidity. Verlässlichkeit as the solidity of the product, here of the shoes, because one can "have confidence in them," says a translator's footnote; the shoe "will not slip off," "one can put one's weight" on it.

— This seems in conformity with the idea of making a binding contract with the shoes, a contract that binds and is bound with their very laces, passed off as a kind of deal [marché], to the letter [au pied de la lettre] or avant la lettre.

— But in common usage, the solidity of a product comes above all from its qualities of physical resistance, the resistance of the materials from which it is made, the resistance of its forms to wearing out, etc. The idea of confidence, of credit, of faith, or of reliability seems rather to be absent from this. On the other hand, when the French translator (but without explaining himself, and whether deliberately or not) sets "solid" in play, in the following sentence, with "soldered" (another unacceptable translation, for gewiss), he restitutes strangely a movement that is legible in the text as I interpret it here. The chain which links solid to solidarity and to solder is indeed that of tightening up, the one that is at work here. Here is the French translation from Holzwege. On first reading and because of the word "solidity," it runs the risk of definitively obscuring the German version. And yet: "the latter [usefulness] in its turn resides in the plenitude of an essential being of the product. We call it solidity (die Verlässlichkeit). Thanks to it (Kraft ihrer), the peasant woman is entrusted (eingelassen) by this product to the silent call (schweigenden Zuruf: the call is silent but is heard and understood, it is not mute; likewise the painting speaks while keeping silent); thanks to the solidity of the product, she is soldered to her world (ist sie ihrer Welt gewiss).

For her, and for those who are with her like her, world and earth
are only there in this way: in the product. We say 'only,' but here
the restriction is wrong (irren dabei). For it is only the solidity of
the product which gives to this so simple world a stability all its
own, in not opposing the permanent flow of the earth." The trans-
lation of this last sentence is so loose that you'd almost wonder
whether it's really from the same text: "Wir sagen 'nur' und irren
dabei; denn die Verlässlichkeit des Zeuges gibt erst der einfachen
Welt ihre Geborgenheit und sichert der Erde die Freiheit ihres
ständigen Andranges." I will certainly refrain from translating in
my turn. Let us note only that the assurance, given to the earth,
of a freedom in the constancy of its pressure (drive, thrust, violent
pressure) is consonant with the Geborgenheit given to the world
by the same reliability. Geborgenheit associates the hidden, crypted
secret with the being-in-safety, with what one must hold in re-
serve or conceal in order to live. Such would be the tightening of
this originary ring, such the effect of Verlässlichkeit. Everything
that one might then seek to adjust to measure, "to the right size,"
in terms of adequation, of reappropriation, of reattribution, of
identification, of readaptation of the part to the whole, of symbolic
reattachment, of restitution, etc., the whole problematic of the
subject, of law and the fetish, in its nowadays available "forms,"
all that would primarily bank on such a reliability. But to say that
it is the soil or the subsoil on which walks a discourse on the
ground, on walking, on the sole, the shoes, the feet, etc., would
not this be already to translate this reliability into the marks of
what it renders possible? And yet once these marks belong to
walking, to the step, to the path (Weg), they are no longer, for this
thinking, forms derivable from figures, tropes, or metaphors.
Thinking thinks on the basis of [à partir de] them.

It remains to know—if it is still a business of knowledge [si
c'est encore de savoir qu'il retourne]—something of the relation
between the trait of un-reattachment (the stricture of the picture
and in the picture) and the speech which permits one to say of
painting that it "has spoken," of itself. How does this speech
[parole]—which is not a discourse—support itself with this trait?[19]
How is it interlaced with it? Nothing is said about that in this
passage of The Origin. Later, further on. Let us let this question
rest.

19. S'entretenir de: also, "how does it hold a conversation about
this trait?"

—Let us admit that in this way we have just reconstituted, restituted, a certain trajectory of *The Origin*, by interpreting it, by negotiating with it. Let us admit that this trajectory had to pass via the very uselessness of the shoes *and* of the painting, of the product and the work; that it needed to speculate on this out-of-service, lacing across the line in both directions, making come back, making go away, making come back again, inside, outside, down there, here, *fort, da.* (Heidegger holds the thing, the shoes in painting, by the lace and plays with the bobbin

— which is, for Schapiro, playing in the same way, that of Van Gogh, "a piece of his own life," "facing us."

— drawing it toward him and then making it go away thanks to the reliability of the lace). He does the same thing with the peasant woman, now in the picture, now outside the picture. Playing with the lace is always possible. But in playing laces with the bobbin of the *fort, da,* you have to take into account the interlacing, and then it's more complicated . . .

— But no, let's not be so sure that we know what the *fort/da* is. What we know is that every step (discursive or pictural in particular) implies a *fort/da.* Every relation to a pictural text implies this double movement doubly interlaced to itself. It is a kind of *fort/da* that is *described by* the circuit of the lace of which we were speaking above. Heidegger's whole discourse (here and else-where) is supported by [*s'entretient du;* also, "chats about"] the *fort/da,* and here of a picture which marks or sets marching [*fait marcher,* takes for a ride] the *fort/da* in painting. Let's say that the title of the picture could just as well be *Painting* (this made you howl just now, and rightly so, but too bad) as *The Shoes* or *Fort/Da.* Where do the shoes start from, to where and to whom do they return, from where do they return as they get closer, etc.? And the whole path of thought, for Heidegger, leads back, by a dis-tancing, to a *Da* (thus the *Da* of *Sein*) which is not merely close, but whose proximity lets the distance of the *fort* play within it. The relation is not one of opposition; each notion offers an eyelet to be traversed by the other, to the figure or the size [*pointure*] of the other. *Fort: Da.* Double eyelet, that is how it must be reknotted/taken up again in writing.

— Let's concede that. But then by the same token—this is
what I wanted to come to—did Heidegger need these shoes to be
those of a peasant? And having crossed that line, did he need to
see, from below, from the stocking, a peasant woman? A peasant
woman standing up?

— It's almost the same question as that of the *fort: da*. The
value of proximity plays a decisive role in this text and in Hei-
degger's thought in general. The shoes of the peasant are *closer*
to that earth to which a return had to be made. But in principle,
the same trajectory would have been possible with town shoes.
It would have been longer, more distancing, more deviated. But
distancing is the subject. As for the peasant woman, she crops up
only in the passages where it's less than elsewhere a question of
describing a picture, when the picture is as far away as possible.
Such at least is the answer which one can attempt to make, relying
on the manifest logic of the text. If one did not want to simplify
too much, it would be necessary to recognize all the resources,
the turns, returns, and cunning twists of this notion of proximity.
From *Sein und Zeit* onwards it governs and disorders all this
thought. Here the "good" relation to the work is twice defined
as a "proximity" (*in der Nähe des Werkes*). But we know since
Sein und Zeit that the "near" can be understood sometimes in
an ontic sense and sometimes in an ontological sense, and that
it is not in simple opposition to the dis-tant of an *Entfernung*
which distances the far-away. Thus painting goes away, thus it
distances. Impossible here to get closer to this near, for lack of—

— I should like to return to more determinable certainties.
We no longer know whose turn it is to speak and how far we've
got. No doubt Schapiro did not get the measure of *The Origin*
(but that was not what he proposed to do), or even of the few
pages about the "famous picture"; so be it. No doubt he simplified.
No doubt he misrecognized the necessity of the argumentation,
the lacing movement of its coming and going and the abyss of its
fort: da. No doubt he ignored its more than philosophical scope.
But having said that, if we were to return to the dimensions which
he himself assigned to this debate (his convention is ours, and
we must accept the contract that he proposes), can one not main-
tain, as to the identification of the picture and the attribution of
the shoes, that *he is right*? And that, as agreed above, if there is
a sense in saying that these are the shoes-of X and not the shoes-

of Y, Heidegger was committing himself heavily. And this is even while admitting the necessity of the Heideggerian procedure in its long trajectory, in its essential trajectory?

— I have not done so yet. I have only followed him, and later, with the questions of the trait, attraction and speech, I will try to interrogate it otherwise.

— All right. But even if we admitted it, could we not grant to Schapiro that on a precise point, albeit on a matter of detail

— But we said just a moment ago that there was only detail; that's as much as to say that there is none, in this business.

— on a precise point Heidegger made a foolish mistake? We were talking just now about a "symptomatic and unjustifiable contradiction" between one sentence bringing out the indeterminacy of the painting, the abstract milieu around the shoes, their nonbelonging in short, and on the other hand the formula which follows immediately, "a pair of peasant shoes," defining dogmatically a minimal belonging which Heidegger would be wrong to consider legible, in an internal manner, from the painted object.

— Yes. But even from this very limited point of view, is it enough for Heidegger to be wrong to make Schapiro right?

— What does Schapiro do? He does not only say: Heidegger was imprudent, nothing proves that they are peasant shoes and this allegation has no meaning. He says: they are not peasant shoes, because *they are* the shoes of Van Gogh. Who was not, at least not at that time, a peasant!

— What does Schapiro do? How does he tear the shoes away from Heidegger to offer them as a "still life" [a "dead nature"] kept alive to the memory of a dead man, like offering him a living piece of Vincent? More than a piece, as we shall see: Vincent himself. Vincent, the signature, becomes the title, the legend, the history, or the definition of the painting, of its subject and its object alike. For what matters to Schapiro is that the shoes should indeed be Vincent's shoes, and that, no matter how detached they may be, it is *from Vincent* that they are detached, as if at the end of an umbilical cord [lacet ombilical]. Giving them back to Vin-

cent, restituting them to him, he offers them in the same move to a third party, like a piece of Vincent or a *pars totalis* which Vincent supposedly untied, provisionally, one day in Paris. Vincent himself would supposedly have offered this detached part, like a precious piece or morsel of himself, he would have given it to—

— Like a severed ear, like that organ (it isn't just any organ) that he is supposed to have sent, dispatched, detached, on a mission, as his representative

— and afterwards painting a bandaged self-portrait, the head wrapped up, pressed tightly in a bandage, hiding this time the missing part, but at the same time exhibiting *in absentia* the lost "personal object." A curious still life.

— I'm not going to compare shoes to an ear. Especially not a pair of shoes to one ear.

— You've abandoned my question. Is it a pair? What is a pair? I should like to have a spectral analysis made of the pair, and of all its ways of being detached, of all the *separations* of the pair. I can see at least five.

— No, no, later.

— I note that Schapiro's title is "The Still Life as a Personal Object." Here it would be a visibly detached personal object (having nothing to do with the ear), like a picture of shoes, in an exhibition, detached from the body of a dead subject. But coming back [*as a ghost*]. Coming back alive to the dead man, who from then on is living, himself [a ghost] returning. Causing to come back. Here is this "personal object," detachable and coming back to the ghost [*revenant au revenant*], being offered in sacrifice to the memory of another dead man who, by definition and as his name indicates, remains stony in this grim feast, made of precious stone like the offering to the name (of that) which remains. But who comes back, too, like a ghost, thanks to the gift of this ghost. While yet making sure—in order to be sure—as he makes sure of Van Gogh and Heidegger, that he stays right where he is. And yet the shoes, too, remain there.

— Which ones? Where, in this *potlatch?*

— There, so that the unconscious of each one puts something of its own into them, puts them on according to its own size.

— No, the ghost's size, the size of the unconscious of the other. That's what it's for. Such is the invoice they present, in the final account.

— But what does Schapiro do, then? How does he operate, in the course of this sacrifice?

— Let's have a closer look. First he recalls that Van Gogh had painted such shoes several times. And that Heidegger, knowing it, denied it, took no account of it, as if the different versions were "interchangeable," serial products and not works, "all presenting the same truth." He treated them as products in series because he failed to recognize the series. We have analyzed this movement. After which, Schapiro in a sense arranges on the table, like playing cards or pieces of evidence, the eight paintings of shoes listed in De la Faille's catalog as being among all the canvases exhibited at the date of *The Origin.* The demonstration begins. Only three of them show "the dark openings of the worn insides," of which Heidegger speaks. This descriptive element is very scanty; it's one of two notations of this type which can be found in *The Origin,* in a paragraph of which, as we have seen, nothing lets us be sure that it has the picture as its object. Nevertheless Schapiro takes it out and retains it. He draws from it an argument for eliminating five paintings or five cards out of eight. Of the three that remain he declares without any other form of demonstration: "They are clearly pictures of the artist's own shoes, not the shoes of a peasant."

— Why "clearly"?

— The dogmatic appeal to manifest obviousness sounds like a decree here. This alleged obviousness cannot be produced by the form of the shoes, by some internal reading of the picture, even supposing that you can get in a single step from an internal description to an inference of the type: therefore the painted shoes belong in reality to *X,* they represent the real shoes belonging in reality to *X.* Furthermore, the internal reading does not legiti-

mately produce any evidence capable of supporting such an in-
ference, even if one were to accept, *concesso non dato*, the prin-
ciple of the inference. For Van Gogh did paint peasant shoes that
have an analogous form—boots, not just clogs. So the proof is
curiously "external": the presumed date of the pictures. Pre-
sumed, for only one of the three pictures bears "Vincent 87," if
you regard that as a proof. At this presumed date, Van Gogh was
in Paris, far away from the peasants! Therefore he could not have
painted peasant shoes! This triumphant conclusion would already
be enough to cause astonishment. But Schapiro raises his bid even
more: therefore he painted his own shoes! The piece is knocked
down, the expert has concluded, the stalls are silent.

What has happened? The expert has alternated two types of
argument. At times he has appealed to an internal description
while conceding that, even in Paris, Van Gogh could paint shoes
which he "had worn in Holland." The date no longer plays a part,
only the form, about which Schapiro seems to claim that it ex-
cluded peasanthood. But if Van Gogh could paint shoes from the
past, and if it is not proved that the form is exclusively of the
city, why would he not have painted peasant shoes in Paris? In
truth, the internal argument is valueless. For two reasons: because
it is an *insufficient* internal argument (there are peasant shoes
like this, in general and in all of Van Gogh's work), and because
it is insufficient insofar as it is an *internal* argument (there is no
sense in drawing from it a conclusion about *external* belonging,
to a real subject outside the picture). At other times the expert
appeals to an external argument, the date, and then he wants to
have us believe that once in Paris Van Gogh could no longer paint
peasant shoes or any shoes other than his own, or the shoes of
nobody. A doubly unacceptable allegation, which presupposes first
of all that Van Gogh was not a peasant, was no longer a peasant,
could no longer identify, however little, however partially, not
even with the tips of his toes, with peasanthood. If this has any
meaning, it is false, as you can demonstrate, and I reserve that
demonstration for later. The same allegation presupposes also that
after his departure from Holland, or in any case after 1887, Van
Gogh ceased to be interested in the peasant world. But even if it
were not gratuitous *in itself*, this stupefying hypothesis is denied
by a letter which Schapiro himself quotes immediately after-
wards: "A second still life of 'Old peasant shoes' is mentioned in
a letter of September 1888 to the painter Emile Bernard, but this
one does not have the characteristic worn surface and dark interior

of Heidegger's description." Nothing works anymore in the logic
of this paragraph. If it were a matter of *proving* something here,
then the letter proves that Van Gogh could paint and had in fact
painted peasant shoes after 1886. So if the shoes mentioned in
the letter do not look like the ones that Heidegger describes (if
he *is* describing a picture), the pictures retained by Schapiro as
pieces of evidence could well, on the other hand, represent peasant
shoes. Hence the one that corresponds to Heidegger's "descrip-
tion" (worn-out surface and dark interior) could well also repre-
sent peasant shoes. Nothing can in any case prove the contrary.
The expert has contradicted himself and his argumentation, by
trying to prove too much, carries itself away. At the moment of
restituting a kettle[20]

— This is an investigation that smells of the police. This
reasoning around a pair of stolen or hijacked shoes is all the more
understandable as coming from a private detective, a Dupin who
wants finally to return the thing, to give back the shoes[21]

— *the* shoe, perhaps, the double of the shoe which has made
a pair for itself, [22] the double's shoe. The spectral analysis of the
internal separation of a pair, as I was proposing a moment ago, in
five points, if—

— from a Dupin who wants to give the thing back to the
rightful owner, to do homage with this restitution (adjusted to
the shoe size of the princess), letting himself be trapped in turn,
the more easily, I was saying, because this police discourse is
fussing around nothing, all in all, remainders of nothing, vestiges,
traces with neither presence nor absence on a soil without ground
or on a foundered subsoil. *Fort, Da:* the shoe size plays with the
comma.

— Elsewhere it's been written that it *can* always *not* arrive
at its destination, it can always not *return* to port (*au port,* to a

20. Cf. Freud's reference to the joke about the borrowed kettle, in
Jokes and Their Relation to the Unconscious, Pelican Freud Library, vol.
6 (Harmondsworth: Penguin, 1976 [1905]), 100, 266–67.

21. *Rendre la chose, remettre les chaussures:* also, to give a ren-
dering of the thing, to put the shoes back on.

22. *Se faire la paire:* colloquially, to "clear off," to "beat it"; cf.
Derrida's use of *se tailler* in "Parergon."

wearing]. That's what the condition of *revenance* is like. In "The Purveyor of Truth," replace the literal "letter" by a "shoe" and you will read: "This is what loses and risks, without guarantee of return, the restance of anything whatsoever: a shoe does not always arrive at its destination, and once that belongs to its structure, one can say that it never truly arrives there, that when it does arrive, its possibility-of-not-arriving torments it with an internal drift." One can fit this statement to the divisibility of a pair. No more than a letter, a pair is not indivisible.

— That's why, not speaking merely as a policeman but above all about police discourse, I did not say, like Heidegger, *they are* peasant shoes, but against him: *nothing proves that they are peasant shoes* (Schapiro's only incontestable proposition, in my view); and I did not say, like Schapiro, they are the shoes of a city dweller and even of Van Gogh, but against him: nothing proves or can prove that "they are the shoes of the artist, by that time a man of the town and city." Each time you read "they are clearly . . . ," "this is clearly . . .," "are evidently . . .," it does not signify that it is clear or evident, very much the contrary, but that it is necessary to deny the intrinsic obscurity of the thing, its essential crypt, and that it's necessary to make us believe that it is clear quite simply because the proof will always be lacking. "Clearly" and "evidently" bear first of all on the restitution of the shoes to Van Gogh, on the *ownership* of the shoes which supposedly revert [*reviendraient*] to him as his sole property (they are less prone to be fetishized as the thing of the other, something other, something else, for being old, familiar, worn, shaped to the foot, stained). I underline: "They are *clearly* pictures of the artist's *own* shoes, not the shoes of a peasant . . ." " '*a pair of old shoes*' which are *evidently* his *own*. . . ." Further on, "clearly" ensures the identification, this time, of a picture on the basis of a letter from Heidegger which made a surprising trajectory. We could speak of it as a prolonged diversion. "In reply to my question, Professor Heidegger has kindly written me that the picture to which he referred is one that he saw in a show at Amsterdam in March 1930. This is clearly de la Faille's no. 255 (see figure 1)." Why is this clear? Nothing is said about that. Is it because the catalog of this exhibition excluded any other possiblity? Then why not say so? In that case the whole of the improbable and laborious demonstration that precedes would have been superfluous. And into the bargain, even if, setting out from Heidegger's reference (in his

letter) to his reference (in his text) as identical to the reference
(in his visit to the exhibition of 1930), even if these references
were superimposable and left no doubt as to *this* picture (De la
Faille no. 255), it would still be necessary to prove (1) that all
peasantliness (if something of the sort existed in the matter of
such shoes) was excluded from it, and (2) that these shoes were
those of Van Gogh. But what we have said about the preceding
paragraph ruins all possibility of proof in this regard.

His certainty seems all the more peremptory in its precision
because immediately after having identified *the* picture, Schapiro
has to evoke the possibility of a contamination between certain
traits belonging to two paintings in Heidegger's reference: "There
was also exhibited at the same time a painting with three pairs
of shoes (6 no. 250), and it is possible that the exposed sole of a
shoe in this picture inspired the reference to the sole in the phi-
losopher's account. But from neither of these pictures, nor from
any of the others, could one properly say that a painting of shoes
by Van Gogh expresses the being or essence of a peasant woman's
shoes and her relation to nature and work. They are the shoes of
the artist, by that time a man of the town and city" (Schapiro,
p. 205). Identification (in all the senses of this word, and they are
numerous), attribution, reappropriation: desire no longer has any
limit. *First moment*, first demand: Schapiro considers the picture
to be a "copy" and ignores an elementary structural law in in-
ferring relations of property in the "reality" external to the paint-
ing, in the alleged model of the copy: not only, he says, does it
not come back to peasant or peasant woman (and this is to jump
too quickly, concluding from the improbable to the excluded) but
they come back to a man, to a man who is a painter, to a painter
who is the signatory of the painting, proprietor of his signature
as much as of his shoes, which here *come back to the same* (*thing*).
Second moment, second demand: since this is not enough for a
perfect restitution, the *real* wearer-holder-proprietor-signatory (so
many accumulated values, so much augmented capital, for these
meanings are added onto, not confused with, one another) of the
painted shoes must be more defined, the shoe size must be more
rigorous and the thing more securely fitted. The man to whom
you're returning his goods must also be "man of the town and
city." And this must, at a given moment ("by that time"), fix him
in his essence, for, otherwise, why wouldn't he have played the
peasant while living in the city? As if Van Gogh could not be from
town *and* country, as if he could not keep in himself something

of the peasant (or keep with him some peasant shoes: what exactly is that?) once he had become provisionally a city dweller! As if he could not paint peasant shoes while wearing town shoes! As if he could not paint, with his brushes, in bare feet! As if one painted shoes with one's shoes! For that is the third demand and the *third moment:* thus defined, the *real* proprietor, etc., of the *painted* shoes (an epithet which retains or produces the whole ambiguity of the relation between model and image) must be situated substantially in time and space. Once you've thought you could identify the picture that Heidegger meant, once you've attributed its subject (certain determinate shoes) to the subject (wearer, holder, proprietor, signatory artist, man, city dweller), it is still necessary that the painter, present *in a certain city on a certain date,* should have been unable to paint anything other than town shoes, the nearest ones (*Da!*) possible. Shoes painted *starting out from* shoes worn, which therefore *do not start out,* or at least don't go far, and are already back. Where? There. Where is there? There, look, here, here right now.

— And yet. Just like Heidegger, whom he quotes with irony on this point, Schapiro rules out the possibility that there might be the slightest "projection" on his own side. Sure of having scientifically determined the content and the origin of the painting (town shoes as the personal object of the painter), Schapiro has an easy time denouncing Heidegger's identificatory projection: Heidegger has annexed the shoes to his social landscape and hypercathected them with his "heavy pathos of the native and the countryman." He has done the very thing he was guarding against: he has "imagined everything and projected it into the painting."

— It's a hallucination, in short. What we're talking about [*nous nous entretenons*] here is hallucination in painting. Does painting have to let a discourse be applied to it that was elaborated elsewhere, a discourse on hallucination? Or else must painting be the decisive test of that discourse, and its condition?

— Several remarks here. Yes, hallucinations and ghosts. But what does that mean? There are many reasons for mistrusting the concept of "projection," as manipulated by Schapiro. What is a projection in painting? What are the limits of a projection? What is it forbidden to project and why? What is an experience without projection? Doesn't this concept of projection belong to an ob-

jectivism, or at least to a system of subject-object relations or of truth (as adequation or as unveiling, as presence in representation or in presentation) which can no longer stand up to the effects of the unconscious, as determined by a certain state of psychoanalytic theory, and especially not to the remainder-structure whose graphics interests us here? Nevertheless, let us take for the moment this concept of projection or of imagination as used quite easily, all in all, by our two correspondents—the one in order to oppose to it the presence of truth in painting as *alētheia*, the other the faithful and mimetic representation, which is true because adequate to the object. Then there might be more hallucinatory projection in Schapiro's own recognition of the picture than he says. We have just demonstrated that nothing in this picture allows us to *see* the shoes, still less the feet or the whole body of Van Gogh the man of the town, Van Gogh in Paris, etc. Conversely, there might (and I do mean "there might") be less of it in Heidegger's "vision" than Schapiro says. For in his case the risks of projection will have been attenuated for the reasons which we developed at length a moment ago concerning the very structure of the reference to the picture in *The Origin*. I shall not return to that but I will here add an argument. It concerns the moment when, with no possible doubt, Heidegger speaks of *the* picture and says imprudently "a pair of peasant shoes." The imprudence and the risk of projection are incontestable, as incontestable as they are on Schapiro's side. But at least one circumstance can attenuate them on Heidegger's side. This attenuating circumstance stems from the context. From the scripturo-pictural context of Van Gogh. It does not only consist in the large number of peasants and peasant women, of peasant shoes (untied or not, and whether or not they are named, declared, or entitled accordingly) which Van Gogh painted, before *and after* 1886; in the large number of scenes and objects from peasant life which he stubbornly wanted to restitute in painting and in truth ("that it should be a true painting *of peasants. I know that is it.* . . . By such paintings, they *learn something useful.*" From letters to his brother Theo, 1883—85; these letters are full of invective against the "city dwellers"). No. It consists in this: the "ideology" which Heidegger is accused of projecting, an "ideology" which to save time we could call rural, of the soil, earthy, artisanal, this "heavy pathos of the native and the countryman"—is it so alien to Van Gogh? To the Van Gogh who said, "When I say that I am a painter of peasants, it is indeed truly so and you will get a better idea from

what follows that it is there that I feel in my element"? These
signs (painting and writings about painting) are too abundant and
too well known. Let us not misuse them. Peasant *and artisanal*
"ideology" in painting, concern for truth in painting ("But truth
is so dear to me, and so is the seeking to make true, that indeed
I believe, I believe I would still rather be a cobbler than a musician
with colors"), that is what he shares with Heidegger, even if *his*
"truth," at least in his *discourse*, remains representational. Let
us not abuse this argument, but let us recognize that Heidegger's
hallucinatory projection, if there is one, is motivated by this iden-
tificatory support. One must, of course, explain why Heidegger
needed to choose a particular type of object (a product said to be
"useful" as a garment, and this particular garment), a particular
type of picture, this particular painter, in order to say what he
intended to. He couldn't have said the same thing just as easily
with other objects, with other painters, with other shoes, those
of Van Eyck, Miró, Magritte, or Adami. Of course you have to
analyze the choice, and the limits, of the exemplary model for
such a discourse on *The Origin of the Work of Art.* And you have
to ask analogous questions about Heidegger's poetic models. But
still what remains is that the risks of projection were more lim-
ited. The "projection" is at work in the choice of the model rather
than in the analysis of it, once the exemplary corpus is that of
Van Gogh. A certain analogy between Heidegger and Van Gogh,
whatever its limits from other points of view, a certain com-
munity of "pathos" paradoxically provided a support for identi-
fication which reduced by so much the risks of "projection," of
hallucinatory delirium. The "pathetic" paragraph on the silent
call of the earth is consonant, in another correspondence, with
this or that letter of Van Gogh.

— I should like to go further. No longer in order to shield
Heidegger from Schapiro's verdict or to find "attenuating circum-
stances" for him. But to bring out, beyond Schapiro's *three de-
mands,* a wave of supplementary identification. Supplementary
since identification, like attribution, has a *supplementary* or *par-
ergonal* structure. And supplementary because this demand for
reattachment is by definition insatiable, unsatisfied, always mak-
ing a higher bid. It always starts out again, it puts more on each
time. After having, in a defensive and critical mode, contested
the right of agricultural property claimed by Heidegger, Schapiro
passes over to the general offensive. The offensive is unleashed

with the following question: does Heidegger's error (the demon-
stration of which is taken for granted) stem simply from a bad
choice of example? No, it is rather that he was unable to analyze
his own example, and even if he had been right to "see" peasant
woman's shoes, he would have missed the essential thing, "the
presence of the artist in his work." Here it is: "Is Heidegger's
mistake simply that he chose a wrong example? Let us imagine
a painting of a peasant woman's shoes by Van Gogh. Would it not
have made manifest just those qualities and that sphere of being
described by Heidegger with such pathos? Heidegger would have
missed an important aspect of the painting: the artist's presence
in the work." From this moment, the reappropriation of the shoes
by his own Van Gogh will have no more limits, for Schapiro. At
the end of the offensive, we will no longer be dealing with a
detachable personal object (a personal item or a piece of the body),
an object in short which would belong to Van Gogh without being
confused with him, even if it were a phantom member. We would
be *in the presence of* Van Gogh himself. The painting would man-
ifest the "presence" of the artist himself in his "self-portrait," not
only "a piece of his own life" but a nondetachable piece and one
which therefore drags his whole body with it, one of those "things
inseparable from his body" and even from his upright, "erect"
body ("the erect body in its contact with the ground"): the step
of Van Gogh returning [as a ghost], *passing* into the picture. Be-
tween the body of this passerby and the shoes, between his feet
and the shoes, between the two shoes themselves, in the *pair*, no
more separation is possible. The real referent of the picture, the
model which was so ingenuously attributed up to now to the
copy, has now grown to take over the totality of the subject.
The title of the picture, its legend: *Hoc est corpus meum.* One is
encouraged to make this deciphering: Van Gogh gives himself,
gives himself to be seen, makes the sacrificial offering of his flesh
in giving his shoes to be seen. And Gauguin, quoted by Schapiro
in conclusion, would confirm it: he has in front of him the "vision
of the resurrected Christ," "the vision of a Jesus preaching good-
ness and humility."

No more detachment: the shoes are no longer attached-
to-Van-Gogh, they *are* Vincent himself, who is undetach-
able from himself. They do not even figure one of his
parts but his whole presence gathered, pulled tight, con-
tracted into itself, with itself, in proximity with itself: a
parousia.

Is it, then, a paradox or a necessity of what was called "correspondence"? Yet the moment when Schapiro seems to oppose Heidegger most radically is also the moment when his procedure most resembles that of his opposite number. How is this mediated identification produced?

So the great offensive begins at the moment when Schapiro pretends, as a tactical concession, to imagine peasant woman's shoes painted by Van Gogh. In order to show that even in this case Heidegger would have missed the essential, the presence of the artist in the work, he has to rediscover the traits of Vincent in the body of the peasant woman: Vincent as a peasant woman. Better still, the peasant woman Van Gogh in her/his shoes. This goes far but would be still more interesting if the protocols of this identification were different. But it matters little. It's now a question of putting a face on (into) the shoes, the face of the signatory. *Vincent Van Gogh fuit hic.* What Heidegger allegedly neglected, ignored ("overlooked"), is the "personal" and the "physiognomic" aspect of these shoes. Unlike the wooden clogs which he painted at other moments (peasant clogs, clear, clean, and with no trace of wear, therefore impersonal), unlike the leather slippers (peasant slippers, seen from behind), here he shows the shoes *face-on,* coming toward us, looking at the spectator ("as if facing us"), staring at us, a staring or stared-at face, with individual traits, wrinkles, a "veridical portrait of aging shoes." Somewhat as one would say "portrait of an old man," or better, to extend Schapiro's intention: *a portrait of the artist as an old thing.*

The reattachment is so tight (absolute) that it is effaced or absolved: the painted shoes are no longer only the real and really present shoes *of* real and present Vincent; they do not only come back to his feet: they *are* Vincent Van Gogh from top to toe. *To shoe* equals *to be:* you should restitute the full consequences of that.

The top: that's where Vincent signed a self-portrait, and illustrated his signature, subject of the painted shoes, and if in this self-portrait he hid the feet, it would not have been in order to abandon empty (*restant*) shoes but because these shoes *are* the face of Vincent: the leather of his aged, wrinkled skin, loaded with experience and weariness, furrowed by life and above all very *familiar* (*heimlich*). If the haunted shoes are without feet, it would not be in order to remain, detached (untied), lower than the soles but to be, higher than any member, absolutely reattached: the point of attachment here is another neck. It elevates

up to the face/figure, it transfigures. The transfigured shoes are in a state of levitation, they are the haloes of themselves. Don't look down any more, toward the low or the very low (the feet, the shoes, the soil, the subsoil) but once more (follow the peasant woman) look up, toward the most high, the face facing you, the Face. We could get the impression that we're at the other pole, in relation to *The Origin*. Heidegger was pulling toward the bottom, the earth, the abyss, etc. Now toward the face of subjectivity. And yet.

And yet, despite or because of this maximal opposition, the words enter into connivance, they begin to resemble each other strangely, to send back each other's image, to be identified by more traits than one. Of course, the identification will not be complete and the correspondence will have its limits. Like any pair. And yet, when Schapiro opposes this self-portrait to Heidegger, his accent recalls that of *The Origin:* "Yet Van Gogh is in many ways like the peasant; as an artist he works, he is stubbornly occupied in a persistent task that is for him his inescapable calling, his life . . . that part of the costume with which we tread the earth and in which we locate the strains of movement, fatigue, pressure, heaviness—the burden of the erect body in its contact with the ground. They mark our inescapable position on the earth."

— Yes, there is indeed this return to the earth and this concentration of a world of the artisanate in the shoes, peasants' work, etc. It is the same "pathos." But Schapiro's statements take their authorization from the analogy between the painter and the peasant. This is not the case with Heidegger.

— It's not so certain, or so simple. This analogy is of course above all a theme of Van Gogh: I am a peasant, I am a cobbler, I belong to this world, and when I paint myself, so often—

— Shall we not take the fact that Van Gogh so often says and paints "me" as an "attenuating circumstance" for Schapiro this time, as with the painter's "peasant" ideology for Heidegger?

— Nobody's being accused, or above all condemned, or even suspected. *There is* painting, writing, restitutions, that's all. Who among you knows Van Gogh? Does anyone here know Heidegger? Goldstein? Schapiro? This square—

— In a way, when Heidegger in *The Origin* proposes to go back behind the late-arrived opposition between the artist and the artisan (the manual worker) and to rethink the *technē* or the *technitēs* (we will touch on this later), he too moves into this space of the analogy between the painter and peasant. To answer this question, you will have to make up your minds to read that passage that I have been announcing for a long time, on the signature, the trait, and attraction.

— Suddenly here we have everything seeming strangely in consonance between Heidegger and Schapiro. Isn't this worrying?

— The consonance is interrupted every time Schapiro says "self," "self-conscious," "self-awareness," "own," "portrait": he puts everything down to a self-consciousness, to a subjectivity to which Heidegger never trusts himself without question, and which he always interrogates as an epoch of metaphysics: the one that, since Descartes, tries to secure for itself, in subjectivity, a *ground* of certainty (an unshakable rock or pedestal on which this time the adhering sole no longer slips). Let us say in this connection that Schapiro gets it wrong when he speaks of a "concept of the metaphysical power of art" which remains a theoretical idea, attributing all that to Heidegger. That is the very thing that is put in question in *The Origin*, in a systematic way. And it's not certain that you would find more traces of it in Heidegger than in the majority—at least—of the theorists of painting. Metaphysical presuppositions seem to me to be more present and more determinant in, for example, Schapiro's *Note*.

— What has just been said about the shoes as a portrait of the painter-peasant-at-work might confirm the suggestion from a moment ago: the shoes are there in painting, they are *there for* (figuring, representing, remarking, de-picting?) painting at work. Not in order to be reattached to the feet of somebody or other, in the painting or outside it, but there *for-painting* (and vice versa)

— painting at work, like the painter in action, like pictural production in its process?

— *for what there is of pictural restance*, a formulation which cannot be reduced to any of the others but which I must abandon here to its ellipsis. Its thread is pulled from elsewhere.

— I had barely begun to read this second part of Schapiro's
Note, this identification with his adversary.

There is that reference to Knut Hamsun describing his own
shoes. Schapiro opposes him to Heidegger. Notably when Hamsun
writes: "They (my shoes) affected me like the ghost of my other
I—a living part of my own self." To conclude from this, as he
seems to do and as Schapiro in any case hastens to decide, that
"my other I" is myself, is *I,* and especially that its ghost is *I,* you
really have to have your fingers stuck in your ears. What is "my
ghost"? What does the phrase "the ghost of my other I" say? My
other I, is that myself or an other I, an other who says "I"? Or a
"myself" which is itself only divided by the phantom of its dou-
ble? Once there is phantom or double as revenant, the logic of
identification—is there any need to insist on this?—is not so
easily appeased as Schapiro seems to think. If I say: these shoes
are the ghost *of* Van Gogh, of the other ghostly I *of* Van Gogh, the
oscillation of the genitive translates all by itself the malaise, the
Unheimlichkeit of the thing: the ghost *of* Van Gogh as the one
who *he is* or as the one whom *he has* in him or in front of him
and who is haunting him—an other, therefore: the phantom (who
is an other) in himself as the ghost of an other, etc. . . .

— But then what about the haunting of these shoes? *Are* they
a ghost (a piece of ghost, a phantom member)? In that case are
they the ghost of Van Gogh *or* the ghost of the *other I* of Van
Gogh, and what does the *other I* mean then? Or else, *without
being* a ghost themselves, do they *have* the ghost, are they the
propitious place for having, bringing back, taking, or keeping the
ghost, and which one? His own or the ghost of the (detachable)
other? Of the unconscious of the other?

— We will not answer that question here but we must see
how it is linked to that of the pair which for a while now you
haven't wanted to listen to. A spectral analysis of the *two* of the
shoes should tell us how they go: whether they go together and
in that case how, and whether they *go* on *to* the feet and in that
case how. *To go with* in the first case, *to go on to* in the second,
but *to go on to* doesn't mean to *render* themselves *to* (such-and-
such a place). In order to *go,* in both cases, to *go together* or to
go on to, two shoes must make a *pair;* this is one of the indis-
pensable conditions. In principle. But as soon as they are no longer

going anywhere, as soon as they are detached, abandoned, unlaced, they may no longer be a pair. The pair separates. What is then the spectrum of possibilities of the possibility of specters?[23] The shoes can be unpaired, each of them can belong to another pair by which they continue to let themselves be haunted. But in this first case of unmatchedness, things can still function [aller] or at least walk [marcher] if the shoe size and the double orientation (right and left) permit. That is a first possibility, almost "normal," although the unpairedness, indicated by other traits, makes limp or squint the disturbed experience that we have in this case. The second possibility: one single shoe. We've already spoken about it. Is it a pair that's had part of it amputated? Is it one shoe amputated from the pair to which it belongs? Is it haunted by the other one? Triumphant and sovereign, alone at last, and capturing for itself the whole of the fetishist investiture? Or the narcissistic investiture? Is it the better-collected double of the dead man or the dead woman? The erection of the limp? The elimination of the double? The misery or monumental sovereignty of the unusable? All these investitures are possible, they remain, open to the syntax of all the specters. The third possibility (I'm sure I'm going to forget some): two right shoes or two left shoes. They cannot be put on, or used, in principle. In any case they do not go together without injuring the wearer, unless he has the feet of a monster. But the two shoes, now detached from wearing and use, reflect each other better. Each one is strangely the double of the other. The accumulation of haunting here finds a supplementary benefit, for it can combine the preceding possibilities, prop them up, augment them. This third possibility divides in two: (1) the two right shoes or two left shoes can belong to two different pairs, and thus to an origin that continues to inhabit them even if they are detached from it. Each one of these pairs is separated from itself but leaves its mark on each shoe. It is recognizable, and this difference between the two right shoes or the two left shoes manages to break up, a little, their air of being superimposable and therefore disturbing, limping, and suspicious; it initiates a repairing which is very quickly inhibited. (2) The two right or left shoes are exactly alike, for they belong to two pairs (separated one from the other and from themselves) which have no difference between them except a numerical one. You would think you were seeing double: two perfectly identical unique

23. Le spectre means both "spectrum" and "specter."

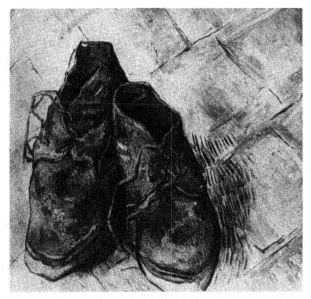

The Shoes.

things. A hallucinogenic fiction. They can't be paired, or compared, or bet on. For a bet always come back to a *comparing*. Furthermore, there has to be a difference which would permit it. But what about when there is no longer any difference? Shall we then say, as we've just done, that to bet becomes impossible? Or on the contrary: that the only thing left to us to do is to bet? That *there is nothing else for it* but to bet? In the case of the shoes, being a pair would fix everything up, inasmuch as the *being-with* of the two individuals (incomplete complete things, whole or parts) does not suppress a difference, but on the contrary preserves it, presupposes it, and sublates it. This difference essentially comes down to [*revient à*] orientation alone (Kant's whole transcendental aesthetic is at issue here) and only to the orientation of a "body proper." *Comparison* in this other sense is possible, then: (no)more bets [*plus de pari*].

— (No) more bets?

— You would say, then, that Schapiro, Heidegger, and a few others, when in front of the picture, very reasonably had a bet on the pair? That they gambled on the pair? And that they did so— (no) more bets—in order to avoid the risks of betting? Which they did not succeed in doing, since you have to reckon with the wager of the unconscious or the unconscious of the wager, if you prefer. Still (no) more bets. With the result that the trap always works in the interlace, or else causes to work/walk, lets walk, or paralyzes. (No) more bets, no bet, a betting step [*pas de pari*]. They bet on the pair, on comparison,on a wager that limits the risks of the *absolute* wager, which limits *itself* and *tightens itself* to the point of self-strangulation. To the point of tying itself so as not to absolve itself. For the cunning twist stems from the fact that the *absolute* bet must never exclude the disparate or *absolute* unevenness [*l'impair*]. So they bet, for good or ill, against the possibility of betting. We'll call *disparate* that which opens up the *fort: da* of shoe size, the play of dis/appearing, to the possibility of dis-pairing. To have tricked fate [*Avoir fait marcher le destin;* also, literally, to have made it walk or work], and to have provoked someone to make an impossible bet: that is what remains of Van Gogh's coup, the genius of his unevenness [*son impair;* also, "his blunder"].

— I'll resume the spectral analysis of this disparateness. The second hypothesis, then, of the third possibility, two right or two left shoes which are not distinguished from each other except numerically. Each shoe is then the perfect double of the other; never was the pair more prevented. The double is all the more what it is

— *Doppelgänger!*

— for not going. It does not go with its perfect double. It is unadaptable: to the other, to the pair, to the feet, to walking.

That's the spectrum/specter. Have I exhausted its possibilities? Four or five of them, I don't know now, and I'm forgetting some, and leaving out the determinant syntax of the secondary variations, in particular that of the shoe sizes.

— But did this spectral analysis concern the real shoes or the shoes in painting?

— The ones that remain, according to the restance of which I speak. The spectral character of the analysis defies the distinction between the real shoes and the shoes in painting. It does not efface it, but defies and doubles it. The spectral analysis concerned, "in truth" they would say, but doubling truth also, the relation of the "painted" shoes to the "real" shoes. They do not make a pair, and would do so even less to the extent that the simulacrum of the double attained a hallucinating perfection. The relation of haunting which preoccupies [*travaille:* works or shapes, torments] the unpaired (and hence the pair) is irreducible to all the mimetologism (I don't say the *mimesis*) which reigns in philosophy or in the philosophical (i.e., sometimes scientific) theory of painting, is not reducible to all its oppositions, to all its pairs of categories. For a pair functions/walks [*marche*] with symmetrical, harmonious, complementary, dialectical oppositions, with a regulated play of identities and differences.

— But doesn't the de-paired (the *disparate*) allow us the better to bring out truth, the parity of the pair, the pair's or the couple's relation to itself

— that's not exactly the same thing.

— the better to think the pair as such?

— the better to think of its repair, no doubt, to dress the wounds [*panser*],[24] to bandage/to get a hard-on, there where the double(s) bind(s)/bandage(s)/get(s) a hard-on

—Let's leave the spectrum/specter of the uneven there. When you want to speak of the shoes that remain, there are many of them, for example, multiplicities of more or less odd pairs, as in that other painting by Van Gogh (*Three Pairs of Shoes*, one of which is fully upturned and exhibits its underside), but you have to know how to stop. Is it possible? The disparateness or the unevenness is that *there is* always one shoe more, or less: a third one or a first one. We were speaking about Knut Hamsun, impressed by his old shoes like "the ghost of another I." Did Schapiro know that Hamsun is also a precious reference for Heidegger? And that there is yet another trait of identification between the

24. A play on the homophones *penser/panser:* cf. note on Derrida's play on *pansable* in "The *Sans* of the Pure Cut," above, p. 88.

correspondents? Hamsun is quoted, for example, in the *Intro-
duction to Metaphysics.* And a few pages before this other allusion
by Heidegger to a "this picture by Van Gogh"—a very brief al-
lusion, this one, picked up in a footnote by Schapiro, who could
read in it at least a critique of the mimetic re-presentation of a
model: "This picture by Van Gogh: a pair of rough peasant shoes.
The picture does not properly represent anything (*Das Bild stellt
eigentlich nichts dar*). Yet what *is* there (*da* ist) is what one is at
once alone with, as if, oneself, one autumn evening when the last
potato fires are glowing, one were returning from the fields with
one's pickax, weary, toward the house. What is there being [*Was
ist da seiend:* you must not, as all the translations do, interfere
with this syntax, at risk of distorting the essentials]? The canvas?
The brushstrokes? The spots of color?"

Is it the same picture as in *The Origin?* How can this be
decided? Heidegger's quotation from Hamsun has no direct re-
lation with the picture or with the shoes, as was the case with
Schapiro's. And yet: it belongs, in the *Introduction to Meta-
physics*, to the same movement as the brief allusion we've just
read to a picture by Van Gogh. The point is to free the question
"what is the being of the existent?" Van Gogh's picture is one of
the examples of what *is* there (*da*), of the existent, of what *is*, of
what is *present*, hence *there* (*da*). It comes beside other examples
of a different type but which have in common that they *are there,*
as existent (the school building, a mountain range, the portal of
a Romanesque church, a state, etc.) but of which it is difficult to
say wherein the being of the existent consists which enables us
to say each time that the existent *is.* That which is, as the being
of this existent, is not (the existent). A certain thinking, a certain
experience of nothingness (of the nonexistent) is required for ac-
cess to this question of the being of the existent, likewise to the
difference between being and the existent. We must go very fast
here. This thinking of nothingness is alien to science, which deals
only with existents. It belongs to philosophy or to poetry. Hamsun
is invoked as a poet who opens himself to the thinking of noth-
ingness, in "this veritable discourse of Nothingness (*wahre Rede
vom Nichts*)" which "remains always strange (*ungewöhnlich*)."
Hamsun is here as for Schapiro the poet of strangeness. The ghostly
is not far away. The relation which unsticks being from the ex-
istent without making something else of it, another existent, but
merely a nothingness, a nonexistent which is there without being
there as being present, this relation has some connivance with

haunting. *Unheimlichkeit* is the condition—take this word however you will—of the question of being, of its being-on-the-way, inasmuch as it (does not) pass(es) via nothing. In *Zeit und Sein*, the experience which relates presence to absence (*Anwesen/Abwesen*) is called *unheimliche.*

— "Ousia and Grammē," which has this passage as its exergue, also speaks of a *pivot of the essence.*

— And there is in Heidegger's quotation from Hamsun a "hole" (*Loch*) which is "not even a hole," like that "hole" (also *Loch*) of Kant's, which led to thinking, in "The *Sans* of the Pure Cut," with and without Kant, a *sans* without lack, "without negativity and without meaning," a nonnegative *not without.*[25] Do we see this *pas sans* or another one in these shoes? There is not even a hole in them.

— Here is Hamsun quoted by Heidegger. Is it a different one from the Hamsun who haunts Schapiro's "Still Life"? He speaks of two ears, of a pair of ears perhaps, apparently undetachable, but whose *being-double* permits the stereophony of the void to let itself be heard. A rumor without origin, nothingness is there without being there. You have to be sitting between your ears (how is it possible?) in order to hear. "The poet says: 'He is seated here between his ears and he hears the veritable void. Completely comic, a phantasmagoria (*Hirngespinst*). On the sea (A. often used to go to the seaside formerly) something (however) was waving, and there was (*gab es*) over there (*dort*) a sound [*Laut:* between noise and voice], something audible, a choir of the waters. Here— nothingness encounters nothingness and is not there (*ist nicht da*), is not even a hole. One can only shake one's head as a sign of giving up [of surrender, resignation: *ergebungsvoll*].' "

— I've returned late; I had to leave you on the way. Did someone answer my first question? Who was it, I don't remember now, who said, "There are no ghosts in Van Gogh's pictures, no visions, no hallucinations. It is the torrid truth . . ."?

— That was Artaud protesting against another way of "suiciding" Van Gogh (*Van Gogh, le suicidé de la société*). This al-

25. *Un* pas sans *pas négatif:* also, "a *not without* a negative step," and "a nonnegative 'step without.' "

legation of ghosts and hallucinations is, according to Artaud, a maneuver by society, delegating its psychiatric police

— but "to suicide" someone, isn't that to make him come back as a ghost or to make him stay, as a ghost, where he is, in short, pretty well buried, having only his "nots" left? Not a revenant. Not a name.[26]

— It's to his name that Van Gogh returns [se rend].

— According to Schapiro, Van Gogh (alias J.C.) rendered himself in his shoes. In a self-portrait you render yourself. To yourself. We would have to annex the problem of narcissism to that of fetishism and go through the whole thing again, from the bottom. We'd never be finished.

— But "render" doesn't have the same meaning in the two phrases: to render oneself in painting and to render something to oneself, to pay oneself [se payer]

— here, to pay for his head,[27] or his ear, or his shoes, to himself. To go somewhere [se rendre quelque part] would be a third sense, that of the shoes, precisely. And to give in to someone [se rendre à quelqu'un], as in a surrender, would be a fourth sense. Van Gogh rendered his shoes, he rendered himself in his shoes, he surrendered with his shoes, he went in his shoes, he went back to his shoes, he surrendered to his shoes, he gave himself back his shoes, he paid his shoes back to himself.[28] All the meanings knot and unknot themselves in the lace/snare of this syntax.

26. Ne disposant plus que de ses pas. Pas de revenant. Pas de nom: also, "having only his steps left at his disposal. Step of a ghost. Step of a name."

27. Se payer used intransitively does indeed mean literally "to pay oneself": used transitively, it means "to treat oneself to something." The sense is complicated here by the colloquial idiom se payer la tête de quelqu'un, "to make fun of someone," which plays across the two paragraphs.

28. The translation offers a selection of possible readings of Derrida's exploitation of the verbs rendre and se rendre—the French reads, "Van Gogh a rendu ses chaussures, il s'est rendu dans ses chaussures, il s'est rendu avec ses chaussures, il s'est rendu à ses chaussures, il s'est rendu ses chaussures." It should be noted that rendre can also mean "to vomit."

— All these shoes remain there, in a sale, so you can compare them, pair them up, unpair them, bet or not bet on the pair. The trap is the inevitability of betting. The logic of the disparate. You can also try to buy the trap and take it home, as a tribute, or the way you think you're taking something away on the soles of painted shoes. All these shoes remain there—for he painted many, and despite the *pas d'idiome* one would like to pin down the very singular cause of this relentless effort: what was he doing, exactly?—as a tribute that cannot be appropriated. Can a ghost be attributed? Can one say "the ghost-of," if one can't say the shoes-of? There is no distributive justice for this tribute. The shoes are always open to the unconscious of the other. Rented out, according to an other topic or the topic of another. Rented out, in a cut-price sale, up for auction, being gambled-for, to be taken however you can, but never to be possessed, still less to be kept. You can only give them back [*rendre*] if you think you have them, and you can only think you're giving them if you haven't got them. When Artaud protests against the ghosts

— Be careful. He protests in the name of a certain truth, without subject, without object, tuned to a music which recurs often in his text (despite his "preference," because of it, Van Gogh is a "formidable musician" according to Artaud). We find interlaced there all the motifs of our correspondence. But what is a motif? And the apparent exclusion of the ghosts, of these and not those, is destined only to let the uncanniness return, the "sensation of occult strangeness." Listen to painting. It would "strip" us, according to Artaud, of the "obsession" of "making objects be other," "of daring in the end to risk the sin of *otherness*. . . ." Listen to painting: "No, there is no ghost in Van Gogh's pictures, no drama, no subject, and I shall even say no object, for what is the motif itself?

"If not something like the iron shadow of the motet of an unutterable antique music, like the leitmotiv of a theme despairing of its own subject.

"It is naked nature and pure sight, such as it reveals itself, when one knows how to get close enough to it. (. . .)

"And I know of no apocalyptic, hieroglyphic, phantomatic or pathetic painting which could give me this sensation of occult strangeness, of the corpse of a useless hermeticism, its head open, rendering up its secret on the executioner's block."

— So we'd again have to "render," in going our separate ways. And even in letting the matter drop.

— To render this secret yet legible right down on the level of the letter, the "useless hermeticism" of the crypted remainder.

— But separation is in itself already, in the word, in the letter, in the pair, the opening of the secret. Its name indicates this. So one would have to render this secret already legible, like a remainder of a useless cipher.

— You don't have to render anything. Just bet on the trap as others swear on a Bible. There will have been something to bet. It gives to be rendered. To be put back on/put off.

— It's just gone.

— It's coming round again.

— It's just gone again.[29]

29 The French here uses an untranslatable syntactic *combinatoire:* "—Ça vient de partir. —Ça revient de partir. —Ça vient de repartir."

Index

Lightning Source UK Ltd.
Milton Keynes UK
UKOW01f2306250817
307995UK00003B/7/P